ICONOLOGY OF CHARITY

ART&RELIGION

— Art & Religion 9 —

Iconology of Charity

Medieval Legends of Saint Elizabeth in Central Europe

by

Ivan Gerát

PEETERS
Leuven – Paris – Bristol, CT
2020

Cover image: Elizabeth cuts a sick man's hair, 1474–1477, panel painting, 126,5×81cm, Košice, cathedral and former parish church of Saint Elizabeth, Photo: Alexander Jiroušek.

A catalogue record for this book is available from the Library of Congress.

ISBN 978-90-429-4171-7
eISBN 978-90-429-4172-4
D/2020/0602/93

CONTENTS

INTRODUCTION

The legends of Saint Elizabeth of Hungary, also known as Elizabeth of Thuringia, are rooted in at least three different systems of representation, which may be tentatively labeled as religious, political, and artistic. Each of these systems uses narratives and images for its own purposes, but none has complete control of the situation in which the images were created. It is possible to say that these systems defined the basic coordinates of the power field in which the creative processes took place. This power field may be imagined as a triangle which is defined by three vertices providing religious, political and artistic viewpoints. Understandably, these vertices are not simple static points, but complex, dynamic, and interrelated systems. They had been created centuries before 1207, when Elizabeth was born to the Hungarian king, Andrew II and his wife, Gertrude of Andechs-Meran.[1] These circumstances influenced the life of the young princess. At the age of four dynastic politics caused her to be sent from Hungary to Thuringia. Later, she single-mindedly devoted herself to following religious tradition. Pope Gregory IX personally advised her to follow the examples of saints to attain eternal glory.[2] Both Elizabeth and the people who influenced her life were inspired by what they had seen and heard in the course of their education and personal experience with religious art. The saint's powerful imagination offered a significant contribution to contemporary spirituality. And once more, this energy was used by religious and political leaders for their own reasons.

[1] The up-to-date biography is O. REBER, *Elisabeth von Thüringen, Landgräfin und Heilige. Eine Biografie,* Regensburg, 2009, which is based on long-standing engagement of the author with the life of the Saint – O. REBER, *Die heilige Elisabeth. Leben und Legende,* St. Ottilien, 1982; O. REBER, *Die Gestaltung des Kultes weiblicher Heiliger im Spätmittelalter; die Verehrung der Heiligen Elizabeth, Klara, Hedwig und Birgitta,* Hersbruck, 1963. Numerous other biographies of Elizabeth reflect different historical perspectives, as well as the various spiritual, intellectual and literary ambitions of their authors. Exceptionally – as in the case of I.F. GÖRRES, *Gespräch über die Heiligkeit: ein Dialog um Elisabeth von Thüringen,* Freiburg, 1940, the biographical writing broaches substantial philosophical questions associated with the concept of sanctity. For an overview of the sources, accompanied by an edition and translation of the popular late medieval German vita of the saint see I. ARNSTEIN, *Das Leben der heiligen Elisabeth: die volkssprachliche Elisabeth-Vita "Der lieben Fröwen Sant Elysabeten der Lantgrefin Leben" – Text, Übersetzung und Untersuchung,* Marburg, 2013.

[2] A. HUYSKENS (ed.), *Libellus de dictis quattuor ancillarum s. Elisabeth confectus,* Kempten – München, 1911, p. 46 (line 1236-1238): "*...exhortans eam ad perseverantiam castitatis et patientie diversa exempla sanctorum ei proponens et eternam gloriam firmiter repromittens.*"

The most memorable moments of Elizabeth's exemplary life were recorded very early on. Written narratives on Elizabeth began to appear after her premature death on 17 November 1231. Some years later the accounts of her life were integrated into the corpus of hagiographic narratives, which were controlled and developed by the decisive forces of Western Christianity. Elizabeth herself acquired her status as an exemplary individual to be worshipped and followed. She became part of the very tradition that guided her personal life. On 7 June 1235, only a few weeks after her canonization, Pope Gregory IX wrote a letter commending the new saint as the perfect model example of virtues such as charity, humility, chastity, compassion, obedience, strength, and truth. The letter reflected Elizabeth's influence on the elite of European society. It was addressed to Queen Beatrix of Castille (also known as Beatrice or Elizabeth of Swabia, 1205–1235), the wife of the saintly king Ferdinand III.[3] In the leading circles of society musing on the saint's life was intended to provide an aid to self-reflection. Her image was understood as an unstained mirror, in which thoughts were visible, even those hidden in the recesses of consciousness, which might offend the eyes of God.[4] However, this untarnished image was created against a backdrop of political struggle against heresy; thus it was used as a part of some rather shady deals, too.

Since the pictorial legends of the saint are rooted in tradition their study must be supported by traditional iconography, which pays attention to the mutual interaction between images and texts.[5] The textual sources of the images discussed in this book have for the most part been identified by previous scholarship, but the material can be interrogated in more complex terms. The evolution of images goes beyond the sphere of pictorial images and interacted with contemporary life. Traditional images presented patterns which served to inspire authors of new images, but these images were also consciously used to define inspirational models of behavior. Thus, it is necessary to supplement traditional

[3] L. LEMMENS, *Zur Biographie der heiligen Elisabeth, Landgräfin von Thüringen*, in *Mittheilungen des Historischen Vereins der Diözese Fulda* 4 (1901) 1-24, pp. 2-6; O. GECSER, *Aspects of the Cult of St. Elizabeth of Hungary with a Special Emphasis on Preaching, 1231-c.1500*, Budapest, 2007, pp. 156-157.

[4] LEMMENS, *Zur Biographie der heiligen Elisabeth, Landgräfin von Thüringen*, p. 6: "…ut in hoc speculo sine macula frequenter aspicias, ne quid in angulis constientiae tuae lateat, quod oculos divinae majestatis offendat…"; D. BLUME – D. JONEITIS, *Eine Elisabethhandschrift vom Hof König Alfons' X. von Kastilien*, in D. BLUME – M. WERNER (eds.), *Elisabeth von Thüringen - eine europäische Heilige. Aufsätze*, Petersberg, 2007, 325-339, pp. 325 and 339.

[5] Comp. C. HOURIHANE – D.L. DRYSDALL, *The Routledge Companion to Medieval Iconography*, London, 2017.

iconography – in which descriptions and comparisons within the realm of images and their source texts predominate – with interpretative iconography, or iconology, which attempts to understand the fundamental role of images in the lives of individuals and societies. As stated above, the chief aim of the present investigation is to chart the position occupied by images within the space between three main systems of representation, which can tentatively be called religious, political, and artistic. Each of these systems provides a different perspective on images. Simultaneously, each one functions as a framework in which the rules and value hierarchies are defined. The values operating within the system, inspired many human lives. Some influential people, who may be regarded co-authors of this system, possessed a certain power over the imagination of their contemporaries. The expression of this power was mediated through works of art. They exerted an influence on both their ways of thinking and their emotional lives. This influence was neither entirely conscious nor unilateral. Nobody was fully informed about how these systems worked and nobody was influenced by only one of them. Although the rules and the hierarchies in each of the systems differed, there were always intersections and correlations. Each of the systems applied its rules and value hierarchies not only within its closest circle, but also continued to propose an evaluation of virtually all spheres of human life during the period. Thus, tensions existed between the requirements of these systems. These tensions, or even conflicts, defined the power field, which in several respects predetermined the possibilities to create, use and perceive the images.

As far as the religious system is concerned, the inspiration provided by traditional iconography can be explained as a part of the hagiographic discourse.[6] In this system the influential images were associated with rich explanatory models based on Biblical narratives, theological commentaries, and their narrative amplification through the impressive stories of other saints. The legends were repeated and explained in learned texts and in sermons delivered regularly to broader audiences. The story of Elizabeth's life was produced within this system which continued to influence the production of images, even if the saint herself claimed she needed no painted images because she carried them in her heart.[7]

[6] S. FLEMMIG, *Hagiografie und Kulturtransfer: Birgitta von Schweden und Hedwig von Polen*, Berlin, 2011, pp. 13-57.

[7] *"Non habeo opus tali imagine, quia eam in corde meo porto"* – HUYSKENS (ed.), *Libellus de dictis quattuor ancillarum s. Elisabeth confectus*, p. 75. See further H. WOLTER-VON DEM KNESEBECK, *Bilder in Büchern - Bilder im Herzen: die Landgrafenpsalterien im Kontext*, in C. BERTELSMEIER-KIERST (ed.), *Elisabeth von Thüringen und die neue Frömmigkeit in Europa*, Frankfurt, 2008,

Her life was inspired by the images she interiorized, as well as the ideals associated with them. Moreover, she developed a sensitivity towards the image and likeness of God, which – as stated in the book of Genesis – provided the model for each human being. According to religious writers of the period, for example Saint Bonaventure, this prototype occupied the highest position in the hierarchy of images. Manufactured pictures (*figurae artificiales*) were understood only as a shadow (*umbra*) or as a vestige (*vestigium*) of the Divine prototype. To understand exactly how this highest image is reflected in human existence more than mere natural senses, or imagination and intellect were required. A special spiritual sense (*sensus spirituales*), or a sensitivity of heart (*sensus cordis*) was necessary.[8] Irrespective of how disputable these philosophical ideas may be, it is an historical fact that Elizabeth developed an extraordinary sensitivity to the images and narratives belonging to the Christian tradition. She lived according to the ideals that inspired the theologians of her time; she was inspired by them in a unique, creative way, which was more practical than theoretical. As a kind of unconscious artist, she performed certain radical actions showing her contemporaries the practical consequences of adhering to the spiritual ideal in human life. Her life – part of the great spiritual tradition – was recorded as such. Subsequent generations had to deal with the narratives, written down by theologians. The spiritual authorities of the time were aware of how difficult it was for other people to understand the ideal aspects of her saintly life.

The images, which were created in the years following Elizabeth's premature death, reflect her saintly life in their own way and gained primacy in the same tradition. They were for the most part based on the testimonies recorded by the Papal commissioners who prepared the early canonization of Elizabeth (1235) and on legends written by pious clerics wishing to commemorate the new saint. Again, the traditional system of religious representation – the verbal and pictorial images of the early hagiographies – played a pivotal role in deciding what was worth recording and in what manner. The authors of textual narratives and

33-51; G. SUCKALE-REDLEFSEN, *Zwei Bilderpsalter für Frauen aus dem frühen 13. Jahrhundert*, in F.O. BÜTTNER (ed.), *The illuminated psalter*, Turnhout, 2004, 249-258, 521-524, p. 251; R. KROOS, *Zu frühen Schrift- und Bildzeugnissen über die helige Elisabeth als Quellen zur Kunst- und Kulturgeschichte, Sankt Elisabeth. Fürstin, Dienerin, Heilige*, Sigmaringen, 1981, 180-239, p. 181.

[8] S. BONAVENTURA, *Works of St. Bonaventure. 2: Itinerarium Mentis in Deum*, 2002; S. BONAVENTURA, *Works of St. Bonaventure. 2: Itinerarium Mentis in Deum*, 2002; see R. GOFFEN, *Spirituality in Conflict: Saint Francis and Giotto's Bardi Chapel*, University Park, PA, 1988, pp. 59-77.

images highlighted what was important from the perspective of the ruling system of spirituality while allowing seemingly irrelevant facts and circumstances to disappear. This merging of the historical and theological perspectives is typical of hagiographic memory informing the images.

At the same time the verbal images of the hagiographies and their material counterparts were a part of a highly charged political game, in which memories were negotiated or even contested.[9] The new narratives and images were inspired not only by the pious meditations of believers, but also the political considerations of their patrons. In the system of political representation lives of the saints became "some of the most polished weapons of an ideological struggle".[10] Religious authors lived in a society governed by various social norms and practices. Thus, the motivations and strategies of reasoning that shaped the verbal and visual images of the legends were not straightforward. Narratives could be used in a battle for temporal power as well as in the ongoing conflict of ideas whose duration surpasses the life of any human being. Elizabeth's cult was negotiated within the framework of complex interrelationships among the Papacy, Empire, religious orders, and their critics. The political and religious leaders attempted to manipulate the image of the popular figure for their own purposes. Thus, Elizabeth's images were used for individual, familial, and institutional self-representation as well as in the struggle against heretics, for improving monastic discipline, and taming social tensions.

The images of the saint were commissioned by the patrons who endeavored to define their own positions among the systems of representation which determined a constellation of powers in each historical situation. As the "empirical producers of communication" they often directed the meanings of images in a novel way.[11] The patrons mostly selected events from the saint's original life that carried the messages they wanted to convey to historical audiences of images. In so doing, an appropriate balance between traditional narratives and

[9] M. WERNER, *Mater Hassiae – Flos Ungariae – Gloria Teutoniae. Politik und Heiligenverehrung im Nachleben der hl. Elisabeth von Thüringen,* in J. PETERSOHN (ed.), *Politik und Heiligenverehrung im Hochmittelalter.* Sigmaringen, 1994, 449-540; G.B. KLANICZAY, *Holy Rulers and Blessed Princesses: Dynastic Cults in Medieval Central Europe,* Cambridge – New York, NY, 2002, 195-242. For similar theoretical insights concerning the recent history of the Central Europe see T. SINDBÆK ANDERSEN – B. TÖRNQUIST PLEWA, *Disputed Memory : Emotions and Memory Politics in Central, Eastern and South-Eastern Europe,* Berlin – Boston, 2016, 1-15.

[10] G. DUBY, *Love and marriage in the Middle Ages,* Chicago, IL, 1994, p. 37.

[11] A. PINKUS, *Patrons and Narratives of the Parler School: The Marian Tympana 1350-1400,* München – Berlin, 2009, p. 37, distinguishes between "empirical producer of communication", (fictional) narrator, focalizator of meanings, donor etc.

other important facets of contemporary life had to be found. This delicate balance was reflected not only in the images, but also through historical narratives and sermons, which directly addressed medieval audiences.[12] Thus the interpretation of the images should consider numerous crucial questions: Which events were selected, and why? How far was the spontaneous memory of historical witnesses influenced by the rules of the hagiographic genre? To what extent have the traditional *topoi* from older hagiographic traditions influenced the new textual and visual narratives?[13] As Elizabeth was a real person from an historically close period her images, which were a part of lively process of memorization, were limited by the ideals and interests of the participants. Some messages of the images were based on an understanding of reality informed by early sacred texts; others accrued from the perspective of the new ideals of Christian sanctity that emerged toward the end of the Middle Ages. It is likely the images were politically relevant even if the chosen narrative did not directly refer to a power struggle in the given historical moment. Important political connotations, understandable to their target audience might be concealed in a seemingly neutral narrative. In our attempt to reconstruct and understand the motivations of the patrons it is helpful to consider their position in society.

What social forces, ideas and struggles might have informed their decisions? This question prompts us to consider the narratives produced by modern historians about the relevant persons, institutions, and situations. The narratives about the decision-makers in the medial landscape to which the visual representations of the saint belonged are frequently influenced by systems of representations produced long after the images under consideration. How does Elizabeth's boundless love for the poor manifest itself in an era of institutionalized social care? Are her charitable deeds to be regarded as an isolated individual manifestation of religious enthusiasm, or as an important step leading to later developments? Were the images of her deeds created primarily to inspire individual mystic ecstasies or was the intention to convey a new form of corporate identity for those institutions whose role was to help the needy and, more generally, to shape the social life of the time?

This book describes a productive conflict or an ongoing dialogue between the ideal dimension of human existence, exemplified by the saint, and the real

[12] O. GECSER, *The Feast and the Pulpit: Preachers, Sermons and the Cult of St. Elizabeth of Hungary, 1235-ca. 1500*, Spoleto, 2012.

[13] For a more detailed description of the topology, see I. GERÁT, *Legendary Scenes: an Essay on Medieval Pictorial Hagiography*, Bratislava, 2013, pp. 9-25.

historical functions of images inspired by her life. Some concepts used in what follows are modern constructs, thus their use in relation to the past may be regarded as anachronistic.[14] The concept of "medium" carries associations with modern communication technologies, which have radically changed the way we perceive how information is disseminated within a society (or even globally). Radical changes in the medial landscape were one of the most important symptoms for leaving the Middle Ages, the epoch, on which this book focuses.[15] These changes, as well as successive ones, have prompted reflection and resulted in numerous publications exploring the complex interrelations between media, politics, culture, society, and identity.[16] Some of these texts have reappraised the meanings of traditional concepts, which are of special relevance to this exploration, e.g. the concept of "supernatural", the perception of religion, of space or the relationship between art and politics.[17] Others have addressed complex philosophical questions, such as the problem of materiality.[18] It comes as no surprise that this broad outlook and forceful stream of reflection has influenced several important studies of medieval art history and related problems.[19] The word "medium" in this book is used in its conventional meaning

[14] In this respect, the present study belongs to a different tradition – art historical, in particular: G. DIDI-HUBERMAN, *The Surviving Image: Phantoms of Time and Time of Phantoms: Aby Warburg's History of Art*, University Park, PA, 2017; G. DIDI-HUBERMAN, *Devant le temps: Histoire de l'art et anachronisme des images*, Paris, 2014; K.P.F. MOXEY, *Visual Time: The Image in History*, Durham, NC, 2013.

[15] J. GREEN, *Printing and Prophecy: Prognostication and Media Change, 1450-1550*, Ann Arbor, MI, 2012; W. BEHRINGER, *Mediale Konstruktionen in der Frühen Neuzeit*, Affalterbach, 2013; H. WENZEL, *Mediengeschichte vor und nach Gutenberg*, Darmstadt, 2007; F.D.R. BARBIER, *Gutenberg's Europe: The Book and the Invention of Western Modernity*, Cambridge, UK – Malden, MA, 2017.

[16] K. SACHS-HOMBACH, *Bild und Medium: kunstgeschichtliche und philosophische Grundlagen der interdisziplinären Bildwissenschaft*, Köln, 2006. More recent publications include A. ANDERSON, *Media, Environment and the Network Society*, London, 2014; C. VOSS – L. ENGELL (eds.), *Mediale Anthropologie*, Paderborn, 2015.

[17] M. LEEDER, *The Modern Supernatural and the Beginnings of Cinema*, London, 2017; H. FINTER, *Medien der Auferstehung*, Frankfurt am Main, 2012; B. GROJS – P. WEIBEL, *Medium Religion: Faith, Geopolitics, Art*, Köln, 2011; W. HOFMANN – H.-O. MÜHLEISEN, *Kunst und Macht: Politik und Herrschaft im Medium der bildenden Kunst*, Münster, 2005; J.R. DÜNNE – H. DOETSCH – R. LÜDEKE, *Von Pilgerwegen, Schriftspuren und Blickpunkten: Raumpraktiken in medienhistorischer Perspektive*, Würzburg, 2004.

[18] B. HERZOGENRATH, *Media Matter: The Materiality of Media, Matter as Medium*, New York, NY, 2015; G. KOCH, *Imaginäre Medialität – immaterielle Medien*, München, 2012.

[19] See for example B. BAERT, *Pneuma and the Visual Medium in the Middle Ages and Early Modernity: Essays on Wind, Ruach, Incarnation, Odour, Stains, Movement, Kairos, Web and Silence*, Leuven – Paris – Bristol, CT, 2016b; B. BAERT, *Kairos or Occasion as Paradigm in the*

– above all, as a means of communication, active in the triangle between various systems of representation. It summons up visual images of people and events through different times placing them in the situations in which they are perceived, mostly in accordance with intentions of the patrons and their theological counselors (if these two figures were not the same). To understand the position of a medium within the triangle it is necessary to consider the third system of representation – the visual languages in which Elizabeth's story was narrated.

The specific character of an individual visual language was mostly determined by the artists or artisans directly responsible for creation of the images. Once again, tradition played an important part in the functioning of the system. Visual languages were based on the artists' long-standing familiarity with their chosen medium. The artists or artisans were mostly employed in established workshops where they learned to work with a visual language handed down from their former *maestri* before becoming leading personalities in their own workshops. The traditions of the medium taught them how to represent figures and narratives. Once they had learnt the rules and conventions of a certain system of visual representation scope remained for the expression of their own feelings and ideas. They were nevertheless compelled to work in line with a prescribed commission and to respond to the demands, which were determined by the first two systems.

The new artistic images, inspired by hagiographic narratives, were necessarily different from the saintly person herself. They built on the possibilities offered by the given medium to express emotions and to depict observable reality. From a theological perspective the artistic rendering of the saint's life can be perceived as an attempt to understand unstained mirror (*speculum sine macula*) in human terms. Any usage of an artificial visual medium necessarily transmutes the purity of spiritual communication into a new riddle, an enigma,

Visual Medium: "Nachleben", Iconography, Hermeneutics, Leuven, 2016a; M.V. SCHWARZ, *Visuelle Medien im christlichen Kult: Fallstudien aus dem 13. bis 16. Jahrhundert*, Wien, 2002; Z. TREPPA, *Obraz jako medium wtajemniczające w misterium: na przykładzie obrazów nie-ręką-ludzką-wykonanych i pochodzących z wizji mistycznych*, Gdańsk, 2017; F. HARTMANN (ed.), *Brief und Kommunikation im Wandel: Medien, Autoren und Kontexte in den Debatten des Investiturstreits*, Köln, 2016; C. KIENING, *Fülle und Mangel: Medialität im Mittelalter*, Zürich, 2016; F. BALKE – B. SIEGERT – J. VOGL, *Medien des Heiligen*, Paderborn, 2015; H. BELTING, *An Anthropology of Images: Picture, Medium, Body*, Princeton, NJ, 2011; B. HAMM – V. LEPPIN – G. SCHNEIDER-LUDORFF, *Media Salutis: Gnaden- und Heilsmedien in der abendländischen Religiosität des Mittelalters und der Frühen Neuzeit*, Tübingen, 2011; S.N. GAYK, *Image, Text, and Religious Reform in fifteenth-century England*, Cambridge – New York, NY, 2010.

posing its own questions and giving rise to new problems. From a perspective of the religious system of representation visual media have formed an important part of the famous mirror, which only dimly reflects the complex mystery of reality (*speculum in aenigmate* – I Corinthians, 13:12). Bonaventure's theology of images gave visual artists the chance to create important artworks. In special circumstances the artist could contrive (*excogitare*) a picture, which expresses and imitates (*exprimit et imitatur*) images of a higher position in the hierarchy. These prototypes of pictures outrank and outlive any individual human being and any fabricated image.[20] Medieval artists largely respected this theological perspective, albeit unconsciously, but the most remarkable results were achieved when they integrated their own observations and feelings into images.

Which Elizabeth was supposed to be present in artistic image? Should the artist pay more attention to her individuality or focus on the generic form which was accepted and understood as an embodiment of ideas associated with her sanctity?[21]

The images discussed in this book form a part of this material world which can be studied from a rationally defined, scholarly perspective. The history of visual arts operates with narratives about the people who physically created the images. How did the tradition of media influence visual representations of the saint? Which elements of her image were already known in the given medium? Were there solutions and prototypes known to the artists who executed picture of the saint? Were there innovative or even surprising elements in artists' work? What was the special contribution of works of art in disseminating or even creating memories in the minds of their audiences? Why did the artists choose to depict an event from Elizabeth's life in a particular way? How did their unique cognitive styles influence the images they produced? How efficiently did they present ideas and narratives to the audience? How did the rhetoric of images influence the viewers on a rational and emotional level? In answering these questions and similar ones, the narratives and theories of modern art historians illuminate another layer of meanings in the images which are discussed in this book.

[20] S. BONAVENTURA, *Works of Saint Bonaventure. 1: St. Bonaventure's on the Reduction of the Arts to Theology*, translated by Zachary Hayes, St. Bonaventure, NY, 1996, pp. 312-319.

[21] M. RENER, *The Making of a Saint*, in C. BERTELSMEIER-KIERST (ed.), *Elisabeth von Thüringen und die neue Frömmigkeit in Europa*, Frankfurt am Main, 2008, pp. 195-210.

The images provide an important testimony of the dynamics of imagery influential in the period in question. Any artist creating an image from the saint's life was acting in an interval between different systems of representation, but the creative artistic imagination was a power with its own right. Even if the possibilities of artists to express their own attitudes were limited by the prevailing conventions, the resulting image was presented with a precise position between the pure ideals of the hagiographic narrative and a more prosaic human perspective of politics or even private perceptions.

Discourses about the unique cognitive and expressive styles of artists have been created by art historians and connoisseurs from later periods. Thus any visual image studied in this book is surrounded by a variety of narratives on all three of the above-adumbrated levels; these include stories of saints, patrons, and artists. In each of these groups, one system of representation plays a decisive role. Sometimes it is hagiographic discourse, sometimes a narrative about historical power struggle, sometimes fine distinctions in personal taste, style, and creative achievement.

The present study explores these complex issues with respect to three sites in medieval central Europe. The first chapter focuses on Marburg, where the saint's body was preserved and the earliest image cycles were produced against a backdrop of the fight against the enemies of the Church. The second chapter analyses the longest pictorial legend of St. Elizabeth in a manuscript produced for a monastery in Český Krumlov, a southern Bohemian town, approximately a century later, in a new situation, marked by the controversy of Franciscan poverty. The third part focuses on Košice, the most important municipal center of Elizabeth's cult in medieval Hungary during the fifteenth century; major contradictions within the traditional systems of representations shortly before they were attacked by the Reformation are analyzed. The individual images and sequences are broadly compared with other influential pictorial legends from across Germany, southern Italy (Naples), Spain (Seville), and Estonia (Tallinn). In the period under consideration the representational systems and their mutual relations formed new constellations. The present text attempts to describe and understand the position of pictorial legends within the coordinates evident in the dominant systems of representation. The religious, political and artistic discourses are described in order to illuminate the historical meanings of a specific set of images. The overall messages, which originated from respectable traditions of sanctity, are reconsidered in relation to the motivations of the patrons, the ordering and financing the cycle of images, and the unique artistic achievements, legible to contemporary sensibilities.

In Central Europe, images of the transnational saint are part of a contested heritage freighted with nationally inflected interpretations. The understanding of these images in the scholarly literature has been traditionally stimulated or obstructed by various national ideologies.[22]

The visual cult of Saint Elizabeth exemplifies just how cultural patterns were shared long before the political integration of European countries. The shared interest in narratives and images has contributed substantially to the mutual understanding of diverse ethnical and social groups in the region and facilitated communication with respect to other contemporary cultural and political issues.

[22] For the broader context of this phenomenon see P. SUROWIEC – V.C. STETKA, *Social Media and Politics in Central and Eastern Europe*, London – New York, 2018; S. FLEMMIG – N. KERSKEN (eds.), *Akteure mittelalterlicher Aussenpolitik: das Beispiel Ostmitteleuropas*, Marburg, 2017; M.J. MAREK – S. KIMMIG-VÖLKNER – E. PLUHAŘOVÁ-GRIGIENĖ – K. WENZEL, *Gestaltungsräume: Studien zur Kunstgeschichte in Mittel- und Ostmitteleuropa: Festschrift zu Ehren von Prof. Dr. Michaela Marek*, Regensburg, 2017; M. DANIELEWSKI – R.T. TOMCZAK (eds.), *Odkrywanie Europy Środkowej – od mitologii do rzeczywistości*, Poznań, 2016; J. BAHLCKE – K.I. BOBKOVÁ – J.I. MIKULEC, *Religious Violence, Confessional Conflicts and Models for Violence Prevention in Central Europe (15th-18th centuries) / Religiöse Gewalt, konfessionelle Konflikte und Modelle von Gewaltprävention in Mitteleuropa (15.-18. Jahrhundert)*, Praha – Stuttgart, 2017; J. BAHLCKE – S. ROHDEWALD – T. WÜNSCH, *Religiöse Erinnerungsorte in Ostmitteleuropa: Konstitution und Konkurrenz im nationen- und epochenübergreifenden Zugriff*, Berlin, 2013.

PART 1.
THE BODY AND MEDIA
IN THE CENTRE OF THE CULT

1.1. The Body and Popular Imagination

For the first few days after the death of Elizabeth on 17 November 1231, the lifeless body was more than just a visible trace of her former personal presence. In accordance with the conventions of hagiographic literature the narrative sources describe the exceptional qualities of the dead body. Foremost amongst these was the supernatural resistance of the corpse to decay together with exceptional olfactory perceptions. The best-attested description is that of Irmengard, one of the handmaidens of the noble deceased, recorded in January 1235 by the canonization committee: "Although the body of blessed Elizabeth lay unburied for four days from the time of her death, no fetid smell emanated from it as would normally have come from the bodies of the dead. Instead, hers had an aromatic odor which seemed to warm the spirit."[23] Such an unusual positive influence of the fragrance on human experience goes beyond physical pleasure. Throughout the middle ages the presence of a supernatural power associated with bodily remains offered the faithful deep spiritual solace and hope. In the popular imagination the bodies of saints were linked with the idea of force (*virtus*).[24] The power of God manifested through the saints was believed to achieve far more than merely preventing the normal decay of the corpse. It promised a miraculous solution to many problems causing everyday distress. Caesarius of Heisterbach relates that the very presence of Saint Elizabeth's body caused miracles to occur on a daily basis.[25] The stakes were high and the hopes

[23] HUYSKENS (ed.), *Libellus de dictis quattuor ancillarum s. Elisabeth confectus*, p. 79 (line 2169-2190): "*Et licet in quartum diem ab hora mortis corpus beate Elysabeth intumulatum iacuisset, nullus penitus fetor, ut consuetum est ab aliis, ab eius corpore exhalabat, immo aromaticum odorem, qui spiritum videbatur refocillare, habebat.*" The English translation is quoted from K.B. WOLF, *The Life and Afterlife of St. Elizabeth of Hungary. Testimony from her Canonization Hearings*, New York, NY, 2011, p. 215. Comp. A. ANGENENDT, *Corpus incorruptum. Eine Leitidee der mittelalterlichen Reliquienverehrung*, in *Saeculum* 42 (1991) pp. 320-348.

[24] A. VAUCHEZ, *La sainteté en Occident aux derniers siècles du Moyen Age: d'après les procès de canonisation et les documents hagiographiques*, Rome — Paris, 1981, p. 499.

[25] "*...miracula, que per eius corpus cotidie fieri non ambigimus*" – *Sermo de translatione beate Elyzabeth*, in CAESARIUS – E. KÖNSGEN, *Das Leben der Heiligen Elisabeth: [und andere Zeugnisse]*, Marburg, 2007, pp. 94-115, here p. 94.

aroused by the belief in sanctity prompted worshippers to act in unusual ways. Irmengard's testimony further indicates that Elizabeth's body, which was arrayed in a grey tunic and her face, wrapped with cloth, was endangered more by the enthusiasm of believers than by natural decay. Since people believed in the sanctity of the deceased woman they tried to acquire precious pieces of her body as relics: "Many, burning with devotion, cut or tore off pieces of cloth. Some cut the hair from her head or pieces of her nails. One even cut off her ears and another the nipples of her breasts to keep as relics."[26] Such a spontaneous, popular approach to the lifeless body was an important sign of her sanctity, but it posed a danger to the precious relics. Therefore, the first task of ecclesiastical authorities was to take measures to protect these. They organized a solemn burial in a chapel of the hospital (*capella hospitalis*), which had been founded by the future saint several years earlier (1228).[27] Once the opportunities of direct personal contact with the relics had dwindled people turned their attention towards secondary relics, such as taking soil from the grave or lying down on the gravestone.[28] The influx of pilgrims thronging Marburg increased so dramatically that their pious donations could finance the new construction. Thus, the simple hospital chapel could be replaced by a larger church built from stone.[29]

[26] HUYSKENS (ed.), *Libellus de dictis quattuor ancillarum s. Elisabeth confectus*, p. 79: "*Indutum autem tunica grisea corpus eius et faciem eius pannis circumligatam plurimi devotione accensi particulas pannorum incidebant, alii rumpebant, alii pilos capitis incidebant et ungues. Quedam autem aures illius truncabant. Etiam summitatem mammilorum eius quidam precidebant et pro reliquiis huiusmodi sibi servabant.*"; WOLF, *The Life and Afterlife of St. Elizabeth of Hungary. Testimony from her Canonization Hearings*, p. 215. The testimonies were further used by Caesarius of Heisterbach in his *Vita S. Elyzabeth lantgravie* and *Sermo de translatione beate Elyzabeth 30* (ed. A. Huyskens), in A. HILKA, (ed.), *Die Wundergeschichten des Caesarius von Heisterbach 3*, Bonn, 1937, p. 331-390. Comp. A. ANGENENDT, *Heilige und Reliquien: die Geschichte ihres Kultes vom frühen Christentum bis zur Gegenwart*, München, 1994, p. 155.

[27] HUYSKENS (ed.), *Libellus de dictis quattuor ancillarum s. Elisabeth confectus*, 2275 (p. 83); M. BIERSCHENK, *Glasmalereien der Elisabethkirche in Marburg: die figürlichen Fenster um 1240*, Berlin, 1991, p. 141.

[28] A. KÖSTLER, *Die Ausstattung der Marburger Elisabethkirche: zur Ästhetisierung des Kultraums im Mittelalter*, Berlin, 1995, p. 17.

[29] "*Plurima ibi oblata sunt, ex quibus ecclesia lapidea super sacrum eius tumultum erecta est*" – *Sermo de translatione beate Elyzabeth*, in: CAESARIUS – KÖNSGEN, *Das Leben der Heiligen Elisabeth: [und andere Zeugnisse]*, here p. 100. See also U. GEESE, *Die Elisabethreliquien in der Wallfahrtskirche*, in H.J. KUNST (ed.), *Die Elisabeth-kirche – Architektur in der Geschichte*, Marburg, 1983, 15-18., p. 15.

1.2. The Controversy over the Narratives

The narratives dealing with the spontaneous posthumous veneration of Elizabeth (and her previous life) would have left fewer traces in the historical sources without the establishment of an institutionally supervised and promoted cult in which she was recognized and worshipped as a Christian saint.[30] The cult of saints was one of the most important systems of representation influencing Elizabeth's legends and images. This system became even more organized in the first decades of the thirteenth century, when the rules of the canonization procedure were officially approved.[31]

The first person to organize the collection of the narratives was her former confessor Conrad of Marburg, known as "tracker dog of the Lord", a name conferred on him by Pope Gregory IX due to his tenacious fight against the heretics.[32] This context is essential to the interpretation of the narratives from the outset.[33] Conrad used the visit of Archbishop Siegried of Mainz to Marburg on the feast of St Lawrence (10 August 1232) as an occasion to organize the earliest official investigation into the extraordinary events at Elizabeth's grave. A document, drawn up on following day, listed 60 miracles to be sent to the Pope. These were interpreted as signs by which Christ confirmed the truth of Roman Catholic self-understanding. The "happy memory" of Elizabeth represented a kind of solace during a period of strife with the besetting heretics

[30] See KLANICZAY, *Holy Rulers and Blessed Princesses: Dynastic Cults in Medieval Central Europe*, pp. 195-294.

[31] O. KRAFFT, *Kommunikation und Kanonisation: die Heiligsprechung der Elisabeth von Thüringen 1235 und das Problem der Mehrfachausfertigung päpstlicher Kanonisationsurkunden seit 1161*, in *Zeitschrift des Vereins für Thüringische Geschichte* 58 (2004) 27-82; H.G. WALTHER, *Der "Fall Elisabeth" an der Kurie. Das Heiligsprechungsverfahren im Wandel des kanonischen Prozeßrechts unter Papst Gregor IX. (1227-1241)*, in D. BLUME – M. WERNER (eds.), *Elisabeth von Thüringen – eine europäische Heilige. Aufsätze*. Petersberg, 2007, 177-186; J. LEINWEBER, *Das kirchliche Heiligsprechungsverfahren bis zum Jahre 1234. Der Kanonisationsprozeß der Heilige Elisabeth von Thüringen, Sankt Elisabeth. Fürstin, Dienerin, Heilige; Aufsätze, Dokumentation, Katalog*, Sigmaringen, 1981, pp. 128-136; G. JARITZ – T. JØRGENSEN – K. SALONEN – ECCLESIA CATHOLICA. SANCTA SEDES, *The Long Arm of Papal Authority: Late Medieval Christian Peripheries and their Communication with the Holy See*, Bergen, 2004.

[32] K. SULLIVAN, *The inner lives of medieval inquisitors*, Chicago – London, 2013, pp. 75-98; R. KIECKHEFER, *Repression of Heresy in Medieval Germany*, Philadelphia, PA, 1979, pp. 14-15; S. WEIGELT (ed.), *Elisabeth von Thüringen in Quellen des 13. bis 16. Jahrhunderts*, Erfurt, 2008, p. 11.

[33] D. ELLIOTT, *Proving Woman. Female Spirituality and Inquisitional Culture in the Later Middle Ages*, Princeton, NJ – Oxford, 2004, on Elizabeth pp. 85-116.

whose persistence, even in Germany, could not be broken by argumentation, condemning, torture or death:

> But Christ, who does not allow his own to be tempted beyond their power, raised up various kinds of torments and death for the sake of overcoming the pertinacity of the heretics, crushing and refuting them in a most marvelous manner, while at the same time revealing the truth of our faith through a great many miracles and exercises of power, worked repeatedly and magnificently to the glory and honor of that lady of happy memory, Elizabeth, the former landgravine of Thuringia.[34]

The letter is a revealing testimony of the importance of the Saint for the politics of the church, or rather, of struggles against people with unorthodox religious convictions. From the outset ecclesiastical dignitaries considered the promotion of the memory and cult of Saint Elizabeth to be an integral part of their political agenda. Nevertheless, the interests of the church and members in the highest echelons of society were necessarily defined by people acting in conflicting situations. The ideas about the appropriate politics regarding heresy differed considerably; in a few years these differences would prove fatal for Conrad, the author of the above-mentioned letter to Pope Gregory IX. In his letter to the Holy See, written on 11th August 1232, he entreated the Pope to initiate the canonization procedure. In support of his *petitio* Conrad produced another letter providing an account of his memories during his time as Elizabeth's confessor and her appointed papal protector (*defensor*) after her husband's death. This document is known as the *Summa vitae* or *Narratio brevis de vita*.[35] To promote the process of canonization he focused on the virtues of "sister Elizabeth" and her extraordinary religious fervor. He did not neglect to mention that

[34] "*Sed Cristus, qui temptari suos non patitur supra vires, pro hereticorum pertinatia convincenda tormentorum et mortis varia suscitavit genera contra eos, quos nunc etiam modo mirabili conprimit et confutat, nostre fidei veritatem ostendens per miracula plurima et virtutes, que ad suam gloriam et honorem felicis recordationis domine Elysabeth olim lantgravie Thuringye multipliciter et magnifice operatur...*". A. Wyss, *Hessisches Urkundenbuch 1. Urkundenbuch der Deutschordens-Ballei Hessen 1, 1207 - 1299*, Leipzig, 1879, Nr. 28, pp. 25-29; A. Huyskens, *Quellenstudien zur Geschichte der hl. Elisabeth, Landgräfin von Thüringen*, Marburg, 1908, p. 155. English translation in Wolf, *The Life and Afterlife of St. Elizabeth of Hungary. Testimony from her Canonization Hearings*, pp. 83-84; U. Geese, *Reliquienverehrung und Herrschaftsvermittlung. Die mediale Beschaffenheit der Reliquien im frühen Elisabethkult*, Darmstadt, 1984, p. 222; N. Ohler, *Alltag im Marburger Raum zur Zeit der heiligen Elisabeth*, in *Archiv für Kulturgeschichte* 67 (1985) pp. 1-40.

[35] Huyskens, *Quellenstudien zur Geschichte der hl. Elisabeth, Landgräfin von Thüringen*, pp. 79-84 and 155-160. English translation in Wolf, *The Life and Afterlife of St. Elizabeth of Hungary. Testimony from her Canonization Hearings*, pp. 91-95.

without his wise counsel, this enthusiasm would lead to extremes such as begging, which was improper to the status of the landgravine.

Pope Gregory IX, prompted by the inventory of miracles having occurred and the *Summa vitae,* initiated an official investigation into the case. It was during this time that the rules of the canonization procedure were formulated. An investigation to distinguish between what was believable and what was obviously the outcome of fantasy was required.[36] The first phase of the canonization procedure, the so-called *informatio,* was an investigation into Elizabeth's saintly renown and the veracity of the miracles described by Conrad. In January 1233, the first papal commission (Archbishop Siegfried of Mainz, the Cistercian abbot Raimund of Eberbach and Conrad of Marburg) met in Marburg to ascertain and officially record which reports of the saintly life and miracles could be accepted as accurate.[37] With the help of the professors of canon law, the prelates heard, examined and recorded more than one hundred testimonies concerning the miracles attributed to the intercession of Elizabeth (a total of 106 miracles were recorded). The investigations and the records of the papal commissions provided important sources of narratives for the continuation of the process.

In July 1233 Conrad of Marburg was murdered by the embittered enemies of his fanatical and callous strategy in the anti-heretic fight, which included burning people upon a mere denunciation without real proof of guilt and accusing influential German nobles of heresy.[38]

The role of the main cult supporter was played by Bishop Conrad II of Hildesheim, who was educated at the University of Paris and active as a crusade preacher. Pope Gregory IX asked Bishop Conrad and the Cistercian Abbot Hermann of Georgenthal to lead the second commission, investigating the case of Elizabeth. The work of the commissioners was to prepare narratives, which would be sufficiently believable to support the unity of the altercating Church.[39] The

[36] H.G. WALTHER, *Der "Fall Elisabeth" an der Kurie. Das Heiligsprechungsverfahren im Wandel des kanonischen Prozeßrechts unter Papst Gregor IX. (1227-1241),* in D. BLUME – M. WERNER (eds.), *Elisabeth von Thüringen - eine europäische Heilige. Aufsätze.* Petersberg, 2007, pp. 177-186.

[37] WOLF, *The Life and Afterlife of St. Elizabeth of Hungary,* pp. 11-40.

[38] E.H. KANTOROWICZ, *Frederick the Second, 1194-1250,* New York, 1957, pp. 400-401; SULLIVAN, *The Inner Lives of Medieval Inquisitors,* pp. 75-78.

[39] *Processus et ordo canonizationis beate Elyzabeth propter quorumdam detractions et calumpnias,* published in HUYSKENS, *Quellenstudien zur Geschichte der hl. Elisabeth, Landgräfin von Thüringen,* p. 142: *"si forsan opinioni res minime responderet, non circumveniretur pia simplicitas ecclesie militantis… "*

example of Elizabeth, the "burning torch of love" illuminating other believers, was not to be snuffed out by heretics or consigned to oblivion.[40] The ardent language in which documents are couched provides insight into the emotional intensity of the disputes elicited by the earliest written narratives on St Elizabeth.

The new commission recorded the hearings of four former companions of the blessed landgravine – pious women Guda, Isentrud, Irmgard and Elizabeth – in January 1235. The written testimonies, traditionally known as *Libellus de dictis quatuor ancillarum*, were used by almost all subsequent hagiographers.[41] This text was one of the most important sources for later textual and pictorial narratives. Therefore, it will be instructive to quote and consider the various excerpts even though this may result in some overlap.

The finished work of the commission led to the final stage of the canonization procedure – the ritual of the *publicatio*. The magnificent canonization ceremony took place on the feast of Pentecost, on 27 May 1235 in Perugia. Pope Gregory IX himself celebrated the mass during which it was declared that Elizabeth was a saint and should be fully honored as such.[42] Thus, one of the earliest canonization processes in the history of Church quickly achieved success.

Another Conrad, the landgrave and brother-in-law of Elizabeth, played an important part in this process. He contributed to the success of the celebrations in Perugia by his substantial donations. Therefore, he was personally visited by the Pope and thousands of believers in the Dominican cloister in Perugia on the occasion of the ceremonial procession.[43] This is a convincing manifestation of the unity between the Church, the landgrave family and the Teutonic Order

[40] According to *Processus et ordo canonizationis beate Elyzabeth propter quorumdam detractions et calumpnias*, published in HUYSKENS, *Quellenstudien zur Geschichte der hl. Elisabeth, Landgräfin von Thüringen*, p. 143: *"lucernam ardentem in caritate ac lucentem aliis in exemplum [...] non sineret sub nubilo sinistre derogationis obscurari vel sub modio heretice suffocari."*

[41] Published in HUYSKENS, *Quellenstudien zur Geschichte der hl. Elisabeth, Landgräfin von Thüringen*, pp. 112-140. English translation of the shorter version *Dicta quatuor ancillarum* in WOLF, *The Life and Afterlife of St. Elizabeth of Hungary. Testimony from her Canonization Hearings*, pp. 193-216, with a commentary on pp. 51-74. See also I. WURTH, *The Life and Afterlife of St. Elizabeth of Hungary: Testimony from Her Canonization Hearings*, in *Austrian History Yearbook* 44 (2013) 328-329.

[42] LEINWEBER, *Das kirchliche Heiligsprechungsverfahren bis zum Jahre 1234. Der Kanonisationsprozeß der Heilige Elisabeth von Thüringen, Sankt Elisabeth. Fürstin, Dienerin, Heilige; Aufsätze, Dokumentation, Katalog*, pp. 128-136; D. HENNIGES, *Die Heilige Messe zu Ehren der Heiligen Elisabeth*, in *Franziskanische Studien* 9 (1922) pp. 158-171.

[43] *Processus et ordo canonizationis beate Elyzabeth propter quorumdam detractions et calumpnias*, published in HUYSKENS, *Quellenstudien zur Geschichte der hl. Elisabeth, Landgräfin von Thüringen*, pp . 145-146. S. WEIGELT (ed.), *Elisabeth von Thüringen in Quellen des 13. bis 16. Jahrhunderts*, Erfurt, 2008, pp. 73, 74.

(Conrad became a member of the Order in 1234 and Grandmaster in 1239). The Order was an important patron of the initial stage of the saint's cult in Marburg.[44]

The ecclesiastical officials who studied and documented reports about the life of the saint and her miracle-working relics redacted Latin texts to which only the elite had access. To preserve the original energy of spontaneous story-telling and actions for the future cult, the narratives which motivated popular enthusiasm had to be transferred, at least partially, to more accessible visual media.[45] The images from the life of the deceased saint represented her actions and ideals for future generations. But even before the creation of the earliest pictorial legends, the patrons of the cult organized large-scale performances, which further reinforced the influence of the tradition on the popular religious imagination.

1.3. The Body in Political Ritual – the *translatio*

Elizabeth's bodily remains were touched again in Marburg on 1 May 1236. Rather than spontaneous and disorganized popular action, this was a ritual carefully orchestrated by the social elite. The handling of the relics was staged for a very broad public. The traditions of emotionally charged performances in which the shrines of the saints became alternative centers of power – in the Germanic territories at least – reached back as far as Charlemagne.[46] Firstly, the relics were removed from the grave (*elevatio*). Then they were *ceremoniously carried* (*translatio*) to the new, albeit not yet fully decorated, sarcophagus into which they were solemnly placed (*deposition*). Caesarius of Heisterbach and the chronicler of the monastery of St Pantaleon in Cologne inform us about the details of this splendid ritual.[47] Even the Holy Roman Emperor Frederick the Second himself made time to be present. Irrespective of his power and wealth, he came barefoot, clad in a simple gray tunic. At the culmination of the ceremonial translation he performed a powerful gesture to demonstrate his reverence towards the holy princess by placing a gem-encrusted golden crown on the

[44] U. ARNOLD – H. LIEBING (eds.), *Elisabeth, der Deutsche Orden und ihre Kirche: Festschrift zur 700 jährigen Wiederkehr der Weihe der Elisabethkirche Marburg 1983*, Marburg, 1983.

[45] See GEESE, *Reliquienverehrung und Herrschaftsvermittlung. Die mediale Beschaffenheit der Reliquien im frühen Elisabethkult*, pp. 7-57.

[46] C. FREEMAN, *Holy Bones, Holy Dust: How Relics Shaped the History of Medieval Europe*, New Haven, CT, 2011, p. 72.

[47] CAESARIUS – KÖNSGEN, *Das Leben der Heiligen Elisabeth: [und andere Zeugnisse]*, .

saint's skull.[48] The head of the saint had been separated from the body by the clergymen who were preparing the translation. Caesarius reported that the churchmen found the body intact and uncorrupt, but only a few lines further on he concedes that in order not to repel the faithful who might look at the flesh and skin with hair these elements had to be separated from the bones.[49] It is improbable that the whole and incorrupt head – if we are to believe the pious narratives – would fill the participants of the feast with greater horror than a naked skull. Alongside the Emperor many dignitaries participated in the feast: archbishops from Cologne, Bremen, Trier and Mainz, the bishop of Hildesheim, and the grand master of the Teutonic knights.[50] Such a prominent gathering was a clear sign of the Saint's religious and political status in the Holy Roman Empire.[51] The Emperor's motivations for attending the ceremony and playing a major role in it started with his distant ties of kinship to Elizabeth, though a degree of political calculation cannot be excluded.[52] The popular enthusiasm surrounding Elizabeth was comparable to the energy surrounding St Francis of Assisi. The Emperor, who had taken a forceful stand against the Pope, knew that the new saint's cult would become an important instrument of papal propaganda. Consequently, Frederick might have tried to re-invigorate

[48] *"Imperator vero coronam auream de lapide pretiose eidem capiti imposuit, in signum devotionis sue sancte Elyzabeth, ques filia regis fuerat, illam offerens"* – Sermo de translatione beate Elyzabeth. In: CAESARIUS – KÖNSGEN, *Das Leben der Heiligen Elisabeth : [und andere Zeugnisse]*, p. 106; KANTOROWICZ, *Frederick the Second, 1194-1250*, pp. 419-421.

[49] *"sacrum corpusculum [...] totum invenerunt integrum and incorruptum"* ... *"Caput vero beate Elyzabeth prius a corpore fuerat separatum et, ne illius visio aliquis horroris intuentibus incuteret, fratres cultello carnes cum pelle et capillis a cranio separaverunt"* – Sermo de translatione beate Elyzabeth. In: CAESARIUS – KÖNSGEN, *Das Leben der Heiligen Elisabeth: [und andere Zeugnisse]*, p. 104. Comp. F. DICKMANN, *Das Schicksal der Elisabethreliquien, St. Elisabeth – Kult, Kirche, Konfessionen. Katalog 700 Jahre Elisabethkirche in Marburg 1283 – 1983*, Marburg, 1983, pp. 35–38, p. 35. Comp. T. FRANKE, *Zur Geschichte der Elisabethreliquien im Mittelalter und in der frühen Neuzeit, Sankt Elisabeth. Fürstin, Dienerin, Heilige*, Sigmaringen, 1981, pp. 167-179; B. REUDENBACH, *Kopf, Arm und Leib. Reliquien und Reliquiare der heiligen Elisabeth*, in D. BLUME – M. WERNER (eds.), *Elisabeth von Thüringen – eine europäische Heilige. Aufsätze*, Petersberg, 2007, pp. 193-202; P.E. SCHRAMM, *Herrschaftszeichen und Staatssymbolik Beiträge zu ihrer Geschichte vom dritten bis zum sechzehnten Jahrhundert*, Stuttgart, 1954, above all pp. 27–32.

[50] GEESE, *Reliquienverehrung und Herrschaftsvermittlung. Die mediale Beschaffenheit der Reliquien im frühen Elisabethkult*, pp. 161-172.

[51] More in H. BEUMANN, *Friedrich II. und die heilige Elisabeth. Zum Besuch des Kaisers in Marburg am 1. Mai 1236, Sankt Elisabeth. Fürstin, Dienerin, Heilige. Aufsätze, Dokumentation, Katalog*, Sigmaringen, 1981, pp. 151-166. J.R. PETERSOHN (ed.), *Politik und Heiligenverehrung im Hochmittelalter*, Sigmaringen, 1994, pp. 117-118.

[52] KLANICZAY, *Holy Rulers and Blessed Princesses: Dynastic Cults in Medieval Central Europe*, pp. 209-211.

Elizabeth's cult for his own purposes, or at least to prevent his enemies from using it against him.[53] However, in Rome Elizabeth's sanctity went undisputed. Thus, the political aspects of her veneration differed substantially from the cult of Charlemagne. His canonization, which was performed in Aachen in 1165 by the Antipope Paschal III with the keen participation of Emperor Frederick Barbarossa, had never been fully recognized.[54]

The crowned skull was placed in a reliquary that comprised an Ottonian chalice fashioned from an antique agate bowl.[55] (Fig. 1) The meaning of the precious relic was underscored by the attachment of a circlet and the arches of a crown, studded with precious stones.[56] The reliquary, frequently identified as the one now in Stockholm, offered a powerful symbolic interpretation of the saint's skull on several levels.[57] The crown alluded to the saint's royal descent as well as to the crown of martyrdom or the apocalyptic *corona vitae*, which in turn pointed to the celebration of the saint in heaven.[58] The relic could only be seen in close proximity through a small opening in the lid of the chalice.[59] In this type of presentation the symbolic and metaphorical values of the saintly body took precedence over its perceived physical likeness. The corporeal presence of the saint was sublimated through multi-layered symbolic meanings. The precious skull could have been placed inside an anthropomorphic head or

[53] KÖSTLER, *Die Ausstattung der Marburger Elisabethkirche: zur Ästhetisierung des Kultraums im Mittelalter*, p. 47 (note 19).

[54] R. MCKITTERICK, *Charlemagne: The Formation of a European Identity*, Cambridge, UK, 2008.

[55] GEESE, *Reliquienverehrung und Herrschaftsvermittlung. Die mediale Beschaffenheit der Reliquien im frühen Elisabethkult*, pp. 173-215.

[56] REUDENBACH, *Kopf, Arm und Leib. Reliquien und Reliquiare der heiligen Elisabeth*, p. 197.

[57] The identification was made long ago by SCHRAMM, *Herrschaftszeichen und Staatssymbolik Beiträge zu ihrer Geschichte vom dritten bis zum sechzehnten Jahrhundert*, vol III, p. 886; W. SAUERLÄNDER, *Two Glances from the North: The Presence and Absence of Frederick II in the Art of the Empire; the court art of Frederick II and the opus francigenum*, in W. TRONZO (ed.), *Intellectual life at the court of Frederick II Hohenstaufen*, Washington, DC, 1994, 189-209, p. 192. The author was unconvinced because of the absence of specific iconographic references to St. Elizabeth among the images of this work of art. Further, the skulls believed to be of Saint Elizabeth are to be found in Vienna, Brussels, Besançon, Bogotá and Viterbo – DICKMANN, *Das Schicksal der Elisabethreliquien, St. Elisabeth – Kult, Kirche, Konfessionen. Katalog 700 Jahre Elisabethkirche in Marburg 1283 – 1983*, pp. 37-38. The skull of St. Elizabeth was allegedly displayed on the main altar of her church in Marburg (altar consecrated in 1290) – A. LEGNER, *Reliquien in Kunst und Kult zwischen Antike und Aufklärung*, Darmstadt, 1995, p. 177.

[58] Rev. 2, 10; see REUDENBACH, *Kopf, Arm und Leib. Reliquien und Reliquiare der heiligen Elisabeth*, p. 198.

[59] A. GOLDSCHMIDT, *Ein Mittelalterliches Reliquiar des Stockholmer Museums*, in *Jahrbuch des preussischen Kunstsammlungen* 40 (1919) p. 8 (dated 1240-1250 on p. 14).

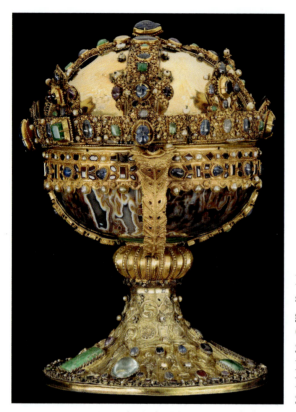

Fig. 1, Head reliquary of the saint, *c.* 1235, agate bowl, gold, gilded silver, gemstones, pearls (*c.* 45×25,8 cm), Stockholm, Statens Historiska Museum, Inv. Nr. 1, Photo: Ola Myrin, National Historical museums, Sweden.

bust reliquary. Such a mediating option (in the sense of how it was presented to the public gaze) was known in Germany from the celebrated head reliquary of an unnamed emperor, given by Frederick Barbarossa to his godfather, Otto of Cappenberg.[60] This tradition had been associated with visual representations of female sanctity going back at least to the celebrated tenth-century figural reliquary of Sainte Foy in Conques.[61] These options were never used in Marburg. Even so, the canonization and the translation encouraged the promotion of

[60] C.J. HAHN, *Strange Beauty: Issues in the Making and Meaning of Reliquaries, 400-circa 1204*, University Park, PA, 2012, on the tradition pp. 117-133, and, for our example in particular p. 132 and fig. 64. For the origins of associations between image and relic see E. THUNØ, *Image and Relic: Mediating the Sacred in Early Medieval Rome*, Rome, 2002.

[61] *Ibid.,* fig. 59; comp. K.M. ASHLEY – P. SHEINGORN, *Writing Faith: Text, Sign & History in the Miracles of Sainte Foy*, Chicago, IL, 1999; B. FRICKE, *Fallen Idols, Risen Saints: Sainte Foy of Conques and the Revival of Monumental Sculpture in Medieval Art*, Turnhout, 2015.

Elizabeth's cult throughout Latin Europe, but especially in Marburg.[62] The Teutonic knights who, upon the death of Conrad of Marburg became the patrons of her pilgrimage church, had to seek alternative solutions to the needs of the numerous pilgrims flocking to Marburg to visit the grave. They decided to construct a new church dedicated to the saint. It was to be in close proximity to both the hospital where she was caring for the needy and the recently built pilgrimage church. The political ambitions of the knights were reflected in the architectural style of the edifice, which was completed in the following decades. For the first time on German territory a new architectonic language drawing upon French Gothic precedents was evident.[63] The replacement of the walls in the new choir by large stained-glass windows offered enough space for the presentation of Christian saints, including the patroness of the church.[64] The early acceptance of High Gothic offered a new experience to pilgrims journeying to Marburg. The church of Saint Elizabeth in that town became the focal point of the cult. Numerous visual representations of its saintly patroness served to remind visitors of the person and life of Elizabeth. The stained-glass choir window (Fig. 2) and the new shrine of the saint (Fig. 3) offered a shining focus for deep reverence.[65] Both works of art, which were created after the saint's canonization in 1235 and before the consecration of the church in 1249, integrated the narratives of Elizabeth into one of the most advanced forms of medial presentation in existence at that time. Their form and imagery reflected both the saint's ideals and the principles of a smoothly functioning image complex which conveyed theological instruction efficiently while proclaiming the grandeur of the mighty patron.

[62] WERNER, *Mater Hassiae – Flos Ungariae – Gloria Teutoniae. Politik und Heiligenverehrung im Nachleben der hl. Elisabeth von Thüringen*, pp. 449-540.

[63] See e.g. H. BAUER, *St. Elisabeth und die Elisabethkirche zu Marburg*, Marburg, 1990; E. LEPPIN, *Die Elisabethkirche in Marburg. Ein Wegweiser zum Verstehen. 700 Jahre Elisabethkirche in Marburg 1283 – 1983, vol. E.*, Marburg, 1983; ARNOLD – LIEBING (eds.), *Elisabeth, der Deutsche Orden und ihre Kirche: Festschrift zur 700 jährigen Wiederkehr der Weihe der Elisabethkirche Marburg 1983*, .

[64] BIERSCHENK, *Glasmalereien der Elisabethkirche in Marburg: die figürlichen Fenster um 1240*, ; D. PARELLO, *Zum Verhältnis von Architektur und Glasmalerei am Beispiel der Marburger Elisabethkirche*, in *ARS* 37 (2004) 19-39.

[65] E. DINKLER-VON SCHUBERT, *Der Schrein der hl. Elisabeth zu Marburg. Studien zu Schrein-Ikonographie*, Marburg, 1964; V. BELGHAUS, *Der erzählte Körper. Die Inszenierung der Reliquien Karls des Grossen und Elisabeths von Thüringen*, Berlin, 2005; KROOS, *Zu frühen Schrift- und Bildzeugnissen über die helige Elisabeth als Quellen zur Kunst- und Kulturgeschichte, Sankt Elisabeth. Fürstin, Dienerin, Heilige*, .

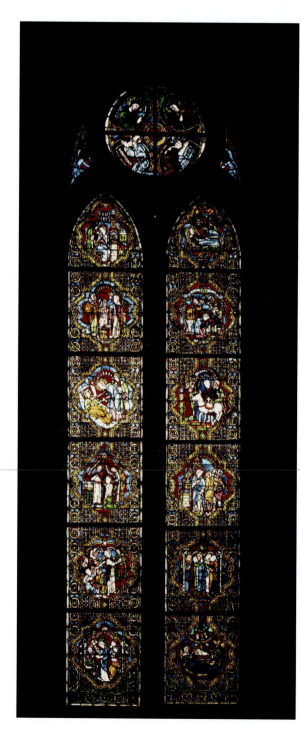

Fig. 2, The choir window, *c.* 1235–1250, stained-glass, Marburg, Church of Saint Elizabeth. Photo: Horst Fenchel, Bildarchiv Foto Marburg, fmc188621.

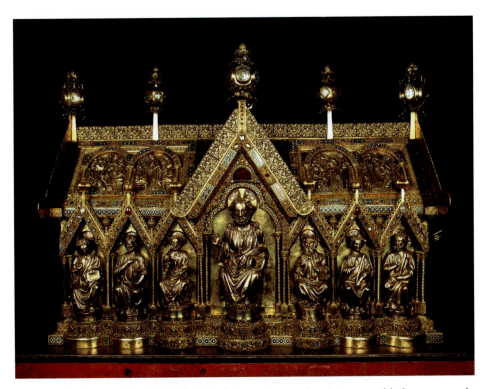

Fig. 3, The shrine of saint Elizabeth, Maiestas side, *c.* 1235–1250, gilded copper and silver on oak-wood core (h: 135 cm, l: 187 cm, w: 63 cm), Marburg, Church of Saint Elizabeth, Photo: Bildarchiv Foto Marburg, fmbc31745_09.

1.4. The Way to Heaven – The Choir Window

The Church of Saint Elizabeth, which took the form of a three-aisled hall with a trefoil-plan choir, was one of the earliest buildings in Germany to be inspired by the new Gothic style of French cathedrals.[66] Two horizontal rows of large tracery windows are placed above each other in the Eastern choir.[67] The basic structure of each window consists of two parallel vertical lancets embellished by

[66] D. PARELLO – R. TOUSSAINT, *Die Elisabethkirche in Marburg*, Regensburg, 2009. The original stained-glass windows are not preserved on the Liebfrauenkirche in Trier, a building, which is in many respects comparable. Comp. N. BORGER-KEWELOH, *Die Liebfrauenkirche in Trier: Studien zur Baugeschichte*, Trier, 1986.

[67] BIERSCHENK, *Glasmalereien der Elisabethkirche in Marburg: die figürlichen Fenster um 1240*, comp. note 1364 on p. 276. D. PARELLO – D. HESS, *Die mittelalterlichen Glasmalereien in Marburg und Nordhessen*, Berlin, 2008.

the oculus above. The architect used a bar tracery design known from the aisle windows at Reims, created around 1215. Although the tracery of the window is strikingly progressive in form, the unusually demanding task of creating large stained-glass panels was handled by a team of local glaziers.[68]

The window with the panels portraying the legend of St Elizabeth was placed in the lower register in keeping with standard practice in churches including Chartres and Bourges.[69] The finer details of the narrative scenes were legible only at the lower level. Generally speaking, the impact of stained-glass windows on the audience was guaranteed by size and the vibrant and luminous radiance and intensity of color.[70] Connecting individual pieces by strips of lead ensured clear legibility of the design. Such a medium became an important means of visual propaganda, especially when explained by a priest or similarly knowledgeable person. It was one of the most efficient tools in the church's fight against heretics and people with unusual beliefs in the time before the advent of printing and book production in the last third of the fifteenth century. The effects of its didactics and consolation can be compared with modern cinema.[71] Nevertheless, the social and psychological functions of images in the 13th century were similar to an "applied theology" of vernacular texts. The concern to rule in public space came at the expense of precise formulation. Clarity, radiant brightness, sharpness, lightness and vividness (*claritas*) came to assume more importance than the authority (*auctoritas*) of learned theological texts, which might be understandable only to a small circle of persons. In contrast to Chartres and Bourges, in Marburg any reference to the donor of the window in its lower register has been omitted.[72] There were no guilds in Marburg to patronize the window which would have required an advertisement of this kind. In a certain sense the fundamental interests of the Teutonic Order pervaded the whole structure of the window.

Not all the questions regarding the original position of the window have been satisfactorily resolved. Given the prohibition of pilgrims from entering

[68] Parello, *Zum Verhältnis von Architektur und Glasmalerei am Beispiel der Marburger Elisabethkirche*, p. 19-21. The discrepancy between the style of the architect and the glaziers has been noted by A. Haseloff, *Die Glasgemälde der Elisabethkirche in Marburg*, Berlin, 1906, p. 19.

[69] Bierschenk, *Glasmalereien der Elisabethkirche in Marburg: die figürlichen Fenster um 1240*, p. 168.

[70] M.H. Caviness, *Paintings on Glass: Studies in Romanesque and Gothic Monumental Art*, Aldershot, Great Britain, 1997, p. 106.

[71] W. Faulstich, *Medien und Öffentlichkeiten im Mittelalter, 800-1400*, Göttingen, 1996, p. 169.

[72] W. Kemp, *The Narratives of Gothic Stained Glass*, Cambridge, 1997, pp. 200-217.

certain parts of the church, the position of the window is of relevance for the original target audience. The window in the eastern apse (its current placement) would have been addressed mainly to the members of the Teutonic Order.[73] If the window had originally been placed in the Northern choir above Elizabeth's tomb, it would have addressed pilgrims coming to visit the final resting place of the saint. Regardless of the exact original position of the window, the audience was sufficiently informed about the basic principles of the Christian doctrine and the narratives of the history of salvation. The basic structure of the window and the pictorial legend were within their grasp, especially when bolstered by preaching. The media contributed to the desired effect on the public.[74] The pictorial legend in the stained-glass window was more than a mere illustration to the well-known narrative. In comparison with the textual legends the given number of scenes offered only limited space for providing information about the historical life of Elizabeth. The transformation of texts into the set of images necessarily entailed compromises.[75] The order of images in stained glass gave the events of the saintly life a constant presence in the church and visibility during daylight. Moreover, individual episodes were integrated into a structure which offered a framework in which they could be understood and interpreted.

The Marburg window, as one of the two earliest pictorial legends of Elizabeth, did not follow traditional iconographic schemes, but drew upon other models. Its overall arrangement, which was based on the example of classic cathedrals, was ideally suited to bringing the key events from the life of the patron saint of the church closer to the believers who came to worship her. The pictorial transposition rendered the events closer to the viewer's everyday existence in a form associated with theological interpretation. The conventions of tracery windows influenced the form the scenes took and the ideological context of their interpretation. The historical life of the saint, her *vita*, found expression in a series of episodes in the right lancet of the window. Elizabeth appears here without

[73] BIERSCHENK, *Glasmalereien der Elisabethkirche in Marburg: die figürlichen Fenster um 1240*, p. 167. This possibility is accepted by PARELLO, *Zum Verhältnis von Architektur und Glasmalerei am Beispiel der Marburger Elisabethkirche*, p. 23; F. MARTIN, *Die heilige Elisabeth in der Glasmalerei. Vermittlungsstrategien eines weiblichen Heiligenmodelles,* in D. BLUME – M. WERNER (eds.), *Elisabeth von Thüringen – eine europäische Heilige. Aufsätze,* Petersberg, 2007, 293-308, p. 294, accepted unreservedly the placement of the window in the northern choir.

[74] FAULSTICH, *Medien und Öffentlichkeiten im Mittelalter, 800-1400*, p. 179.

[75] W. KEMP, *Sermo corporeus: die Erzählung der mittelalterlichen Glasfenster*, München, 1987, p. 265. English translation – KEMP, *The Narratives of Gothic Stained Glass*.

a nimbus, acquiring the halo only at the moment of her passing away. The column of scenes ran upwards in accordance with the contemporary conventions for reading stained glass and provided a parallel to Elizabeth's works of mercy (*opera*), represented in the left lancet. In this part, which offers a symbolic interpretation (*allegoria*), she is constantly shown with the aureole. The allegorical interpretation is based on the visual proximity of the narratives and does not work with horizontal connections at each level. The differentiation between historical life and exemplary deeds is perhaps based on the idea that actively putting into practice selfless love (*agape*) through the works of mercy is a way of raising one's own life to eternity in a Christian sense. All elements appear to converge towards the crowning of Elizabeth and Francis, placed at the apex of the window as an image of arrival and acceptance in heaven. In this sense, the structure of the window opened up other opportunities for pictorial narrative beyond those offered by the reliefs of the shrine. The culmination is reached in the oculus in which the Virgin Mary, placed in a semicircle above, is crowning St Elizabeth, who kneels below her on the right-hand side. In the left half of the circle Christ is offering a crown to St Francis of Assisi in a similar arrangement, thus creating a meaningful visual symmetry. (Fig. 4) As is well known, Elizabeth was influenced by her contemporary, Saint Francis of Assisi, when exhibiting a new and radical understanding of some of Christ's teachings concerning the problem of poverty.[76]

Both saints had originally interpreted the traditional ideals of following Christ.[77] The applicability of this pattern in Elizabeth's case is somewhat limited by her gender identity. As a woman, she imitated mercy, selfless love and compassion (*imitatio misericordiae*), but unlike St Francis in the Franciscan church in Erfurt her gender obviously excludes an interpretation of her as a second Christ (*alter Christus*).[78] Considerations of this type were within the

[76] A. VAUCHEZ, *Charité et pauvreté chez Sainte Elisabeth de Thuringe d'après les actes du procès de canonisation*, in M. MOLLAT (ed.), *Études sur l'histoire de la pauvreté*, Paris, 1974, 163-173; K. BOSL, *Das Armutsideal des heiligen Franziskus als Ausdruck der hochmittelalterlichen Gesellschaftsbewegung*, in H. KÜHNAL – H. EGGER (eds.), *800 Jahre Franz von Assisi. Franziskanische Kunst und Kultur des Mittelalters: Niederösterreichische Landesausstellung, Krems-Stein, Minoritenkirche, 15. Mai-17 Obt. 1982*, Wien, 1982, 1-12.

[77] W. TELESKO, *Imitatio Christi und Christoformitas. Heilsgeschichte und Heiligengeschichte in den Programmen Hochmittelalterlicher Reliquienschreine*, in G. KERSCHER (ed.), *Hagiographie und Kunst*, Berlin, 1993, 369-384.

[78] The idea is discussed by MARTIN, *Die heilige Elisabeth in der Glasmalerei. Vermittlungsstrategien eines weiblichen Heiligenmodelles*, pp. 298-303. The idea of a relationship to the iconographic type of the Merciful Virgin Mary (*Madonna della Misericordiae*) is supported by examples from the later period.

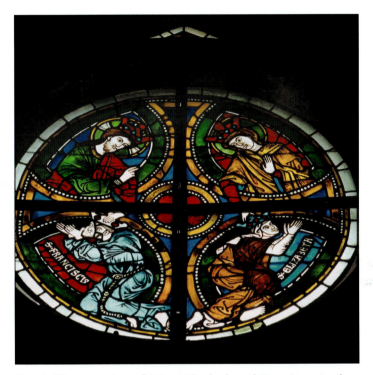

Fig. 4, The crowning of Saints Elizabeth and Francis, stained-glass, *c.* 1235–1250, Marburg, Church of Saint Elizabeth, Photo: Bildarchiv Foto Marburg, fmc426937.

purview of educated viewers. A simple pilgrim visiting the church may have experienced the feeling of being rescued from the common aspects of his or her everyday life by the dazzling beauty of the window. The psychological effect of the medium would have gained further theological resonance. Abbot Suger of St Denis, who introduced the conventional upwards reading of scenes, interpreted this order as a path from material things to immaterial phenomena (*de materialibus ad immaterialia*).[79] Heavenly Jerusalem was the final aim of

[79] See E. PANOFSKY, *Abbot Suger on the Abbey Church of St.-Denis and Its Art Treasures*, Princeton, NJ, 1979, p. 20; P. KIDSON, *Panofsky, Suger and St. Denis*, in *Journal of the Warburg and Courtauld Institutes* 50 (1987) 1-17, calls into questions the Neo-Platonic aspects of Panofsky's interpretation. Recently M. BÜCHSEL, *Licht und Metaphysik in der Gotik – noch einmal zu Suger von Saint-Denis*, in E. BADSTÜBNER (ed.), *Licht und Farbe in der mittelalterlichen Backsteinarchitektur des südlichen Ostseeraums*, Berlin, 2005, 24-37. See also G. SPIEGEL, *History as Enlightenment: Suger and the Mos Anagogicus*, in P. LIEBER GERSON (ed.), *Abbot Suger and Saint-Denis a Symposium*, New York, NY, 1986, 151-158.

spiritual elevation (*mos anagogicus*). Ornamental borders greatly enhanced the effect of the overall decorative vocabulary; an ornamental border visually connected the individual scenes thereby underscoring the vertical axis of the window leading to the oculus.[80] The vertical upwards thrust is reinforced by rhythmic alternations of red and blue colors which for a medieval audience may well have evoked the precious stones mentioned in the description of the celestial city. Ceasarius of Heisterbach compared the six works of mercy with the six gates of Jerusalem.[81] The window in its entirety constituted a major element of church adornment (*ornamenta ecclesiae*).[82] It appealed to the senses and offered many possibilities for symbolic readings. Elizabeth's memory was integrated into a unique artistic experience. Its complexity was firmly embedded in the discourses and iconographic traditions alive in the culture of that time.

The message of Elizabeth's life influenced believers in a variety of ways. While it is altogether possible that some people were deeply fascinated, others may have regarded her ascetic ideal as too extreme and exacting to be emulated or even have found it intimidating. Despite the individual differences the shared content of images and of imagination may have contributed to the creation of emotional communities.[83]

The figures on the reliquary and in the window can be interpreted as an important testimony to the increasing attention paid to the expressive potential of body language. The possibilities offered by contemporary visual language were exploited to convey emotional messages. On occasion images appear to offer a representation of emotional life that may have been informed by the artist's perceptions. Even so, such scenes are relatively restrained compared with the rhetorically powerful textual narratives of the period.

[80] For the analysis of the technical and formal aspects of the window see BIERSCHENK, *Glasmalereien der Elisabethkirche in Marburg: die figürlichen Fenster um 1240*, pp. 183-184.

[81] *"Sex portas habuisse legitur Ierusalem terrestris, per quas sex opera misericordie designatur"* – *Sermo de translatione beate Elyzabeth*. In: CAESARIUS – KÖNSGEN, *Das Leben der Heiligen Elisabeth: [und andere Zeugnisse]*, p. 94.

[82] The key medieval concept was popularized by the 1985 exhibition in Cologne – A. LEGNER (ed.), *Ornamenta Ecclesiae: Kunst und Künstler der Romanik: Katalog zur Ausstellung des Schnütgen-Museums in der Josef-Haubrich-Kunsthalle*, Köln, 1985.

[83] B.H. ROSENWEIN, *Emotional communities in the early Middle Ages*, Ithaca, N.Y., 2006. For a methodological discussion of related questions comp. P. BURKE, *Is There a Cultural History of Emotions?*, in P. GOUK – H. HILLS (eds.), *Representing Emotions*. Surrey – Burlington, VT, 2005, 35-47; W.M. REDDY, *The Navigation of Feeling: A Framework for the History of Emotions*, Cambridge – New York, NY, 2001.

The compositions of the narrative scenes on the reliquary and the window are closely comparable, even though they were created by different artists working in different media. This similarity provides an important testimony concerning the influence of iconographic tradition in the processes of image production. It should not be dismissed as the simple copying of a solution created by a colleague working nearby. Rather, it should be regarded as the result of a dialogue with the topic, firmly embedded in contemporary imagery. Its specific forms and accessible interpretations were not deliberate creation of an artist, but rather they were to a large extent influenced by patrons and their spiritual advisors, who were eager to see the time-honored tradition prolonged into their own time and beyond.

1.5. Works of Mercy

The works of mercy exemplify the most important iconographic tradition associated with St Elizabeth. These figure prominently in the earliest pictorial legends of Elizabeth in Marburg. The left half of the choir window and at least three of the eight reliefs on the roof of the shrine are devoted to the theme.

There are compelling reasons for thinking that the creators of the Marburg cycles were familiar with the six acts of mercy which were portrayed in a significant number of sites, Romanesque portals which were the most readily accessible. One of the examples in close proximity to Marburg could be encountered when going up the river Rhine in Basel (the north portal of the Minster, around 1170).[84] On their journey from Elizabeth's canonization ceremony in Perugia, some people may have stopped at Parma to visit the baptistery with its magnificent sculptural decoration created by Benedetto Antelami and his workshop. Completed sometime after 1196, it was sufficiently new to attract the attention of visitors. On the left jamb of the west portal, devoted primarily to the Last Judgement, the works of mercy are included in the iconographic program.[85] (Fig. 5) The central figure of the six scenes, who is offering his services to the

[84] H.-R. MEIER – D.S. SCHÜRMANN – S. ALBRECHT – G. BONO – P. BURCKHARDT, *Schwelle zum Paradies: die Galluspforte des Basler Münsters*, Basel, 2002.

[85] M. WOELK, *Benedetto Antelami: die Werke in Parma und Fidenza*, Münster, 1995, 124-125; C. FRUGONI – A. DIETL, *Benedetto Antelami e il Battistero di Parma*, Torino, 1995, 75-77; R.V. BÜHREN, *Die Werke der Barmherzigkeit in der Kunst des 12. - 18. Jahrhunderts. Zum Wandel eines Bildmotivs vor dem Hintergrund neuzeitlicher Rhetorikrezeption*, Hildesheim – Zürich – New York, NY, 1998, 35-36; F. BOTANA, *The Works of Mercy in Italian Medieval Art (c. 1050 – c. 1400)*, Turnhout, 2011, 28-48.

Fig. 5, Benedetto Antelami
(workshop), works of
mercy, after 1196, the west
portal of the baptistery,
Parma, Photo: author.

destitute, is a bearded man clad in tunic, with no further indication of his of his
identity. Elsewhere, the identification of the figure performing the charitable
deeds was even more abstract. In Hildesheim, for instance, the personification
of Mercy (bearing the inscription 'Misericordia'), dispensing victuals, is featured
within the complex iconography of one of the most elaborate medieval baptis-
mal fonts.[86]

[86] Hildesheim, Cathedral, St. Georges Chapel, c. 1226; see P. BARNET – M. BRANDT –
G. LUTZ, *Medieval Treasures from Hildesheim*, New York, NY, 2013, 104-107; BÜHREN, *Die*

ICONOLOGY OF CHARITY

ART&RELIGION

— Art & Religion 9 —

Iconology of Charity

Medieval Legends of Saint Elizabeth
in Central Europe

by

Ivan Gerát

PEETERS
Leuven – Paris – Bristol, CT
2020

A catalogue record for this book is available from the Library of Congress.

ISBN 978-90-429-4171-7
eISBN 978-90-429-4172-4
D/2020/0602/93

© 2020, Peeters, Bondgenotenlaan 153, 3000 Leuven – Belgium

CONTENTS

INTRODUCTION

The legends of Saint Elizabeth of Hungary, also known as Elizabeth of Thuringia, are rooted in at least three different systems of representation, which may be tentatively labeled as religious, political, and artistic. Each of these systems uses narratives and images for its own purposes, but none has complete control of the situation in which the images were created. It is possible to say that these systems defined the basic coordinates of the power field in which the creative processes took place. This power field may be imagined as a triangle which is defined by three vertices providing religious, political and artistic viewpoints. Understandably, these vertices are not simple static points, but complex, dynamic, and interrelated systems. They had been created centuries before 1207, when Elizabeth was born to the Hungarian king, Andrew II and his wife, Gertrude of Andechs-Meran.[1] These circumstances influenced the life of the young princess. At the age of four dynastic politics caused her to be sent from Hungary to Thuringia. Later, she single-mindedly devoted herself to following religious tradition. Pope Gregory IX personally advised her to follow the examples of saints to attain eternal glory.[2] Both Elizabeth and the people who influenced her life were inspired by what they had seen and heard in the course of their education and personal experience with religious art. The saint's powerful imagination offered a significant contribution to contemporary spirituality. And once more, this energy was used by religious and political leaders for their own reasons.

[1] The up-to-date biography is O. REBER, *Elisabeth von Thüringen, Landgräfin und Heilige. Eine Biografie,* Regensburg, 2009, which is based on long-standing engagement of the author with the life of the Saint – O. REBER, *Die heilige Elisabeth. Leben und Legende,* St. Ottilien, 1982; O. REBER, *Die Gestaltung des Kultes weiblicher Heiliger im Spätmittelalter; die Verehrung der Heiligen Elizabeth, Klara, Hedwig und Birgitta,* Hersbruck, 1963. Numerous other biographies of Elizabeth reflect different historical perspectives, as well as the various spiritual, intellectual and literary ambitions of their authors. Exceptionally – as in the case of I.F. GÖRRES, *Gespräch über die Heiligkeit: ein Dialog um Elisabeth von Thüringen,* Freiburg, 1940, the biographical writing broaches substantial philosophical questions associated with the concept of sanctity. For an overview of the sources, accompanied by an edition and translation of the popular late medieval German vita of the saint see I. ARNSTEIN, *Das Leben der heiligen Elisabeth: die volkssprachliche Elisabeth-Vita "Der lieben Fröwen Sant Elysabeten der Lantgrefin Leben" – Text, Übersetzung und Untersuchung,* Marburg, 2013.

[2] A. HUYSKENS (ed.), *Libellus de dictis quattuor ancillarum s. Elisabeth confectus,* Kempten – München, 1911, p. 46 (line 1236-1238): "*...exhortans eam ad perseverantiam castitatis et patientie diversa exempla sanctorum ei proponens et eternam gloriam firmiter repromittens.*"

The most memorable moments of Elizabeth's exemplary life were recorded very early on. Written narratives on Elizabeth began to appear after her premature death on 17 November 1231. Some years later the accounts of her life were integrated into the corpus of hagiographic narratives, which were controlled and developed by the decisive forces of Western Christianity. Elizabeth herself acquired her status as an exemplary individual to be worshipped and followed. She became part of the very tradition that guided her personal life. On 7 June 1235, only a few weeks after her canonization, Pope Gregory IX wrote a letter commending the new saint as the perfect model example of virtues such as charity, humility, chastity, compassion, obedience, strength, and truth. The letter reflected Elizabeth's influence on the elite of European society. It was addressed to Queen Beatrix of Castille (also known as Beatrice or Elizabeth of Swabia, 1205–1235), the wife of the saintly king Ferdinand III.[3] In the leading circles of society musing on the saint's life was intended to provide an aid to self-reflection. Her image was understood as an unstained mirror, in which thoughts were visible, even those hidden in the recesses of consciousness, which might offend the eyes of God.[4] However, this untarnished image was created against a backdrop of political struggle against heresy; thus it was used as a part of some rather shady deals, too.

Since the pictorial legends of the saint are rooted in tradition their study must be supported by traditional iconography, which pays attention to the mutual interaction between images and texts.[5] The textual sources of the images discussed in this book have for the most part been identified by previous scholarship, but the material can be interrogated in more complex terms. The evolution of images goes beyond the sphere of pictorial images and interacted with contemporary life. Traditional images presented patterns which served to inspire authors of new images, but these images were also consciously used to define inspirational models of behavior. Thus, it is necessary to supplement traditional

[3] L. LEMMENS, *Zur Biographie der heiligen Elisabeth, Landgräfin von Thüringen*, in *Mittheilungen des Historischen Vereins der Diözese Fulda* 4 (1901) 1-24, pp. 2-6; O. GECSER, *Aspects of the Cult of St. Elizabeth of Hungary with a Special Emphasis on Preaching, 1231-c.1500*, Budapest, 2007, pp. 156-157.

[4] LEMMENS, *Zur Biographie der heiligen Elisabeth, Landgräfin von Thüringen*, p. 6: "…ut in hoc speculo sine macula frequenter aspicias, ne quid in angulis constientiae tuae lateat, quod oculos divinae majestatis offendat…"; D. BLUME – D. JONEITIS, *Eine Elisabethhandschrift vom Hof König Alfons' X. von Kastilien*, in D. BLUME – M. WERNER (eds.), *Elisabeth von Thüringen - eine europäische Heilige. Aufsätze*, Petersberg, 2007, 325-339, pp. 325 and 339.

[5] Comp. C. HOURIHANE – D.L. DRYSDALL, *The Routledge Companion to Medieval Iconography*, London, 2017.

iconography – in which descriptions and comparisons within the realm of images and their source texts predominate – with interpretative iconography, or iconology, which attempts to understand the fundamental role of images in the lives of individuals and societies. As stated above, the chief aim of the present investigation is to chart the position occupied by images within the space between three main systems of representation, which can tentatively be called religious, political, and artistic. Each of these systems provides a different perspective on images. Simultaneously, each one functions as a framework in which the rules and value hierarchies are defined. The values operating within the system, inspired many human lives. Some influential people, who may be regarded co-authors of this system, possessed a certain power over the imagination of their contemporaries. The expression of this power was mediated through works of art. They exerted an influence on both their ways of thinking and their emotional lives. This influence was neither entirely conscious nor unilateral. Nobody was fully informed about how these systems worked and nobody was influenced by only one of them. Although the rules and the hierarchies in each of the systems differed, there were always intersections and correlations. Each of the systems applied its rules and value hierarchies not only within its closest circle, but also continued to propose an evaluation of virtually all spheres of human life during the period. Thus, tensions existed between the requirements of these systems. These tensions, or even conflicts, defined the power field, which in several respects predetermined the possibilities to create, use and perceive the images.

As far as the religious system is concerned, the inspiration provided by traditional iconography can be explained as a part of the hagiographic discourse.[6] In this system the influential images were associated with rich explanatory models based on Biblical narratives, theological commentaries, and their narrative amplification through the impressive stories of other saints. The legends were repeated and explained in learned texts and in sermons delivered regularly to broader audiences. The story of Elizabeth's life was produced within this system which continued to influence the production of images, even if the saint herself claimed she needed no painted images because she carried them in her heart.[7]

[6] S. FLEMMIG, *Hagiografie und Kulturtransfer: Birgitta von Schweden und Hedwig von Polen*, Berlin, 2011, pp. 13-57.

[7] *"Non habeo opus tali imagine, quia eam in corde meo porto"* – HUYSKENS (ed.), *Libellus de dictis quattuor ancillarum s. Elisabeth confectus*, p. 75. See further H. WOLTER-VON DEM KNESEBECK, *Bilder in Büchern - Bilder im Herzen: die Landgrafenpsalterien im Kontext*, in C. BERTELSMEIER-KIERST (ed.), *Elisabeth von Thüringen und die neue Frömmigkeit in Europa*, Frankfurt, 2008,

Her life was inspired by the images she interiorized, as well as the ideals associated with them. Moreover, she developed a sensitivity towards the image and likeness of God, which – as stated in the book of Genesis – provided the model for each human being. According to religious writers of the period, for example Saint Bonaventure, this prototype occupied the highest position in the hierarchy of images. Manufactured pictures (*figurae artificiales*) were understood only as a shadow (*umbra*) or as a vestige (*vestigium*) of the Divine prototype. To understand exactly how this highest image is reflected in human existence more than mere natural senses, or imagination and intellect were required. A special spiritual sense (*sensus spirituales*), or a sensitivity of heart (*sensus cordis*) was necessary.[8] Irrespective of how disputable these philosophical ideas may be, it is an historical fact that Elizabeth developed an extraordinary sensitivity to the images and narratives belonging to the Christian tradition. She lived according to the ideals that inspired the theologians of her time; she was inspired by them in a unique, creative way, which was more practical than theoretical. As a kind of unconscious artist, she performed certain radical actions showing her contemporaries the practical consequences of adhering to the spiritual ideal in human life. Her life – part of the great spiritual tradition – was recorded as such. Subsequent generations had to deal with the narratives, written down by theologians. The spiritual authorities of the time were aware of how difficult it was for other people to understand the ideal aspects of her saintly life.

The images, which were created in the years following Elizabeth's premature death, reflect her saintly life in their own way and gained primacy in the same tradition. They were for the most part based on the testimonies recorded by the Papal commissioners who prepared the early canonization of Elizabeth (1235) and on legends written by pious clerics wishing to commemorate the new saint. Again, the traditional system of religious representation – the verbal and pictorial images of the early hagiographies – played a pivotal role in deciding what was worth recording and in what manner. The authors of textual narratives and

33-51; G. SUCKALE-REDLEFSEN, *Zwei Bilderpsalter für Frauen aus dem frühen 13. Jahrhundert*, in F.O. BÜTTNER (ed.), *The illuminated psalter*, Turnhout, 2004, 249-258, 521-524, p. 251; R. KROOS, *Zu frühen Schrift- und Bildzeugnissen über die helige Elisabeth als Quellen zur Kunst- und Kulturgeschichte, Sankt Elisabeth. Fürstin, Dienerin, Heilige*, Sigmaringen, 1981, 180-239, p. 181.

[8] S. BONAVENTURA, *Works of St. Bonaventure. 2: Itinerarium Mentis in Deum*, 2002; S. BONAVENTURA, *Works of St. Bonaventure. 2: Itinerarium Mentis in Deum*, 2002; see R. GOFFEN, *Spirituality in Conflict: Saint Francis and Giotto's Bardi Chapel*, University Park, PA, 1988, pp. 59-77.

images highlighted what was important from the perspective of the ruling system of spirituality while allowing seemingly irrelevant facts and circumstances to disappear. This merging of the historical and theological perspectives is typical of hagiographic memory informing the images.

At the same time the verbal images of the hagiographies and their material counterparts were a part of a highly charged political game, in which memories were negotiated or even contested.[9] The new narratives and images were inspired not only by the pious meditations of believers, but also the political considerations of their patrons. In the system of political representation lives of the saints became "some of the most polished weapons of an ideological struggle".[10] Religious authors lived in a society governed by various social norms and practices. Thus, the motivations and strategies of reasoning that shaped the verbal and visual images of the legends were not straightforward. Narratives could be used in a battle for temporal power as well as in the ongoing conflict of ideas whose duration surpasses the life of any human being. Elizabeth's cult was negotiated within the framework of complex interrelationships among the Papacy, Empire, religious orders, and their critics. The political and religious leaders attempted to manipulate the image of the popular figure for their own purposes. Thus, Elizabeth's images were used for individual, familial, and institutional self-representation as well as in the struggle against heretics, for improving monastic discipline, and taming social tensions.

The images of the saint were commissioned by the patrons who endeavored to define their own positions among the systems of representation which determined a constellation of powers in each historical situation. As the "empirical producers of communication" they often directed the meanings of images in a novel way.[11] The patrons mostly selected events from the saint's original life that carried the messages they wanted to convey to historical audiences of images. In so doing, an appropriate balance between traditional narratives and

[9] M. WERNER, *Mater Hassiae – Flos Ungariae – Gloria Teutoniae. Politik und Heiligenverehrung im Nachleben der hl. Elisabeth von Thüringen*, in J. PETERSOHN (ed.), *Politik und Heiligenverehrung im Hochmittelalter*. Sigmaringen, 1994, 449-540; G.B. KLANICZAY, *Holy Rulers and Blessed Princesses: Dynastic Cults in Medieval Central Europe*, Cambridge – New York, NY, 2002, 195-242. For similar theoretical insights concerning the recent history of the Central Europe see T. SINDBÆK ANDERSEN – B. TÖRNQUIST PLEWA, *Disputed Memory : Emotions and Memory Politics in Central, Eastern and South-Eastern Europe*, Berlin – Boston, 2016, 1-15.

[10] G. DUBY, *Love and marriage in the Middle Ages*, Chicago, IL, 1994, p. 37.

[11] A. PINKUS, *Patrons and Narratives of the Parler School: The Marian Tympana 1350-1400*, München – Berlin, 2009, p. 37, distinguishes between "empirical producer of communication", (fictional) narrator, focalizator of meanings, donor etc.

other important facets of contemporary life had to be found. This delicate balance was reflected not only in the images, but also through historical narratives and sermons, which directly addressed medieval audiences.[12] Thus the interpretation of the images should consider numerous crucial questions: Which events were selected, and why? How far was the spontaneous memory of historical witnesses influenced by the rules of the hagiographic genre? To what extent have the traditional *topoi* from older hagiographic traditions influenced the new textual and visual narratives?[13] As Elizabeth was a real person from an historically close period her images, which were a part of lively process of memorization, were limited by the ideals and interests of the participants. Some messages of the images were based on an understanding of reality informed by early sacred texts; others accrued from the perspective of the new ideals of Christian sanctity that emerged toward the end of the Middle Ages. It is likely the images were politically relevant even if the chosen narrative did not directly refer to a power struggle in the given historical moment. Important political connotations, understandable to their target audience might be concealed in a seemingly neutral narrative. In our attempt to reconstruct and understand the motivations of the patrons it is helpful to consider their position in society.

What social forces, ideas and struggles might have informed their decisions? This question prompts us to consider the narratives produced by modern historians about the relevant persons, institutions, and situations. The narratives about the decision-makers in the medial landscape to which the visual representations of the saint belonged are frequently influenced by systems of representations produced long after the images under consideration. How does Elizabeth's boundless love for the poor manifest itself in an era of institutionalized social care? Are her charitable deeds to be regarded as an isolated individual manifestation of religious enthusiasm, or as an important step leading to later developments? Were the images of her deeds created primarily to inspire individual mystic ecstasies or was the intention to convey a new form of corporate identity for those institutions whose role was to help the needy and, more generally, to shape the social life of the time?

This book describes a productive conflict or an ongoing dialogue between the ideal dimension of human existence, exemplified by the saint, and the real

[12] O. GECSER, *The Feast and the Pulpit: Preachers, Sermons and the Cult of St. Elizabeth of Hungary, 1235-ca. 1500*, Spoleto, 2012.

[13] For a more detailed description of the topology, see I. GERÁT, *Legendary Scenes: an Essay on Medieval Pictorial Hagiography*, Bratislava, 2013, pp. 9-25.

historical functions of images inspired by her life. Some concepts used in what follows are modern constructs, thus their use in relation to the past may be regarded as anachronistic.[14] The concept of "medium" carries associations with modern communication technologies, which have radically changed the way we perceive how information is disseminated within a society (or even globally). Radical changes in the medial landscape were one of the most important symptoms for leaving the Middle Ages, the epoch, on which this book focuses.[15] These changes, as well as successive ones, have prompted reflection and resulted in numerous publications exploring the complex interrelations between media, politics, culture, society, and identity.[16] Some of these texts have reappraised the meanings of traditional concepts, which are of special relevance to this exploration, e.g. the concept of "supernatural", the perception of religion, of space or the relationship between art and politics.[17] Others have addressed complex philosophical questions, such as the problem of materiality.[18] It comes as no surprise that this broad outlook and forceful stream of reflection has influenced several important studies of medieval art history and related problems.[19] The word "medium" in this book is used in its conventional meaning

[14] In this respect, the present study belongs to a different tradition – art historical, in particular: G. DIDI-HUBERMAN, *The Surviving Image: Phantoms of Time and Time of Phantoms: Aby Warburg's History of Art*, University Park, PA, 2017; G. DIDI-HUBERMAN, *Devant le temps: Histoire de l'art et anachronisme des images*, Paris, 2014; K.P.F. MOXEY, *Visual Time: The Image in History*, Durham, NC, 2013.

[15] J. GREEN, *Printing and Prophecy: Prognostication and Media Change, 1450-1550*, Ann Arbor, MI, 2012; W. BEHRINGER, *Mediale Konstruktionen in der Frühen Neuzeit*, Affalterbach, 2013; H. WENZEL, *Mediengeschichte vor und nach Gutenberg*, Darmstadt, 2007; F.D.R. BARBIER, *Gutenberg's Europe: The Book and the Invention of Western Modernity*, Cambridge, UK – Malden, MA, 2017.

[16] K. SACHS-HOMBACH, *Bild und Medium: kunstgeschichtliche und philosophische Grundlagen der interdisziplinären Bildwissenschaft*, Köln, 2006. More recent publications include A. ANDERSON, *Media, Environment and the Network Society*, London, 2014; C. VOSS – L. ENGELL (eds.), *Mediale Anthropologie*, Paderborn, 2015.

[17] M. LEEDER, *The Modern Supernatural and the Beginnings of Cinema*, London, 2017; H. FINTER, *Medien der Auferstehung*, Frankfurt am Main, 2012; B. GROJS – P. WEIBEL, *Medium Religion: Faith, Geopolitics, Art*, Köln, 2011; W. HOFMANN – H.-O. MÜHLEISEN, *Kunst und Macht: Politik und Herrschaft im Medium der bildenden Kunst*, Münster, 2005; J.R. DÜNNE – H. DOETSCH – R. LÜDEKE, *Von Pilgerwegen, Schriftspuren und Blickpunkten: Raumpraktiken in medienhistorischer Perspektive*, Würzburg, 2004.

[18] B. HERZOGENRATH, *Media Matter: The Materiality of Media, Matter as Medium*, New York, NY, 2015; G. KOCH, *Imaginäre Medialität – immaterielle Medien*, München, 2012.

[19] See for example B. BAERT, *Pneuma and the Visual Medium in the Middle Ages and Early Modernity: Essays on Wind, Ruach, Incarnation, Odour, Stains, Movement, Kairos, Web and Silence*, Leuven – Paris – Bristol, CT, 2016b; B. BAERT, *Kairos or Occasion as Paradigm in the*

– above all, as a means of communication, active in the triangle between various systems of representation. It summons up visual images of people and events through different times placing them in the situations in which they are perceived, mostly in accordance with intentions of the patrons and their theological counselors (if these two figures were not the same). To understand the position of a medium within the triangle it is necessary to consider the third system of representation – the visual languages in which Elizabeth's story was narrated.

The specific character of an individual visual language was mostly determined by the artists or artisans directly responsible for creation of the images. Once again, tradition played an important part in the functioning of the system. Visual languages were based on the artists' long-standing familiarity with their chosen medium. The artists or artisans were mostly employed in established workshops where they learned to work with a visual language handed down from their former *maestri* before becoming leading personalities in their own workshops. The traditions of the medium taught them how to represent figures and narratives. Once they had learnt the rules and conventions of a certain system of visual representation scope remained for the expression of their own feelings and ideas. They were nevertheless compelled to work in line with a prescribed commission and to respond to the demands, which were determined by the first two systems.

The new artistic images, inspired by hagiographic narratives, were necessarily different from the saintly person herself. They built on the possibilities offered by the given medium to express emotions and to depict observable reality. From a theological perspective the artistic rendering of the saint's life can be perceived as an attempt to understand unstained mirror (*speculum sine macula*) in human terms. Any usage of an artificial visual medium necessarily transmutes the purity of spiritual communication into a new riddle, an enigma,

Visual Medium: "Nachleben", Iconography, Hermeneutics, Leuven, 2016a; M.V. SCHWARZ, *Visuelle Medien im christlichen Kult: Fallstudien aus dem 13. bis 16. Jahrhundert,* Wien, 2002; Z. TREPPA, *Obraz jako medium wtajemniczające w misterium: na przykładzie obrazów nie-ręką-ludzką-wykonanych i pochodzących z wizji mistycznych,* Gdańsk, 2017; F. HARTMANN (ed.), *Brief und Kommunikation im Wandel: Medien, Autoren und Kontexte in den Debatten des Investiturstreits,* Köln, 2016; C. KIENING, *Fülle und Mangel: Medialität im Mittelalter,* Zürich, 2016; F. BALKE – B. SIEGERT – J. VOGL, *Medien des Heiligen,* Paderborn, 2015; H. BELTING, *An Anthropology of Images: Picture, Medium, Body,* Princeton, NJ, 2011; B. HAMM – V. LEPPIN – G. SCHNEIDER-LUDORFF, *Media Salutis: Gnaden- und Heilsmedien in der abendländischen Religiosität des Mittelalters und der Frühen Neuzeit,* Tübingen, 2011; S.N. GAYK, *Image, Text, and Religious Reform in fifteenth-century England,* Cambridge – New York, NY, 2010.

posing its own questions and giving rise to new problems. From a perspective of the religious system of representation visual media have formed an important part of the famous mirror, which only dimly reflects the complex mystery of reality (*speculum in aenigmate* – I Corinthians, 13:12). Bonaventure's theology of images gave visual artists the chance to create important artworks. In special circumstances the artist could contrive (*excogitare*) a picture, which expresses and imitates (*exprimit et imitatur*) images of a higher position in the hierarchy. These prototypes of pictures outrank and outlive any individual human being and any fabricated image.[20] Medieval artists largely respected this theological perspective, albeit unconsciously, but the most remarkable results were achieved when they integrated their own observations and feelings into images.

Which Elizabeth was supposed to be present in artistic image? Should the artist pay more attention to her individuality or focus on the generic form which was accepted and understood as an embodiment of ideas associated with her sanctity?[21]

The images discussed in this book form a part of this material world which can be studied from a rationally defined, scholarly perspective. The history of visual arts operates with narratives about the people who physically created the images. How did the tradition of media influence visual representations of the saint? Which elements of her image were already known in the given medium? Were there solutions and prototypes known to the artists who executed picture of the saint? Were there innovative or even surprising elements in artists' work? What was the special contribution of works of art in disseminating or even creating memories in the minds of their audiences? Why did the artists choose to depict an event from Elizabeth's life in a particular way? How did their unique cognitive styles influence the images they produced? How efficiently did they present ideas and narratives to the audience? How did the rhetoric of images influence the viewers on a rational and emotional level? In answering these questions and similar ones, the narratives and theories of modern art historians illuminate another layer of meanings in the images which are discussed in this book.

[20] S. BONAVENTURA, *Works of Saint Bonaventure. 1: St. Bonaventure's on the Reduction of the Arts to Theology*, translated by Zachary Hayes, St. Bonaventure, NY, 1996, pp. 312-319.

[21] M. RENER, *The Making of a Saint*, in C. BERTELSMEIER-KIERST (ed.), *Elisabeth von Thüringen und die neue Frömmigkeit in Europa*, Frankfurt am Main, 2008, pp. 195-210.

The images provide an important testimony of the dynamics of imagery influential in the period in question. Any artist creating an image from the saint's life was acting in an interval between different systems of representation, but the creative artistic imagination was a power with its own right. Even if the possibilities of artists to express their own attitudes were limited by the prevailing conventions, the resulting image was presented with a precise position between the pure ideals of the hagiographic narrative and a more prosaic human perspective of politics or even private perceptions.

Discourses about the unique cognitive and expressive styles of artists have been created by art historians and connoisseurs from later periods. Thus any visual image studied in this book is surrounded by a variety of narratives on all three of the above-adumbrated levels; these include stories of saints, patrons, and artists. In each of these groups, one system of representation plays a decisive role. Sometimes it is hagiographic discourse, sometimes a narrative about historical power struggle, sometimes fine distinctions in personal taste, style, and creative achievement.

The present study explores these complex issues with respect to three sites in medieval central Europe. The first chapter focuses on Marburg, where the saint's body was preserved and the earliest image cycles were produced against a backdrop of the fight against the enemies of the Church. The second chapter analyses the longest pictorial legend of St. Elizabeth in a manuscript produced for a monastery in Český Krumlov, a southern Bohemian town, approximately a century later, in a new situation, marked by the controversy of Franciscan poverty. The third part focuses on Košice, the most important municipal center of Elizabeth's cult in medieval Hungary during the fifteenth century; major contradictions within the traditional systems of representations shortly before they were attacked by the Reformation are analyzed. The individual images and sequences are broadly compared with other influential pictorial legends from across Germany, southern Italy (Naples), Spain (Seville), and Estonia (Tallinn). In the period under consideration the representational systems and their mutual relations formed new constellations. The present text attempts to describe and understand the position of pictorial legends within the coordinates evident in the dominant systems of representation. The religious, political and artistic discourses are described in order to illuminate the historical meanings of a specific set of images. The overall messages, which originated from respectable traditions of sanctity, are reconsidered in relation to the motivations of the patrons, the ordering and financing the cycle of images, and the unique artistic achievements, legible to contemporary sensibilities.

In Central Europe, images of the transnational saint are part of a contested heritage freighted with nationally inflected interpretations. The understanding of these images in the scholarly literature has been traditionally stimulated or obstructed by various national ideologies.[22]

The visual cult of Saint Elizabeth exemplifies just how cultural patterns were shared long before the political integration of European countries. The shared interest in narratives and images has contributed substantially to the mutual understanding of diverse ethnical and social groups in the region and facilitated communication with respect to other contemporary cultural and political issues.

[22] For the broader context of this phenomenon see P. SUROWIEC – V.C. STETKA, *Social Media and Politics in Central and Eastern Europe*, London – New York, 2018; S. FLEMMIG – N. KERSKEN (eds.), *Akteure mittelalterlicher Aussenpolitik: das Beispiel Ostmitteleuropas*, Marburg, 2017; M.J. MAREK – S. KIMMIG-VÖLKNER – E. PLUHAŘOVÁ-GRIGIENĖ – K. WENZEL, *Gestaltungsräume: Studien zur Kunstgeschichte in Mittel- und Ostmitteleuropa: Festschrift zu Ehren von Prof. Dr. Michaela Marek*, Regensburg, 2017; M. DANIELEWSKI – R.T. TOMCZAK (eds.), *Odkrywanie Europy Środkowej – od mitologii do rzeczywistości*, Poznań, 2016; J. BAHLCKE – K.I. BOBKOVÁ – J.I. MIKULEC, *Religious Violence, Confessional Conflicts and Models for Violence Prevention in Central Europe (15th-18th centuries) / Religiöse Gewalt, konfessionelle Konflikte und Modelle von Gewaltprävention in Mitteleuropa (15.-18. Jahrhundert)*, Praha – Stuttgart, 2017; J. BAHLCKE – S. ROHDEWALD – T. WÜNSCH, *Religiöse Erinnerungsorte in Ostmitteleuropa: Konstitution und Konkurrenz im nationen- und epochenübergreifenden Zugriff*, Berlin, 2013.

PART 1.
THE BODY AND MEDIA
IN THE CENTRE OF THE CULT

1.1. The Body and Popular Imagination

For the first few days after the death of Elizabeth on 17 November 1231, the lifeless body was more than just a visible trace of her former personal presence. In accordance with the conventions of hagiographic literature the narrative sources describe the exceptional qualities of the dead body. Foremost amongst these was the supernatural resistance of the corpse to decay together with exceptional olfactory perceptions. The best-attested description is that of Irmengard, one of the handmaidens of the noble deceased, recorded in January 1235 by the canonization committee: "Although the body of blessed Elizabeth lay unburied for four days from the time of her death, no fetid smell emanated from it as would normally have come from the bodies of the dead. Instead, hers had an aromatic odor which seemed to warm the spirit."[23] Such an unusual positive influence of the fragrance on human experience goes beyond physical pleasure. Throughout the middle ages the presence of a supernatural power associated with bodily remains offered the faithful deep spiritual solace and hope. In the popular imagination the bodies of saints were linked with the idea of force (*virtus*).[24] The power of God manifested through the saints was believed to achieve far more than merely preventing the normal decay of the corpse. It promised a miraculous solution to many problems causing everyday distress. Caesarius of Heisterbach relates that the very presence of Saint Elizabeth's body caused miracles to occur on a daily basis.[25] The stakes were high and the hopes

[23] HUYSKENS (ed.), *Libellus de dictis quattuor ancillarum s. Elisabeth confectus*, p. 79 (line 2169-2190): *"Et licet in quartum diem ab hora mortis corpus beate Elysabeth intumulatum iacuisset, nullus penitus fetor, ut consuetum est ab aliis, ab eius corpore exhalabat, immo aromaticum odorem, qui spiritum videbatur refocillare, habebat."* The English translation is quoted from K.B. WOLF, *The Life and Afterlife of St. Elizabeth of Hungary. Testimony from her Canonization Hearings*, New York, NY, 2011, p. 215. Comp. A. ANGENENDT, *Corpus incorruptum. Eine Leitidee der mittelalterlichen Reliquienverehrung*, in *Saeculum* 42 (1991) pp. 320-348.

[24] A. VAUCHEZ, *La sainteté en Occident aux derniers siècles du Moyen Age: d'après les procès de canonisation et les documents hagiographiques*, Rome — Paris, 1981, p. 499.

[25] *"...miracula, que per eius corpus cotidie fieri non ambigimus"* – *Sermo de translatione beate Elyzabeth*, in CAESARIUS – E. KÖNSGEN, *Das Leben der Heiligen Elisabeth: [und andere Zeugnisse]*, Marburg, 2007, pp. 94-115, here p. 94.

aroused by the belief in sanctity prompted worshippers to act in unusual ways. Irmengard's testimony further indicates that Elizabeth's body, which was arrayed in a grey tunic and her face, wrapped with cloth, was endangered more by the enthusiasm of believers than by natural decay. Since people believed in the sanctity of the deceased woman they tried to acquire precious pieces of her body as relics: "Many, burning with devotion, cut or tore off pieces of cloth. Some cut the hair from her head or pieces of her nails. One even cut off her ears and another the nipples of her breasts to keep as relics."[26] Such a spontaneous, popular approach to the lifeless body was an important sign of her sanctity, but it posed a danger to the precious relics. Therefore, the first task of ecclesiastical authorities was to take measures to protect these. They organized a solemn burial in a chapel of the hospital (*capella hospitalis*), which had been founded by the future saint several years earlier (1228).[27] Once the opportunities of direct personal contact with the relics had dwindled people turned their attention towards secondary relics, such as taking soil from the grave or lying down on the gravestone.[28] The influx of pilgrims thronging Marburg increased so dramatically that their pious donations could finance the new construction. Thus, the simple hospital chapel could be replaced by a larger church built from stone.[29]

[26] HUYSKENS (ed.), *Libellus de dictis quattuor ancillarum s. Elisabeth confectus*, p. 79: "*Indutum autem tunica grisea corpus eius et faciem eius pannis circumligatam plurimi devotione accensi particulas pannorum incidebant, alii rumpebant, alii pilos capitis incidebant et ungues. Quedam autem aures illius truncabant. Etiam summitatem mammilorum eius quidam precidebant et pro reliquiis huiusmodi sibi servabant.*"; WOLF, *The Life and Afterlife of St. Elizabeth of Hungary. Testimony from her Canonization Hearings*, p. 215. The testimonies were further used by Caesarius of Heisterbach in his *Vita S. Elyzabeth lantgravie* and *Sermo de translatione beate Elyzabeth* 30 (ed. A. Huyskens), in A. HILKA, (ed.), *Die Wundergeschichten des Caesarius von Heisterbach 3*, Bonn, 1937, p. 331-390. Comp. A. ANGENENDT, *Heilige und Reliquien: die Geschichte ihres Kultes vom frühen Christentum bis zur Gegenwart*, München, 1994, p. 155.

[27] HUYSKENS (ed.), *Libellus de dictis quattuor ancillarum s. Elisabeth confectus*, 2275 (p. 83); M. BIERSCHENK, *Glasmalereien der Elisabethkirche in Marburg: die figürlichen Fenster um 1240*, Berlin, 1991, p. 141.

[28] A. KÖSTLER, *Die Ausstattung der Marburger Elisabethkirche: zur Ästhetisierung des Kultraums im Mittelalter*, Berlin, 1995, p. 17.

[29] "*Plurima ibi oblata sunt, ex quibus ecclesia lapidea super sacrum eius tumultum erecta est*" – *Sermo de translatione beate Elyzabeth*, in: CAESARIUS – KÖNSGEN, *Das Leben der Heiligen Elisabeth: [und andere Zeugnisse]*, here p. 100. See also U. GEESE, *Die Elisabethreliquien in der Wallfahrtskirche*, in H.J. KUNST (ed.), *Die Elisabeth-kirche – Architektur in der Geschichte*, Marburg, 1983, 15-18., p. 15.

1.2. The Controversy over the Narratives

The narratives dealing with the spontaneous posthumous veneration of Elizabeth (and her previous life) would have left fewer traces in the historical sources without the establishment of an institutionally supervised and promoted cult in which she was recognized and worshipped as a Christian saint.[30] The cult of saints was one of the most important systems of representation influencing Elizabeth's legends and images. This system became even more organized in the first decades of the thirteenth century, when the rules of the canonization procedure were officially approved.[31]

The first person to organize the collection of the narratives was her former confessor Conrad of Marburg, known as "tracker dog of the Lord", a name conferred on him by Pope Gregory IX due to his tenacious fight against the heretics.[32] This context is essential to the interpretation of the narratives from the outset.[33] Conrad used the visit of Archbishop Siegried of Mainz to Marburg on the feast of St Lawrence (10 August 1232) as an occasion to organize the earliest official investigation into the extraordinary events at Elizabeth's grave. A document, drawn up on following day, listed 60 miracles to be sent to the Pope. These were interpreted as signs by which Christ confirmed the truth of Roman Catholic self-understanding. The "happy memory" of Elizabeth represented a kind of solace during a period of strife with the besetting heretics

[30] See KLANICZAY, *Holy Rulers and Blessed Princesses: Dynastic Cults in Medieval Central Europe*, pp. 195-294.

[31] O. KRAFFT, *Kommunikation und Kanonisation: die Heiligsprechung der Elisabeth von Thüringen 1235 und das Problem der Mehrfachausfertigung päpstlicher Kanonisationsurkunden seit 1161*, in *Zeitschrift des Vereins für Thüringische Geschichte* 58 (2004) 27-82; H.G. WALTHER, *Der "Fall Elisabeth" an der Kurie. Das Heiligsprechungsverfahren im Wandel des kanonischen Prozeßrechts unter Papst Gregor IX. (1227-1241)*, in D. BLUME – M. WERNER (eds.), *Elisabeth von Thüringen – eine europäische Heilige. Aufsätze*. Petersberg, 2007, 177-186; J. LEINWEBER, *Das kirchliche Heiligsprechungsverfahren bis zum Jahre 1234. Der Kanonisationsprozeß der Heilige Elisabeth von Thüringen, Sankt Elisabeth. Fürstin, Dienerin, Heilige; Aufsätze, Dokumentation, Katalog*, Sigmaringen, 1981, pp. 128-136; G. JARITZ – T. JØRGENSEN – K. SALONEN – ECCLESIA CATHOLICA. SANCTA SEDES, *The Long Arm of Papal Authority: Late Medieval Christian Peripheries and their Communication with the Holy See*, Bergen, 2004.

[32] K. SULLIVAN, *The inner lives of medieval inquisitors*, Chicago – London, 2013, pp. 75-98; R. KIECKHEFER, *Repression of Heresy in Medieval Germany*, Philadelphia, PA, 1979, pp. 14-15; S. WEIGELT (ed.), *Elisabeth von Thüringen in Quellen des 13. bis 16. Jahrhunderts*, Erfurt, 2008, p. 11.

[33] D. ELLIOTT, *Proving Woman. Female Spirituality and Inquisitional Culture in the Later Middle Ages*, Princeton, NJ – Oxford, 2004, on Elizabeth pp. 85-116.

whose persistence, even in Germany, could not be broken by argumentation, condemning, torture or death:

> But Christ, who does not allow his own to be tempted beyond their power, raised up various kinds of torments and death for the sake of overcoming the pertinacity of the heretics, crushing and refuting them in a most marvelous manner, while at the same time revealing the truth of our faith through a great many miracles and exercises of power, worked repeatedly and magnificently to the glory and honor of that lady of happy memory, Elizabeth, the former landgravine of Thuringia.[34]

The letter is a revealing testimony of the importance of the Saint for the politics of the church, or rather, of struggles against people with unorthodox religious convictions. From the outset ecclesiastical dignitaries considered the promotion of the memory and cult of Saint Elizabeth to be an integral part of their political agenda. Nevertheless, the interests of the church and members in the highest echelons of society were necessarily defined by people acting in conflicting situations. The ideas about the appropriate politics regarding heresy differed considerably; in a few years these differences would prove fatal for Conrad, the author of the above-mentioned letter to Pope Gregory IX. In his letter to the Holy See, written on 11th August 1232, he entreated the Pope to initiate the canonization procedure. In support of his *petitio* Conrad produced another letter providing an account of his memories during his time as Elizabeth's confessor and her appointed papal protector (*defensor*) after her husband's death. This document is known as the *Summa vitae* or *Narratio brevis de vita*.[35] To promote the process of canonization he focused on the virtues of "sister Elizabeth" and her extraordinary religious fervor. He did not neglect to mention that

[34] *"Sed Cristus, qui temptari suos non patitur supra vires, pro hereticorum pertinatia convincenda tormentorum et mortis varia suscitavit genera contra eos, quos nunc etiam modo mirabili conprimit et confutat, nostre fidei veritatem ostendens per miracula plurima et virtutes, que ad suam gloriam et honorem felicis recordationis domine Elysabeth olim lantgravie Thuringye multipliciter et magnifice operatur…"*. A. WYSS, *Hessisches Urkundenbuch 1. Urkundenbuch der Deutschordens-Ballei Hessen 1, 1207 - 1299*, Leipzig, 1879, Nr. 28, pp. 25-29; A. HUYSKENS, *Quellenstudien zur Geschichte der hl. Elisabeth, Landgräfin von Thüringen*, Marburg, 1908, p. 155. English translation in WOLF, *The Life and Afterlife of St. Elizabeth of Hungary. Testimony from her Canonization Hearings*, pp. 83-84; U. GEESE, *Reliquienverehrung und Herrschaftsvermittlung. Die mediale Beschaffenheit der Reliquien im frühen Elisabethkult*, Darmstadt, 1984, p. 222; N. OHLER, *Alltag im Marburger Raum zur Zeit der heiligen Elisabeth*, in *Archiv für Kulturgeschichte* 67 (1985) pp. 1-40.

[35] HUYSKENS, *Quellenstudien zur Geschichte der hl. Elisabeth, Landgräfin von Thüringen*, pp. 79-84 and 155-160. English translation in WOLF, *The Life and Afterlife of St. Elizabeth of Hungary. Testimony from her Canonization Hearings*, pp. 91-95.

without his wise counsel, this enthusiasm would lead to extremes such as begging, which was improper to the status of the landgravine.

Pope Gregory IX, prompted by the inventory of miracles having occurred and the *Summa vitae,* initiated an official investigation into the case. It was during this time that the rules of the canonization procedure were formulated. An investigation to distinguish between what was believable and what was obviously the outcome of fantasy was required.[36] The first phase of the canonization procedure, the so-called *informatio,* was an investigation into Elizabeth's saintly renown and the veracity of the miracles described by Conrad. In January 1233, the first papal commission (Archbishop Siegfried of Mainz, the Cistercian abbot Raimund of Eberbach and Conrad of Marburg) met in Marburg to ascertain and officially record which reports of the saintly life and miracles could be accepted as accurate.[37] With the help of the professors of canon law, the prelates heard, examined and recorded more than one hundred testimonies concerning the miracles attributed to the intercession of Elizabeth (a total of 106 miracles were recorded). The investigations and the records of the papal commissions provided important sources of narratives for the continuation of the process.

In July 1233 Conrad of Marburg was murdered by the embittered enemies of his fanatical and callous strategy in the anti-heretic fight, which included burning people upon a mere denunciation without real proof of guilt and accusing influential German nobles of heresy.[38]

The role of the main cult supporter was played by Bishop Conrad II of Hildesheim, who was educated at the University of Paris and active as a crusade preacher. Pope Gregory IX asked Bishop Conrad and the Cistercian Abbot Hermann of Georgenthal to lead the second commission, investigating the case of Elizabeth. The work of the commissioners was to prepare narratives, which would be sufficiently believable to support the unity of the altercating Church.[39] The

[36] H.G. WALTHER, *Der "Fall Elisabeth" an der Kurie. Das Heiligsprechungsverfahren im Wandel des kanonischen Prozeßrechts unter Papst Gregor IX. (1227-1241),* in D. BLUME – M. WERNER (eds.), *Elisabeth von Thüringen - eine europäische Heilige. Aufsätze.* Petersberg, 2007, pp. 177-186.

[37] WOLF, *The Life and Afterlife of St. Elizabeth of Hungary,* pp. 11-40.

[38] E.H. KANTOROWICZ, *Frederick the Second, 1194-1250,* New York, 1957, pp. 400-401; SULLIVAN, *The Inner Lives of Medieval Inquisitors,* pp. 75-78.

[39] *Processus et ordo canonizationis beate Elyzabeth propter quorumdam detractions et calumpnias,* published in HUYSKENS, *Quellenstudien zur Geschichte der hl. Elisabeth, Landgräfin von Thüringen,* p. 142: *"si forsan opinioni res minime responderet, non circumveniretur pia simplicitas ecclesie militantis…"*

example of Elizabeth, the "burning torch of love" illuminating other believers, was not to be snuffed out by heretics or consigned to oblivion.[40] The ardent language in which documents are couched provides insight into the emotional intensity of the disputes elicited by the earliest written narratives on St Elizabeth.

The new commission recorded the hearings of four former companions of the blessed landgravine – pious women Guda, Isentrud, Irmgard and Elizabeth – in January 1235. The written testimonies, traditionally known as *Libellus de dictis quatuor ancillarum*, were used by almost all subsequent hagiographers.[41] This text was one of the most important sources for later textual and pictorial narratives. Therefore, it will be instructive to quote and consider the various excerpts even though this may result in some overlap.

The finished work of the commission led to the final stage of the canonization procedure – the ritual of the *publicatio*. The magnificent canonization ceremony took place on the feast of Pentecost, on 27 May 1235 in Perugia. Pope Gregory IX himself celebrated the mass during which it was declared that Elizabeth was a saint and should be fully honored as such.[42] Thus, one of the earliest canonization processes in the history of Church quickly achieved success.

Another Conrad, the landgrave and brother-in-law of Elizabeth, played an important part in this process. He contributed to the success of the celebrations in Perugia by his substantial donations. Therefore, he was personally visited by the Pope and thousands of believers in the Dominican cloister in Perugia on the occasion of the ceremonial procession.[43] This is a convincing manifestation of the unity between the Church, the landgrave family and the Teutonic Order

[40] According to *Processus et ordo canonizationis beate Elyzabeth propter quorumdam detractions et calumpnias*, published in HUYSKENS, *Quellenstudien zur Geschichte der hl. Elisabeth, Landgräfin von Thüringen*, p. 143: *"lucernam ardentem in caritate ac lucentem aliis in exemplum [...] non sineret sub nubilo sinistre derogationis obscurari vel sub modio heretice suffocari."*

[41] Published in HUYSKENS, *Quellenstudien zur Geschichte der hl. Elisabeth, Landgräfin von Thüringen*, pp. 112-140. English translation of the shorter version *Dicta quatuor ancillarum* in WOLF, *The Life and Afterlife of St. Elizabeth of Hungary. Testimony from her Canonization Hearings*, pp. 193-216, with a commentary on pp. 51-74. See also I. WURTH, *The Life and Afterlife of St. Elizabeth of Hungary: Testimony from Her Canonization Hearings*, in *Austrian History Yearbook* 44 (2013) 328-329.

[42] LEINWEBER, *Das kirchliche Heiligsprechungsverfahren bis zum Jahre 1234. Der Kanonisationsprozeß der Heilige Elisabeth von Thüringen, Sankt Elisabeth. Fürstin, Dienerin, Heilige; Aufsätze, Dokumentation, Katalog*, pp. 128-136; D. HENNIGES, *Die Heilige Messe zu Ehren der Heiligen Elisabeth*, in *Franziskanische Studien* 9 (1922) pp. 158-171.

[43] *Processus et ordo canonizationis beate Elyzabeth propter quorumdam detractions et calumpnias*, published in HUYSKENS, *Quellenstudien zur Geschichte der hl. Elisabeth, Landgräfin von Thüringen*, pp . 145-146. S. WEIGELT (ed.), *Elisabeth von Thüringen in Quellen des 13. bis 16. Jahrhunderts*, Erfurt, 2008, pp. 73, 74.

(Conrad became a member of the Order in 1234 and Grandmaster in 1239). The Order was an important patron of the initial stage of the saint's cult in Marburg.[44]

The ecclesiastical officials who studied and documented reports about the life of the saint and her miracle-working relics redacted Latin texts to which only the elite had access. To preserve the original energy of spontaneous story-telling and actions for the future cult, the narratives which motivated popular enthusiasm had to be transferred, at least partially, to more accessible visual media.[45] The images from the life of the deceased saint represented her actions and ideals for future generations. But even before the creation of the earliest pictorial legends, the patrons of the cult organized large-scale performances, which further reinforced the influence of the tradition on the popular religious imagination.

1.3. The Body in Political Ritual – the *translatio*

Elizabeth's bodily remains were touched again in Marburg on 1 May 1236. Rather than spontaneous and disorganized popular action, this was a ritual carefully orchestrated by the social elite. The handling of the relics was staged for a very broad public. The traditions of emotionally charged performances in which the shrines of the saints became alternative centers of power – in the Germanic territories at least – reached back as far as Charlemagne.[46] Firstly, the relics were removed from the grave (*elevatio*). Then they were *ceremoniously carried* (*translatio*) to the new, albeit not yet fully decorated, sarcophagus into which they were solemnly placed (*deposition*). Caesarius of Heisterbach and the chronicler of the monastery of St Pantaleon in Cologne inform us about the details of this splendid ritual.[47] Even the Holy Roman Emperor Frederick the Second himself made time to be present. Irrespective of his power and wealth, he came barefoot, clad in a simple gray tunic. At the culmination of the cere-monial translation he performed a powerful gesture to demonstrate his rever-ence towards the holy princess by placing a gem-encrusted golden crown on the

[44] U. ARNOLD – H. LIEBING (eds.), *Elisabeth, der Deutsche Orden und ihre Kirche: Festschrift zur 700 jährigen Wiederkehr der Weihe der Elisabethkirche Marburg 1983*, Marburg, 1983.

[45] See GEESE, *Reliquienverehrung und Herrschaftsvermittlung. Die mediale Beschaffenheit der Reliquien im frühen Elisabethkult*, pp. 7-57.

[46] C. FREEMAN, *Holy Bones, Holy Dust: How Relics Shaped the History of Medieval Europe*, New Haven, CT, 2011, p. 72.

[47] CAESARIUS – KÖNSGEN, *Das Leben der Heiligen Elisabeth: [und andere Zeugnisse]*, .

saint's skull.[48] The head of the saint had been separated from the body by the clergymen who were preparing the translation. Caesarius reported that the churchmen found the body intact and uncorrupt, but only a few lines further on he concedes that in order not to repel the faithful who might look at the flesh and skin with hair these elements had to be separated from the bones.[49] It is improbable that the whole and incorrupt head – if we are to believe the pious narratives – would fill the participants of the feast with greater horror than a naked skull. Alongside the Emperor many dignitaries participated in the feast: archbishops from Cologne, Bremen, Trier and Mainz, the bishop of Hildesheim, and the grand master of the Teutonic knights.[50] Such a prominent gathering was a clear sign of the Saint's religious and political status in the Holy Roman Empire.[51] The Emperor's motivations for attending the ceremony and playing a major role in it started with his distant ties of kinship to Elizabeth, though a degree of political calculation cannot be excluded.[52] The popular enthusiasm surrounding Elizabeth was comparable to the energy surrounding St Francis of Assisi. The Emperor, who had taken a forceful stand against the Pope, knew that the new saint's cult would become an important instrument of papal propaganda. Consequently, Frederick might have tried to re-invigorate

[48] *"Imperator vero coronam auream de lapide pretiose eidem capiti imposuit, in signum devotionis sue sancte Elyzabeth, ques filia regis fuerat, illam offerens"* – *Sermo de translatione beate Elyzabeth.* In: CAESARIUS – KÖNSGEN, *Das Leben der Heiligen Elisabeth : [und andere Zeugnisse],* p. 106; KANTOROWICZ, *Frederick the Second, 1194-1250,* pp. 419-421.

[49] *"sacrum corpusculum […] totum invenerunt integrum and incorruptum"* … *"Caput vero beate Elyzabeth prius a corpore fuerat separatum et, ne illius visio aliquis horroris intuentibus incuteret, fratres cultello carnes cum pelle et capillis a cranio separaverunt"* – *Sermo de translatione beate Elyzabeth.* In: CAESARIUS – KÖNSGEN, *Das Leben der Heiligen Elisabeth : [und andere Zeugnisse],* p. 104. Comp. F. DICKMANN, *Das Schicksal der Elisabethreliquien, St. Elisabeth – Kult, Kirche, Konfessionen. Katalog 700 Jahre Elisabethkirche in Marburg 1283 – 1983,* Marburg, 1983, pp. 35–38, p. 35. Comp. T. FRANKE, *Zur Geschichte der Elisabethreliquien im Mittelalter und in der frühen Neuzeit, Sankt Elisabeth. Fürstin, Dienerin, Heilige,* Sigmaringen, 1981, pp. 167-179; B. REUDENBACH, *Kopf, Arm und Leib. Reliquien und Reliquiare der heiligen Elisabeth,* in D. BLUME – M. WERNER (eds.), *Elisabeth von Thüringen – eine europäische Heilige. Aufsätze,* Petersberg, 2007, pp. 193-202; P.E. SCHRAMM, *Herrschaftszeichen und Staatssymbolik Beiträge zu ihrer Geschichte vom dritten bis zum sechzehnten Jahrhundert,* Stuttgart, 1954, above all pp. 27–32.

[50] GEESE, *Reliquienverehrung und Herrschaftsvermittlung. Die mediale Beschaffenheit der Reliquien im frühen Elisabethkult,* pp. 161-172.

[51] More in H. BEUMANN, *Friedrich II. und die heilige Elisabeth. Zum Besuch des Kaisers in Marburg am 1. Mai 1236, Sankt Elisabeth. Fürstin, Dienerin, Heilige. Aufsätze, Dokumentation, Katalog,* Sigmaringen, 1981, pp. 151-166. J.R. PETERSOHN (ed.), *Politik und Heiligenverehrung im Hochmittelalter,* Sigmaringen, 1994, pp. 117-118.

[52] KLANICZAY, *Holy Rulers and Blessed Princesses : Dynastic Cults in Medieval Central Europe,* pp. 209-211.

Elizabeth's cult for his own purposes, or at least to prevent his enemies from using it against him.[53] However, in Rome Elizabeth's sanctity went undisputed. Thus, the political aspects of her veneration differed substantially from the cult of Charlemagne. His canonization, which was performed in Aachen in 1165 by the Antipope Paschal III with the keen participation of Emperor Frederick Barbarossa, had never been fully recognized.[54]

The crowned skull was placed in a reliquary that comprised an Ottonian chalice fashioned from an antique agate bowl.[55] (Fig. 1) The meaning of the precious relic was underscored by the attachment of a circlet and the arches of a crown, studded with precious stones.[56] The reliquary, frequently identified as the one now in Stockholm, offered a powerful symbolic interpretation of the saint's skull on several levels.[57] The crown alluded to the saint's royal descent as well as to the crown of martyrdom or the apocalyptic *corona vitae*, which in turn pointed to the celebration of the saint in heaven.[58] The relic could only be seen in close proximity through a small opening in the lid of the chalice.[59] In this type of presentation the symbolic and metaphorical values of the saintly body took precedence over its perceived physical likeness. The corporeal presence of the saint was sublimated through multi-layered symbolic meanings. The precious skull could have been placed inside an anthropomorphic head or

[53] KÖSTLER, *Die Ausstattung der Marburger Elisabethkirche: zur Ästhetisierung des Kultraums im Mittelalter*, p. 47 (note 19).

[54] R. McKITTERICK, *Charlemagne: The Formation of a European Identity*, Cambridge, UK, 2008.

[55] GEESE, *Reliquienverehrung und Herrschaftsvermittlung. Die mediale Beschaffenheit der Reliquien im frühen Elisabethkult*, pp. 173-215.

[56] REUDENBACH, *Kopf, Arm und Leib. Reliquien und Reliquiare der heiligen Elisabeth*, p. 197.

[57] The identification was made long ago by SCHRAMM, *Herrschaftszeichen und Staatssymbolik Beiträge zu ihrer Geschichte vom dritten bis zum sechzehnten Jahrhundert*, vol III, p. 886; W. SAUERLÄNDER, *Two Glances from the North: The Presence and Absence of Frederick II in the Art of the Empire; the court art of Frederick II and the opus francigenum*, in W. TRONZO (ed.), *Intellectual life at the court of Frederick II Hohenstaufen*, Washington, DC, 1994, 189-209, p. 192. The author was unconvinced because of the absence of specific iconographic references to St. Elizabeth among the images of this work of art. Further, the skulls believed to be of Saint Elizabeth are to be found in Vienna, Brussels, Besançon, Bogotá and Viterbo – DICKMANN, *Das Schicksal der Elisabethreliquien, St. Elisabeth – Kult, Kirche, Konfessionen. Katalog 700 Jahre Elisabethkirche in Marburg 1283 – 1983*, pp. 37-38. The skull of St. Elizabeth was allegedly displayed on the main altar of her church in Marburg (altar consecrated in 1290) – A. LEGNER, *Reliquien in Kunst und Kult zwischen Antike und Aufklärung*, Darmstadt, 1995, p. 177.

[58] Rev. 2, 10; see REUDENBACH, *Kopf, Arm und Leib. Reliquien und Reliquiare der heiligen Elisabeth*, p. 198.

[59] A. GOLDSCHMIDT, *Ein Mittelalterliches Reliquiar des Stockholmer Museums*, in *Jahrbuch des preussischen Kunstsammlungen* 40 (1919) p. 8 (dated 1240-1250 on p. 14).

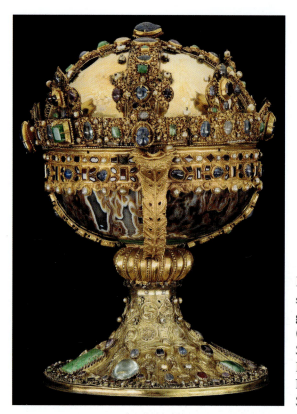

Fig. 1, Head reliquary of the saint, *c.* 1235, agate bowl, gold, gilded silver, gemstones, pearls (*c.* 45×25,8 cm), Stockholm, Statens Historiska Museum, Inv. Nr. 1, Photo: Ola Myrin, National Historical museums, Sweden.

bust reliquary. Such a mediating option (in the sense of how it was presented to the public gaze) was known in Germany from the celebrated head reliquary of an unnamed emperor, given by Frederick Barbarossa to his godfather, Otto of Cappenberg.[60] This tradition had been associated with visual representations of female sanctity going back at least to the celebrated tenth-century figural reliquary of Sainte Foy in Conques.[61] These options were never used in Marburg. Even so, the canonization and the translation encouraged the promotion of

[60] C.J. HAHN, *Strange Beauty: Issues in the Making and Meaning of Reliquaries, 400-circa 1204*, University Park, PA, 2012, on the tradition pp. 117-133, and, for our example in particular p. 132 and fig. 64. For the origins of associations between image and relic see E. THUNØ, *Image and Relic: Mediating the Sacred in Early Medieval Rome*, Rome, 2002.

[61] *Ibid.*, fig. 59; comp. K.M. ASHLEY – P. SHEINGORN, *Writing Faith: Text, Sign & History in the Miracles of Sainte Foy*, Chicago, IL, 1999; B. FRICKE, *Fallen Idols, Risen Saints: Sainte Foy of Conques and the Revival of Monumental Sculpture in Medieval Art*, Turnhout, 2015.

Elizabeth's cult throughout Latin Europe, but especially in Marburg.[62] The Teutonic knights who, upon the death of Conrad of Marburg became the patrons of her pilgrimage church, had to seek alternative solutions to the needs of the numerous pilgrims flocking to Marburg to visit the grave. They decided to construct a new church dedicated to the saint. It was to be in close proximity to both the hospital where she was caring for the needy and the recently built pilgrimage church. The political ambitions of the knights were reflected in the architectural style of the edifice, which was completed in the following decades. For the first time on German territory a new architectonic language drawing upon French Gothic precedents was evident.[63] The replacement of the walls in the new choir by large stained-glass windows offered enough space for the presentation of Christian saints, including the patroness of the church.[64] The early acceptance of High Gothic offered a new experience to pilgrims journeying to Marburg. The church of Saint Elizabeth in that town became the focal point of the cult. Numerous visual representations of its saintly patroness served to remind visitors of the person and life of Elizabeth. The stained-glass choir window (Fig. 2) and the new shrine of the saint (Fig. 3) offered a shining focus for deep reverence.[65] Both works of art, which were created after the saint's canonization in 1235 and before the consecration of the church in 1249, integrated the narratives of Elizabeth into one of the most advanced forms of medial presentation in existence at that time. Their form and imagery reflected both the saint's ideals and the principles of a smoothly functioning image complex which conveyed theological instruction efficiently while proclaiming the grandeur of the mighty patron.

[62] WERNER, *Mater Hassiae – Flos Ungariae – Gloria Teutoniae. Politik und Heiligenverehrung im Nachleben der hl. Elisabeth von Thüringen*, pp. 449-540.

[63] See e.g. H. BAUER, *St. Elisabeth und die Elisabethkirche zu Marburg*, Marburg, 1990; E. LEPPIN, *Die Elisabethkirche in Marburg. Ein Wegweiser zum Verstehen. 700 Jahre Elisabethkirche in Marburg 1283 – 1983, vol. E.*, Marburg, 1983; ARNOLD – LIEBING (eds.), *Elisabeth, der Deutsche Orden und ihre Kirche: Festschrift zur 700 jährigen Wiederkehr der Weihe der Elisabethkirche Marburg 1983*, .

[64] BIERSCHENK, *Glasmalereien der Elisabethkirche in Marburg: die figürlichen Fenster um 1240*, ; D. PARELLO, *Zum Verhältnis von Architektur und Glasmalerei am Beispiel der Marburger Elisabethkirche*, in ARS 37 (2004) 19-39.

[65] E. DINKLER-VON SCHUBERT, *Der Schrein der hl. Elisabeth zu Marburg. Studien zu Schrein-Ikonographie*, Marburg, 1964; V. BELGHAUS, *Der erzählte Körper. Die Inszenierung der Reliquien Karls des Grossen und Elisabeths von Thüringen*, Berlin, 2005; KROOS, *Zu frühen Schrift- und Bildzeugnissen über die helige Elisabeth als Quellen zur Kunst- und Kulturgeschichte, Sankt Elisabeth. Fürstin, Dienerin, Heilige*, .

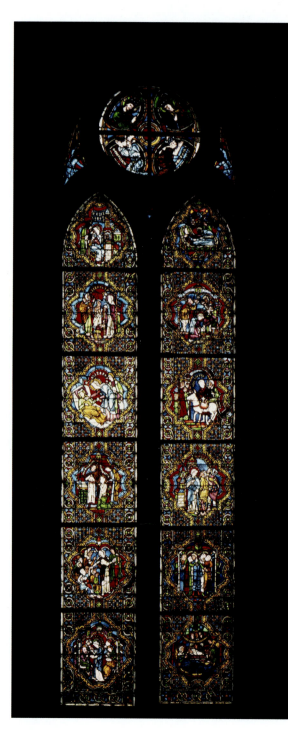

Fig. 2, The choir window,
c. 1235–1250, stained-glass,
Marburg, Church of Saint
Elizabeth. Photo: Horst
Fenchel, Bildarchiv Foto
Marburg, fmc188621.

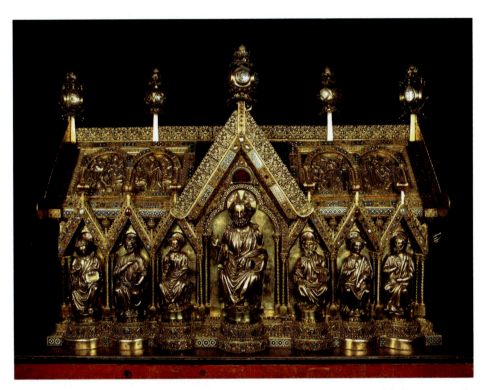

Fig. 3, The shrine of saint Elizabeth, Maiestas side, *c.* 1235–1250, gilded copper and silver on oak-wood core (h: 135 cm, l: 187 cm, w: 63 cm), Marburg, Church of Saint Elizabeth, Photo: Bildarchiv Foto Marburg, fmbc31745_09.

1.4. The Way to Heaven – The Choir Window

The Church of Saint Elizabeth, which took the form of a three-aisled hall with a trefoil-plan choir, was one of the earliest buildings in Germany to be inspired by the new Gothic style of French cathedrals.[66] Two horizontal rows of large tracery windows are placed above each other in the Eastern choir.[67] The basic structure of each window consists of two parallel vertical lancets embellished by

[66] D. PARELLO – R. TOUSSAINT, *Die Elisabethkirche in Marburg*, Regensburg, 2009. The original stained-glass windows are not preserved on the Liebfrauenkirche in Trier, a building, which is in many respects comparable. Comp. N. BORGER-KEWELOH, *Die Liebfrauenkirche in Trier: Studien zur Baugeschichte*, Trier, 1986.

[67] BIERSCHENK, *Glasmalereien der Elisabethkirche in Marburg: die figürlichen Fenster um 1240*, comp. note 1364 on p. 276. D. PARELLO – D. HESS, *Die mittelalterlichen Glasmalereien in Marburg und Nordhessen*, Berlin, 2008.

the oculus above. The architect used a bar tracery design known from the aisle windows at Reims, created around 1215. Although the tracery of the window is strikingly progressive in form, the unusually demanding task of creating large stained-glass panels was handled by a team of local glaziers.[68]

The window with the panels portraying the legend of St Elizabeth was placed in the lower register in keeping with standard practice in churches including Chartres and Bourges.[69] The finer details of the narrative scenes were legible only at the lower level. Generally speaking, the impact of stained-glass windows on the audience was guaranteed by size and the vibrant and luminous radiance and intensity of color.[70] Connecting individual pieces by strips of lead ensured clear legibility of the design. Such a medium became an important means of visual propaganda, especially when explained by a priest or similarly knowledgeable person. It was one of the most efficient tools in the church's fight against heretics and people with unusual beliefs in the time before the advent of printing and book production in the last third of the fifteenth century. The effects of its didactics and consolation can be compared with modern cinema.[71] Nevertheless, the social and psychological functions of images in the 13th century were similar to an "applied theology" of vernacular texts. The concern to rule in public space came at the expense of precise formulation. Clarity, radiant brightness, sharpness, lightness and vividness (*claritas*) came to assume more importance than the authority (*auctoritas*) of learned theological texts, which might be understandable only to a small circle of persons. In contrast to Chartres and Bourges, in Marburg any reference to the donor of the window in its lower register has been omitted.[72] There were no guilds in Marburg to patronize the window which would have required an advertisement of this kind. In a certain sense the fundamental interests of the Teutonic Order pervaded the whole structure of the window.

Not all the questions regarding the original position of the window have been satisfactorily resolved. Given the prohibition of pilgrims from entering

[68] PARELLO, *Zum Verhältnis von Architektur und Glasmalerei am Beispiel der Marburger Elisabethkirche*, p. 19-21. The discrepancy between the style of the architect and the glaziers has been noted by A. HASELOFF, *Die Glasgemälde der Elisabethkirche in Marburg*, Berlin, 1906, p. 19.

[69] BIERSCHENK, *Glasmalereien der Elisabethkirche in Marburg: die figürlichen Fenster um 1240*, p. 168.

[70] M.H. CAVINESS, *Paintings on Glass: Studies in Romanesque and Gothic Monumental Art*, Aldershot, Great Britain, 1997, p. 106.

[71] W. FAULSTICH, *Medien und Öffentlichkeiten im Mittelalter, 800-1400*, Göttingen, 1996, p. 169.

[72] W. KEMP, *The Narratives of Gothic Stained Glass*, Cambridge, 1997, pp. 200-217.

certain parts of the church, the position of the window is of relevance for the original target audience. The window in the eastern apse (its current placement) would have been addressed mainly to the members of the Teutonic Order.[73] If the window had originally been placed in the Northern choir above Elizabeth's tomb, it would have addressed pilgrims coming to visit the final resting place of the saint. Regardless of the exact original position of the window, the audience was sufficiently informed about the basic principles of the Christian doctrine and the narratives of the history of salvation. The basic structure of the window and the pictorial legend were within their grasp, especially when bolstered by preaching. The media contributed to the desired effect on the public.[74] The pictorial legend in the stained-glass window was more than a mere illustration to the well-known narrative. In comparison with the textual legends the given number of scenes offered only limited space for providing information about the historical life of Elizabeth. The transformation of texts into the set of images necessarily entailed compromises.[75] The order of images in stained glass gave the events of the saintly life a constant presence in the church and visibility during daylight. Moreover, individual episodes were integrated into a structure which offered a framework in which they could be understood and interpreted.

The Marburg window, as one of the two earliest pictorial legends of Elizabeth, did not follow traditional iconographic schemes, but drew upon other models. Its overall arrangement, which was based on the example of classic cathedrals, was ideally suited to bringing the key events from the life of the patron saint of the church closer to the believers who came to worship her. The pictorial transposition rendered the events closer to the viewer's everyday existence in a form associated with theological interpretation. The conventions of tracery windows influenced the form the scenes took and the ideological context of their interpretation. The historical life of the saint, her *vita*, found expression in a series of episodes in the right lancet of the window. Elizabeth appears here without

[73] BIERSCHENK, *Glasmalereien der Elisabethkirche in Marburg: die figürlichen Fenster um 1240*, p. 167. This possibility is accepted by PARELLO, *Zum Verhältnis von Architektur und Glasmalerei am Beispiel der Marburger Elisabethkirche*, p. 23; F. MARTIN, *Die heilige Elisabeth in der Glasmalerei. Vermittlungsstrategien eines weiblichen Heiligenmodelles,* in D. BLUME – M. WERNER (eds.), *Elisabeth von Thüringen – eine europäische Heilige. Aufsätze*, Petersberg, 2007, 293-308, p. 294, accepted unreservedly the placement of the window in the northern choir.

[74] FAULSTICH, *Medien und Öffentlichkeiten im Mittelalter, 800-1400*, p. 179.

[75] W. KEMP, *Sermo corporeus: die Erzählung der mittelalterlichen Glasfenster*, München, 1987, p. 265. English translation – KEMP, *The Narratives of Gothic Stained Glass.*

a nimbus, acquiring the halo only at the moment of her passing away. The column of scenes ran upwards in accordance with the contemporary conventions for reading stained glass and provided a parallel to Elizabeth's works of mercy (*opera*), represented in the left lancet. In this part, which offers a symbolic interpretation (*allegoria*), she is constantly shown with the aureole. The allegorical interpretation is based on the visual proximity of the narratives and does not work with horizontal connections at each level. The differentiation between historical life and exemplary deeds is perhaps based on the idea that actively putting into practice selfless love (*agape*) through the works of mercy is a way of raising one's own life to eternity in a Christian sense. All elements appear to converge towards the crowning of Elizabeth and Francis, placed at the apex of the window as an image of arrival and acceptance in heaven. In this sense, the structure of the window opened up other opportunities for pictorial narrative beyond those offered by the reliefs of the shrine. The culmination is reached in the oculus in which the Virgin Mary, placed in a semicircle above, is crowning St Elizabeth, who kneels below her on the right-hand side. In the left half of the circle Christ is offering a crown to St Francis of Assisi in a similar arrangement, thus creating a meaningful visual symmetry. (Fig. 4) As is well known, Elizabeth was influenced by her contemporary, Saint Francis of Assisi, when exhibiting a new and radical understanding of some of Christ's teachings concerning the problem of poverty.[76]

Both saints had originally interpreted the traditional ideals of following Christ.[77] The applicability of this pattern in Elizabeth's case is somewhat limited by her gender identity. As a woman, she imitated mercy, selfless love and compassion (*imitatio misericordiae*), but unlike St Francis in the Franciscan church in Erfurt her gender obviously excludes an interpretation of her as a second Christ (*alter Christus*).[78] Considerations of this type were within the

[76] A. VAUCHEZ, *Charité et pauvreté chez Sainte Elisabeth de Thuringe d'après les actes du procès de canonisation*, in M. MOLLAT (ed.), *Études sur l'histoire de la pauvreté*, Paris, 1974, 163-173; K. BOSL, *Das Armutsideal des heiligen Franziskus als Ausdruck der hochmittelalterlichen Gesellschaftsbewegung*, in H. KÜHNAL – H. EGGER (eds.), *800 Jahre Franz von Assisi. Franziskanische Kunst und Kultur des Mittelalters : Niederösterreichische Landesausstellung, Krems-Stein, Minoritenkirche, 15. Mai-17 Obt. 1982*, Wien, 1982, 1-12.

[77] W. TELESKO, *Imitatio Christi und Christoformitas. Heilsgeschichte und Heiligengeschichte in den Programmen Hochmittelalterlicher Reliquienschreine*, in G. KERSCHER (ed.), *Hagiographie und Kunst*, Berlin, 1993, 369-384.

[78] The idea is discussed by MARTIN, *Die heilige Elisabeth in der Glasmalerei. Vermittlungsstrategien eines weiblichen Heiligenmodelles*, pp. 298-303. The idea of a relationship to the iconographic type of the Merciful Virgin Mary (*Madonna della Misericordiae*) is supported by examples from the later period.

Fig. 4, The crowning of Saints Elizabeth and Francis, stained-glass, *c.* 1235–1250, Marburg, Church of Saint Elizabeth, Photo: Bildarchiv Foto Marburg, fmc426937.

purview of educated viewers. A simple pilgrim visiting the church may have experienced the feeling of being rescued from the common aspects of his or her everyday life by the dazzling beauty of the window. The psychological effect of the medium would have gained further theological resonance. Abbot Suger of St Denis, who introduced the conventional upwards reading of scenes, interpreted this order as a path from material things to immaterial phenomena (*de materialibus ad immaterialia*).[79] Heavenly Jerusalem was the final aim of

[79] See E. Panofsky, *Abbot Suger on the Abbey Church of St.-Denis and Its Art Treasures*, Princeton, NJ, 1979, p. 20; P. Kidson, *Panofsky, Suger and St. Denis*, in *Journal of the Warburg and Courtauld Institutes* 50 (1987) 1-17, calls into questions the Neo-Platonic aspects of Panofsky's interpretation. Recently M. Büchsel, *Licht und Metaphysik in der Gotik – noch einmal zu Suger von Saint-Denis*, in E. Badstübner (ed.), *Licht und Farbe in der mittelalterlichen Backsteinarchitektur des südlichen Ostseeraums*, Berlin, 2005, 24-37. See also G. Spiegel, *History as Enlightenment: Suger and the Mos Anagogicus*, in P. Lieber Gerson (ed.), *Abbot Suger and Saint-Denis a Symposium*, New York, NY, 1986, 151-158.

spiritual elevation (*mos anagogicus*). Ornamental borders greatly enhanced the effect of the overall decorative vocabulary; an ornamental border visually connected the individual scenes thereby underscoring the vertical axis of the window leading to the oculus.[80] The vertical upwards thrust is reinforced by rhythmic alternations of red and blue colors which for a medieval audience may well have evoked the precious stones mentioned in the description of the celestial city. Ceasarius of Heisterbach compared the six works of mercy with the six gates of Jerusalem.[81] The window in its entirety constituted a major element of church adornment (*ornamenta ecclesiae*).[82] It appealed to the senses and offered many possibilities for symbolic readings. Elizabeth's memory was integrated into a unique artistic experience. Its complexity was firmly embedded in the discourses and iconographic traditions alive in the culture of that time.

The message of Elizabeth's life influenced believers in a variety of ways. While it is altogether possible that some people were deeply fascinated, others may have regarded her ascetic ideal as too extreme and exacting to be emulated or even have found it intimidating. Despite the individual differences the shared content of images and of imagination may have contributed to the creation of emotional communities.[83]

The figures on the reliquary and in the window can be interpreted as an important testimony to the increasing attention paid to the expressive potential of body language. The possibilities offered by contemporary visual language were exploited to convey emotional messages. On occasion images appear to offer a representation of emotional life that may have been informed by the artist's perceptions. Even so, such scenes are relatively restrained compared with the rhetorically powerful textual narratives of the period.

[80] For the analysis of the technical and formal aspects of the window see BIERSCHENK, *Glasmalereien der Elisabethkirche in Marburg: die figürlichen Fenster um 1240*, pp. 183-184.

[81] *"Sex portas habuisse legitur Ierusalem terrestris, per quas sex opera misericordie designatur"* – *Sermo de translatione beate Elyzabeth.* In: CAESARIUS – KÖNSGEN, *Das Leben der Heiligen Elisabeth: [und andere Zeugnisse]*, p. 94.

[82] The key medieval concept was popularized by the 1985 exhibition in Cologne – A. LEGNER (ed.), *Ornamenta Ecclesiae: Kunst und Künstler der Romanik: Katalog zur Ausstellung des Schnütgen-Museums in der Josef-Haubrich-Kunsthalle*, Köln, 1985.

[83] B.H. ROSENWEIN, *Emotional communities in the early Middle Ages*, Ithaca, N.Y., 2006. For a methodological discussion of related questions comp. P. BURKE, *Is There a Cultural History of Emotions?*, in P. GOUK – H. HILLS (eds.), *Representing Emotions.* Surrey – Burlington, VT, 2005, 35-47; W.M. REDDY, *The Navigation of Feeling: A Framework for the History of Emotions*, Cambridge – New York, NY, 2001.

The compositions of the narrative scenes on the reliquary and the window are closely comparable, even though they were created by different artists working in different media. This similarity provides an important testimony concerning the influence of iconographic tradition in the processes of image production. It should not be dismissed as the simple copying of a solution created by a colleague working nearby. Rather, it should be regarded as the result of a dialogue with the topic, firmly embedded in contemporary imagery. Its specific forms and accessible interpretations were not deliberate creation of an artist, but rather they were to a large extent influenced by patrons and their spiritual advisors, who were eager to see the time-honored tradition prolonged into their own time and beyond.

1.5. Works of Mercy

The works of mercy exemplify the most important iconographic tradition associated with St Elizabeth. These figure prominently in the earliest pictorial legends of Elizabeth in Marburg. The left half of the choir window and at least three of the eight reliefs on the roof of the shrine are devoted to the theme.

There are compelling reasons for thinking that the creators of the Marburg cycles were familiar with the six acts of mercy which were portrayed in a significant number of sites, Romanesque portals which were the most readily accessible. One of the examples in close proximity to Marburg could be encountered when going up the river Rhine in Basel (the north portal of the Minster, around 1170).[84] On their journey from Elizabeth's canonization ceremony in Perugia, some people may have stopped at Parma to visit the baptistery with its magnificent sculptural decoration created by Benedetto Antelami and his workshop. Completed sometime after 1196, it was sufficiently new to attract the attention of visitors. On the left jamb of the west portal, devoted primarily to the Last Judgement, the works of mercy are included in the iconographic program.[85] (Fig. 5) The central figure of the six scenes, who is offering his services to the

[84] H.-R. MEIER – D.S. SCHÜRMANN – S. ALBRECHT – G. BONO – P. BURCKHARDT, *Schwelle zum Paradies: die Galluspforte des Basler Münsters*, Basel, 2002.

[85] M. WOELK, *Benedetto Antelami: die Werke in Parma und Fidenza*, Münster, 1995, 124-125; C. FRUGONI – A. DIETL, *Benedetto Antelami e il Battistero di Parma*, Torino, 1995, 75-77; R.V. BÜHREN, *Die Werke der Barmherzigkeit in der Kunst des 12. - 18. Jahrhunderts. Zum Wandel eines Bildmotivs vor dem Hintergrund neuzeitlicher Rhetorikrezeption*, Hildesheim – Zürich – New York, NY, 1998, 35-36; F. BOTANA, *The Works of Mercy in Italian Medieval Art (c. 1050 – c. 1400)*, Turnhout, 2011, 28-48.

Fig. 5, Benedetto Antelami (workshop), works of mercy, after 1196, the west portal of the baptistery, Parma, Photo: author.

destitute, is a bearded man clad in tunic, with no further indication of his of his identity. Elsewhere, the identification of the figure performing the charitable deeds was even more abstract. In Hildesheim, for instance, the personification of Mercy (bearing the inscription '*Misericordia*'), dispensing victuals, is featured within the complex iconography of one of the most elaborate medieval baptismal fonts.[86]

[86] Hildesheim, Cathedral, St. Georges Chapel, c. 1226; see P. BARNET – M. BRANDT – G. LUTZ, *Medieval Treasures from Hildesheim*, New York, NY, 2013, 104-107; BÜHREN, *Die*

In the pictorial legends in Marburg the conventional or standard group of six or seven works of mercy is shown together with the Saint's biography. The association with an established pattern of imagination demonstrates that the princess – despite her royal descent and privileged social position – was on her way to the heavenly kingdom. She was following the model of saintly life and iconography based on biblical testimony recording Christ's words which will be spoken at the end of time:

> Come, o blessed of my father, inherit the kingdom prepared for you from the foundation of the world, for I was hungry and you gave me food, I was thirsty and you gave me drink, I was a stranger and you welcomed me, I was naked and you clothed me, I was sick and you visited me, I was in prison and you came to me.[87]

The six activities mentioned in the gospel text were frequently depicted in medieval art. They were interpreted as models of behavior to be emulated. Even uneducated believers were shown the correct course of action in order to achieve salvation. Elizabeth became an example of Christian charity by following this model.

It is beyond doubt that the reference to this tradition in the left column of the choir window and on the roof of the shrine in Marburg comprised the main theological message of the both cycles. The lowest scene of the window cycle represents the feeding of the hungry. (Fig. 6) Elizabeth, portrayed standing at the center of the composition, is giving food to a man seated in front of her. The spoon which she used to feed the man was soon to become an important signifier as the saint's personal attribute. In many iconic images created in subsequent centuries she is portrayed proudly bearing this attribute. Behind the man who is being fed a woman eats from a bowl. Two more figures are portrayed eating behind, thus exemplifying the greater scope of her charitable activity, and lending symmetry to the composition thereby underscoring Elizabeth as the protagonist in the scene. The composition on the roof of the shrine is closely comparable. The charitable activity depicted conveyed complex meanings for medieval audiences. On a material level it was highly relevant to the frequently encountered problem of famine. Spiritually, it pointed to a special connection between the Saint and Christ. This level of meaning was based not only on the words of Bible. The *officium,* which was read aloud at the

Werke der Barmherzigkeit in der Kunst des 12. - 18. Jahrhunderts. Zum Wandel eines Bildmotivs vor dem Hintergrund neuzeitlicher Rhetorikrezeption, pp. 37-39, 231-232, fig. 9.

[87] Mathew 25: 34-35.

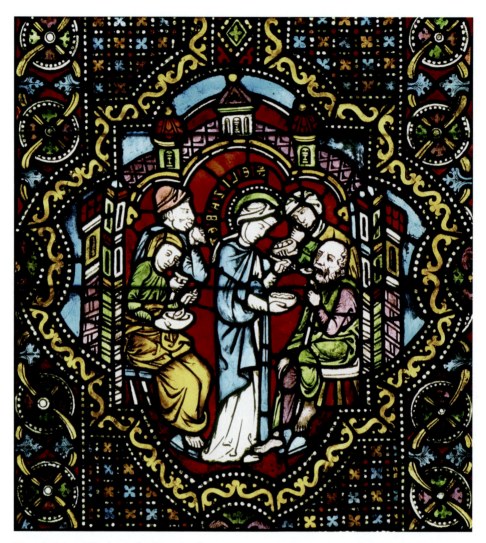

Fig. 6, Saint Elizabeth feeding the hungry, *c.* 1235–1250, stained-glass window, Marburg, Church of Saint Elizabeth, Photo: Bildarchiv Foto Marburg, fmc188615.

canonization ceremony in Perugia praises the new saint as "the Satisfaction of God".[88] Educated believers who gave thought to this somewhat cryptic metaphorical term might have found a new way to interpret the pictures. They may

[88] *Ut de regum ramis nata / juste vere sis vocata / Tu Dei saturitas*; the text edited and discussed by D. HENNIGES, *Die Heilige Messe zu Ehren der Heiligen Elisabeth*, in *Franziskanische Studien* 9 (1922) 158-171.

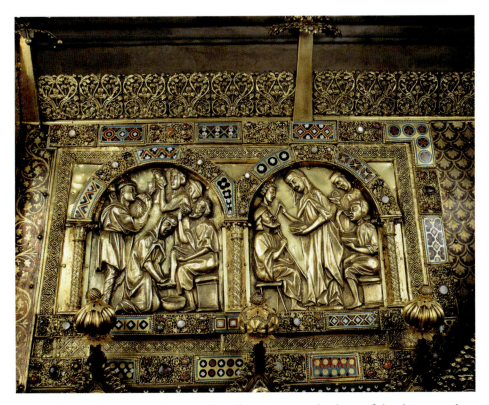

Fig. 7, Saint Elizabeth washing the feet of a poor man, drinking of the thirsty, and feeding of the hungry, *c.* 1235–1250, gilded copper, Marburg, Church of Saint Elizabeth, Photo: Bildarchiv Foto Marburg, fmc411686.

have seen Elizabeth literally satiating Christ, even if – unlike in some other cycles in which the subject was portrayed – the needy are not marked by the cross nimbus as *alter Christus*.[89]

The second image of the window (and the image of the Maiestas side on the shrine) shows a modified work of mercy. (Fig. 7) The drinking of the thirsty is set alongside the episode of washing the feet of a poor man. Such a combination may well have been inspired by the above-mentioned cycle in the Parma baptistery, where the washing of the feet is also shown. Another possible source of inspiration may have been the life of Saint Radegond of Poitiers (*c.* 520–587), described by Venantius Fortunatus. While caring for the infirm, Radegund was

[89] The closest example of this kind is offered by the late 13th-century murals in the sacristy of the church of St. Hubert in Mardorf, near Marburg.

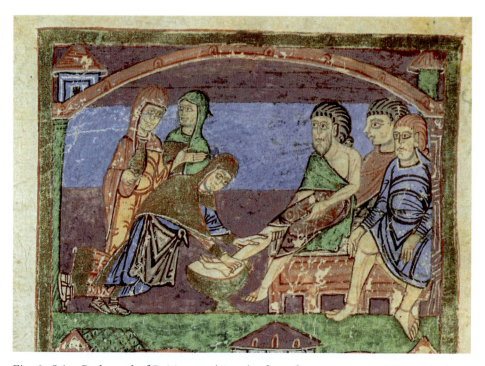

Fig. 8, Saint Radegond of Poitiers washing the feet of a poor man, *c.* 1050, painting on parchment, Poitiers, Bibliothèque municipale, manuscrit 250, fol. 29v. From La vie de sainte Radegonde par Fortunat. Photo: author.

"washing and kissing their feet".[90] She also washed the feet of the visitors she received and ministered to. The upper part of the whole-page illumination of a manuscript of this legend, produced *c.* 1050, is devoted to the topic of feet-washing.[91] (Fig. 8) Radegond's legend prefigured the activities of Elizabeth in several ways. The Hungarian princess and Landgravine of Thuringia followed the example of the Thuringian princess and Frankish queen in other respects, too.[92]

[90] *Vita Radegundis*, c. XXIV: "pedes lavans et osculans" –V.H.C. FORTUNATUS – R. FAVREAU, *La vie de sainte Radegonde par Fortunat: Poitiers, Bibliothèque municipale, manuscrit 250 (136),* Paris, 1995,p. 92. For an English translation comp. http://people.uwm.edu/carlin/venantius-fortunatus-life-of-st-radegund/ (visited on March 29, 2017).

[91] Poitiers, Bibliothèque Municipal, Médiathèque François-Mitterrand, Ms. 250, fol. 29v; DINKLER-VON SCHUBERT, *Der Schrein der hl. Elisabeth zu Marburg. Studien zu Schrein-Ikonographie,* p. 191, fig. 103.

[92] M.E. CARRASCO, *Spirituality in Context: the Romanesque Illustrated Life of St. Radegund of Poitiers.* in *The Art Bulletin* 72 (1990) 414-435, p. 425; C. HAHN, *Portrayed on the Heart. Nar-*

The representation of Elizabeth's extraordinary gesture of humility bears complex theological and iconographical references. Primarily, it was a way of representing the visual identity of the saint with Christ, based on the principle of *christoformitas*. It emulated the washing of the feet of Peter by Christ, which was a subject commonly depicted in medieval art. In Elizabeth's case its Christological meaning and significance were consciously exploited. Her legend, written by the Dominican writer Dietrich of Apolda, states that during feetwashing and the distribution of alms the Saint acted as '*Christi imitatrix*'.[93]

At a deeper level, the image referred to Mary Magdalene anointing the feet of Jesus.[94] The presence of this reference at the time of the production of the Marburg images is testified by the anonymous Franciscan, writing between 1250–1280, who saw in Elizabeth "another Magdalene, crowned by humility, always ready to bathe the poor at the Lord's supper, washing their feet with her tears like the feet of the Lord sitting in the house of Simon the leper, and drying them with the veil she wears on her head and tears poured forth from her eyes."[95] The intensity of corporeal intimacy between the saint and the poverty-stricken man in the scene of the washing of the feet would be further reinforced a few decades later in the fresco cycle in Mardorf, where, – as in the well-known prototype of Mary Magdalene – Elizabeth bows to kiss a pauper's leg.[96]

rative Effect in Pictorial Lives of Saints from the Tenth through the Thirteenth Century, Berkley, CA, 2001, pp. 259-276.

[93] *"ea die (qua domini celebratur cena) semper solempne mandatum Christi imitatrix exhibere pauperibus: Duodecim enim pedes pauperum lavit singulis nummos duodecim pannumque pro vestimento et panem similaginis tribuens"* – M. RENER (ed.), *Die Vita der heiligen Elisabeth des Dietrich von Apolda*, Marburg, 1993, pp. 45-46; DINKLER-VON SCHUBERT, *Der Schrein der hl. Elisabeth zu Marburg. Studien zu Schrein-Ikonographie,* p. 94.

[94] Matthew 26, Mark 14, Luke 7, and John 12. See T.J. HORNSBY, *Annointing Jesus,* in A.-J. LEVINE – D.C. ALLISON, JR. – J.D. CROSSAN, *The historical Jesus in context,* Princeton, N.J., 2006, pp. 339-342. On the inclusion of that episode in later legends of Mary Magdalene see K.L. JANSEN, *The Making of the Magdalen: Preaching and Popular Devotion in the later Middle Ages,* Princeton, N.J., 2000.

[95] *"… tamquam alteram Magdalenam, humilitate turritam, semper in cena Domini lotioni pauperum insistentem, pedes eorum instar pedes Domini recumbentis in domo Simonis leprosi lacrimis suis lavantem et capitis sui velo tergentem"* – GECSER, *The Feast and the Pulpit: Preachers, Sermons and the Cult of St. Elizabeth of Hungary, 1235-ca. 1500,* p. 20.

[96] D. BLUME – G. JACOBS – A. KINDLER, *Wechselnde Blickwinkel. Die Bildzyklen der Heiligen Elisabeth vor der Reformation,* in D. BLUME – M. WERNER (eds.), *Elisabeth von Thüringen - eine europäische Heilige. Aufsätze.* Petersberg, 2007, pp. 271-292, p. 273; comp. M. VOGT, *Weil wir wie das Schilfrohr im Flusse sind: Begegnungen mit der Heiligen Elisabeth in Hessen und Thüringen,* Regensburg, 2006, pp. 176-179.

Liturgical references were also included in the complex levels of meaning in this scene. The washing of the feet of the poor (*mandatum Christi*) was one of the earliest rites to be performed on Maundy Thursday.[97] It was also on this day that the liturgy commemorating the institution of the Eucharist during the Last Supper took place. The man whose feet are being washed is portrayed drinking, while in the background two further figures are likewise engaged. In the corresponding scene on the shrine even more people are shown drinking. The author of the relief perhaps wished to allude to a larger crowd (possibly the twelve persons mentioned in the legend quoted above). When associated with drinking (and eating), washing of the feet can be understood as a complex Eucharistic allusion. By offering food and drink to the poverty-stricken and exemplifying humility, Elizabeth provides not only material, but also spiritual sustenance and assistance. Thus, in this multi-layered action she is identified with the traditional model of humble behavior, which had long been accepted and identified in images of the life of Christ and in the liturgy. Unlike the works of mercy, the liturgical ceremony took place only once a year. Nevertheless, Elizabeth fostered a new understanding of humility and a solidarity with the marginalized that amounted to more than a mere symbolic gesture. Her Christian, and more significantly, her human appeal diverged from the generally acknowledged forms of ritualized gestures of help, focusing instead on everyday life.[98] Without a doubt her deeds amounted to more than just washing the feet of the poor; the legend informs us that her acts of devotion included washing feet and hands as well as the terrible sores and the ulcerous skin of lepers: "She gathered on that same day many lepers by washing their feet and hands and she prostrated herself at their feet with great humility kissing their ulcerated and gruesome sores."[99]

The third image of the window (and the only image of this series on the Crucifixion side of the shrine roof), represents the clothing of the naked. (Fig. 9) In both cases, the saint, depicted standing in the doorway of a house, is giving a voluminous mantle to a praying man. In the window image, a half-naked man is fully engaged in putting on the blue shirt offered to him; on the shrine a man stands with slightly bent knees and hands folded in a gesture of

[97] G. RAMSHAW, *The three-day feast: Maundy Thursday, Good Friday, Easter*, Minneapolis, MIN, 2004, p. 33.

[98] VAUCHEZ, *Charité et pauvreté chez Sainte Elisabeth de Thuringe d'après les actes du procès de canonisation*, p. 166.

[99] "*Collegit…ipsa die multos leprosos eorum pedes manusque lavans et in ipsis loca ulcerosa et horrenda deosculans pedibus eorum humillime se prostravit*" – RENER (ed.) *Die Vita der heiligen Elisabeth des Dietrich von Apolda*, p. 46.

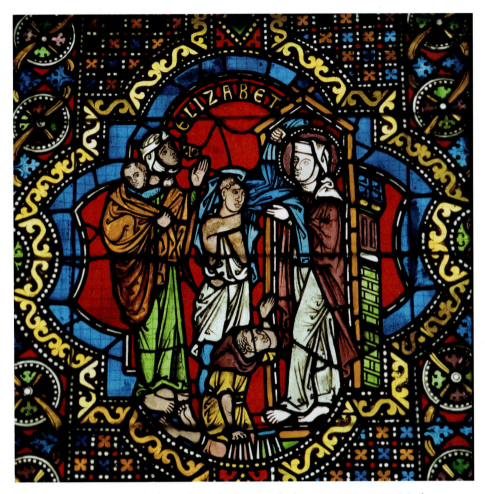

Fig. 9, Saint Elizabeth clothing the naked, stained-glass, *c.* 1235–1250, Marburg, Church of Saint Elizabeth, Photo: Bildarchiv Foto Marburg, fmc426930.

praying while he receives the mantle from Elizabeth. Two further figures can be discerned: a beggar kneeling in the foreground and a woman carrying a child in her bag. The representation of child, hitherto uncommon in medieval art, is an important testimony to the changes in mentality associated with this type of artwork and more broadly with the new spiritual movement of women, of which Elizabeth was a prominent exponent.[100] In the relief (Fig. 10), the greater

[100] H. ZIELINSKI, *Elisabeth von Thüringen und die Kinder*, in ARNOLD – LIEBING (eds.), *Elisabeth, der Deutsche Orden und ihre Kirche: Festschrift zur 700 jährigen Wiederkehr der Weihe der Elisabethkirche Marburg 1983*, pp. 27-38.

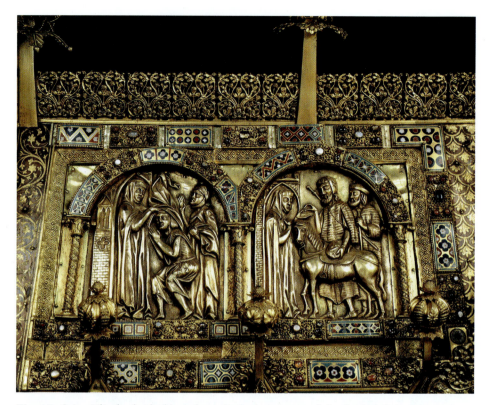

Fig. 10, Saint Elizabeth clothing the naked, the return of the Ludwig's bones,
c. 1235–1250, gilded copper, Marburg, Church of Saint Elizabeth, Photo: Bildarchiv
Foto Marburg, fmbc3173713.

extent of this activity is suggested only by a woman carrying more pieces of
cloth. The figure of Elizabeth standing at the porch of a building shown on the
reliquary may allude to welcoming the strangers; this topic would otherwise
have been absent from the cycle. Such a reading is supported by an adjacent
scene with arriving messengers. The strategy of combining different possible
readings of individual scenes is also to be encountered in other scenes of the
reliquary roof.

In the window, a separate scene – the fourth image in this sequence – is
devoted to housing strangers. (Fig. 11) Two men are approaching the saint,
who stands in front of a somewhat more elaborate structure, possibly a castle.
The first guest is clad in coarse garments; there are large holes in his yellow
mantle and brownish pants; the second one is identifiable as a pilgrim as evi-
denced by the three red scallop shells which adorn his bag and one more on his

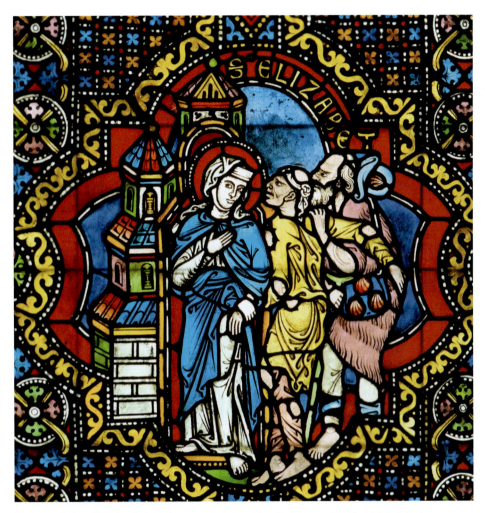

Fig. 11, Saint Elizabeth housing strangers, stained-glass, *c.* 1235–1250, Marburg, Church of Saint Elizabeth, Photo: Bildarchiv Foto Marburg, fmc426928.

cap. This combination conveys two different applications of this topic in real life: ministering to the needy and assisting people travelling from afar to cross foreign lands during their pilgrimage. Considered in this light it is not to be excluded that the image was of direct personal importance for the large crowds of pilgrims visiting the church in Marburg.[101]

[101] See GEESE, *Die Elisabethreliquien in der Wallfahrtskirche*, p. 15.

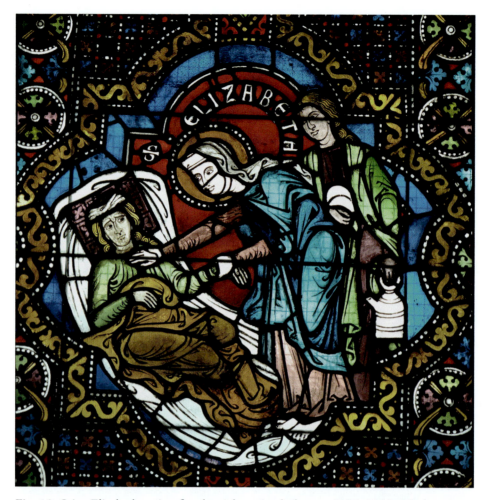

Fig. 12, Saint Elizabeth caring for the sick, stained-glass, *c.* 1235–1250, Marburg, Church of Saint Elizabeth, Photo: Bildarchiv Foto Marburg, fmc426935.

The fifth image of the series portrayed in the window is limited to caring for the sick and infirm. (Fig. 12) Elizabeth, having arrived with her maid, holds in her left, the hand of a man lying in a bed. She looks with compassion at the patient, whose facial expression conveys suffering. The right hand of the saint is placed on the patient's chest. A slight similarity between the gestures of the Saint and those of Christ resuscitating the daughter of Jairus (Mk 5,23; Mk 5,41) is evident.[102] Nevertheless, Elizabeth was not reputed to have performed

[102] BIERSCHENK, *Glasmalereien der Elisabethkirche in Marburg: die figürlichen Fenster um 1240*, pp. 240-271.

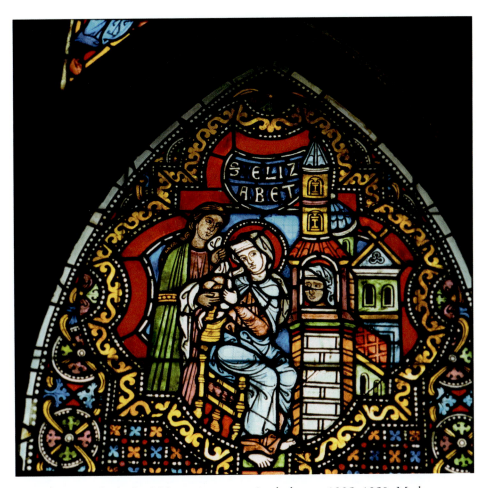

Fig. 13, Saint Elizabeth visiting prisoners, stained-glass, *c.* 1235–1250, Marburg, Church of Saint Elizabeth, Photo: Bildarchiv Foto Marburg, fmc426936.

any miracles while visiting the sick. The accounts of miracles collected during the canonization procedure focus exclusively on posthumous events. Given the importance of this theme in later pictorial legends the absence of miracles in the first image cycles devoted to Elizabeth may occasion surprise.

A small image at the top of this window sequence is devoted to visiting prisoners. (Fig. 13) The Saint is seated next to a prison, depicted as a tower, with the face of just one inmate visible. The presence of a scarf indicates that the face is probably that of woman prisoner. The maid accompanying Elizabeth carries small gifts to alleviate the prisoner's fate. Unlike in the other scenes and at odds with the theological interpretation, the Saint's facial expression and the way her

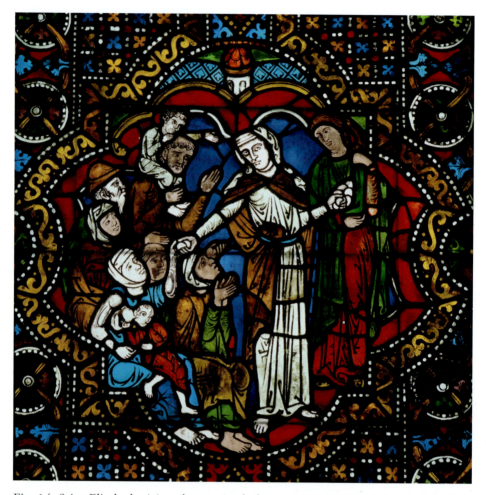

Fig. 14, Saint Elizabeth giving alms, stained-glass, *c.* 1235–1250, Marburg, Church of Saint Elizabeth, Photo: Bildarchiv Foto Marburg, fmc426936.

head is inclined sideways may imply certain misgivings rather than unconditional love and compassion.

An additional scene representing almsgiving is shown on the reliquary and in the window (at the top of the biographical sequence in the right lancet). (Figs. 14, 15) This topic is more congruent with the documented life of the saint than with the canonical works of mercy.[103] The biblical reference for such

[103] For the relevant text from her biography see RENER (ed.), *Die Vita der heiligen Elisabeth des Dietrich von Apolda*, pp. 98-99 (the passage beginning "*De larga elemosina una die distributa*").

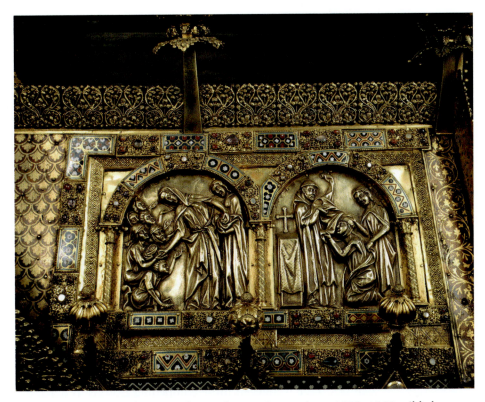

Fig. 15, Saint Elizabeth giving alms and accepting tunic, *c.* 1235–1250, gilded copper, Marburg, Church of Saint Elizabeth, Photo: Bildarchiv Foto Marburg, fmbc31740_07.

a type of image is to be found elsewhere. Elizabeth was probably following the words of Christ: "Sell all your possessions and distribute them to the poor, and you will have treasure in the heaven".[104]

This picture is derived from the general pictorial tradition of almsgiving of the early to mid-twelfth century, as is found, for example, in a manuscript version of the Life and Miracles of St. Edmund which is dated to circa 1130 (New York, Pierpont Morgan Library M.736 fol. 9r.)[105] An additional level of meaning is conveyed by the medium used for the presentation of the scene. The intrinsic material value of the reliquary reflects the choice to invest in the Saint's

[104] Luke 18, 22.
[105] For an analysis of almsgiving, see G.B. GUEST, *A Discourse on the Poor: the Hours of Jeanne d'Evreux*, in *Viator* 26 (1995) 153-180.

pictorial propaganda instead of distributing the reliquary's economic value to the lower levels of contemporary society. Such a decision was based on current practice in ecclesiastical art in clerical centers throughout Western Europe. The ideological reasoning in favor of this decision included biblical ideas about the need to celebrate the presence of the Savior on Earth. In this case, the ensemble of ideas was modified to celebrate the extraordinary saintly life. It was also an investment in the process of memory. The success of this investment strategy has not escaped the attention of modern art historians either; just how it manifested itself will be seen in what follows.

1.6. Mediating the Precious Relics – Shrines

Reliquaries were often chosen by medieval patrons to commemorate a saint whose precious relics they possessed.[106] The early cult of Saint Elizabeth was supported by an elaborate reliquary in the shape of a house with a transept. (Fig. 3) In many respects this architectural form of the work of art and its imagery followed influential prototypes, which had recently been created in the broader area around the Rhine. The shrine had to be large enough to contain practically the whole body of the saint (apart from the head). Thus ivory, the material chosen for smaller shrines carved in the Rhineland around 1200, was excluded.[107] However, as we shall see, there were even more compelling reasons to make the shrine as large as a sarcophagus (or even larger), even though the actual relics therein contained were much smaller: Reliquaries became the focus of large-scale spectacles which were attempting to impress large gatherings of believers.

The most influential shrines were the center of attention in prominent sites in the Holy Roman Empire. The young emperor Frederick II's triumphal entry into Aachen, Charlemagne's city, consciously operated with its sacred imperial tradition. Through the ceremonial taking of the cross Frederick was nominated as a leader of the new Crusade.[108] The elaborate reliquary of Charlemagne, the first Holy Roman Emperor, completed at the time of Frederick's entry in 1215,

[106] B. REUDENBACH – G. TOUSSAINT, *Reliquiare im Mittelalter,* Berlin, 2011; HAHN, *Strange Beauty: Issues in the Making and Meaning of Reliquaries, 400-circa 1204.* For the origins of the tradition THUNØ, *Image and relic: mediating the sacred in early medieval Rome;* M. BAGNOLI – H.A. KLEIN – G.C. MANN – J. ROBINSON (eds.), *Treasures of Heaven: Saints, Relics, and Devotion in Medieval Europe,* Cleveland, OH – Baltimore – London – New Haven, CONN, 2010.

[107] Comp. H.V. OS, *Der Weg zum Himmel. Reliquienverehrung im Mittelalter,* Regensburg, 2001, p. 116 and figs. 130, 131 on p. 113.

[108] KANTOROWICZ, *Frederick the Second, 1194-1250,* pp. 72-74.

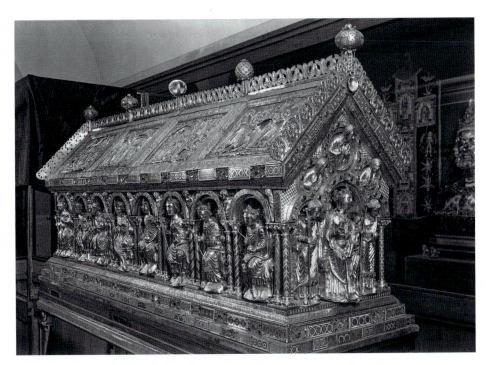

Fig. 16, The shrine of Charlemagne, 1182–1215, Aachen, Cathedral Treasury, Photo: Bildarchiv Foto Marburg, fm63434.

was one of the most precious accoutrements of this great political performance.[109] (Fig. 16) Frederick II himself is shown among the rulers represented on each side of the reliquary. The intention was clearly to declare himself as the legal successor of Saint Charlemagne and to proclaim his plan to take part in the crusade.[110] Featuring Charlemagne's military campaign in Spain, the reliquary's imagery was of significance to the crusaders.

Shortly after Frederick's triumphal performance (but before 1239), the treasury of magnificent reliquaries in Aachen Cathedral was enriched by the shrine of Holy Virgin.[111] (Fig. 17) It goes without saying that the body of Mary was

[109] F. MÜTHERICH, *Der Schrein Karls des Grossen: Bestand und Sicherung 1982-1988*, Aachen, 1998.

[110] SAUERLÄNDER, *Two Glances from the North: The Presence and Absence of Frederick II in the Art of the Empire; the court art of Frederick II and the opus francigenum*, p. 190 and fig. I on p. 188.

[111] E.G. GRIMME, *Der Karlsschrein und der Marienschrein im Aachener Dom*, Aachen, 2002; D.P.J. WYNANDS, *Der Aachener Marienschrein: eine Festschrift*, Aachen, 2000.

believed to be in heaven, but there were some minor secondary relics – the loin cloth and the diaper of the infant Jesus, and Mary's cloak. Together with the decapitation cloth of John the Baptist these relics attracted large crowds of pilgrims to Aachen. Even if the actual relics were somewhat smaller, the shrine of Mary in Aachen was the same size as a real sarcophagus. Furthermore, the shrine represented a substantial innovation to the basic architectural form of a church: a transept was added at the center of a simple longitudinal form, a characteristic feature of older shrines. Thus, two additional frontal sides – facades of the transept – were created where the key figures were displayed. A similar cruciform ground plan was used for Elizabeth's shrine in Marburg where the fronts of the transept were reserved for Jesus: on one side he is enthroned in majesty while on the other he was crucified on the cross on which traces of branch work were visible.[112] The latter motive, which hints at the rich symbolic imagination surrounding the tree of life, provided a kind of theological explanation of suffering in the history of salvation. On the other side of the transept, the shining Majesty displays the victory of Christ over the forces of death and evil. This Christological component, positioned in the immediate proximity to the saint's images, offered a key to the interpretation of the deeper layers of meaning associated with the pictorial legend of Elizabeth in contemporary imagination.

Another analogy is represented by the shrine of the Three Kings, which was created in Cologne before 1230 to preserve the precious relics of the Holy Magi. (Fig. 18) These had been translated from Milan and became the focus of intense pilgrimage.[113] This tradition had codified an inspiring framework for Elizabeth's new reliquary. This inspiration also accounts for the substantial differences between the medial presentation of Elizabeth and Italian saints of the period. Saints like Francis, Dominic, or Anthony of Padua had been canonized shortly before or after Elizabeth and were, in many respects, similar to her.[114] St Dominic (1170–1221), one of the most influential protagonists of voluntary religious

[112] The Crucifixion, which has not survived, is recorded by a drawing from 1737 – see DINKLER-VON SCHUBERT, Der Schrein der hl. Elisabeth zu Marburg. Studien zu Schrein-Ikonographie, plate 4.

[113] M. BEER – M. WOELK – J. MICHAEL, The Magi: Legend, Art and Cult: Catalogue Published for the Exhibition at the Museum Schnütgen, Cologne, 25 October 2014 – 25 January 2015, Munich – Cologne, 2014.

[114] See L. BOURDUA, The Franciscans and Art Patronage in Late Medieval Italy, Cambridge – New York, NY, 2004, esp. pp. 90-100; D. COOPER, 'In loco tutissimo e firmissimo': The Tomb of St. Francis in History, Legend and Art, in W.R. COOK (ed.), The Art of the Franciscan Order in Italy, Leiden, 2005, p. 9.

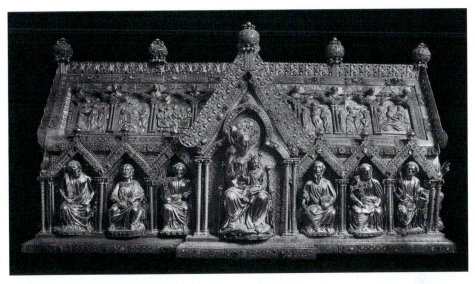

Fig. 17, The shrine of Virgin Mary, 1220–1239, Aachen, Cathedral Treasury, Photo: Bildarchiv Foto Marburg, fm131928.

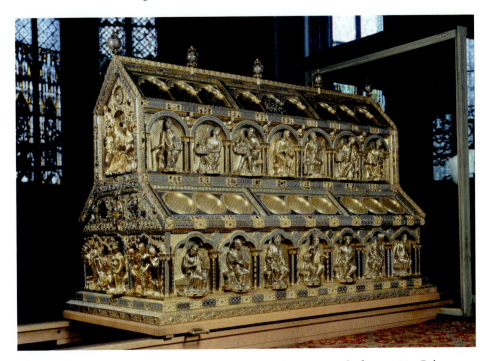

Fig. 18, Nicholas of Verdun, The shrine of the Three Kings, before 1230, Cologne, Rheinisches Bildarchiv Köln, rba_c002806, Photo: Bildarchiv Foto Marburg.

poverty, was canonized on 3 July 1234 by the same Pope Gregory IX.[115] Dominic's cult, organized by the Order of which he was the founder, included the translation of his remains into a simple an unadorned marble sarcophagus in 1233. His magnificent shrine in Bologna (*Arca di San Domenico*) comprises an elaborately carved marble tomb, decorated with scenes from his *vita* and miracles.[116] Largely inspired by ancient sarcophagi, this form of presentation was firmly rooted in the Italian tradition.[117] In contrast, Elizabeth's shrine belongs to the above-mentioned northern tradition with a greater emphasis on metalwork combined with precious stones and on pictorial propaganda of crusading activities.

The extensive use of the most precious materials to indicate the reverence towards the relics was part of the long-established tradition of the production of reliquaries.[118] The visible surface of the shrine consisted of silver- and copper-gilt plates applied to its wooden core.[119] The material value of the work was

[115] J. CANNON, *Religious Poverty, Visual Riches: Art in the Dominican Churches of Central Italy in the thirteenth and fourteenth Centuries*, New Haven, CT, 2013, p. 92.

[116] *Ibid.*, p. 102. The artwork was created c. 1264-1267 by Nicola Pisano and his workshop. The original arrangement of the sculpted reliefs around the carved shrine is still a subject of intense discussion because the form of the grave underwent a number of changes in subsequent centuries. The burial place of St. Francis under his church in Assisi was hidden by brother Elias of Cortona (c. 1180-1253) to protect it from robbery. In 1310 the remains of St. Anthony of Padua were translated into a tomb in the center of his basilica in Padua.

[117] Since all four sides are sculpted it is not to be excluded that the longer sides address two different audiences. The frontal side portraying the saint Dominic resurrecting Napoleone Orsini having fallen from his horse, the standing Madonna and The Miracle of the Book rejected by Fire may well have been primarily created for the public and pilgrims. The more sophisticated rear side where Dominic entreats the Pope to approve the Order of Friars Preachers, the Dream of the Pope, the Founding of the Order, the figure of Christ, and Reginald of Orléans making his promises, being healed by the Virgin and entering the Order could address the monastic community. See A.F. MOSKOWITZ, *Nicola Pisano's Arca di San Domenico and its Legacy*, University Park, PA, 1994, pp. 5-25. For 14th-century examples of similar shrines see also A.F. MOSKOWITZ, *Italian Gothic Sculpture: c. 1250-c. 1400*, New York, NY, 2001, pp. 170-173 (Arca di San Donato, Arezzo), pp. 203-207 (Arca di San Pietro Martire, Milan), pp. 209-213 (Arca di San Agostino, Pavia). C. BRUZELIUS, *From Empire to Commune to Kingdom. Notes on the Revival of Monumental Sculpture in Gothic Italy*, in C. HOURIHANE (ed.), *Gothic Art & Thought in the Later Medieval Period*, University Park, PA, 2011, 134-155, p. 149.

[118] J. BRAUN, *Die Reliquiare des christlichen Kultes und ihre Entwicklung*, Freiburg i.B., 1940, pp. 83, 140, 515 and numerous examples on pp. 85-141, 518-557.

[119] On the technological aspects of similar work see K. ANHEUSER – C. WERNER, *Medieval Reliquary Shrines and Precious Metalwork: Proceedings of a Conference at the Musée d'art et d'histoire, Geneva, 12-15 September 2001 / Châsses-reliquaires et orfèvrerie médiévales: actes du colloque au Musee d'art et d'histoire, Genève, 12-15 septembre 2001*, London, 2007, pp. 55-61 specifically on the conservation of the shrine of Mary in Aachen (by Herta Lepie).

enhanced by the use of precious stones and finely worked enamel shields.[120] The reasons for this practice are complex and include a symbolic reading based on theological precepts. One of the most influential theological treatises on high medieval reliquaries, the *Flores Epytaphii Sanctorum*, was written around 1100 by Abbot Thiofrid of Echternach.[121] This learned churchman explained the material qualities of precious shrines using metaphors associated with the bodily presence of a saintly person, which – like the soul in the body – cannot be seen, yet is capable of working wonders.[122] He argued that the soul is present in both the shrine and the transcendental sphere of Heavenly Jerusalem. Its supernatural power is miraculously active in the body and even more so in the dust of relics. It is a power than suffuses all the precious material covers including the copious ornamentation.[123]

Costly reliquaries held great attraction for pilgrims and facilitated ecclesiastic control over the saint's cult. The practical value of a substantial investment in the materiality of the reliquary was already apparent in the 12th century to ascetically minded critics, who attacked practices such as idolatry. The most influential critical mind, St Bernard of Clairvaux, offered several analytical perspectives of this kind in his celebrated *Apologia ad Guillelmum abbatem* (A Justification to Abbot William). His comments on reliquaries reveal a sharp observation of existing practice:

> Eyes are fixed on relics covered with gold, and purses are opened. The thoroughly beautiful image of some male or female saint is exhibited and that saint is believed to be the more holy the more highly colored the image is. People rush to kiss it, they are invited to donate, and they admire the beautiful more than they venerate the sacred.[124]

[120] BELGHAUS, *Der erzählte Körper. Die Inszenierung der Reliquien Karls des Grossen und Elisabeths von Thüringen*, p. 137.

[121] A.O.E. THIOFRID – M.C. FERRARI, *Thiofridi Abbatis Epternacensis Flores epytaphii sanctorum*, Turnholti [Belgium], 1996.

[122] HAHN, *Strange Beauty: Issues in the Making and Meaning of Reliquaries, 400-circa 1204*, p. 24.

[123] THIOFRID – FERRARI, *Thiofridi Abbatis Epternacensis Flores epytaphii sanctorum*, p. 37: "… et quicquid (sanctae uis animae) per carnem et ossa mirabile gerit idem mirabilius de dissoluto puluere in omnia tam exteriora quam interiora cuiuscumque materie uel precii tantae fauillae ornamenta et operimenta transfundit." Comp. B. REUDENBACH, *Visualizing Holy Bodies: Observations on Body-Part Reliquaries*, in C. HOURIHANE (ed.), *Romanesque art and thought in the twelfth century*, Princeton, NJ, 2008, 95-106; HAHN, *Strange Beauty: Issues in the Making and Meaning of Reliquaries, 400-circa 1204*, p. 68.

[124] "*Auro tectis reliquiis signantur oculi, et loculi aperiuntur. Ostenditur pulcherrima forma Sancti vel Sanctae alicuius, et eo creditur sanctior, quo coloratior. Currunt homines ad osculandum,*

Despite his moral doubts, Bernard's account includes a detailed criticism of a highly successful investment strategy:

> …[M]oney is sown with such a skill that it may be multiplied. It is expended so it may be increased and pouring it out produces abundance. The reason is that the very sight of these costly but wonderful illusions inflames men more to give than to pray. In this way wealth is derived from wealth, in this way money attracts money…[125]

Moreover, the precious medium confirmed, developed, and supported the presence of an image of the saint in historical memory. When considered in the context of the reliquary, Elizabeth's image was placed within the spectrum of theological and liturgical texts, traditionally associated with the medial presentation of relics. The Saint's life was integrated into the system of interpretation defined by the Christian history of salvation. This system operated with interpretations on several levels, thus creating a delicate balance within the tension between distance and closeness. Christ, represented in his suffering on the cross and in eternal glory, provided a Christological perspective. The remaining "facades" on the narrow ends of the house were reserved for prominent statues of the Virgin Mary and Elizabeth. (Fig. 19) The saint was accorded the same pride of place in the hierarchy of the structure as the Mother of God. (Fig. 20) This judicious arrangement of images conveyed a clear message to viewers: the saint occupied a key position among the most important citizens of the heavenly city. Represented on the same scale, she seemed even to be their equal.

Seen from a Christological perspective, Elizabeth's life and active mercy provided pilgrims and other visitors to the church a visual example of the most propitious way to follow the Savior in their own time and society. Simultaneously, the large figure of the Virgin Mary underscored the associations between Elizabeth and the most fitting example of compassion, embodying patient,

invitantur ad donandum; et magis mirantur pulchra, quam venerantur sacra.“ Bernardus Claraevallensis: *Apologia ad Guillelmum abbatem*, caput XII, 28 – 29; Comp. C. RUDOLPH – BERNARD, *The "things of greater importance": Bernard of Clairvaux's Apologia and the Medieval Attitude toward Art*, Philadelphia, PA, 1990, pp. 280-281; B.F. ABOU-EL-HAJ, *The Medieval Cult of Saints. Formations and Transformations*, New York, NY, 1994, p. 17.

[125] *"Tali quadam arte spargitur aes, ut multiplicetur. Expenditur ut augeatur, et effusion compiam parit. Ipso quique visu sumptuosarum, sed mirandarum vanitatum, accenduntur homines magis ad offerendum quam ad orandum Sic opes opibus hauriuntur, sic pecunia pecuniam trahit…"* RUDOLPH – BERNARD, *The "things of greater importance": Bernard of Clairvaux's Apologia and the Medieval Attitude toward Art*, pp. 280-281.

humble, acceptance of suffering, which was believed to be a prerequisite for salvation.

The figures of apostles on the sides of the shrine, namely the traditional guards of the Heavenly Jerusalem, pointed to the basic tenets of the Christian credo by means of succinct passages of text which surmount each figure. The idea of the celestial city, redolent with symbolic meanings, was echoed by the many minor motifs on the reliquary, as well as its basic structure. The architectural form of the reliquary was divided by the transept into two halves so that the apostles are placed symmetrically according to the two main axes of the reliquary in four groups of three figures seated next to each other. Such

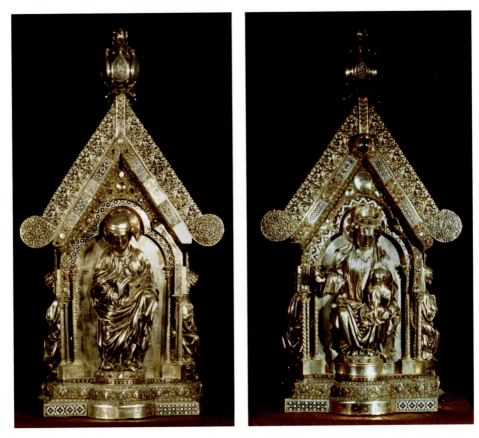

Fig. 19, Saint Elizabeth, *c.* 1235–1250, gilded copper, Marburg, Church of Saint Elizabeth, Photo: Bildarchiv Foto Marburg, fmlac4241_18.

Fig. 20, Virgin Mary, *c.* 1235–1250, gilded copper, Marburg, Church of Saint Elizabeth, Photo: Bildarchiv Foto Marburg, fmlac4240_08.

a configuration was inspired by tradition rooted in the apocalyptic vision of the Heavenly Jerusalem.[126] Viewed from the longer side displaying Christ's Majesty in the center, it closely resembles the depiction of the celestial city in high medieval book illumination devoted to the apocalyptic revelation which was believed to have been seen by St. John. A similar image of the celestial city from approximately the same period (after 1219) can be found in an illustrated Bible (*Bible moralisée*), preserved in the Austrian National Library in Vienna.[127] (Fig. 21) Such a reference was not purely spiritual – the acceleration of urbanization in the region of Central Europe since the thirteenth century had enriched visual representations of the Holy City with important new connotations, firmly linked with the interests, fears and hopes of Christian communities in new urban centers.[128]

Anyone wondering why the recently deceased person might have acquired such an important position among the inhabitants of the heavenly city only needed to look at the roof of the house for confirmation. The eight relief plates with the narrative scenes were suitably placed in order to underscore the key moments of Elizabeth's life. This layout of the pictorial legend was also based on precedents. The closest parallel of a hagiographic legend placed on the roof of a reliquary was the Shrine of Charlemagne (1215) in Aachen Cathedral.[129] (Fig. 16)

The narrative scenes conveyed basic information about the Saint to the pilgrims visiting the shrine. Elizabeth exemplified the ideal of *sanctitas*; she staunchly confronted the hardships of life and attained heavenly glory by becoming a stone of the Heavenly Jerusalem.[130] In this sense, the work of art contributed to the seamless functioning of the site where the saint was remembered and venerated. The ideal of sanctity was mediated in line with the wishes of contemporary viewers.[131] The authors of the reliquary created a balance

[126] Comp. B. KÜHNEL, *From the Earthly to the Heavenly Jerusalem: Representations of the Holy City in Christian Art of the First Millennium*, Freiburg im Breisgau, 1987; B. KÜHNEL – G. NOGA-BANAI – H. VORHOLT, *Visual Constructs of Jerusalem*, Turnhout, 2015.

[127] Vienna, Austrian National Library, Cod. Vind. 1179, fol. 244 r. See J. LOWDEN, *The Making of the Bibles Moralisées*, University Park, PA, 2000, pp. 55-94.

[128] D. TABOR, *The Holy City: Idea and Representation in the Medieval Art of Central Europe*, in J. WENTA – M. KOPCZYŃSKA (eds.), *Sacred Space in the State of the Teutonic Order in Prussia*, Toruń, 2013, 243-256, pp. 243-256.

[129] See above, p. **.

[130] DINKLER-VON SCHUBERT, *Der Schrein der hl. Elisabeth zu Marburg. Studien zu Schrein-Ikonographie*, p. 87.

[131] W. KEMP, *Narrative*, in R.S. NELSON – R. SHIFF (eds.), *Critical Terms for Art History. 2nd ed.*, Chicago, IL, 2010, 62-74; C. HAHN, *Portrayed on the Heart. Narrative Effect in Picto-*

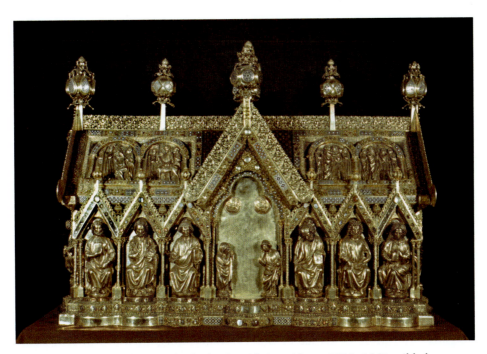

Fig. 21, The shrine of saint Elizabeth, Crucifixion side, *c.* 1235–1250, gilded copper and silver on oak-wood core (h: 135 cm, l: 187 cm, w: 63 cm), Marburg, Church of Saint Elizabeth, Photo: Bildarchiv Foto Marburg, fmlac4240_13.

between the elevated ethic ideal of the saint and the needs of ordinary visitors to the church. The aesthetics of the work of art complement its didactic purpose. The extensive use of costly materials was intended to evoke the beauty of Paradise which may in turn have made the Christian way of life more attractive. The effectiveness of the teaching had served also as an argument against the suspicion of idolatry known at least since the time of Gregory the Great.[132] The saint's original ideals were transformed into a medial message in keeping with the liturgical cult. The beauty of the sumptuous celebration may have accounted, at least in part, for drawing the viewer's attention away from the moments of self-sacrifice – performed by Elizabeth in her effort to actively help the needy.

rial Lives of Saints from the Tenth through the Thirteenth Century, Berkley, CA, 2001, above all pp. 29-57.

[132] Comp. L.G. DUGGAN, *Was Art really the "Book of the Illiterate"?*, in *Word and Image* 5 (1989) 227-251.

The visual medium moderated the urgency of the original message of Elizabeth's life. The abundance of precious stones and metals appears only as a means to achieve the desired effect of the visual medium on a contemporary audience. This reliquary provided ecclesiastical dignitaries a judicious means of exercising prudent control of individuals as well as the mutual relations among believers belonging to different social groups.

1.7. The Crusaders and the Saint

The other important area of associations regarding the hagiographic narratives in Marburg was more directly associated with specific political messages. Some images were intended to instill a favorable attitude among contemporary audiences to the crusader activities. This agency was of particular importance to the Teutonic Knights, the patrons of the shrine and the church. According to the testimony of liturgical manuscripts the Order honored Elizabeth, who together with the Virgin Mary and Saint George was its patron saint, with a liturgical feast of the highest rank (*totum duplex*).[133] The original name of this knightly institution – "Order of the Teutonic House of Mary in Jerusalem" (*Ordo domus Sanctæ Mariæ Theutonicorum Hierosolimitanorum*) – in its unabridged form would seem to suggest a special interest not only in the heavenly Jerusalem, but also in the real historical Jerusalem.[134] Moreover, modeling their own identity on the ideals of *milites Christi,* the knights proclaimed themselves bearers of an important social mission: "spiritual elitism was superimposed with a sense of social elitism."[135]

The Order supported the crusade after the knights were expelled from Hungary in 1225 by Elizabeth's father, King Andrew II. On 23 October 1233, Bishop Conrad II of Hildesheim was appointed by Pope Gregory IX as a guardian of the Landgrave of Thuringia, whose name was also Conrad. As the brother-in-law of Elizabeth, the latter was another key figure during the early

[133] A. LÖFFLER, *Elizabeth in der Liturgie des Deutschen Ordens*, in C. BERTELSMEIER-KIERST (ed.), *Elisabeth von Thüringen und die neue Frömmigkeit in Europa*, Frankfurt am Main, 2008, 133-149, p. 138.

[134] See ARNOLD – LIEBING (eds.), *Elisabeth, der Deutsche Orden und ihre Kirche: Festschrift zur 700 jährigen Wiederkehr der Weihe der Elisabethkirche Marburg 1983*, .

[135] M. JAKUBEK-RACZKOWSKA, *Between the Ideology of Power and Lay Piety. Visual Arts in the State of the Teutonic Order in Prussia (from the late thirteenth to the middle fifteenth century)*, in J. WENTA – M. KOPCZYŃSKA (eds.), *Sacred Space in the State of the Teutonic Order in Prussia*, Toruń, 2013, 181-208, p. 191.

phase of her cult.[136] His family was in very close contact with the Teutonic order. The Landgrave Conrad himself entered the Teutonic order in 1234 and soon proved to be a highly influential member. In 1239, just one year before his death, he was appointed Master of the Order. Even after his death, the family of landgraves continued to influence the cult and the politics of the Order.

Did the clever political maneuvering of the family in the political struggles between the Pope and Emperor have an impact on how the saint was perceived in the above-discussed works of art? This important question should be kept in mind while analyzing the pictorial legends.

Allusions are evident in both pictorial legends. First of all, we have seen that their visual form may have been read as a reference to the Heavenly Jerusalem. Such an encompassing theological message is commonly found in medieval works of art. However, the two cycles from the life of St. Elizabeth in Marburg transcend straightforward allusions to crusading.

The reliquary cycle begins with an intense narrative account of the personal sacrifice undertaken by Elizabeth – but to an even greater extent by her husband Ludwig IV of Thuringia (1200–1227) – in support of the crusade. This topic features in three of the eight scenes placed on the roof of the shrine.[137] The first image visualizes a ritual in which the Landgrave takes up the cross. (Fig. 22) At the center of the image two men are facing each other: Bishop Conrad II of Hildesheim raises his right hand to bless Ludwig, who holds a small cross in his folded hands. Elizabeth is not present, even if – according to the *Golden Legend*, she herself urged her husband to use the strength of his weapons to defend the faith in the Holy Land.[138] The authors of the early cycles attributed greater importance to Ludwig's decision to go to the Holy Land than to the whole early life of the saint and her family (topics that were not chosen for the representation). Conrad II of Hildesheim was active as a bishop until 1246, when he was forced to resign after the excommunication

[136] DINKLER-VON SCHUBERT, *Der Schrein der hl. Elisabeth zu Marburg. Studien zu Schrein-Ikonographie*, p. 162.

[137] S. HAARLÄNDER, *Zwischen Ehe und Weltentsagung. Die verheiratete Heilige – Ein Dilemma der Hagiographie*, in C. BERTELSMEIER-KIERST (ed.), *Elisabeth von Thüringen und die neue Frömmigkeit in Europa*, Frankfurt am Main, 2008, 211-229.

[138] I.D. VARAZZE, *Legenda aurea*, in G.P. MAGGIONI (ed.), *Legenda aurea. Testo critico riveduto e commento a cura di Giovanni Paolo Maggioni*, Firenze, 2007, p. 1304: "*Cupiens uero beata Elizabeth ut uir suus in fidei defensionem potentie sue arma conuerteret, ipsum salubri exhortatione induxit ut ad terram sanctam pergeret uisitandam.*"

Fig. 22, Taking up the cross and the farewell, *c.* 1235–1250, gilded copper, Marburg, Church of Saint Elizabeth, Bildarchiv Foto Marburg, Foto: Fenchel, Horst, fmbc31733_16.

of Emperor Frederick II by Pope Innocent IV at the council of Lyon.[139] In spite of his resignation he remained one of the most influential figures in the cult of Saint Elizabeth in Marburg until his death in 1248. Regarding his education, position, and interests, he may be regarded as the author of the iconographic program of the first cycles.[140] In this case, personal reasons may also

[139] See the Bull Deposing The Emperor Frederick II, the document, issued by Innocent IV at Lyons on 17 July 1245 (as introduced and translated in N.P. TANNER (ed.), *Decrees of the Ecumenical Councils*, Washington, DC, 1990.) http://www.papalencyclicals.net/Councils/ecum 13.htm#Bull%20of%20excommunication (08/24/2015)

[140] DINKLER-VON SCHUBERT, *Der Schrein der hl. Elisabeth zu Marburg. Studien zu Schrein-Ikonographie*, p. 164; BELGHAUS, *Der erzählte Körper. Die Inszenierung der Reliquien Karls des Grossen und Elisabeths von Thüringen*, p. 137. Further arguments in favor of this hypothesis can be seen in the remainder of both cycles depicting the works of mercy. Conrad II may have known this topic from the baptistery of Parma which he visited in 1236. He may also have been

account for his presence in the image. The bishop required considerable resources in order to construct the large building and to commission expensive works of art. In this respect, his good relationship with the family of the landgraves of Thuringia was of especial importance and this was not without its consequences in the iconography of the cycles.

The act of benediction, represented in the first image, was described by Durandus (*c.* 1237–1296), one of the most influential liturgical writers and canonists of the time.[141] The ritual served as a confirmation of the fighter's intention to follow Christ by taking part in the crusade. The general features of the initiation ritual were similar to the benediction of pilgrims departing for Rome or Santiago de Compostela, since participation in the crusade was interpreted as a religious pilgrimage.[142] Ludwig gave a similarly solemn promise to Emperor Frederic II on the Imperial Diet of Cremona (1226).[143] Although the event is omitted in earliest accounts of the life of Saint Elizabeth it features in Dietrich of Apolda's text.[144] The most important written source associated with this scene is the biography of the Landgrave. *Vita Ludovici*, which was written shortly after his death (11 September 1228) in Latin has come down to us only in a German translation.[145] The ceremony was also of extraordinary political importance on several levels. The widest context was established by agreements between the Emperor and the Popes, starting with the complicated story of the promise made by Frederick II during his coronation by the Pope Honorius III in 1220 to organize the sixth crusade, which he attempted undertake after Gregory IX became Pope in 1227. After the ritual promise Ludwig obtained

responsible for the iconography of the baptismal font in Hildesheim, where the works of mercy are portrayed. The topic of the corporeal works of mercy was also important for the crusaders; around 1135, the works, performed by a crusader king, were depicted in the Psalter of Queen Melisende from the scriptorium of the Holy Sepulchre (London, British Library, MS Egerton 1139) – J. FOLDA, *The Art of Crusaders in the Holy Land 1098–1187*, Cambridge – New York, NY – Melbourne, 1995, p. 158 and Plate 12.

[141] Durandus: *De benedictione et impositione crucis proficiscentium in subsidium terre sancte.* See in DINKLER-VON SCHUBERT, *Der Schrein der hl. Elisabeth zu Marburg. Studien zu Schrein-Ikonographie*, pp. 97-98. Comp. J.A. BRUNDAGE, *Medieval canon law and the crusader*, Madison, 1969, pp. 119-120.

[142] See more in REBER, *Elisabeth von Thüringen, Landgräfin und Heilige. Eine Biografie*, p. 108; N. OHLER, *The Medieval Traveller*, Woodbridge, 2010, pp. 86-88.

[143] For the crusading activities of Frederick II see in A.V. MURRAY, *The Crusades: An Encyclopedia*, Santa Barbara, CA, 2006, pp. 475-477.

[144] RENER (ed.), *Die Vita der heiligen Elisabeth des Dietrich von Apolda*, p. 61.

[145] H. RÜCKERT, *Das Leben des heiligen Ludwig, Landgrafen in Thüringen, Gemahls der heiligen Elisabeth*, Leipzig, 1851. Comp. BELGHAUS, *Der erzählte Körper. Die Inszenierung der Reliquien Karls des Grossen und Elisabeths von Thüringen*, p. 160.

protection from the archbishop of Mainz, who otherwise opposed the interests of the landgrave family.[146] It was also for this reason that participation in the crusade was an important sign of good relations between the landgrave family and the knights who were later to become the patrons of the church of St Elizabeth – the saintly patroness of their order. Thus, Ludwig's promise was ultimately beneficial in creating a social network to support the cult of Elizabeth including the creation of the shrine on which the scene is shown. The self-representation of the ecclesiastic dignitary in the image of this important ritual act contributed to reinforcing the extraordinary social status of his professional activities in contemporary society.

An analogous scene is missing from the Elizabethan window, which otherwise reiterates all the scenes portrayed on the reliquary. Its striking absence might be explained by the fact that this part of the window was destroyed.[147]

At the center of the second scene Ludwig and Elizabeth are portrayed in embrace and looking into each other's eyes.[148] (Fig. 22, comp. fig. 23) The cross on the Landgrave's bag refers to the preceding scene while also reiterating the complex meanings of the crusade. The viewer's compassion would have been elicited by the addition of a female figure wiping her tears away behind Elizabeth. The tragic atmosphere of this event made a great impression on contemporaries. A song, which was sung in the vernacular in the region of Marburg, forcefully expressed the sorrow caused by the departure.[149] Dietrich of Apolda created a similar atmosphere in his account of the event, remarking that the farewell of the couple caused nearly everyone to weep.[150] The deep meanings of the emotions, associated with the couple's farewell are illustrated by the story of a half-blind wife, who made another pilgrimage to Elizabeth's grave; her eyesight was restored only when moved to tears of compassion by the

[146] BEUMANN, *Friedrich II. und die heilige Elisabeth. Zum Besuch des Kaisers in Marburg am 1. Mai 1236, Sankt Elisabeth. Fürstin, Dienerin, Heilige. Aufsätze, Dokumentation, Katalog,* p. 152.

[147] See extended discussion in BIERSCHENK, *Glasmalereien der Elisabethkirche in Marburg: die figürlichen Fenster um 1240,* pp. 195-196 and KROOS, *Zu frühen Schrift- und Bildzeugnissen über die heilige Elisabeth als Quellen zur Kunst- und Kulturgeschichte, Sankt Elisabeth. Fürstin, Dienerin, Heilige,* p. 215.

[148] This stance was also interpreted as a sign of matrimonial harmony – C. HAHN, *Portrayed on the Heart. Narrative Effect in Pictorial Lives of Saints from the Tenth through the Thirteenth Century,* Berkley, CA, 2001, pp. 29-57.

[149] Miracula I, see in HUYSKENS, *Quellenstudien zur Geschichte der hl. Elisabeth, Landgräfin von Thüringen,* p. 84. See also L. WOLFF, *Die heilige Elisabeth in der Literatur des deutschen Mittelalters,* in *Hessisches Jahrbuch für Landesgeschichte* 13 (1963) 23-38, p. 33.

[150] RENER (ed.), *Die Vita der heiligen Elisabeth des Dietrich von Apolda,* p. 64-66.

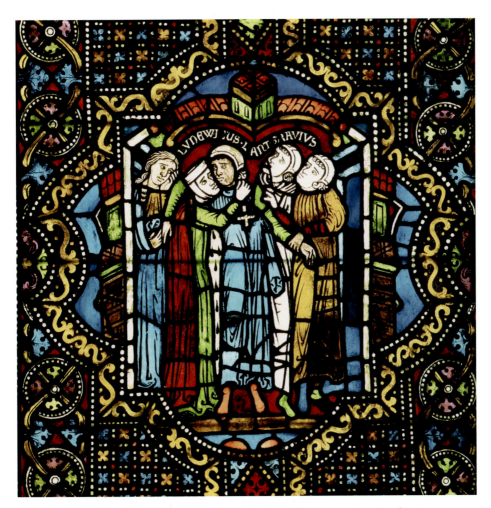

Fig. 23, The farewell, *c.* 1235–1250, stained-glass, Marburg, Church of Saint Elizabeth, Photo: Bildarchiv Foto Marburg, fmc188611.

above-mentioned song.[151] Notwithstanding the similarities, an image of the event in the choir window was even more dramatic. Here the couple are shown with their cheeks touching, a gesture which conjures up the illuminations of chivalrous romances.[152] Thus, the fundamental symmetry of the composition

[151] I. WÜRTH, *Bericht über die Heilung Mathildes aus Biedenkopf,* in D. BLUME – M. WERNER (eds.), *Elisabeth von Thüringen – eine europäische Heilige. Katalog,* Petersberg, 2007, 194-195, p. 195.

[152] KROOS, *Zu frühen Schrift- und Bildzeugnissen über die helige Elisabeth als Quellen zur Kunst- und Kulturgeschichte, Sankt Elisabeth. Fürstin, Dienerin, Heilige,* p. 216. For analogies of

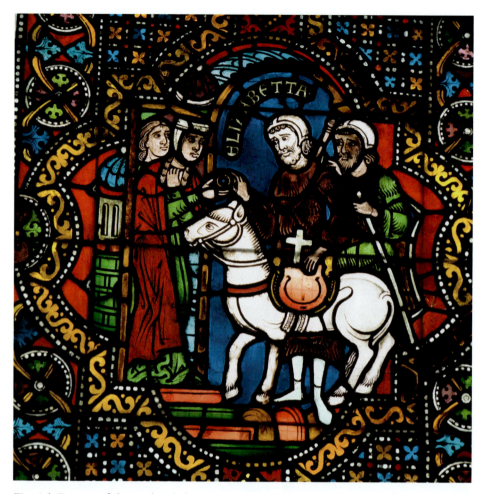

Fig. 24, Return of the Ludwig's bones, *c.* 1235–1250, stained-glass, Marburg, Church of Saint Elizabeth, Photo: Bildarchiv Foto Marburg, fmc426927.

was sacrificed and the cross on the chest of the Landgrave (identified by an inscription: "LUDEWICVS LANTGRAVIVS") was placed at the center of the composition.

Although a specific event from the saint's life is highlighted, it is possible that the image was not an entirely original creation. Taking leave of loved ones

the touching by the cheeks motif in the contemporary knightly romances, esp. in Willehalm (Munich, Staatsbibliothek, CGM 63, fol. 60v) – BIERSCHENK, *Glasmalereien der Elisabethkirche in Marburg: die figürlichen Fenster um 1240*, p. 189.

was an experience known to many crusaders and this highly charged event was not unprecedented in visual images. A twelfth-century relief depicting the mutual embrace between a crusader and his wife in the cloister of the Belval Priory (Lorraine, France) is a case in point. While it is unlikely that these two works of art or their sculptors are linked in any way, the similarity between them indicates that the relationships between religious imagery and real life of the crusaders were negotiated incrementally.[153]

The last scene of the crusader sequence on the reliquary shows the return of Ludwig's bones from the crusade. (Fig. 10, comp. fig. 24) Having fallen ill he died in Otranto on 11 September 1227 at the outset of his journey to Jerusalem. His fellow-travelers, afflicted by an epidemic, returned to Italy after the crusade resulting in the excommunication of Frederick II by Gregory IX for breaking his crusader vow. Elizabeth, standing at the doorway of a building, is looking at two pilgrims approaching from the right. The first gives her a ring as proof of her husband's death. The bones of the deceased are in the bag carried by an animal – a kind of pony or ass. The most important symbol of the narrative – the cross – is clearly visible on the bag containing the remains (buried in the cloister of Reinhardsbrunn, the monastery of the Ludovingian Landgraves of Thuringia, in 1228). Only brief mention is made of the return of crusaders in the *Libellus*; we glean further information from Dietrich and the German song where it is recounted that on learning of the tragic news Elizabeth reacted by reciting a prayer expressing gratitude for the grace of having the bones and humbly accepting the will of the Lord– even if she loved her husband very much and would have given everything to have him back, without the will of God she did not want back a single hair.

> Lord, I thank you for having comforted me in your mercifulness through having my husband's much longed for bones. You know that much as I do not begrudge the fact that he has been sacrificed in keeping with your will and for my protection of the Holy Land. I'd give the world to have him back even if I always had to go begging with him. But against your will I would not have him back (without a witness) for the price of a single hair, so I recommend both him and me to your grace. Let be done with us what your will is.[154]

[153] D.H. WEISS, *Art and Crusade in the age of Saint Louis*, Cambridge, 1998; J. FOLDA, *Crusader art in the Holy Land: from the Third Crusade to the fall of Acre, 1187-1291*, Cambridge, UK, 2005; J. FOLDA, *Crusader Art: The Art of the Crusaders in the Holy Land, 1099-1291*, Aldershot, 2008.

[154] According to her maid Guda she said: "*Domine, gratias ago tibi, quia in ossibus mei mariti multum desideratis misericorditer me es consolatus. Tu scis quod quantumlibet eum dilectis-*

The Thuringian Landgraves' family successfully shielded the early cult from such aspects, which were potentially detrimental to family interests. Conflict between the saint and family is omitted from the Marburg cycles, for example, Elizabeth's expulsion from Wartburg Castle after the death of her husband Ludwig was represented only in much later pictures, which were no longer influenced by the family. Not only the citizens of Marburg, but also the many pilgrims visiting the Saint's grave in the following centuries would have seen the message, which was based on from the family's perspective and expunged of any distracting details. The close relationship to the saint resulted in the creation of pictorial legends, which were adapted more to influential topics of contemporary discussion than to the real life of the family. The scenes connected with the crusading of Ludwig were an ideal substitution for embarrassing family incidents – the Landgrave, as one of the most prominent family members – was portrayed as the hero ready to sacrifice his life for a higher purpose. At the same time, the military interests of the Order were circulated in the legend of the saint, who never took part in any military campaign.[155]

The importance of these scenes resides also in the fact that they comprise a substantial part of the narrative and are placed at the beginning. Military subjects take precedence over the individual biography of the patron saint. Her husband's decision to go to the Holy Land was deemed more important than the entire early life of the saint and her family. The situation was to change substantially in the later legends which were no longer influenced by the Teutonic order.

simum tibi a se ipso et a me in subsidium terre sancte oblatum non invideo. Si possem eum habere, pro toto mundo eum acciperem, semper secum mendicatura. Sed contra voluntatem tuam te teste nollem eum uno crine redimere, nunc ipsum et me tue gratie commendo, de nobis fiat tua voluntas." HUYSKENS (ed.), *Libellus de dictis quattuor ancillarum s. Elisabeth confectus*, lines 114-116. Other sources are described by KROOS, *Zu frühen Schrift- und Bildzeugnissen über die helige Elisabeth als Quellen zur Kunst- und Kulturgeschichte, Sankt Elisabeth. Fürstin, Dienerin, Heilige*, p. 217. The meeting of Elizabeth with the remains of Ludwig took place in the cathedral of Bamberg – REBER, *Elisabeth von Thüringen, Landgräfin und Heilige. Eine Biografie*, p. 136.

[155] The main patron of the Order – the Virgin Mary, who also occupies a prominent position on Elizabeth's shrine – was even less suitable for any military propaganda. As a result, this role could only be played by the secondary patrons of the order – either by Saint Elizabeth or Saint George. See further U. ARNOLD, *Elisabeth und Georg als Pfarrpatrone im Deutschordensland Preußen. Zum Selbstverständnis des Deutschen Ordens*, in ARNOLD – LIEBING (eds.), *Elisabeth, der Deutsche Orden und ihre Kirche: Festschrift zur 700 jährigen Wiederkehr der Weihe der Elisabethkirche Marburg 1983*, p. 163-185. I would like to express my sincere thanks to Prof. Udo Arnold for kindly sending me the publication. The use of religious imagery for crusading purposes was standard practice in other parts of Europe – see D.H. WEISS – L. MAHONEY (eds.), *France and the Holy Land: Frankish Culture at the End of the Crusades*, Baltimore, 2004; FOLDA, *Crusader Art in the Holy Land: From the Third Crusade to the Fall of Acre, 1187-1291*, .

1.8. Elizabeth and Conrad of Marburg

The image of Elizabeth kneeling in front of an altar to accept a tunic from the hands of a tonsured cleric depicts a ritual that pointed to the integration of the saint into the institutional framework of the official church. (Fig. 25) The scene on the reliquary created a parallel to the crusader's vow on the right-hand side where the works of mercy are shown. (Fig. 15) The composition in the window also resembles the vignette of clothing the naked on the opposite side. Nevertheless, in this case it is the Saint rather than the beggar who is accepting the cloth and Conrad of Marburg assumes her previous place of as the person

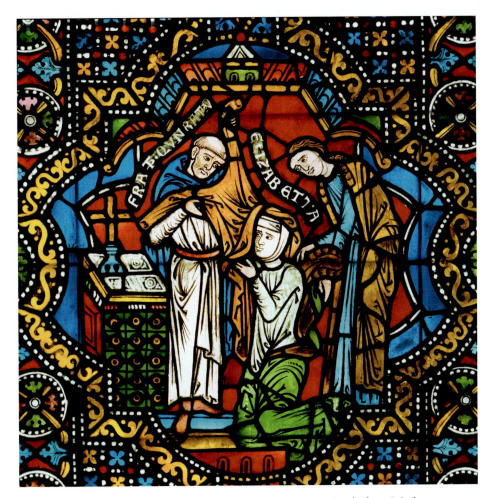

Fig. 25, Saint Elizabeth accepting tunic, *c.* 1235–1250, stained-glass, Marburg, Church of Saint Elizabeth, Photo: Bildarchiv Foto Marburg, fmc426938.

who gives the cloth. The saint is shown in a subordinate position to the cleric. Thus, the scene offers a straightforward commentary to what was in fact a highly complex personal relationship.[156]

The historical position of the ritual depicted is not entirely clear. Several sources may be associated with the representation. The earliest possible reference is offered by Conrad himself in the *Summa vitae*. We learn that Elizabeth decided to renounce "her parentage, her children, her own free will, and all the pomp of this world; all of those things which the Savior of the world advised in the Gospels were to be left behind".[157] This ritual took place in the Franciscan chapel in Eisenach under the castle of Wartburg on 24 March 1228, on the Good Friday after the death of Landgrave Ludwig. Conrad describes the act of placing one's hands on the altar without mentioning any piece of cloth or referring to his own presence.[158] The account given in the *Libellus* about Elizabeth accepting from the hands of Conrad a grey tunic (*tunica grisea*), which was the standard attire of sisters working in the hospital is more in keeping with the scene.[159] Mention should be made also of a source written by the anonymous Cistercian from Zwettl in Austria, who visited the saint's grave between 1236 and 1239. His report includes a sentence in which the *tunica grisea* is interpreted as the clothing of the minor brothers: Elizabeth "following the order of

[156] See e.g. ELLIOTT, *Proving Woman. Female Spirituality and Inquisitional Culture in the Later Middle Ages*, p. 85-116; A. WESTPHÄLINGER, *Der Mann hinter der Heiligen: die Beichtväter der Elisabeth von Schönau, der Elisabeth von Thüringen und der Dorothea von Montau*, Krems, 2007.

[157] *"parentibus et pueris, et proprie voluntati et omnibus pompis mundi et hiis, que salvator mundi in ewangelio consulit reliquenda renuntiavit."* HUYSKENS, *Quellenstudien zur Geschichte der hl. Elisabeth, Landgräfin von Thüringen*, p. 157; English translation in WOLF, *The Life and Afterlife of St. Elizabeth of Hungary. Testimony from her Canonization Hearings*, p. 93. The document is discussed further in GECSER, *The Feast and the Pulpit: Preachers, Sermons and the Cult of St. Elizabeth of Hungary, 1235-ca. 1500*, p. 10; on circumstances and form of the ritual REBER, *Elisabeth von Thüringen, Landgräfin und Heilige. Eine Biografie*, p. 129.

[158] *"… cum nudata essent altaria, positis manibus super altare in quadam capella sui oppidi, ubi minores fratres locaverat, presentibus quibusdam fratribus…"*

[159] *"Beata Elysabeth professa fuit induens griseam tunicam de manu magistri Conradi de Marpurch"* – HUYSKENS, *Quellenstudien zur Geschichte der hl. Elisabeth, Landgräfin von Thüringen*, p. 43. The sisters in hospitals probably observed the Rule of St. Augustine, prescribing the basic regulations of common life. When entering the cloister they were obliged to give the monastery their possessions and to promise poverty, chastity and obedience – REBER, *Elisabeth von Thüringen, Landgräfin und Heilige. Eine Biografie*, p. 142; KROOS, *Zu frühen Schrift- und Bildzeugnissen über die helige Elisabeth als Quellen zur Kunst- und Kulturgeschichte, Sankt Elisabeth. Fürstin, Dienerin, Heilige*, p. 218; M. WERNER, *Elisabeth von Thüringen, Franziskus von Assisi und Konrad von Marburg*, in D. BLUME – M. WERNER (eds.), *Elisabeth von Thüringen – eine europäische Heilige. Aufsätze*, Petersberg, 2007, p. 122.

master Conrad took on in Marburg the gray habit of the minor brothers com-
pletely and publicly giving up all enticements of worldly life".[160] Thus, the
scene may be interpreted as Elizabeth entering the third order of St Francis.
However, other sources confirm the existence of the third order of St Francis in
Germany only in the 14th century.[161] Elsewhere the scene is associated with
the benediction of the widow, described by Durandus.[162] The vow of eternal
chastity expressing the faithful connection with Christ would be a part of such
a ritual. A more practical reading of the image equates the luxurious habit of
noble aristocrat with a typical *Gebende* on her head under the new tunic. This
approach to the image criticizes the inauthentic representation of the saint as
a result of clerical influence.[163]

The high level of conventionality, typical of thirteenth-century images, is
a consequence of subordinating artistic processes to the task of spreading theo-
logical messages. The highly conventional artistic language offered only limited
scope for creating a dense web of interrelations with the reality of everyday
existence or observations of minor details. It was more concerned with what
appeared to be the most important element in the message. Thus, the earliest
cycles leave many gaps in their visual reporting, and these were completed by
later authors who worked in a more realistic style. These authors and their
audiences appear to be interested in this world more than were their predeces-
sors in Marburg.

[160] *"Ad mandatum fratris cunradi prefati fratrum minorum habitum griseum induens aput
Marpurch in totum et publice se vite secularis illecebris abdicavit"* – D. HENNIGES, *Vita sanctae
Elisabeth, Landgraviae Thuringiae auctore anonymo nunc primum in luce edita*, in *Archivum Fran-
ciscanum Historicum* 2 (1909) 240-268, p. 256.

[161] P. SÄGER, *Der Weg der Hl. Elisabeth von Thüringen, 800 Jahre Franz von Assisi. Franzis-
kanische Kunst und Kultur des Mittelalters Katalog des NÖ Landesmuseums*, Wien, 1982, pp. 146-
147; M.P. ALBERZONI, *Elisabeth von Thüringen, Klara von Assisi und Agnes von Böhmen. Das
franziskanische Modell der Nachfolge Christi diesseits und jenseits der Alpen*, in M. WERNER –
D. BLUME (eds.), *Elisabeth von Thüringen: eine europäische Heilige. Aufsätze*, Petersberg, 2007,
pp. 47-55. The third order was officially established in 1289 by subsuming various penitent
communities under Franciscan control – GECSER, *Aspects of the Cult of St. Elizabeth of Hungary
with a Special Emphasis on Preaching, 1231-c.1500*, p. 20.

[162] DINKLER-VON SCHUBERT, *Der Schrein der hl. Elisabeth zu Marburg. Studien zu Schrein-
Ikonographie*, p. 96. See A. DAVRIL – T.M. THIBODEAU (eds.), *Gvillelmi Dvranti Rationale divi-
norvm officiorvm*, 1 – 3, Turnholti 1995 – 2000. This interpretation was rejected by KROOS, *Zu
frühen Schrift- und Bildzeugnissen über die helige Elisabeth als Quellen zur Kunst- und Kultur-
geschichte, Sankt Elisabeth. Fürstin, Dienerin, Heilige*, p. 234.

[163] BELGHAUS, *Der erzählte Körper. Die Inszenierung der Reliquien Karls des Grossen und Elis-
abeths von Thüringen*, p. 67.

PART 2.
BETWEEN COURT AND CLOISTER –
OBSERVATIONS ON THE *LIBER DEPICTUS*

2.1. Elizabeth's Life in the Manuscripts

After her canonization, the cult of St Elizabeth was quickly taken up by members in the highest echelons of society of the time in several of the European countries that respected the authority of the Pope. In the introduction, mention was made of the letter written by Pope Gregory IX to Beatrice of Swabia (1205–1235), the wife of King Ferdinand III (*c.* 1200–1252) of Castile and León. The Pope recommended the new saint as a pure mirror in which thoughts could be seen, even those hidden in the darkest corners of one's conscience.[164] The queen had only a few months left in which to follow Elizabeth's example, but it seems that the sown word had found a fertile soil in her lineage so the inspiring memory of the saint continued to be influential even after the premature death of Beatrice. The favorable conditions for this to happen continued into the next generation when the legend of the Hungarian princess and the Thuringian landgrave was most successfully narrated in an illuminated book that still survives and is now preserved in Paris.[165] (Fig. 26)

The conditions for creating a splendidly decorated book at the court of Castile were close to ideal. The son of Beatrice and Ferdinand III, later known as King Alfonso X, called the Wise (1221–1284), was an extraordinary supporter of arts, science, and literature. His interests ranged from the natural sciences to politics and even women other than his wife. Unlike the library of the saintly King Louis IX of France, he possessed many books of a rather worldly character, including works on games like chess.[166] He sustained a scriptorium, which developed several innovative solutions to the problems of pictorial narrative in an illuminated codex. The theologians, poets, musicians and artists working for Alfonso created two codices with songs which were devoted to the Holy Virgin – *Cantigas de Santa Maria* (1283). The manuscripts were clearly religious in

[164] See above, Introduction.

[165] Bibliothèque nationale de France, Paris, Nouvelle acquisition latine 868. BLUME – JONEITIS, *Eine Elisabethhandschrift vom Hof König Alfons' X. von Kastilien*, pp. 325-339.

[166] J. WOLLESEN, *'Sub Specie Ludi'. Text and Images in Alfonso el Sabio's Libro de Acedrex, Dados e Tablas*, in *Zeitschrift fuer Kunstgeschichte* 53 (1990) 277-308.

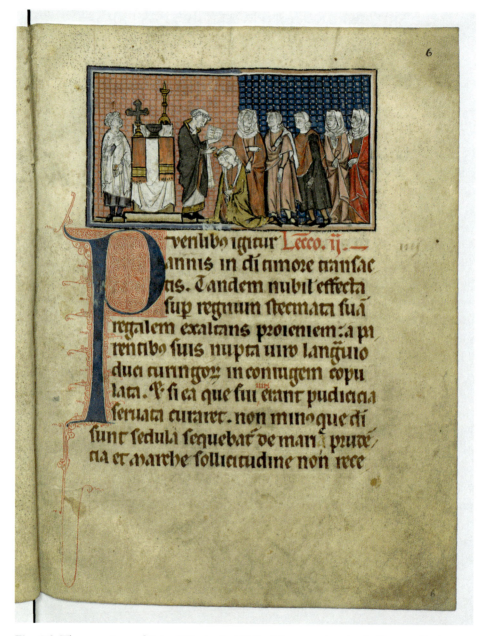

6

Fig. 26, The marriage of Saint Elizabeth, Bibliothèque nationale de France, Paris, Nouvelle acquisition latine 868, fol. 6r., Photo : BNF Paris.

nature, but their illuminations achieved distinction for the close attention paid to a wealth of details on everyday life.[167] Family relationships may have accounted for the choice of Elizabeth as the topic. Alfonso's wife Violante (Yolanda) of Aragon was a niece of St. Elizabeth (a daughter of her sister, Yolanda of Hungary).[168]

The pictorial legend of Elizabeth and other works of this scriptorium present close similarities. The manuscripts use clear narrative pictures within a flat space and mostly rectangular framings. The interior spaces are frequently indicated by placing Gothic niches above them. There are also important stylistic affinities in the way the figures were set against and painted on an embellished background. This style was also used for rendering images of contemporary reality: a closely comparable illumination shows Alfonso flanked by his councilors and musicians.[169] The pictorial rendering of Elizabeth's story was clearly influenced by scriptorium practice. Therefore, the sequence of illuminations evinces a disparity between the two ideals. On the one hand Elizabeth provided an example for pious women who wished to foster a spiritual connection with Christ in religious contemplation. On the other hand, the saint's desire to follow Christ through her radical practical support of the poor partly contravened the prevalent models of a lavish lifestyle, typical of the court. In this context it is interesting to note how exactly the tension between these ideals influenced the pictorial narratives.

A comparison between these different perspectives is even more telling, if we look closely at another manuscript, which was produced for monastic audiences in medieval Bohemia around the middle of the fourteenth century. The narrative cycle in the so-called *Liber depictus,* now preserved in the Austrian National Library in Vienna, seems to be the largest of the known pictorial vitae

[167] J. E. KELLER – A.G. CASH, *Daily Life Depicted in the Cantigas de Santa Maria.* Lexington, 1998.

[168] GECSER, *The Feast and the Pulpit: Preachers, Sermons and the Cult of St. Elizabeth of Hungary, 1235-ca. 1500*, p. 22. On the artistic patronage of the queen see M.R. KATZ, *The Non-Gendered Appeal of Vierge Ouvrante Sculpture: Audience, Patronage, and Purpose in Medieval Iberia*, in T. MARTIN (ed.), *Reassessing the Roles of Women as 'Makers' of Medieval Art and Architecture*, Leiden – Boston, 2012, pp. 71-74.

[169] Madrid, Real Biblioteca de Escorial, Ms. T.I.1, fol. 29r. Comp. M. LÓPEZ SERRANO, *Cantigas de Santa María de Alfonso X el Sabio, Rey de Castilla*, Madrid, 1974; S.G. ARMISTEAD – I.J. KATZ – J.E. KELLER – J.T. SNOW, *Studies on the Cantigas de Santa Maria: Art, Music, and Poetry. Proceedings of the International Symposium on the Cantigas de Santa Maria of Alfonso X, el Sabio (1221-1284) in commemoration of its 700th anniversary year--1981 (New York, November 19-21)*, Madison, WI, 1987; E. SÁEZ – O. ENGELS, *Alfons X. der Weise*, in *Lexikon des Mittelalters*, vol. 1, col. 396-397.

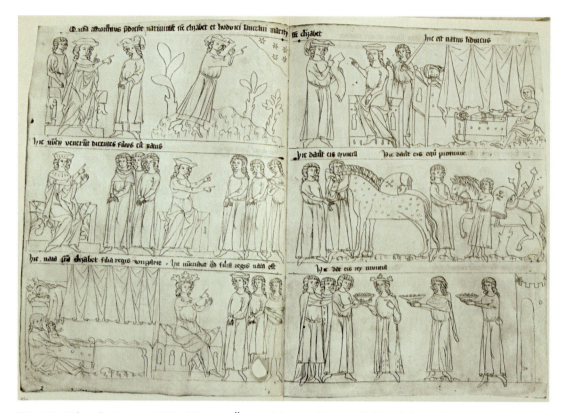

Fig. 27, *Liber depictus, c.* 1350, Vienna, Österreichische Nationalbibliothek, Cod. Vind. 370, fol. 85v-86r.

of St Elizabeth.[170] (Fig. 27) The pictorial narrative, which comprises 83 scenes, unfurls in three registers, extending over eight double pages (fol. 85v–95r), and

[170] Vienna, Österreichische Nationalbibliothek, Cod. 370, fol. 85v. - 96r. – For the art historical perspective see: G. SCHMIDT – F. UNTERKIRCHER, *Der Krumauer Bildercodex*, Graz, 1967, vol. 2 (Textband), 7-42. The name *Liber depictus* is based on a note written on fol. 1r. of the manuscript. For a description of the codex: U. JENNI – M. THEISEN, *Mitteleuropäische Schulen III (ca. 1350-1400): Böhmen-Mähren-Schlesien-Ungarn*, Wien, 2004, Textband, 3-53 (Jenni). The total number of scenes is only approximate since the dividing lines between individual episodes are not always clear. Gerhard Schmidt dated the codex after 1358, which is the year of the consecration of the convent in Krumlov. J. KRÁSA, *Review of SCHMIDT/UNTERKIRCHER 1967*, in *Umění* 16 (1968) 419-422, offered a stylistic argumentation in favor of dating "c. 1350", which was later accepted by G. SCHMIDT, *Die Fresken von Strakonice und der Krumauer Bilderkodex*, in *Umění* 41 (1993) 145-152. The texts have been republished in G. SCHMIDT – M. ROLAND, *Malerei der Gotik: Fixpunkte und Ausblicke*, Graz, 2005. Band 1: Malerei der Gotik in Mitteleuropa. pp. 259-303, 305-310.

the upper register of the next double page (95v and 96r). A glance at these illuminations instantly reveals differences in style. The author's intention was not to impress the viewer through the use of sumptuous colorful pictures or costly materials. The drawings were realized in a unique brownish hue, leaving most of the parchment untouched. Any embellishment is closely related to the chief message of the story. Even though the parchment as such was relatively valuable, the ink used to produce the drawings was far less costly than the exquisite colors used at the royal court. The overall impression is one of modesty.

The artist operated only with lines, which were essential for recounting the story and conveying its meanings to viewers. It is the concentration on the essential meanings that makes the legend in *Liber depictus* the most radical manifestation of contemporary monastic ideals in connection with Saint Elizabeth. The present chapter will delineate this radicalism within a variety of contexts.

The basic coordinates of these contexts are conveyed through several facts. First, before it was brought to Vienna, the codex was part of the library of the of the Poor Clares' and Minorite Friars' double monastery in the south Bohemian town of Český Krumlov (Krumau in German).[171] The Poor Clares in this monastery lived according to the Rule, written by an authorial team of Franciscans under the guidance of Saint Bonaventure (1221–1274), one of the leading figures in this mendicant Order, for their sisters at Longchamp almost a century earlier, around 1259–1260.[172] Thus despite the lack of specifically Franciscan saints depicted in the codex Franciscan ideals and traditions were likely to have been of considerable importance.[173]

Second, heraldic evidence relates the codex to the Rosenbergs (Rožmberk in Czech), who were the foremost noble family in southern Bohemia at that

[171] The remark on fol. 1r *"conventus beatae virginis cru…"*, was characteristic of this library –A. MATĚJČEK – J. ŠÁMAL, *Legendy o českých patronech v obrázkové knize ze XIV. století*, Praha, 1940, pp. 134-135. Most recently on the monastery, D. RYWIKOVÁ (ed.), *Klášter minoritů a klarisek v Českém Krumlově. Umění, zbožnost, architektura*, České Budějovice, 2015.

[172] J. KAŠPÁRKOVÁ, *Úhelný kámen zakládání a života. Regula pro sorores minores inclusae v Českém Krumlově (The Cornerstone of Foundation and Life: Regula pro sorores minores inclusae in Český Krumlov)*, in D. RYWIKOVÁ – R. LAVIČKA (eds.), *Ordo et paupertas. Českokrumlovský klášter minoritů a klarisek ve středověku v kontextu řádové zbožnosti, kultury a umění*, Ostrava, 2017, pp. 63-74.

[173] SCHMIDT, *Die Fresken von Strakonice und der Krumauer Bilderkodex*, p. 150; M. NODL, *Tři studie o době Karla IV.*, Praha, 2006, p. 134.

time.[174] Several members of this family held prestigious positions in the Imperial court of Charles IV in Prague. Therefore, we should also carefully consider the neglected questions concerning the cult of the Saint at his court.

The third group of associations lies in the links of the family to the Cistercian Abbey in Vyšší Brod (Hohenfurt in German), the family foundation and its burial place.[175] There was another influential Cistercian Abbey in Zlatá Koruna (*Sancta Corona*; *Heiligenkron* or *Guldein Chron* in German), which is in close proximity to Krumlov.[176] Thus, the Cistercian context needs also to be considered.

The saint held an important position in Bohemia and within the Rosenberg family.[177] The charter of Peter I of Rosenberg, issued on 1 September 1347, mentions the Hospital of St Elizabeth in Vyšší Brod.[178] Peter I's widow and sons founded the cloister in Krumlov on May 1, 1350; the first monks arrived in 1357 and the official confirmation of the Minorite Order and the Order of St Clare convents by the Roman Curia followed in 1358.[179]

[174] On the Rosenberg family see: L. BOBKOVÁ – M. BLÁHOVÁ – L. BOBKOVÁ – V. VANÍČEK, *Velké dějiny zemí Koruny české*, Praha, 2003; B. KOPIČKOVÁ, *Eliška Přemyslovna: královna česká, 1292-1330*, Praha, 2008; A. KUBÍKOVÁ, *Petr I. z Rožmberka a jeho synové*, České Budějovice, 2011; A. KUBÍKOVÁ, *Rožmberské kroniky – krátký a sumovní výtah od Václava Březana*, České Budějovice, 2005; R. ŠIMŮNEK – R. LAVIČKA, *Páni z Rožmberka 1250-1520: Jižní Čechy ve středověku: Kulturněhistorický obraz šlechtického dominia ve středověkých Čechách*, České Budějovice, 2011; B.R. NĚMEC, *Rožmberkové: Životopisná encyklopedie panského rodu*, České Budějovice, 2002. There is no consensus on the relationship between the codex and the family, a problem to be discussed later in this chapter.

[175] K. CHARVÁTOVÁ, *Dějiny cisterckého řádu v Čechách 1142-1420*, Praha, 2002, pp. 9-80.

[176] *Ibid.*, pp. 81-131. V. SCHMIDT (ed.), *Das Todtenbuch des Cistercienserstiftes Goldenkron in Böhmen*, in *Studien und Mitteilungen aus dem Benediktiner und Cistercienser Orden* 6, 1885; M. PANGERL (ed.), *Urkundenbuch des Cistercienstiftes Goldenkron in Böhmen*, in *Fontes rerum Austriacarum* XXVII, Wien 1872. The cloisters and town are situated on the river Vltava (Moldau in German) – Vyšší Brod approx. 30 km upstream from the town, Zlatá Koruna c. 8 km downstream.

[177] H.S. SCHMIDTBERGER, *Die Verehrung der Heiligen Elisabeth in Böhmen und Mähren bis zum Ende des Mittelalters*, Marburg, 1992.

[178] J. KUTHAN, *Počátky a rozmach gotické architektury v Čechách. K problematice cicterciácké stavební tvorby*, Praha, 1983, p. 221; Peter II of Rosenberg achieved a tax exemption for the cloister by Charles IV – CHARVÁTOVÁ, *Dějiny cisterckého řádu v Čechách 1142-1420*, p. 34.

[179] M. HRADILOVÁ, *Příspěvky k dějinám knihovny minoritů v Českém Krumlově v době předhusitské (On the History of the Minorite Library in Český Krumlov during the pre-Hussite period)*, Praha, 2014, pp. 15, 33, 34, 65-69; KUBÍKOVÁ, *Rožmberské kroniky – krátký a sumovní výtah od Václava Březana*, pp. 29 and 110.

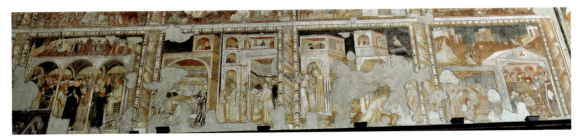

Fig. 28, Life of Saint Elizabeth, *c.* 1320, Church of Santa Maria Donna Regina, Naples.

2.2. Division of the Chapter and Comparative Horizons

This chapter is divided into several subchapters each of which focuses on a problem associated with a sequence of images in the *Liber depictus*. This sequence will be described in terms of its originality in relation to other legends of the Saint. The first cycle to be considered will be the one from the above-mentioned Paris manuscript. Several important points can be made with respect to the cycle of murals in the Church of Santa Maria Donna Regina in Naples.[180] (Fig. 28) This pictorial legend was also produced in an intense dialogue between royal and monastic contexts. Mary of Hungary, the wife of the Neapolitan king, Charles II from the Angevin dynasty, was an one of the foremost patrons of the church and its decoration.[181] She contributed substantially to its reconstruction following the earthquake in 1293 by generously donating many precious items to the cloister.[182] The new church, which was consecrated in 1320,

[180] C. WARR, *The Golden Legend and the Cycle of the 'Life of Saint Elizabeth of Thuringia – Hungary*, in J. ELLIOTT – C. WARR (eds.), *The Church of Santa Maria Donna Regina. Art, Iconography and Patronage in Fourteenth-Century Naples*, Aldershot – Burlington, VT, 2004, 155-174, here p. 160.

[181] Mary's coats-of-arms can be seen in many places in the church where she found her final resting place in 1323 (in a grave designed and sculpted by Tino da Camaiano): T. MICHALSKY, *Mater Serenissimi Principis: The Tomb of Maria of Hungary*, in *ibid.*, pp. 61-77; C.A. FLECK, *'Blessed the Eyes that See Those Things you See': The Trecento Choir Frescoes at Santa Maria Donnaregina in Naples*, in *Zeitschrift für Kunstgeschichte* 67 (2004a) 201-224; M.R. PROKOPP – Z.N.G.R. HORVÁTH, *Nápoly középkori magyar emlékei a XIII-XV. századból / Ricordi ungheresi medievali dei secoli XIII – XV a Napoli*, Budapest, 2014; M.R. PROKOPP, *Szent Erszébet falképciklus a nápolyi Santa Maria Donnaregina-templomban*, in G. KLANICZAY – B. NAGY (eds.), *A középkor szeretete: történeti tanulmányok Sz. Jónás Ilona tiszteletére*, Budapest, 1999, 414-423; J. GARDNER, *The Tomb and the Tiara: Curial Tomb Sculpture in Rome and Avignon in the later Middle Ages*, Oxford – New York, NY, 1992, p. 42, note 20.

[182] S.S. WOLOHOJIAN, *Closed Encounters: Female Piety, Art, and Visual Experience in the Church of Santa Maria Donna Regina in Naples*, Cambridge, MA, 1994, p. 203.

was to become one of the major elite convents.[183] The royal patronage is reflected in the sophistication and high artistic quality of the frescoes.[184] The queen's deep personal worship of Elizabeth was at least partially based on their common roots. Mary was the granddaughter of the Hungarian King Bela IV, the saint's brother.[185] There were similarities also in their biographies. Like her saintly great-aunt, Mary married into a foreign court and was familiar with the maternal role. In her testament, the queen mentioned that she possessed two

[183] R.A. GENOVESE, *La chiesa trecentesca di Donnaregina*, Napoli, 1993; C. BRUZELIUS, *The Stones of Naples. Church Building in Angevin Italy, 1266–1343*, New Haven, CT, 2004b, pp. 56, 99-103; C. BRUZELIUS, *The Architectural Context of Santa Maria Donna Regina*, in J. ELLIOTT – C. WARR (eds.), *The Church of Sta. Maria Donna Regina: Art, Iconography and Patronage in Fourteenth-Century Naples*, Aldershot – Burlington, VT, 2004a, 79-92. The images of the saintly kings Stephen and Ladislas of Hungary, and the saintly Hungarian prince Emeric, placed to the left of Elizabeth's legend, served the dynastic representation of the Queen as a person from the "saintly" dynasty of Arpadians. C.A. FLECK, '*To exercise yourself in these things by continued contemplation*': *Visual and Textual Literacy in the Frescoes at Santa Maria Donna Regina*, in J. ELLIOTT & C. WARR (eds.), *The Church of Santa Maria Donna Regina. Art, Iconography and Patronage in Fourteenth-Century Naples*, Aldershot – Burlington, VT, 2004b, 109-128, on p. 203 identifies the image of Emeric as another image of Elizabeth, not taking into account the obvious visual discrepancies and the traditional iconography of the three "holy kings of Hungary." (On the last comp. D. NASTASOIU, *Political Aspects of the Mural Representations of sancti reges Hungariae in the Fourteenth and Fifteenth Centuries*, in *Annual of Medieval Studies at CEU* 16 (2010) 1-27.

[184] The creators of the frescoes belonged to the broader circle of Pietro Cavallini, whose activity in Naples is documented in the years around 1308. S. PAONE, *Gli affreschi in Santa Maria Donnaregina Vecchia: percorsi stilistici nella Napoli angioina*. in *Arte Medievale* 2 (2004) 87-118. Elizabeth's legend was enriched by the artistic language which included some progressive elements, especially in the rendering of the spatial character of the architectural setting of the scenes. These elements were invented by Giotto working in the Capella Peruzzi in the Franciscan Church Santa Croce in Florence before and around 1320 – P.L. DE CASTRIS, *Pietro Cavallini: Napoli prima di Giotto*, Napoli, 2013, 112-154, here p. 117 and 148. The Florentine paintings may have been well known, not only among the Franciscans, but also among the Angevin family in Naples, who maintained lively business and financial contacts with Florence. For example, Charles II borrowed considerable sums of money from the Bardi family, who were among the most important sponsors of the Santa Croce decoration. J. GARDNER, *Giotto and his Publics: Three Paradigms of Patronage*, Cambridge, MA, 2011, p. 54. The authors of the iconographic program of the Florentine Bardi Chapel chose to portray Elizabeth wearing roses in her apron – KLANICZAY, *Holy Rulers and Blessed Princesses: Dynastic Cults in Medieval Central Europe*, p. 320. This motif is a reference to the miracle of the roses, which appears – albeit in a different form – in the Neapolitan cycle.

[185] See V. FRAKNÓI, *Mária, V. István király leánya, nápolyi királyné*, in *Budapesti szemle* 34 (1906) 321-358; more recently M.J. CLEAR, *Maria of Hungary as Queen, Patron and Exemplar*, in J. ELLIOTT – C. WARR (eds.), *The Church of Santa Maria Donna Regina. Art, Iconography and Patronage in Fourteenth-Century Naples*, Aldershot – Burlington, VT, 2004, 45-60.

books of Elizabeth's life, which have long been missing.[186] Thus a comparison with murals may at least partially compensate for this significant loss.

2.3. Astrology, Predestination, and Diplomacy

The first thematic unit of the *Liber depictus* (fol. 85v–86r) focuses on the preparation of the saint's marriage. (Fig. 27) The future familial bond was presented in the codex as the result of predestination, recognized by a prophetic astrologer. Instead of a passionate love story, so well-known in medieval romances, the continuation focused on the practical preparation for the alliance of two influential families through a diplomatic exchange of messages and gifts between Hungary and Thuringia. The aim of these gestures, which were fully in keeping with the collective code of behavior typical of high social ranks in medieval society, was not only a union between two persons of noble birth, "but also the joining of two social units".[187] The narrative about the relationship between Elizabeth and her husband also represents a story of political bonds between dynasties and states.

It is clear from the outset that the destiny of the future couple is written in the stars. (Fig. 29) The ruler consults an astrologer, who is next shown studying the stars and reporting his findings, which foretell the births of Elizabeth and Ludwig.[188] It is not to be excluded that the source of this motif is Dietrich of Apolda, who had mentioned a certain Klingsohr, a seer from Transylvania, saying:

> I see a beautiful star rising in Hungary, the rays of which extend to Marburg, and from Marburg over all the world. Know even that on this night there is born to my lord, the King of Hungary, a daughter who shall be named Elizabeth. She shall be given in marriage to the son of your prince, she shall become a saint, and her sanctity shall rejoice and console the entire world.[189]

[186] "*libros duos continentes vitam beate Elisabet*" – D. FALVAY, *The Multiple Regional Identity of a Neapolitan Queen. Mary of Hungary's Readings and Saints*, in S. KUZMOVÁ – A. MARINKOVIĆ – T. VEDRIŠ (eds.), *Cuius Patrocinio Tota Gaudet Regio: Saints' Cults and the Dynamics of Regional Cohesion*, Zagreb, 2014, 213-229, p. 222.

[187] DUBY, *Love and marriage in the Middle Ages*, p. 3.

[188] Fol. 85v, the *titulus*: "*Quidam astronomus prediscit nativitatem sancte Elizabet et Lwdvici lancravi marity sante Elizabet.*"

[189] RENER (ed.), *Die Vita der heiligen Elisabeth des Dietrich von Apolda*, p. 24; SCHMIDT-BERGER, *Die Verehrung der Heiligen Elisabeth in Böhmen und Mähren bis zum Ende des Mittelalters*, pp. 144-146. The oracle of Elizabeth's birth was depicted in murals dating from the 16th century in Frankfurt am Main, with an inscription "*Ich sihe ainen schönen Stern, der leuchtet von*

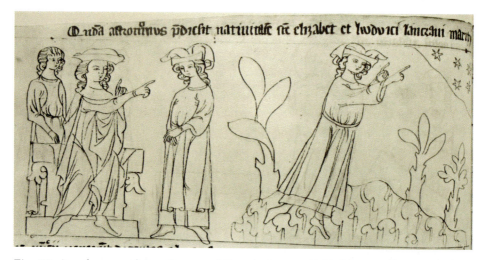

Fig. 29, Astrologer studying the stars, *Liber depictus, c.* 1350, Vienna, Österreichische Nationalbibliothek, Cod. Vind. 370, fol. 85v.

The images in this codex reflect the medieval belief in the possibility of understanding the miraculous working of divine providence in the world by careful study of the movements of stars and planets. The traditional strength of this belief at the royal court in Prague is well illustrated by a thirteenth-century celestial globe, as well as by astrological manuscripts, preserved in the German town of Bernkastel-Kues.[190] The *topos* of the astrologer predicting the birth of the narrative's hero appears elsewhere in the manuscript, too, but not in a systematic way.[191] In terms of religious iconography, the narrative about a star

Hungern biß gen Marckburg", F. SCHMOLL, *Die heilige Elisabeth in der bildenden Kunst des 13. bis 16. Jahrhunderts*, Marburg, 1918, p. 60.

[190] E. URBÁNKOVÁ – K. STEJSKAL, *Pasionál Přemyslovny Kunhuty; Passionale abbatissae Cunegundis*, Praha, 1975, p. 38; K. STEJSKAL – J. KRÁSA, *Astralvorstellungen in der mittelalterlichen Kunst Böhmens*, in *Sborník prací Filozofické fakulty brněnské univerzity. F, Řada uměnovědná* 13 (1964) 61-84; A. HADRAVOVÁ – P. HADRAVA, *Reflection of Ancient Greek Tradition in the 13th c. Premyslid Celestial Globe Saved in Bernkastel-Kues*, in G. KATSIAMPOURA (ed.), *Scientific Cosmopolitanism and Local Cultures: Religions, Ideologies, Societies*, Athens 2014, 45-50. On the earlier traditions of the this theme – D. BLUME – M. HAFFNER – W. METZGER, *Sternbilder des Mittelalters: der gemalte Himmel zwischen Wissenschaft und Phantasie*, Berlin, 2012.

[191] The astrologer predicting the birth of Judas appears on fol. 102v; a similar figure announcing the birth of St. John the Baptist has replaced the conventional angel (fol. 58v and 59r).

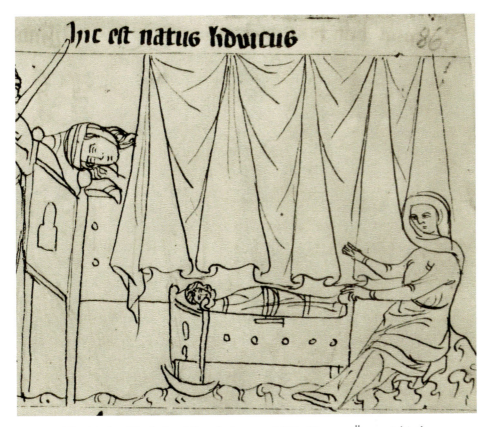

Fig. 30, The birth of Ludwig, *Liber depictus*, *c.* 1350, Vienna, Österreichische Nationalbibliothek, Cod. Vind. 370, fol. 86r.

associated with noble births was probably modeled on the biblical narrative of the Star of Bethlehem which led the Magi to the place where Jesus was born.[192]

Indeed, this parallel may explain several motifs in this sequence, starting with the next image, showing the birth of Ludwig: the mother lies in bed while a maid cares for the noble infant in a crib.[193] (Fig. 30) The entire first line of the narrative presents a highly original iconography, which was unprecedented in pictorial legends of Elizabeth.

[192] Mat 2, 2; comp. Num 22-24. Comp. P. BARTHEL – G.H. KOOTEN, *The Star of Bethlehem and the Magi: Interdisciplinary Perspectives from Experts on the Ancient Near East, the Greco-Roman World, and Modern Astronomy*, Leiden – Boston, MA, 2015.

[193] Fol. 86r: *"hic est natus lidvicus."*

In the second line (middle register) of the double page messengers are shown approaching an enthroned ruler who is often identified as Ludwig's father, the landgrave Hermann[194]; here he bestows rich presents, including some palfreys, on the messengers.[195] Hermann sends the gifts to Hungary, thus starting a diplomatic exchange of presents. This sequence sketches out an indirect representation of negotiations between the ruling families of Hungary and of Thuringia. The immediate result of the negotiations – the journey of a four-year-old princess to Thuringia – is not depicted in this manuscript. It is altogether possible that that an image of the diplomatic communication contributed to the prestige of the saint in leading circles of society. This may account for the repetition of the birth and the exchange of gifts in the lowest register of the first double page. In this instance they directly represent the birth of Saint Elizabeth.[196] (Fig. 31) This sequence, which features the royal gestures of magnanimity, firmly situates the future pair in influential social circles. The unusual emphasis on the noble origin of Elizabeth and Ludwig in this cycle may have been the decision also of a distinguished patron.[197]

The fact that Ludwig is accorded at least as much attention as the saint is unprecedented in the context of a hagiographic legend. Other pictorial lives of St Elizabeth ignored the birth of Ludwig, who was not a saint, in order to minimize the risk of an excessively detailed portrayal distracting the viewer from the saintly status of his wife. The story of Ludwig acquires greater meaning within the framework of a highly complex pictorial meditation on the topic of marriage. The real marriage, even if omitted from the manuscript, was pre-arranged within the framework of dynastic policy and predicted by an astrologer. This is the starting point of a complex meditation, which surprises readers through the various twists in the development of the topic over the subsequent pages.

[194] JENNI – THEISEN, *Mitteleuropäische Schulen III (ca. 1350-1400): Böhmen-Mähren-Schlesien-Ungarn*, p. 27.

[195] Fol. 85v: "*hic nuntii venerunt dicentes: 'filius est natus'. hic dantur eis munera. hic dantur eis equi pro munera*". The use of a messenger as a means of communication occurs at many points in the codex (a messenger was devoted a special parallel on fol 30v; associated with a birth on 99r. Its further appearances: fol. 40r, 48r, 68r, 142v, 143v). Comp. S. KRÄMER – A. ENNS, *Medium, Messenger, Transmission: An Approach to Media Philosophy*, Amsterdam, 2015.

[196] Fol. 85v-86r: "*hic nata sancta elizabet filia regis ungarie. hic nunciant quod filia regis nata est. hic dat eis rex munera.*"

[197] SCHMIDTBERGER, *Die Verehrung der Heiligen Elisabeth in Böhmen und Mähren bis zum Ende des Mittelalters*, p. 54.

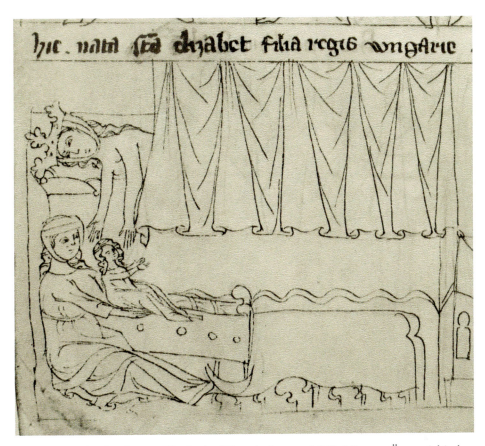

Fig. 31, The birth of Saint Elizabeth, *Liber depictus, c.* 1350, Vienna, Österreichische Nationalbibliothek, Cod. Vind. 370, fol. 85v.

2.4. The Virgin at Play

The second double-page of the legend (fol. 86v–87r) shows the most important milestones marking Elizabeth's spiritual development. (Fig. 32) In keeping with childhood it is gentle and playful beginning of the saint's dialogue with less fortunate persons as well as with religious authorities.[198] The scenes from childhood could have been integrated into the cycle to target younger readers

[198] On medieval perceptions of childhood – see P. ARIÈS, *Centuries of Childhood: A Social History of Family Life,* New York, NY, 1962; E. SEARS, *The Ages of Man: Medieval Interpretations of the Life Cycle,* Princeton, NJ, 1986; C. FRUGONI, *Vivere nel Medioevo: donne, uomini e soprattutto bambini,* Bologna, 2017.

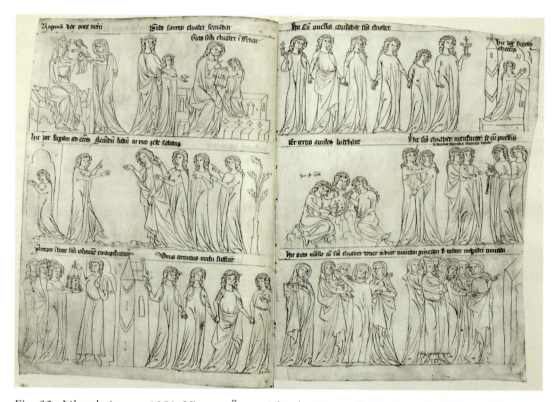

Fig. 32, *Liber depictus, c.* 1350, Vienna, Österreichische Nationalbibliothek, Cod. Vind. 370, fol. 86v-87r.

for whom the saint may have served as an example of early developed religiosity.[199]

The sequence begins with the tiny figure of a baby handed over by her mother, Queen Gertrud, to Guda, who would be responsible for Elizabeth's upbringing.[200] Elizabeth is portrayed as an ordinary girl, playing with her

[199] SCHMIDTBERGER, *Die Verehrung der Heiligen Elisabeth in Böhmen und Mähren bis zum Ende des Mittelalters*, p. 54; the representation of children as such contradicts Philippe Ariès's well known line of argument – see H. ZIELINSKI, *Elisabeth von Thüringen und die Kinder*, in ARNOLD – LIEBING (eds.), *Elisabeth, der Deutsche Orden und ihre Kirche: Festschrift zur 700 jährigen Wiederkehr der Weihe der Elisabethkirche Marburg 1983*, pp. 27-38, in particular 29.

[200] Fol. 86v: "*Regina dat puerum* (sic!) *nutrici. Guda sanctae Elizabet servabat. Guda sanctam Elizabet instruebat.*" – comp. JENNI – THEISEN, *Mitteleuropäische Schulen III (ca. 1350 - 1400): Böhmen-Mähren-Schlesien-Ungarn*, p. 27. Similar images are to be found on fol. 103r, 103v, and 139r. The contexts differ considerably, with roots in the stories of Oedipus (incest) and Moses

contemporaries. Little differentiation is made between Elizabeth and her play-mates, who sit with her on the ground. Her identity is indicated only by the laconic inscription: "*Hic est ipsa*". Therefore, some readers may have identified with Elizabeth's companions. Throughout the pictorial legend, the illuminator has chosen not to mark the saint with a traditional halo, even if this sign of sanctity was adopted in other legends in the codex. Although portrayed as an ordinary child, every opportunity is taken to show her engaged during the games in inconsipicuous religious activities, such as absconding to a chapel or genuflecting during a dance.[201] Unlike the Neapolitan image from the saint's childhood, there is no codex placed in front of Elizabeth as she kneels in the chapel.

The meaning of the episode described by the titulus as *Saint Elizabeth measuring herself with other girls* may have escaped the illuminator.[202] He depicted a mutual comparison of height between two girls who are portrayed standing. According to *Libellus*, the measuring was done lying on the ground because Elizabeth wanted to perform genuflections in secret accompanied by *Ave Marias* which she has promised to God as a reward for winning the game.[203]

2.5. Marriage and Virginity

Elizabeth considered her religious vocation at a very early age when she accepted St. John the Evangelist as the patron of her virginity.[204] (Fig. 33) The events represented in this highly original image were described by Guda in her testimony for the papal commission preparing the canonization of Elizabeth (1235): "When she [Elizabeth] was a little older, she longed to have the blessed evangelist John, the custodian of chastity, as her apostle."[205] In the drawing the man

(a child in a basket placed on water and found). The scenes of instruction of education on fol. 32r, 128v, and 131r.

[201] Fol. 86v-87r: "*Hic cum puellis corisabat sancta Elizabet. Hic dat fugam ad ecclesiam. Hic dat fugam ad ecclesiam.*[repeated] *Secundum ludum in uno pede saltans.*"

[202] Fol. 87r: "*Hic sancta Elizabet mensurat se cum puellis…*"

[203] WOLF, *The Life and Afterlife of St. Elizabeth of Hungary. Testimony from her Canonization Hearings*, p. 194.

[204] Fol. 86v: "*Accepit in sortem sanctum Johanem Evangelistam*"; RENER (ed.), *Die Vita der heiligen Elisabeth des Dietrich von Apolda*, p. 28: "*castitatis amatrix Ioannem evangelistam virginitatis sue custodem optabat habere patronum.*"

[205] HUYSKENS (ed.), *Libellus de dictis quattuor ancillarum s. Elisabeth confectus*, p. 13, line 308 – 312; WOLF, *The Life and Afterlife of St. Elizabeth of Hungary. Testimony from her Canonization Hearings*, p. 194.

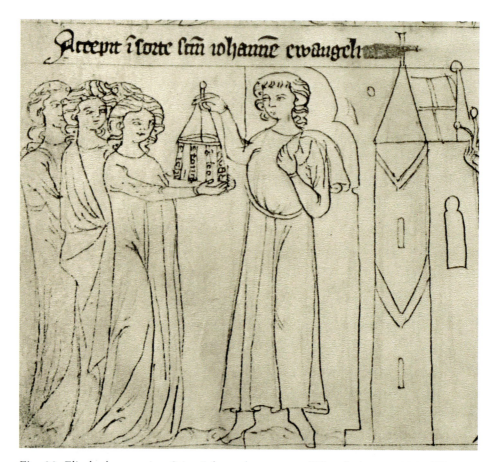

Fig. 33, Elizabeth accepting Saint John as her patron, *Liber depictus*, *c.* 1350, Vienna, Österreichische Nationalbibliothek, Cod. Vind. 370, fol. 86v.

standing in front of Elizabeth and her maids holds a ring on which strips of paper were placed bearing the names *Johannes*, *Thomas*, and *Leo*. Then the ring was spun and when it stopped the strip naming John pointed to Elizabeth.[206] What exactly was the meaning of this promise? Why was it so important that a woman who would become the wife of a real man and mother to three children had promised her virginity and chosen as her patron an apostle who lived twelve centuries earlier?

[206] U. JENNI, *Realistische Elemente im Krumauer Bildercodex*, in K. BENEŠOVSKÁ (ed.), *King John of Luxembourg and the Art of his Era (1296-1346)*, Prague, 1998, 260-269, p. 266.

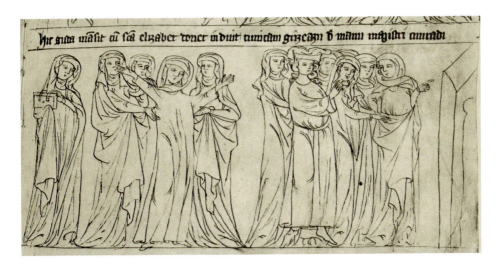

Fig. 34, Elizabeth receiving a grey tunic, *Liber depictus, c.* 1350, Vienna, Österreichische Nationalbibliothek, Cod. Vind. 370, fol. 87r.

The depiction of this scene assumes even greater significance when we consider the fact that Elizabeth's wedding ceremony is not shown in this most extensive of the pictorial cycles, even though the scene had been depicted in Seville and in Naples. This decision could have been motivated by controversial perceptions of Elizabeth's marriage. Her status as a married woman was at odds with the ideal of virginity typical of female saints.[207] In trying to achieve the canonization of the saint, Conrad of Marburg downplayed the role of Elizabeth's volition in marrying Ludwig. He described her as "upset because, having already for some time been married, she would not able to this present life as a virgin."[208] Conrad is depicted on the same double-page of *Liber depictus.* (Fig. 34) Elizabeth, accompanied by Guda, receives for the first time a gray tunic, marking her religious dedication.[209] She stands like an orant and her maids help her to put on the tunic. In the next episode she is introduced by

[207] A. VAUCHEZ, *Lay People's Sanctity in Western Europe: Evolution of a Pattern*, in R. KOSINSKI-BLUMENFELD – T.R. SZELL (eds.), *Images of Sainthood in Medieval Europe*, Ithaca, NY – London, 1991, 21-32; HAARLÄNDER, *Zwischen Ehe und Weltentsagung. Die verheiratete Heilige / Ein Dilemma der Hagiographie*, pp. 211-229.

[208] HUYSKENS, *Quellenstudien zur Geschichte der hl. Elisabeth, Landgräfin von Thüringen,* , p. 156; WOLF, *The Life and Afterlife of St. Elizabeth of Hungary. Testimony from her Canonization Hearings,* p. 92.

[209] Fol. 87r: "*Hic Guda mansit cum sanctam Elizabet donec induit tunicam grizeam de manu magistri Cunradi.*"

Conrad into a church or chapel which is sketched in the border of the page.[210] The saint is smiling, for the decision to yield to Christ fills her with joy. A similar emotional undertone in her relationship with Jesus surfaces later in the codex. A possible source for the inspiration of this understanding of religious experience may be the illustrated theological manuscripts of the *Speculum Humanae Salvationis*, which show considerable affinities with our codex also in other respects.[211] Not only were they illuminated by monochrome drawings, but they also were intended to guide readers on their path to a deeper rational and emotional understanding of theological messages.

Historically, the topic of these images draws on a ceremony held in the monastery of St Catherine in Eisenach in 1226, where Elizabeth "swore obedience to Master Conrad of Marburg, except with regard to the rights of her husband".[212] On the same occasion, she made a promise of perpetual chastity "if she happened to outlive her husband". Thus, in the person of Conrad she found a new, earthly patron of her virginity, which had been redefined to comply with her duties as a married woman and mother. Conrad reappears elsewhere in the codex, especially in relation to Elizabeth's asceticism. His role as her spiritual leader was accepted and recognized by Ludwig. Thus, Conrad is by no means to be perceived as a competitor for Elizabeth's heart.

In contrast, the marriage scene in the Seville codex (fol. 6r.) features Ludwig and Elizabeth kneeling before a priest who holds an open codex. (Fig. 26) Behind him stands the altar on which the liturgical objects are placed (cross, chalice, candlestick); and an acolyte clad in white. Meanwhile the guests placed behind the young couple belong to the secular world; this is accentuated by the blue background on the right-hand side of the image, whereas the young couple already belongs to the clerical world on the left-hand side, set against a red background. It is possible to read the layout of the image conferring a special status not only on Elizabeth, but also on her husband Ludwig. Like Conrad, Caesarius of Heisterbach claimed that Elizabeth was "betrothed to and united

[210] On the earliest depictions of Elizabeth in Marburg receiving the tunic from Magister Conrad see above, 1.5.3.

[211] Comp. H.M. FLAHERTY, *The Place of the Speculum Humanae Salvationis in the Rise of Affective Piety in the Later Middle Ages*, Ann Arbor, MI, 2006.

[212] HUYSKENS (ed.), *Libellus de dictis quattuor ancillarum s. Elisabeth confectus*, p. 17: *"fecit magistro Conrado de Marpurch obedientiam salvo tamen iure mariti sui"*; WOLF, *The Life and Afterlife of St. Elizabeth of Hungary. Testimony from her Canonization Hearings*, p. 196; KLANICZAY, *Holy Rulers and Blessed Princesses: Dynastic Cults in Medieval Central Europe*, p. 284.

in marriage with the noblest prince Ludwig against the desire of her heart".[213] However, in the subsequent passage he praises Ludwig's virtuous character and religiosity, as though to state that marriage with such an excellent Christian could never pose a problem. This logic held an appeal for those women in the court, who took a keen interest in the interrelationship between ideals of saintly life and obligations of family life; further, this may account for the choice to depict the nuptials.[214]

In Naples the marriage of Elizabeth to Ludwig of Thuringia became one of the most prominent scenes which in many respects surpassed the somewhat restrained Seville image – many guests are shown at the ceremony, in keeping with a courtly festivity.[215] (Fig. 35) The center of the image is occupied by a sacramental scene – a priest blesses the hands of the young couple. The ritual joining of right hands (*dextrarum iunctio*), confirmed by the priest, was an important gesture in medieval wedding ceremonies. The bride and the bridegroom stand symmetrically on either side of the priest thus showing considerable affinity with the depiction of The Virgin's Wedding Feast in the Arena Chapel in Padua. However, the gestures differ – their hands are closer but not yet touching.[216] The columns behind the bride and bridegroom divide the image field into three parts without making any breaks in the broad vaulted space where many other figures are portrayed. Men and women in sumptuous robes attend the marriage ceremony; on the left-hand side musicians are playing and on the right an enthroned ruler is shown. The gazes are directed toward the key event. The fresco offers a positive answer to the important question of the compatibility between saintly life and marriage thereby transforming, rather

[213] "...*contra cordis suis desiderium nobilissimo principi Ludewico lantgravio desponsata est et matrimonio iuncta.*" – CAESARIUS – E. KÖNSGEN, *Das Leben der Heiligen Elisabeth*, Marburg, 2007, p. 24

[214] GECSER, *Aspects of the Cult of St. Elizabeth of Hungary with a Special Emphasis on Preaching, 1231-c.1500*, p. 112. For an overview of this nuptial theme see contributions in S. ROUSH – C.L. BASKINS, *The Medieval Marriage Scene: Prudence, Passion, Policy*, Tempe, AR, 2005; L. ELSBREE, *Ritual Passages and Narrative Structures*, New York, NY, 1991; L. PIEPER, *Saint Elizabeth of Hungary: The Voice of a Medieval Woman and Franciscan Penitent in the Sources for her Life*, New York, NY, 2016, pp. 97-100.

[215] Comp. L. MITCHELL, *"Through Marriage Marvelously Blended": Visual Representations of Matrimonial Rituals in the Burgundian and Habsburg Netherlands, 1384 to 1555*, MA, University of Ottawa, 2014; D.L. D'AVRAY, *Medieval Marriage: Symbolism and Society*, Oxford, 2005.

[216] M. BARASCH, *Giotto and the language of gesture*, Cambridge, 1987, pp. 42, 43. On the background of the problem comp. C. DAVIDSON (ed.), *Gesture in medieval drama and art*, Kalamazoo, MICH, 2001; G. DALLI REGOLI, *Il gesto e la mano: convenzione e invenzione nel linguaggio figurativo fra Medioevo e Rinascimento*, Florence, 2000.

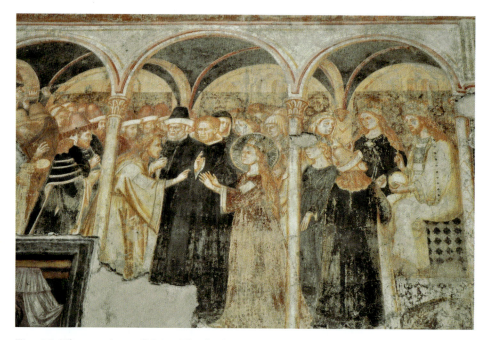

Fig. 35, The marriage of Saint Elizabeth, *c.* 1320, Church of Santa Maria Donna Regina, Naples.

than entirely eliminating, the ideal of chastity. Intercourse between a husband and his wife was posited not as a source of pleasure, but as a necessary precondition for the maternal role of a potentially saintly woman.[217] This idea was of great importance for the worldly patron of the cycle – Queen Mary. As the mother of fourteen children, she exemplified the royal uxorial role and later that of exemplary widow, with a high level of engagement in religious matters.[218] The garments of the figures in this wonderfully lavish scene reflect the material wealth of contemporary courtly culture. The dress code of the participants in the event indirectly hints at the behavioral norm of aristocratic society: an acceptable, or even ideal, marriage had to be arranged between partners of equal or similar social standing. The fanciful environment of the aristocratic nunnery influenced the lens through which Elizabeth's life was perceived, contemplated and represented. Many nuns in the cloister came from a privileged

[217] DUBY, *Love and marriage in the Middle Ages*, p. 40.
[218] WARR, *The Golden Legend and the Cycle of the 'Life of Saint Elizabeth of Thuringia – Hungary*, p. 171; MICHALSKY, *Mater Serenissimi Principis: The Tomb of Maria of Hungary*, pp. 61-77.

background. Their families were sufficiently wealthy to be able to choose poverty as a voluntary way of life.[219]

Nuns, who were the primary audience of this cycle, were debarred from marrying. In fact, young aristocratic women were often chosen for the monastic life because their families were unable to provide a sufficient dowry. The sisters of the "Second Order" of Saint Francis, also known as Clarisses, followed the established monastic orders; various versions of their rule prescribed the observance of the ideals of chastity.[220] These rules were expressed to striking effect by the large-format frescoed allegory in the Lower Church of St. Francis in Assisi. The personification of Chastity enclosed in a fortified tower constitutes a compelling representation of what was expected from nuns closed in the monastery – they should pray, hoping for an angelic reward. Carnal love, personified by Cupid, should be banished from their lives.

These observations lead back to a complex nexus of ideas around marriage and virginity in which it was possible for virginity to be miraculously restored by divine omnipotence.[221] This was an important connection in Elizabeth's ascetic practices during her marriage and was depicted later within this pictorial narrative.

Elizabeth renounced several things because of John, but an even more important reason for renouncing worldly pleasures becomes evident in the next scene, where she satisfies herself with one round of a dance, omitting the following one "because of God".[222] The relationship with Jesus Christ, later in this legend

[219] Comp. GARDNER, *Giotto and his Publics: Three Paradigms of Patronage*, p. 51; CANNON, *Religious Poverty, Visual Riches: Art in the Dominican Churches of Central Italy in the thirteenth and fourteenth Centuries*, p. 20.

[220] E.M. MAKOWSKI, *Canon Law and Cloistered Women: Periculoso and its Commentators, 1298-1545*, Washington, D.C., 1997; J.R.H. MOORMAN, *A History of the Franciscan Order: From its Origins to the Year 1517*, Oxford – New York, NY, 1968, pp. 211-215; J. MUELLER, *The Privilege of Poverty: Clare of Assisi, Agnes of Prague, and the Struggle for a Franciscan Rule for Women*, University Park, PA, 2006; B. ROEST, *Order and Disorder: The Poor Clares between Foundation and Reform*, Leiden – Boston, 2013, pp. 44, 48, 49. On the situation in Krumlov monastery see KAŠPÁRKOVÁ, *Úhelný kámen zakládání a života. Regula pro sorores minores inclusae v Českém Krumlově (The Cornerstone of Foundation and Life: Regula pro sorores minores inclusae in Český Krumlov)*, p. 63-74.

[221] Thomas Aquinas was an exponent of these ideas – I.M. RESNICK, *Peter Damian on the Restoration of Virginity: A Problem for Medieval Theology*, in *Journal of Theological Studies* 39 (1988) 125-134, p. 125.

[222] Fol. 86v: "*Unus circuitus michi sufficit.*". *Libellus*, the original source, records the words of Elizabeth: "*Sufficit michi unus circuitus pro mundo, alios pro deo dimittam.*" HUYSKENS (ed.), *Libellus de dictis quattuor ancillarum s. Elisabeth confectus*, p. 14. Elizabeth's restraint during

interpreted as spiritual marriage, will be one of the driving sources of inspiration in the subsequent life of the saint.[223]

2.6. Asceticism and Marital Life

A marked inclination towards asceticism and a genuine sympathy for the poor and weak characterized the marital life of Elizabeth and Ludwig, with the behavior of the landgravine sometimes contravening established social norms. (Fig. 36) Aware that washing and cutting a beggar's hair, for instance, would be regarded as an outrageous thing to do, and even provoke revulsion, she hid herself away in the castle garden to do it. The canonization commission recorded the testimony of a certain Isentrud, a woman who accompanied Elizabeth during the five years of her marriage:

When she still lived in the habit of her secular glory, she secretly took in a sick beggar who was horrendous in appearance, suffering from a skin disease on his head. With her own hands, she trimmed his horrid locks while his head was lying in her lap. Later she washed his head in an out-of-the-way place of hers beyond the walls, wanting to keep him out of sight.[224]

The artist has eschewed any corporeal closeness between the saint and the man, which is mentioned in the text. Elizabeth, robed in the full garment of a married woman and the nearly naked man are portrayed at a distance from each other; only the hands of the merciful landgravine bridge this disparity. Moreover, it should be noted that the medium of monochrome drawing was probably not the most suitable for rendering the horrendous appearance of the beggar as described in Isentrud's testimony. His hairstyle would appear also to be at odds with the chronology of the episodes. In the washing scene at the beginning of the register, his hair is almost invisible, appearing only in the second scene, where it is being cut. The two figures are portrayed alone in the garden, which is represented only by a couple of trees, even though the

these ludic activities is mentioned also by RENER (ed.), *Die Vita der heiligen Elisabeth des Dietrich von Apolda*, p. 28.

[223] The *sponsus / sponsa* are depicted close to the *Noli me tangere* on fol. 24r.

[224] WOLF, *The Life and Afterlife of St. Elizabeth of Hungary. Testimony from her Canonization Hearings*, p. 195; HUYSKENS (ed.), *Libellus de dictis quattuor ancillarum s. Elisabeth confectus*, p. 17, line 431-442: "*Item beata Elysabeth adhuc existens in habitu glorie secularis quendam mendicum infirmum horrendum aspectu, capitis infirmitate laborantem, secrete assumpsit, probriis manibus tondens horridos capillos ipsius, capite suo in sinu eius reclinato, posteo lavit caput eius in secreto loco pomerii sui, hominum volens vitare aspectum.*" A strikingly similar description of the event appears in RENER (ed.), *Die Vita der heiligen Elisabeth des Dietrich von Apolda*, p. 40.

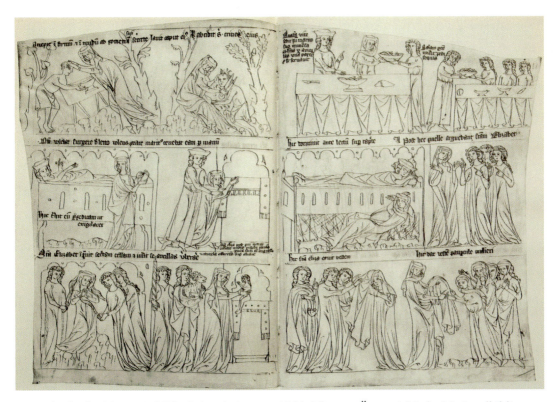

Fig. 36, Elizabeth's marital life, *Liber depictus, c.* 1350, Vienna, Österreichische Nationalbibliothek, Cod. Vind. 370, fol. 87v-88r.

presence of the maids is mentioned later in the text. It was only in subsequent cycles that their presence was taken into consideration.

The problems of food asceticism are taken up again in the right-hand side of the same register in relation to Elizabeth's household economy.[225] There is only one general scene devoted to this topic, whereas in Seville the subject merited three images. Although succinct, this cycle is a more explicit representation of how food – apart from five birds – from the landgrave table reaches the table of the poor.[226] Inspired by Conrad, Elizabeth refused certain meals, because their origins (undue burden on suppliers) would have weighed on her

[225] See further: C.W. BYNUM, *Holy Feast and Holy Fast: The Religious Significance of Food to Medieval Women*, Berkeley, CA, 1987, pp. 189, 218, and 296.

[226] Fol. 88r: "*Quadam vice sedit cum marito suo in mensa, ab huius V aviculas unam partem pro se servavit, secundam partem misit pedisequis.*"

conscience. In certain conditions an ascetic decision of this sort may well have been accepted by the authors of the codex – elsewhere in the manuscript, the depiction of a feast could have positive or negative meanings depending on the context. Obviously the Last Supper could not be seen in a negative light and there are other feasts in the manuscript, which are conveyed in a positive light.[227] Images of banqueting do however occur in a parable narrated elsewhere in the codex.[228] In this instance, instead of feeding a princess a man feeds a dog he was looking after. This was an obvious example of improper use, which was meant to be read allegorically as a hint to anyone who might neglect their own soul.

Elizabeth's married life with Ludwig is not represented as a source of pleasure. Even during the night, they both undertake spiritual exertions together, waking each other up to pray.[229] After praying together, the saint does not lie in bed with her husband. Instead, she sleeps on a carpet next to the bed.[230] This sequence follows a model prefigured by the legend and images of Saint Radegund (520/25–587), whose fate resembles that of Elizabeth in several respects. The daughter of Thuringian King Berthar, she was borne away to the Frankish court in 531, where she married Clothar I in 540.[231] Her legend, written by Venantius Fortunatus (c. 530– c. 600/609), comments on the discrepancy between her husband and the Heavenly Bridegroom: "though married to a terrestrial prince, she was not separated from the celestial one (…) she was more Christ's partner than her husband's companion".[232] An illumination of this legend shows the saint leaving her husband's bed to pray.[233] (Fig. 37) The contrast between sleep and vigilance had been a topic of Christian moral instruction

[227] The Last Supper fol. 14r, other feasts fol. 9v/10r; 141r, 154r, 163/164.

[228] Fol. 141r.

[229] Fol. 87v: "*Quando volebat surgere de lecto volens orare, maritus tenebat eam per manum. Hic trahit eum per pedicam, ut evigilaret.*" A similar image can be seen on fol. 119r.

[230] Fol. 88r: "*Hic dormivit ante lectum super tapete.*"

[231] KLANICZAY, *Holy Rulers and Blessed Princesses: Dynastic Cults in Medieval Central Europe*, p. 72.

[232] "*Nubit ergo nerreno principi, nec tamen separata caelesti … plus participata Christo quam sociata coniugo.*" FORTUNATUS – FAVREAU, *La vie de sainte Radegonde par Fortunat: Poitiers, Bibliothèque municipale, manuscrit 250 (136)*, p. 366; KLANICZAY, *Holy Rulers and Blessed Princesses: Dynastic Cults in Medieval Central Europe*, p. 73.

[233] Poitiers, Bibliothèque municipale, manuscrit 250, fol. 24r. The scene is discussed by FORTUNATUS – FAVREAU, *La vie de sainte Radegonde par Fortunat: Poitiers, Bibliothèque municipale, manuscrit 250 (136)*, pp. 158-161; P. SKUBISZEWSKI, *Un Manuscrit peint de la «Vita Radegundis» conservé à Poitiers les idées hagiographiques de Venance Fortunat et la spiritualité monastique du XIe siècle*, Treviso, 1993.

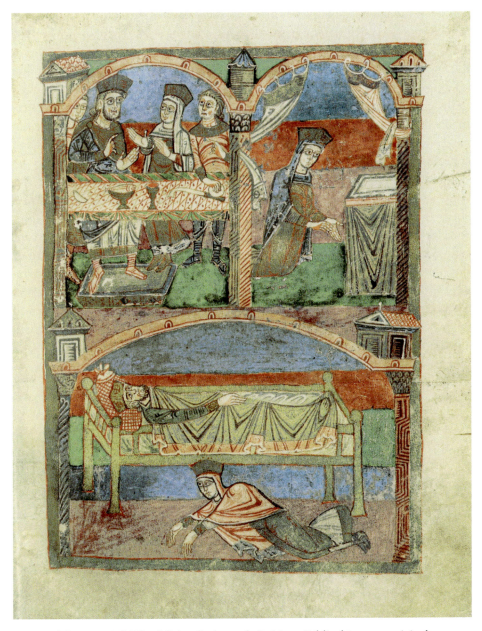

Fig. 37, The married life of Saint Radegund, Poitiers, Bibliothèque municipale, manuscrit 250, fol. 24r..

since biblical times, acquiring a special importance within a monastic context.[234] Although Elizabeth's belonged to such a venerable tradition, the *Liber depictus* followed a different path, showing Ludwig's full participation in the pious ascetic life of his wife. Unlike Radegund's husband (who merely slept), Ludwig discusses her nocturnal prayer with Elizabeth, standing behind her and holding her hand as she kneels in front of the altar (Radegund prayed alone). Ludwig appears to have been more understanding of his wife's pious practices than were the respective husbands of St. Radegund and St. Hedwig, depicted in her 1353 legend.[235] Hedwig prays alone in front of the altar, while her husband continues to sleep in a large bed which occupies most of the scene.[236]

Ludwig's complex psychology in this scene had already been described initially already by Isentrud. When Elizabeth rose at night to pray, her husband "begged her not to afflict herself so. Sometimes he took one of her hands in his and, for as long as she prayed, pleaded with her, asking her to come back, concerned as he was about her discomfort."[237] In the third scene of the sequence the contrast between vigil and sleep is no longer dominant theme of the narrative. Elizabeth sleeps on the carpet next to the marital bed because she was tired, just as Radegund in the above-mentioned illumination prostrated herself in the same place. This scene emphasizes the peace and harmony in Elizabeth and Ludwig's marriage. Not sleeping in the marital bed makes their conjugal harmony compatible with monastic ideals of chastity.

[234] FORTUNATUS – FAVREAU, *La vie de sainte Radegonde par Fortunat: Poitiers, Bibliothèque municipale, manuscrit 250 (136)*, pp. 142-143. (Comp. Mat. 24,42; Colos. 4.2; Thes. 5.6; Cor. 6.5; 1 Pet. 5.8)

[235] Los Angeles, Getty Museum (Ms Ludwig XI 7), fol. 11r. See W. BRAUNFELS – P. MORAW, *Der Hedwigs-Codex von 1353: Sammlung Ludwig*, Berlin, 1972; D. TABOR: *Malarstwo książkowe na Śląsku w XIV wieku*, Kraków, 2008, pp. 129-145. Also compare the essays in E. GRUNEWALD (ed.), *Das Bild der heiligen Hedwig in Mittelalter und Neuzeit*, München, 1996.

[236] U. JENNI, *Die Elisabeth-Legende im Krumauer Bildercodex*, in D. BLUME – M. WERNER (eds.), *Elisabeth von Thüringen – eine europäische Heilige. Aufsätze*, Petersberg, 2007, 353-380, p. 357.

[237] WOLF, *The Life and Afterlife of St. Elizabeth of Hungary. Testimony from her Canonization Hearings*, p. 197. HUYSKENS (ed.), *Libellus de dictis quattuor ancillarum s. Elisabeth confectus*, p. 21 (line 565-570): "[…] *frequenter ad orationem surgebat marito petente, ne se affligeret. Et quandoque ipse eius unam manum in sua tenebat, quamdiu orabat, rogans eam redire de eius incommodo sollicitus.*"

2.7. Flagellation, *Christoformitas*, and Authority

The next two images develop the motifs of chastity and religious zeal in yet another direction. According to the *Libellus,* Elizabeth, left alone by her husband during his military activities, spent many nights on her knees in prayer receiving scourging.[238] Cesarius of Heisterbach, Dietrich of Apolda and Jacopo da Varazze further commented on this motif.[239] The *Legenda aurea* explicitly stated that the aim of scourging was "to come closer to the scourged Savior and to protect her body from lasciviousness".[240] Hostility towards bodily pleasure was not unusual for the monastic culture in which the manuscript was produced. In many European nunneries of the time nuns were instructed to be obedient even if the required self-denial caused them agony. Obedience, or rather, the patient subordination of one's will to authority, was the supreme value in monastic life. Indeed, in some instances, physical suffering was considered beneficial. While dealing with intense inner conflicts and tensions associated with physical suffering, nuns might feel close to the experience of Jesus in the garden of Gethsemane before his Passion.[241]

In the *Liber depictus*, this motif is shown in two scenes. In the first one, Elizabeth is reproached by her maids. Then, in a remarkable reversal of existing social hierarchies, the saint, hidden in a secret chamber, orders the maids to scourge her.[242] From the perspective of the hagiographic ideal of *imitatio Christi*, this scene can be explained by a parallel within the *Liber depictus*. The introductory sequence of the codex, based on the structure of a picture Bible for the poor (Armenbibel, *biblia pauperum*), focuses on Christ. In one of these scenes, the flogged Jesus stands behind a column with his hands unbound.[243] (Fig. 38) This might indicate a voluntary acceptance of humiliation, pain, and

[238] HUYSKENS (ed.), *Libellus de dictis quattuor ancillarum s. Elisabeth confectus*, p. 22 (line 612 – 615): "*Absente autem marito in vigiliis genuumflectionibus, verberibus et orationibus multas noctes deducebat.*"; WOLF, *The Life and Afterlife of St. Elizabeth of Hungary. Testimony from her Canonization Hearings*, p. 198.

[239] Dietrich of Apolda mentions the motive of scourging repeatedly – RENER (ed.), *Die Vita der heiligen Elisabeth des Dietrich von Apolda*, pp. 35 and 39.

[240] "*Sepe etiam per manus ancillarum faciebat se in cubiculo fortiter uerberari ut et saluatori flagellato uicem rependeret et carnem ab omni lasciuia coerceret*" – VARAZZE, *Legenda aurea*, p. 1300.

[241] Comp. J.F. HAMBURGER, *Nuns as Artists: the Visual Culture of a Medieval Convent*, Berkeley, CA, 1997, p. 94.

[242] Fol. 88r and 87v: "*Post hec puelle arguebant sanctam Elizabet. S. Elibabet intravit secretam cellam et iussit se ancillas verberare.*"

[243] Fol. 18r: "*Flagelatur*"

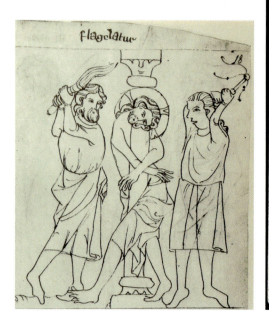

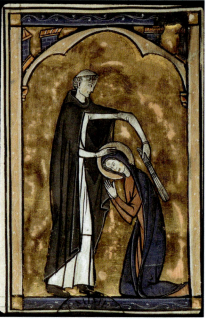

Fig. 38, The flagellation of Christ, *Liber depictus*, *c.* 1350, Vienna, Österreichische Nationalbibliothek, Cod. Vind. 370, fol. 18r.

Fig. 39, Conrad of Marburg flogging St Elizabeth, *c.* 1260, Paris, Bibliothèque Sainte-Geneviève, Ms 2689, fol. 12r, Photo: BSG Paris.

suffering. This phenomenon requires further contextualization, as there were alternative approaches to this question, even in the *Liber depictus*. One alternative is offered by the second scene of scourging in Elizabeth's legend where both the saint and her maids are whipped by Magister Conrad.[244] They fall to the inquisitor's feet to be beaten, but why they are portrayed in this fashion is unclear. In the image, Conrad's raised finger perhaps indicates reproach. According to the *Libellus*, they were punished for failing to attend one of his

[244] Fol. 89r: "*Sancta Eli(zabet) ad pedes magistri Cunradi cecidit cum allis virginibus et ipse verberavit eas.*" Comp. D.F. TINSLEY, *The Sourge and the Cross: Ascetic Mentalities of the Later Middle Ages*, Paris – Walpole, MA, 2010; O. FREIBERGER, *Asceticism and its Critics: Historical Accounts and Comparative Perspectives*, Oxford – New York, NY, 2006; G.D. FLOOD, *The Ascetic Self: Subjectivity, Memory, and Tradition*, Cambridge – New York, NY, 2004; P. NOLD, *Two Views of John XXII as a Heretical Pope*, in M.F. CUSATO – G. GELTNER (eds.), *Defenders and Critics of Franciscan Life. Essays in Honor of John V. Fleming*, Leiden, 2009, 139-158.

sermons.[245] In the context of the *Liber depictus*, beating could also represent a punishment for Elizabeth's inappropriately close relationship with the poor, depicted above on the same page. Contemporary sources mention the various reactions among the people of her class towards the saint's sympathy and genuine concern for the poor and the weak, as well as the efforts of her spiritual leader Conrad of Marburg to conduct these activities in a more acceptable guise.[246]

The images of flagellation continued a pictorial tradition which had begun almost a century ago, around 1260, in the Psalter from the Augustinian convent of Genlis. (Fig. 39) In this instance Conrad of Marburg flogs only St Elizabeth, without any witnesses. This manuscript illumination may well exemplify private asceticism on the part of the original owner, Elizabeth of Genlis (†1264).[247] In his great effort to usurp power from Elizabeth, Conrad positioned himself as the rival to her husband Ludwig.[248] Conrad, who was ultimately buried next to Elizabeth in her church, emerges as the victor in this dispute.[249]

The scourging or beating of saints is a subject occurring in other legends of the codex, but not always as something accepted voluntarily – some of the saints are shown with hands bound.[250] Further, the whip could be used as a weapon against good or evil adversaries, or as a simple punishment, strengthening the user's authority. One pagan ruler, Drahomira, raised a scourge to expel priests and Christians from a temple, a teacher used whip to educate the young Judas, the Virgin Mary scourged the demons, and even Lucifer was shown flogging demons who had failed to bring him a saintly soul.[251]

[245] WOLF, *The Life and Afterlife of St. Elizabeth of Hungary. Testimony from her Canonization Hearings*, p. 199.

[246] Comp. A. SCHÜTZ, *Das Geschlecht der Andechs-Meranier im europäischen Hochmittelalter*, in J. KIRMEIER – E. BROCKHOFF (eds.), *Herzöge und Heilige: das Geschlecht der Andechs-Meranier im europäischen Hochmittelalter*, Regensburg, 1993, 22-187.

[247] Paris, Bibliothèque Sainte-Geneviève, Ms 2689, fol. 12. A. BRÄM, „*Fratrum minorum mater*". *Heiligenbilder als Angleichung und zum Patronat in Frankreich und Flandern und in der Anjou – Hofkunst Neapels*, in D. BLUME – M. WERNER (eds.), *Elisabeth von Thüringen – eine europäische Heilige. Aufsätze*, Petersberg, 2007, 309-324, p. 312 and fig. 5 on p. 313.

[248] KLANICZAY, *Holy Rulers and Blessed Princesses: Dynastic Cults in Medieval Central Europe*, p. 284.

[249] ELLIOTT, *Proving Woman. Female Spirituality and Inquisitional Culture in the Later Middle Ages*, p. 95.

[250] Comp. St Christopher (fol. 54v) and St Lawrence (fol. 65v).

[251] Fol. 34v (Drahomira), 103r (Judas), 121r (Mary), 170r (Lucifer).

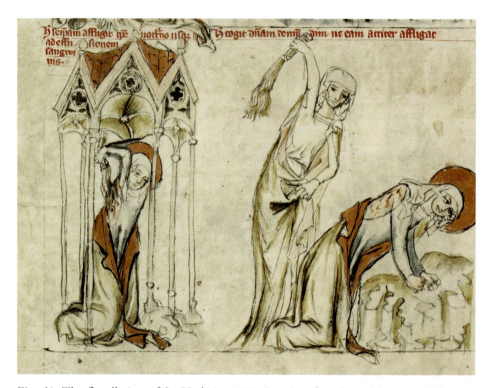

Fig. 40, The flagellation of St. Hedwig, 1353, Los Angeles, Getty Museum, MS Ludwig XI 7, fol. 38v. From: Der Hedwigs-Codex von 1353. Photo: author.

The subject of saints who voluntarily accepted pain and suffering was portrayed also in other manuscripts. The closest parallel to flagellation in the vita of Elizabeth is offered by the scene of a self-flagellation and flagellation by a nun of St Hedwig, the aunt of Elizabeth, as depicted by an illumination from 1353.[252] (Fig. 40) For some medieval authors, the use of a whip even by Jesus to create a better person was conceivable. The most celebrated example is the fifteenth-century illumination, showing Christ scourging a nun, allegorically representing human soul.[253] In this case, *christoformitas* (i.e. being spiritually

[252] Getty Museum, Los Angeles, MS Ludwig XI 7, fol. 38v; KLANICZAY, *Holy Rulers and Blessed Princesses: Dynastic Cults in Medieval Central Europe*, p. 267.

[253] Einsiedeln, Klosterbibliothek, Codex 710, fol. 6r, *c.* 1490, the illumination belonged to a text by Heinrich Seuse Gedicht von Christus und der minnenden Seele. See R. BANZ, *Christus und die minnende Seele, zwei spätmittelhochdeutsche mystische Gedichte; im Anhang, ein Prosadisput verwandten Inhaltes. Untersuchungen und Texte*, Breslau, 1908; O. LANG, *Katalog der Handschriften in der Stiftsbibliothek Einsiedeln. Zweiter Teil, Codex 501-1318*, Basel, 2009, pp. 276-

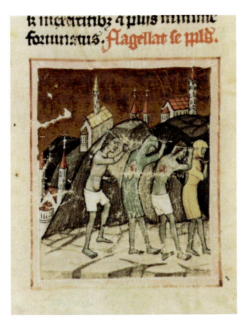

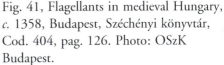

Fig. 41, Flagellants in medieval Hungary, *c.* 1358, Budapest, Széchényi könyvtár, Cod. 404, pag. 126. Photo: OSzK Budapest.

improved by Christ) was different from a pure *Imitatio Christi* (imitation of Christ, *Christomimesis*): the nun is castigated by Jesus who, in an exceptional reversal of roles, is shown as the active flagellator rather than as a passive victim of aggression.

The various meanings associated with flagellation around 1350 can be understood in the context of the flagellant movement, which was to evolve in Central Europe with renewed intensity after the plague of 1348.[254] The relevance of this movement for book illumination in the region of Central Europe is exemplified by an image from the *Chronicon Pictum*, representing practices of the flagellant movement in medieval Hungary.[255] (Fig. 41)

280; I. Gerat – M. Zervan, *Flagellation in Medieval Imagination and Thinking*, in *Kultúrne dejiny* 10 (2019) 25-41.

[254] A. Dehmer, *Passio und Compassio: Geisselungsrituale italienischer Bussbruderschaften im späten Mittelalter*, in J.F.v. Dijkhuizen – K.A.E. Enenkel (eds.), *The Sense of Suffering: Constructions of Physical Pain in Early Modern Culture*, Leiden – Boston, 2009, 221-251.

[255] D. Ganz, *Medien der Offenbarung: Visionsdarstellungen im Mittelalter*, Berlin, 2008, Cod. 404, pag. 126, (c. 1358). Comp. D. Dercsényi, *Képes krónika és kora*, in K. Csapodiné Gárdonyi – D. Dercsényi – L. Geréb – L. Mezey (eds.), *Képes krónika*, Budapest, 1964. Another famous image from the period represents the flagellants at Doornik (Tournai), from the Chronicle by Gilles Li Muisis, Bibliothèque Royale de Belgique, Brussels; fol. 16v (1349).

Franciscan ideology was an important source of ideas on asceticism.[256] St Bonaventure wrote that asceticism was a means of exercising the senses (*sensuum exercitium*). Such a practice belonged to monastic life with its ideals of purification, mortification, voluntary self-humiliation, patience, obedience, and poverty. Asceticism was instrumental in redirecting of an individual's desire from persons and things in the natural world to the supernatural world.[257] This nexus of ideas was to maintain its importance in the continuation of the pictorial legend whilst also being enriched by ideas and images from other sources.

2.8. *Imitatio Mariae*

The authority exercised by Conrad over Elizabeth was so oppressive that he persuaded her to abandon her three children under the pretext that they caused her to be too attached to this world. Having internalized this pressure from Conrad Elizabeth prayed to God "that He remove from her the love that she had for her children."[258] In this manuscript she is depicted humbly entering the church, barefoot, to place her newborn son on the altar.[259] (Fig. 36) This image resembles the well-known iconography of the Presentation of Jesus in the temple, associated with the Feast of the Purification of the Blessed Virgin Mary. (Fig. 42) This topic appears at the beginning and therefore the most important part of the codex.[260] Elizabeth underwent the ritual of purification "after the birth of each of her children" when she "carried her child in her own arms and offered it on the altar along with a candle and a lamb". The afore-mentioned image highlights the details from the report of the *Libellus* – a report with which the authors would have been familiar inasmuch as the saint was "following the example of the blessed Virgin".[261] Certainly, she was not the only saint

[256] Comp. TINSLEY, *The Sourge and the Cross: Ascetic Mentalities of the Later Middle Ages*, ; FREIBERGER, *Asceticism and its Critics: Historical Accounts and Comparative Perspectives*, ; FLOOD, *The Ascetic Self: Subjectivity, Memory, and Tradition*, .

[257] *Epistola De imitatione Christi*, in BONAVENTURE – J.G. BOUGEROL – C.B. DEL ZOTTO – L. SILEO – CONFERENZA ITALIANA MINISTRI PROVINCIALI O.F.M., *Opere di san Bonaventura*, Roma, 1990, t. 8, pp. 499-504.

[258] WOLF, *The Life and Afterlife of St. Elizabeth of Hungary. Testimony from her Canonization Hearings*, p. 205.

[259] Fol. 87v: "*Sancta Elizabet post partum intrat ecclesiam nudis pedibus portans puerum suum cum angnello et candella offerens super altare.*"

[260] *purificatio mariae*, fol. 3v.

[261] WOLF, *The Life and Afterlife of St. Elizabeth of Hungary. Testimony from her Canonization Hearings*, p. 198.

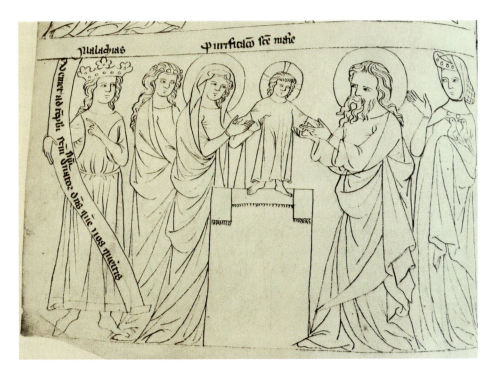

Fig. 42, Presentation of Jesus in the temple, *Liber depictus*, *c.* 1350, Vienna, Österreichische Nationalbibliothek, Cod. Vind. 370, fol. 3v.

to do so; even in the *Liber depictus* a similar image is to be found in the legend of Saint Mary Magdalene.[262]

The reference to virginity would have resonated with the experiences of the nuns, to whom the manuscript may well have been addressed. The connection between rituals and monastic life is to be found elsewhere in the codex, too. In one scene, for example, Elizabeth is portrayed cutting off the abundant hair of a girl, who is kneeling in front of her.[263] The meaning of this gesture is explained by a late fourteenth-century Czech legend. The girl cherished her hair so much that it became an obstacle on her way to God, barring her from being admitted into the monastic order.[264] Upon the removal of this obstacle, Elizabeth stands

[262] fol 84v.

[263] Fol. 90v: "*Cuidam virgini absciduntur crines.*"

[264] T. ŠTÍTNÝ ZE ŠTÍTNÉHO, *Život svaté Alžběty*, in J. KOLÁR (ed.) *Život svaté Alžběty*, Praha, 2006, p. 54. The medieval author constructs a moralizing interpretation of the Old Testament example – the fateful hair of Absalom (2 Samuel 18.9).

among monks, who are initiating the girl into religious life.[265] These images would have been particularly apposite for the monastic audience of the codex since all monks and nuns underwent similar rituals. After they had risen in the hierarchy, they could identify with the Saint performing the gestures of initiation, or even with magister Conrad, who is shown seated next to Elizabeth on a bench and reprimands her maids with a resolute gesture.[266] It goes without saying that gestures of renunciation, abnegation, and self-denial comprised an inherent part of monastic experience.

The principle of *imitatio Mariae* surfaces once again in this pictorial legend, when Elizabeth shelters a leper under her gown.[267] (Fig. 43) The protective gesture of taking someone under their mantle was highly symbolic. The mantle of protection may well have been known from the images of Mary of Mercy, one of the most popular themes in late medieval art. Cesarius of Heisterbach, who was the author of one of the earliest legends of Saint Elizabeth, substantially contributed to the popularizing of this iconography, which was rooted in Byzantine Marian cults.[268] Cesarius described the vision of a Cistercian monk who, unable to find his brothers in heaven, asked the Virgin what accounted for this. In reply to his question, she outspread her mantle thus revealing to him the Cistercians beneath.[269] This topic was known in the Franciscan milieu through one of the first images of this type, painted in the late thirteenth century by Duccio. (Fig. 44) The painting features three Franciscan monks kneeling under the Virgin's protective mantle.[270] Elizabeth, who escorts the leper under her gown, assumes a similar protective role. The association of this Marian gesture with living persons was a familiar practice in Franciscan circles. Anyone visiting the main church of the Franciscans in Assisi would have recalled the bishop's protective gesture. With his mantle he covered the nakedness of St Francis, who had publicly divested himself of his clothing in the image of

[265] Fol. 90v: "*Et hic traditur religioni.*"

[266] Fol. 91r: "*Magister Cunradus repulit puellas a beata Elizabet.*"

[267] Fol. 92r: "*hic ducit leprosum sub palio eius.*" This is yet another instance testifying to the importance attributed to pieces of cloth for the authors of the cycle.

[268] K.T. BROWN, *Mary of Mercy in Medieval and Renaissance Italian Art: Devotional Image and Civic Emblem*, Abingdon, 2017, pp. 58-80.

[269] H. CAESARIUS VON, *Dialogus Miraculorum*, in H. SCHNEIDER – N. NÖSGES (eds.), Turnhout, 2009, book VI, last chapter; P. PERDRIZET, *La Vierge de Miséricorde: étude d'un thème iconographique*, Paris, 1908, pp. 21-22.

[270] Siena, Pinacoteca Nazionale, no. 20, original provenance unknown; J. WHITE, *Duccio: Tuscan Art and the Medieval Workshop*, New York, NY, 1979; J.H. STUBBLEBINE, *Duccio di Buoninsegna and his school*, Princeton, N.J., 1979, pp. 19-21.

Fig. 43, The story of Saint Elizabeth and the leper, *Liber depictus, c.* 1350, Vienna, Österreichische Nationalbibliothek, Cod. Vind. 370, fol. 92r.

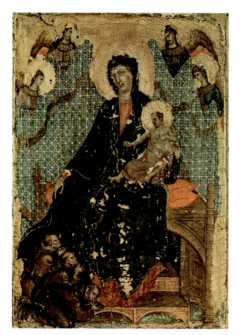

Fig. 44, Duccio, Mary of Mercy, Siena, Pinacoteca Nazionale, no. 20.

a renunciation of worldly goods. The significance of this gesture is abundantly clear from its reiterated presence in the church – even if it was painted around 1260 in the Lower Church, it was repeated before the end of the century in the Upper Church.[271]

The significance of the gesture in the *Liber depictus* is confirmed by its repetitions. In the lowermost register of the same page Elizabeth leads the leper, whom she has offered a bath, under her mantle, again.[272] (Fig. 43) The efficacy of this visual *topos* in the codex is further demonstrated in the legend of St. Paul the Hermit, where the Virgin Mary rescues the hermit from the onslaught of demons by means of a very similar gesture.[273] (Fig. 45)

The images discussed suggest that the principle of *imitatio Mariae* had a bearing on some of the superficial resemblances between images; an exchange that might be vaguely called "interpictoriality". Nevertheless, the influence of

[271] GOFFEN, *Spirituality in Conflict: Saint Francis and Giotto's Bardi Chapel*, p. 35 and plate 3A; D. COOPER – J. ROBSON, *The Making of Assisi: The Pope, the Franciscans and the Painting of the Basilica*, New Haven, CT, 2013, pp. 111 and 154.

[272] Fol. 92r: "*hic lavat leprosum in doleo. hic ducit leprosum.*"

[273] Fol. 123v.

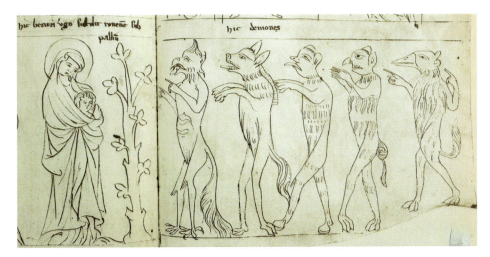

Fig. 45, Virgin Mary protecting the hermit, *Liber depictus, c.* 1350, Vienna, Österreichische Nationalbibliothek, Cod. Vind. 370, fol. 123v-124r.

imitatio Mariae went beyond purely visual experience. It was an inherent part of the spirituality of the Franciscan Order. An even closer look prompts us to draw the conclusion that *imitatio Mariae* played a role in less predictable places. It may well have had an impact on the creation and perception of other parts of our pictorial legend where almsgiving and the work of the saint are represented.

2.9. Almsgiving and Franciscan Spirituality

Almsgiving is undoubtedly one of the most important topics in the *Liber depictus*. A parable was especially devoted to the subject and corresponding scenes were depicted throughout the codex.[274] This is the case of St Procopius, whose textual legend refers to the words of Christ: "If you want to be perfect, go, sell your possessions and give to the poor, and you will have treasure in heaven" (Mat 19, 21).[275] This Biblical reference was frequently cited as an argument in favor of giving. The authors of the book went beyond the mere integration and appreciation of this traditional motif of Elizabeth's pictorial lives in the Biblical context. Merciful gifts held extraordinary importance for monks, who lived on

[274] The parable on fol. 29r, depictions on fol. 29v, 33r, 46v, 95v, 110v, 116v, 117v.
[275] Comp. fol. 70v: *Hic sanctus Procopius dat bona pauperibus*; MATĚJČEK – ŠÁMAL, *Legendy o českých patronech v obrázkové knize ze XIV. století*, p. 106; another example on fol. 127v.

alms. Several pictorial legends in the manuscript depict monks or priests receiving gifts.[276] The merciful donation is frequently followed by the donor in question entering a monastic Order, which represents the salvation attained through making gifts.

It is instructive to examine the position occupied by almsgiving in the spirituality and visual culture of the order. The illustrations of a manuscript of the *Meditations on the Life of Christ*, which was written by a Franciscan friar for a Franciscan nun, are almost contemporaneous with those of the *Liber depictus*.[277] At least 217 surviving copies affirm the popularity of this text.[278] It is highly probable that this work was known to the authors of the *Liber depictus*. Almsgiving plays a prominent role in the *Meditations*. The earliest illustrated manuscript of this type, now preserved in Paris, even features the Virgin Mary giving gifts which she has received from the Magi to the poor.[279] (Fig. 46) Portrayed standing, she extends her hand towards a group of poor people. A similar grouping of figures was used several times in Elizabeth's legend in the *Liber depictus*. Once again, these images should be seen in the light of the principle of *imitatio Mariae*.

Elizabeth's experiences of giving were multifaceted. Her generosity became apparent at a very early age. The sequence from her childhood in the manuscript shows her giving one tenth of the rings she had won in a game to poorer girls.[280] (Fig. 32) Some scholars regard this to be in accordance with feudal rules governing the levying of tithes. [281] But giving such a small part is at odds with the afore-cited recommendation of Christ, and the principle of radicalism which inspired so many of Elizabeth's actions. Thus, this scene was only a modest beginning.

One of the most significant objects she donated was a mantle (or a portion of it), the importance of which is frequently associated with a miracle that

[276] Fol. 97v (monks), 117r (priests).

[277] H. FLORA, *The Devout Belief of the Imagination: The Paris Meditationes Vitae Christi and Female Franciscan Spirituality in Trecento Italy*, Turnhout, 2009, p. 17.

[278] C. FISCHER, *Die „Meditationes vitae Christi": Ihre handschriftliche Ueberlieferung und die Verfasserfrage*, Firenze, 1932.

[279] Paris, Bibliothèque Nationale, cod. Ital. 115, fol. 30v; FLORA, *The Devout Belief of the Imagination: The Paris Meditationes Vitae Christi and Female Franciscan Spirituality in Trecento Italy*, p. 210, fig. 81.

[280] Fol. 87r: *"Et tercio anulos ludebant. Hic sancta Elizabet et anuli aquistis decimas dabat."*

[281] WOLF, *The Life and Afterlife of St. Elizabeth of Hungary. Testimony from her Canonization Hearings*, p. 194.

Fig. 46, Virgin Mary giving gifts to the poor, Meditations on the Life of Christ, Paris, Bibliothèque Nationale, cod. Ital. 115, fol. 30v, Photo : BNF Paris.

happened after the donation.[282] Giving a tunic, mantle or sleeve was a crucial gesture in the legends of Elizabeth. After the purification ritual, she offers her clothing to a poor woman. (Fig. 36) This case was based on the testimonies from *the Libellus*: "… she would give the tunic and cloak that she had worn [during the purification ritual] to some poor woman."[283] This episode is portrayed in two stages in the drawings: Elizabeth, assisted by her maids, takes off her tunic and then she is seen giving it to a poor woman who accepts it.[284] An expression of mild surprise is clearly visible on her face; three more women stand behind her. The poor woman's joy and gratitude is represented in three images in the pictorial legend. In the final episode, the woman falls to her knees, thanking Elizabeth for the shoes and toga.[285]

[282] Fol. 64r, 80v, 97r, 111v, 167r.

[283] WOLF, *The Life and Afterlife of St. Elizabeth of Hungary. Testimony from her Canonization Hearings*, p. 198.

[284] Fol. 88r: "*Hic sancta Elizabet exuit vestem. Hic dat vestem paupercule mulieri.*"

[285] Tituli: "*Sancta Eli(zabet) dat calceos paupercule mulieri. Sancta Eli(zabet) dat togam pauperi mulieri. Hic pre gaudio cecidit ad pedes sanctae Elizabet.*"

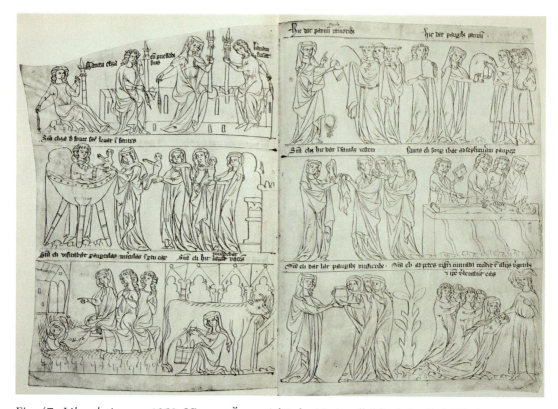

Fig. 47, *Liber depictus*, *c.* 1350, Vienna, Österreichische Nationalbibliothek, Cod. Vind. 370, fol. 88v–89r. From *Der Krumauer Bildercodex.*

Almsgiving even contributed to a transformation of the traditional iconography of the saint's merciful works. The traditional scene of visiting the sick has been portrayed in the space of a hospital, where Elizabeth gives money to some poor boys.[286]

Some of Elizabeth's donations, which are shown in the manuscript, specifically address the Franciscans. The saint distributed cloth to two kinds of poor – the poor brothers, Minorites, and the needy catechumens.[287] (Fig. 47) According to the testimonies of her handmaids recorded by the papal commission in January 1235, she "arranged for cloth to be made […] to be used for clothing

[286] Fol. 89v: "*Sancta Eli(zabet) intrabat domum ubi pueri iacebant et tum anulos vitreos et oliculas eis dabat.*". The small crutches, *oliculas*, are omitted from the image.

[287] Fol. 89r: "*Hic dat pannum fratribus minoribus. Hic dat pauperibus pannum.*"

for the Friar Minor and the poor. She also sewed clothes for poor catechumens with her own hands."[288] Three tonsured monks are portrayed with their hands concealed under their own tunics, perhaps out of reverence for the Saint's gifts. This narrative from Elizabeth's life may have been a source of sustenance to the Christian community in a Franciscan cloister.

Not only is the gesture of giving interspersed throughout the manuscript, but it also acquires highly charged symbolic meanings, as we shall see, both in terms of her relationship to Ludwig and the broader context of Franciscan iconography.

The monastic environment constituted an important context for the perception of images in respect of Franciscan spirituality and the political disputes associated with the poverty controversy of the fourteenth century.[289] From the outset the principle of apostolic poverty underpinned the ideas of the Franciscan Order. The Franciscans believed in the poverty of Christ and his apostles as well as in the importance of poverty on the path to spiritual perfection: on entering the Order, the vow of poverty was as important as the vows of obedience and chastity. This principle remained undisputed, though it did give rise to much controversy regarding its interpretation and especially around the question of how poverty should be practiced. The moderate members of

[288] HUYSKENS (ed.): *Libellus De Dictis Quattuor Ancillarum S. Elisabeth Confectus*, p. 118: "... *ipsa cum suis ancillis lanam filabat, telam fieri faciens ad vestes fratrum minorum et pauperum; vestes et catecuminis pauperibus propriis manibus consuebat...*"; WOLF, *The Life and Afterlife of St. Elizabeth of Hungary. Testimony from her Canonization Hearings*, p. 198.

[289] See, most recently: B. ROEST, *Franciscan Learning, Preaching and Mission c. 1220-1650: cum scientia sit donum dei, armatura ad defendendam sanctam fidem catholicam*, Boston, MA, 2014; ROEST, *Order and Disorder: The Poor Clares between Foundation and Reform*, ; G. BUFFON, *Storia dell'ordine francescano: problemi e prospettive di metodo*, Roma, 2013; X.J. SEUBERT – O.V. BYCHKOV, *Beyond the Text: Franciscan Art and the Construction of Religion*, St. Bonaventure, NY, 2013; S. MCNAMER, *Affective Meditation and the Invention of Medieval Compassion*, Philadelphia, PA, 2010; D.F. BERG – L. LEHMANN (eds.), *Franziskus-Quellen: die Schriften des Heiligen Franziskus, Lebensbeschreibungen, Chroniken und Zeugnisse über ihn und seinen Orden*, Kevelaer, 2009; A. MARCHI – A. MAZZACCHERA, *Arte francescana: tra Montefeltro e papato, 1234-1528*, Milano, 2007; T. ERTL, *Religion und Disziplin: Selbstdeutung und Weltordnung im frühen deutschen Franziskanertum*, Berlin, 2006; C. JÄGGI, *Frauenklöster im Spätmittelalter: die Kirchen der Klarissen und Dominikanerinnen im 13. und 14. Jahrhundert*, Petersberg, 2006; BOURDUA, *The Franciscans and Art Patronage in Late Medieval Italy*, ; D. BURR, *The Spiritual Franciscans: From Protest to Persecution in the Century after Saint Francis*, University Park, PA, 2001; D. BERG, *Armut und Geschichte: Studien zur Geschichte der Bettelorden im Hohen und Späten Mittelalter*, Kevelaer, 2001; R. LAMBERTINI, *La povertà pensata: evoluzione storica della definizione dell'identità minoritica da Bonaventura ad Ockham*, Modena, 2000; C.H. LAWRENCE, *The Friars: The Impact of the Early Mendicant Movement on Western Society*, London, 1996.

the Order, who were known as Conventuals, were satisfied with a legal solution established in the thirteenth century: The Order did not own anything, but rather benefitted from the property of the church. In their sermons the friars participated in the fight against radical sectarianism of the Valdenser.[290]

As adumbrated above, the Spirituals, who constituted the more radical members of the Order, criticized the use of possessions in the church. The most prominent and radical supporter of the Spirituals in Central Europe was Ludwig IV of Bavaria (1282–1347).[291] Ludwig had been excommunicated by Pope John XXII, but he continued to fight for ascetic religious ideals. He declared the Pope heretical and installed a spiritual Franciscan, Pietro Rainalducci, as Antipope Nicholas V. Shortly before our manuscript was created, in 1346, Charles IV of Bohemia from the House of Luxemburg, was elected Emperor with the support of Pope Clement VI. Charles opposed the politics of Ludwig. His support for the cult of St Elizabeth was shared by the Rosenberg family, the donors of our manuscript.[292] Understandably, they had reservations about St Elizabeth's radical deeds. Thus the *Liber depictus* can hardly be understood as anti-papal propaganda – there is even a scene, in which an incestuous mother and murderer is helped by confessing directly to the Pope.[293] A large illustrated codex certainly did not conform to the ideals of St Francis and it appealed still less to some of the Spirituals, who radically rejected books as an unnecessary luxury.[294]

2.10. The Saint at Work

There is a distinction to be drawn between resources for maintaining a monastic community which had been acquired through alms, or from work. Begging

[290] HRADILOVÁ, *Příspěvky k dějinám knihovny minoritů v Českém Krumlově v době předhusitské (On the History of the Minorite Library in Český Krumlov during the pre-Hussite period)*, pp. 33-34; more on the topic of inquisition A. PATSCHOVSKY, *Die Anfänge einer ständigen Inquisition in Böhmen: ein Prager Inquisitoren-Handbuch aus der ersten Hälfte des 14. Jahrhunderts*, Berlin – New York, NY, 1975; A. PATSCHOVSKY, *Quellen zur böhmischen Inquisition im 14. Jahrhundert*, Weimar, 1979. Preachers had used the example of St. Elizabeth in the fight against heresy since the time of her canonization in 1235.

[291] R. SUCKALE, *Die Hofkunst Kaiser Ludwigs des Bayern,* München, 1993.

[292] See above note 6.

[293] Fol. 105v; The Pope, seeking to overcome demons in the legend of St. Paul the Hermit (fol. 121v, 122r), seems to be less successful.

[294] P. HLAVÁČEK, *Die böhmischen Franziskaner im ausgehenden Mittelalter: Studien zur Kirchen- und Kulturgeschichte Ostmitteleuropas*, Stuttgart, 2011; P. HLAVÁČEK, *Čeští františkáni na přelomu středověku a novověku*, Prague, 2005, p. 94.

was standard practice among the mendicant orders. Work, which was of paramount importance in the Benedictine tradition, was now being re-evaluated by the Cistercians.[295] It is likely that both traditions influenced Elizabeth's pictorial legend in Krumlov. In the Minorite and Poor Clares Monastery in Český Krumlov, where the manuscript was originally housed, the labor of the saint was perceived as a model of active support for the monastic institution and an example of humility. An image of monks at work does occur in the *Liber depictus*, but this is exceptional.[296] The Minorites in Krumlov did not take part in the radical Franciscan movements which led to the establishment of the reformed branch of the Observant Friars around 1350.[297]

The fourth opening of the pictorial cycle (fol. 88v–89r) links Elizabeth's assistance to the poor even more forcefully with a broad range of problems related to work. (Fig. 47) In the initial scene the saint is spinning wool with her maids.[298] This topic had already appeared in the royal manuscript from Seville.[299] In the *Liber depictus*, the connotations of this thematic circle were enriched by associations with new forms of Marian devotion which were typical in Franciscan circles. Once again, the principle of *imitatio Mariae* appears to offer a strategy for shaping Elizabeth's legend.

In earlier medieval art, the *topos* of work had mostly been depicted as a punishment after the expulsion from Paradise. Elizabeth spinning may well have been associated with the punished Eve, but in the saint's case the work stemmed from her own volition. Elizabeth primarily followed the Virgin Mary, the new Eve. In this respect, spinning was a suitable activity, because the Holy Virgin spinning in the Temple became the archetypal image of pious labor for medieval nuns.[300] When the nuns saw Elizabeth working with her maids, they could follow her example even when working in a small group.[301] In the last instance,

[295] Comp. the image of a monk at work in the initial Q from Gregory the Great: *Moralia in Job*, illustrated in Citeaux c. 1110 (today Dijon, Bibl. mun. ms. 170, fol. 75v.).

[296] There is a depiction of monks at work on fol. 159v. of the codex.

[297] Comp. P. ČERNÝ, *Pozdně gotické iluminované rukopisy františkánských konventů v olomouckých sbírkách*, in RYWIKOVÁ (ed.), *Klášter minoritů a klarisek v Českém Krumlově. Umění, zbožnost, architektura*, p. 289.

[298] Fol. 88v: "*Sancta Elizabet cum puellabus suis lanam fusat.*"

[299] See above, chapter 2.1.

[300] As exemplified in an image created around 1400 in Erfurt – HAMBURGER, *Nuns as Artists: The Visual Culture of a Medieval Convent*, p. 186 (fig. 103).

[301] For the Virgin working with her companions in an image from Cologne, c. 1460, see *Ibid.*, p. 187.

Fig. 48, Virgin mary at work and in prayer, Meditations on the Life of Christ, Paris, Bibliothèque Nationale, cod. Ital. 115, fol. 16v. Photo : BNF Paris.

the monastic production of textiles provided a medium in which the legend of Saint Elizabeth would be repeatedly depicted in the fifteenth century.[302]

A closer look at surviving manuscripts shows the importance of this tradition in the Franciscan milieu around 1350. Images of the Virgin Mary spinning played an important role in the Paris manuscript of the Meditations on the Life of Christ, featuring Mary sewing and spinning next to the doubting Joseph before the birth of Christ.[303] (Fig. 48) Mary's work continues throughout the life of the holy family during their exile in Egypt – here, Mary, who is engaged

[302] K. Böse, *Elisabeth von Thüringen als Identifikationsfigur in spätmittelalterlichen Frauen-klöstern. Die Teppiche in Wienhausen und Helmstedt*, in: C. Bertelsmeier-Kierst (ed.), *Elisabeth von Thüringen und die neue Frömmigkeit in Europa*, Frankfurt am Main, 2008, 231-250.

[303] Paris, Bibliothèque Nationale, cod. Ital. 115, with the image of Mary spinning on fol. 16v; sewing on 16r. Flora, *The Devout Belief of the Imagination: The Paris Meditationes Vitae Christi and Female Franciscan Spirituality in Trecento Italy*, p. 217, fig. 88. The accompanying text edited by R.B. Green – I. Ragusa, *Meditations on the Life of Christ: An Illustrated Manuscript of the Fourteenth Century, Paris, Bibliothèque nationale, Ms. Ital. 115*, Princeton, N.J., 1977, pp. 27-28.

in sewing, collaborates with two women who are also engaged in handiwork.[304] This group of women at work resembles Elizabeth with her maids in the *Liber depictus*.[305] The positive attitude towards work evident in the Paris manuscript is also confirmed by an image of Saint Joseph, a qualified carpenter, at work.[306] It is not to be excluded that in the *Liber depictus*, the image of Elizabeth working was also inspired by the legends of Wenceslas (908–935), the patron saint of Bohemia. The manuscript from Krumlov contains an entire sequence with Wenceslas working in secret to prepare the wafers and wine for the Eucharist.[307] (Fig. 49) The work of Wenceslas had been described extensively in his legend, the *Crescente fide*.[308] For example, he purloined wood from his own forest and brought it to a poor woman, even though it resulted in his being beaten by the woodsman.[309] The radical efforts to help the poor through one's own work seem to be a recurrent motif in the narratives of *Liber depictus*.[310]

[304] Paris, Bibliothèque Nationale, cod. Ital. 115, fol. 42r; GREEN – RAGUSA, *Meditations on the Life of Christ: An Illustrated Manuscript of the Fourteenth Century, Paris, Bibliothèque nationale, Ms. Ital. 115*, pp. 73, 418.

[305] Österreichische Nationalbibliothek. Codex 370, fol. 88v. and 91r.

[306] Paris, Bibliothèque Nationale, cod. Ital. 115, fol. 43v; FLORA, *The Devout Belief of the Imagination: The Paris Meditationes Vitae Christi and Female Franciscan Spirituality in Trecento Italy*, p. 218, fig. 89.

[307] Österreichische Nationalbibliothek. Codex 370, fol. 33v–34r. MATĚJČEK — ŠÁMAL, *Legendy o českých patronech v obrázkové knize ze XIV. století*, p. 137. According to them, the source is the legend *Ut annuncietur*, preserved in the manuscript of the National Library in Prague (VIII A) and edited by Antonín Podlaha in 1917. These themes were introduced into his hagiography (*Crescente fide*) after 974 under the influence of the reform movement in the monastery of St. Emeram in Regensburg – D.A. TŘEŠTÍK, *Počátky Přemyslovců: vstup Čechů do dějin, 530-935*, Praha, 1997, pp. 380-382.

[308] "… rising during the night, he would secretly walk to the fields, reap wheat, and carry it home on his own shoulders. Then he would thresh the wheat, grind it in a small mill and sift the flour. Also, in the dead of the night he would take a pail, along with one of the members of his retinue, and hasten for water. And while drawing the water he would say, 'in the name of Father and of the Son and of the Holy Ghost.' After he brought it home and mixed it with the flour, he baked wafers. Also, during the quiet of the night, he would hasten to his vineyard along with a faithful companion. Gathering grapes, they would put them in baskets and carry them secretly to his chambers. And there they sould squeeze the wine so that from this the priests could bring a sacrifice to the Lord." – KLANICZAY, *Holy Rulers and Blessed Princesses: Dynastic Cults in Medieval Central Europe*, p. 104. Original source FRB I, p. 184.

[309] Österreichische Nationalbibliothek. Codex 370, fol. 35r.

[310] St. Eustache, who is shown hewing wood on fol. 139v. More on the importance of work in the Middle Ages J. LE GOFF, *Time, Work & Culture in the Middle Ages*, Chicago, IL, 1980; A.I.a.K. GUREVICH – J. HOWLETT, *Historical Anthropology of the Middle Ages*, Chicago, IL, 1992. Working as the specific features of the Cistercian economy was slightly less important in Vyšší Brod – CHARVÁTOVÁ, *Dějiny cisterckého řádu v Čechách 1142-1420*, p. 56.

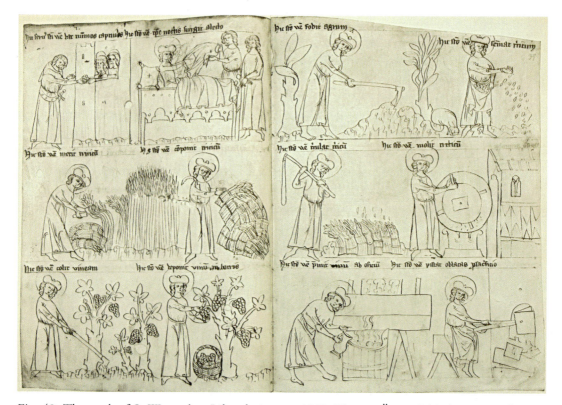

Fig. 49, The work of St Wenceslas, *Liber depictus*, *c.* 1350, Vienna, Österreichische National-bibliothek, Cod. Vind. 370, fol. 33v–34r. From *Der Krumauer Bildercodex*.

The idea of illuminating this topic was not original; it had featured around 1340 in the Velislas Bible.[311]

The constant efforts of the authors of the codex to underscore the intensity and versatility of Elizabeth's active benevolence may have been facilitated by the pattern associated with Wenceslas. Her works of charity culminate in the lowermost register, where she is portrayed helping a poor woman in labor, lying on the straw-strewn ground.[312] In order to give milk to this woman, the noble lady milks a cow herself.[313] (Fig. 50)

According to textual sources, she only attempted to milk the cow and could not complete the task. It is recorded in a testimony of the *Libellus* that the

[311] Prague, National Library, Cod. XXIII C 124, fol. 183r.
[312] Fol. 88v: "*Sancta Eli(zabet) visitabat pauperculas materculas in partum earum.*"
[313] Fol. 88v: "*Sancta Eli(zabet) hic mulgebat vaccam.*"

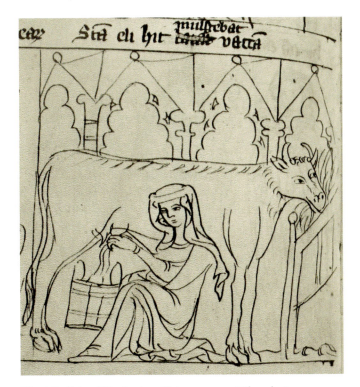

Fig. 50, Saint Elizabeth milking a cow, *Liber depictus*,
c. 1350, Vienna, Österreichische Nationalbibliothek, Cod.
Vind. 370, fol. 88v. From *Der Krumauer Bildercodex*

princess was unable to milk the cow: "One day in a far-off place she wanted to milk the cow to appease the hunger of a pauper who was asking for milk, but the cow was stubborn and would not tolerate Elizabeth handling it".[314] However, the authors of the pictorial cycles do not allude to any problems in performing the milking: the cow stands calmly while the lady works intently, and in the next image Elizabeth is shown handing the milk to the woman.[315] Thus the portrayal of the saint's scandalous behavior, already known from Seville and Naples, was enriched with new motifs.[316]

[314] WOLF, *The Life and Afterlife of St. Elizabeth of Hungary. Testimony from her Canonization Hearings*, p. 199.
[315] Fol. 89r: "*Sancta Eli(zabet) dat lac pauperibus mulieribus.*"
[316] A similar scene was painted c. 1350 in a more modest context in the Austrian Weitra – E. LANC, *Corpus der mittelalterlichen Wandmalereien. Österreich I. Wien und Niederösterreich*, Vienna, 1983, pp. 368-373.

Incorporating this behavior in a broader narrative context, such as the verification of scandalous reports, which had been initiated by the Hungarian king Andrew II was unprecedented. In an image which refers to the beginning of the legend, the king sits on the left-hand side and sends messengers to his daughter.[317] On the right hand side of the register, the count, who has led a group of riders, finds the royal daughter, Elizabeth carding wool.[318] (Fig. 51) A further innovation is the depiction of works of the saint which had featured in textual narratives before, but had not been not represented visually. The image of Elizabeth washing dishes is unique in the pictorial tradition.[319] (Fig. 52) The original textual source is once more provided by the *Libellus*: "Irmgard also said that blessed Elizabeth washed their pots, bowls and plates and frequently sent her handmaids away lest they prevent her from doing such things. Returning, they would often find her still washing bowls and other things".[320] Superfluous depictions of the saint with her maids are omitted from this illustration, probably because they had been discharged by Conrad earlier in the narrative (this event is depicted in the upper register on fol. 91r).[321] It comes as no surprise that participation in such activities was at odds with the norms of behavior expected from a woman of Elizabeth's social standing.[322] However, it is unlikely that this representation was sufficiently persuasive to modify existing norms by disseminating, or even prescribing, such models of behavior.[323] It is more likely that such representations were intended to prompt monks and nuns to meditate on the Saint's exceptional humility.

[317] Fol. 90v: "*Hic rex missit nunccios pro filia sua.*"

[318] Fol. 91r: "*Hic comes invenit eam colum et lanam verentem*"

[319] Fol. 90v: "*sancta elizabet lavat scutellas et servat eas.*"

[320] WOLF, *The Life and Afterlife of St. Elizabeth of Hungary. Testimony from her Canonization Hearings*, p. 213. Elizabeth washing dishes after her maids were sent away is mentioned in Conrad's Summa vitae – *Ibid.*, p. 93.

[321] Fol. 91r: "*Magister Cunradus repulit puellas a beata Elisabet*"

[322] B. STARK, *Elisabeth von Thüringen: Die Entdeckung individueller Züge in der Biographie einer Heiligen*, in J. AERSTEN – A. SPEER (eds.), *Individuum und Individualität im Mittelalter*, Berlin – Boston, 1996, 704-721; SCHMIDTBERGER, *Die Verehrung der Heiligen Elisabeth in Böhmen und Mähren bis zum Ende des Mittelalters*, pp. 22-23.

[323] Comp. W. BUSCH, *Kunst und Funktion – Zur Einleitung in die Fragestellung*, in W. BUSCH (ed.), *Funkkolleg Kunst. Eine Geschichte der Kunst im Wandel ihrer Funktionen*, Munich, 1997, 5-26.

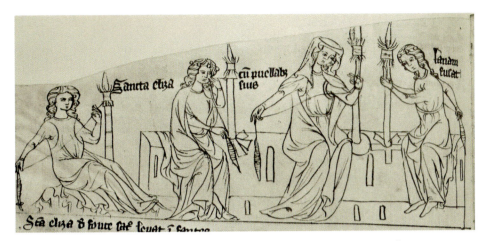

Fig. 51, Saint Elizabeth carding wool, *Liber depictus, c.* 1350, Vienna, Österreichische Nationalbibliothek, Cod. Vind. 370, fol. 91r. From *Der Krumauer Bildercodex.*

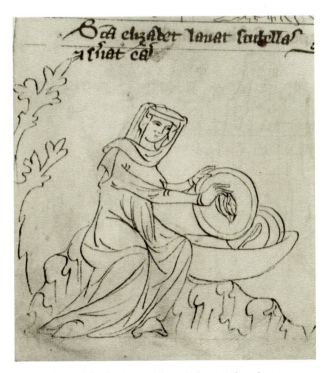

Fig. 52, Saint Elizabeth washing dishes, *Liber depictus,*
c. 1350, Vienna, Österreichische Nationalbibliothek, Cod.
Vind. 370, fol. 90v. From *Der Krumauer Bildercodex.*

2.11. Mercy and Mysticism

Long sequences of the pictorial legend expound on Elizabeth's works of mercy, making them more explicit and contextualizing them within her mystical experience.

Elizabeth's charitable acts affected various members of her community, from newborn infants and their mothers, the poor, and the recently deceased. Her care for newborns acquires a sacramental dimension, when the landgravine takes the children in her arms immediately after baptism. Then she returns the infants, swathed, to their mothers.[324] The next sacramental activity in which she participates is the burying of the poor dead. (Fig. 47) This work of mercy was not included in the early pictorial cycles, but it may have been known to the reader of the codex from the preceding legend of St Wenceslas.[325]

The topic of magnanimity dominates in the upper register of the next double page. (Fig. 53) The middle register starts with the traditional scene of washing the feet of the poor.[326] The most striking innovation is the absence of the Saint's servant.[327] The scene is related to Elizabeth's work in the hospital and calls to mind the attending to the sores of the lepers which was depicted in the Life of Hedwig of Silesia (Elizabeth's aunt) dating from 1353.[328] The washing of feet was praised by Bernard of Clairvaux, whose works survive in the cloister library in Vyšší Brod, as an example of humility and the imitation of Christ.[329]

Humility and humiliation are the topic of the next pair of images too. However, they are represented not only as a way of following Christ's example, but with Him as the Heavenly Bridegroom. Several medieval theologians celebrated

[324] Fol. 88v: "*Sancta Eliz(abet) de fonte sacro levat infantes. Sancta eliz(abet) hic dat infantibus vestem.*"

[325] Fol. 89r: "*Sancta Eli(zabet) semper ibat ad sepluturam (sic!) pauperum.*"; Venceslas fol. 34v.

[326] Fol. 89v: "*sancta e(lizabet) leprosis lavat pedes et ulcera eorum*"

[327] Paris, Bibliothèque Nationale, Nouvelle acquisition latine 868 – D. BLUME – D. JONEITIS, *Eine Elisabethhandschrift vom Hof König Alfons' X. von Kastilien*, in D. BLUME – M. WERNER (eds.), *Elisabeth von Thüringen – eine europäische Heilige. Aufsätze.* Petersberg, 2007, 325-339, p. 331; Nouvelle acquisition française 16251, fol. 103v (c. 1285) – BRÄM, „*Fratrum minorum mater“. Heiligenbilder als Angleichung und zum Patronat in Frankreich und Flandern und in der Anjou - Hofkunst Neapels,* in *ibid.*, pp. 309-324, fig. č7.

[328] The similarities with the codex in the Getty Museum (Ms Ludwig XI 7) have been emphasized by JENNI, *Die Elisabeth-Legende im Krumauer Bildercodex*, pp. 356-359. Comp. REBER, *Die Gestaltung des Kultes weiblicher Heiliger im Spätmittelalter; die Verehrung der Heiligen Elizabeth, Klara, Hedwig und Birgitta,* .

[329] St. Bernard of Clairvaux, *De gradibus humilitatis et superbiae* (The Steps of Humility and Pride) 7.20.

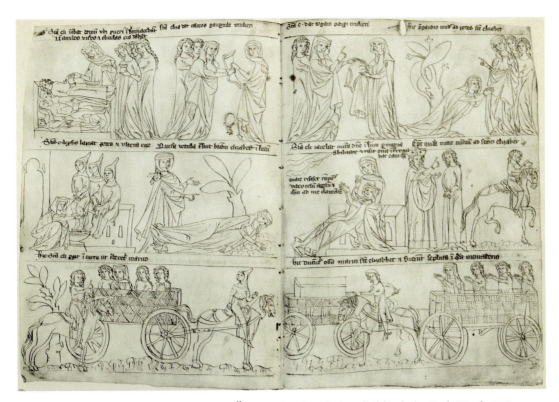

Fig. 53, *Liber depictus*, *c.* 1350, Vienna, Österreichische Nationalbibliothek, Cod. Vind. 370, fol. 89v–90r. From *Der Krumauer Bildercodex*.

Christ as the teacher and model of humility ("*magister humilitatis verbo et exemplo*").[330] This Christian interpretation of humility circulated in Bohemia primarily through the activities of the Cistercian and Franciscan Orders. The patrons of the codex were certainly familiar with the example of St Francis of Assisi, for whom Humility went hand in hand with his cherished ideal of Poverty.[331]

Elizabeth's legends depict an unusual personal relationship between herself and Christ. The emotional aspects of similar religious experiences in late medieval Europe were substantially influenced by the traditional celebrations of the Saint's love for the Heavenly Bridegroom. Once more it is Saint Bernard of

[330] J. WEISMAYER, *Demut. II. In Kirchen- und Frömmigkeitsgeschichte*, in W. KASPER (ed.), *Lexikon für Theologie und Kirche*. Freiburg – Basel – Wien, 2006, 90-91, p. 90.
[331] *Ibid*, p. 91.

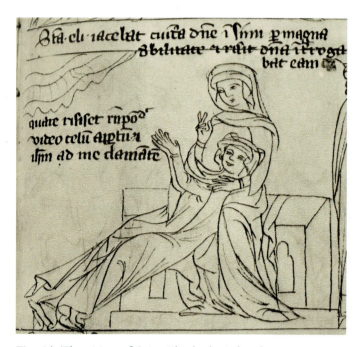

Fig. 54, The vision of Saint Elizabeth, *Liber depictus, c.* 1350, Vienna, Österreichische Nationalbibliothek, Cod. Vind. 370, fol. 90r. From *Der Krumauer Bildercodex.*

Clairvaux who appears to be the most influential author.[332] His ideas informed the narrative of St. Elizabeth being pushed into the mud by an ungrateful beggar.[333] Unprecedented in the *Liber depictus* is the Saint's cheerful acceptance of this scandalous event, which had been motivated by a visionary experience. (Fig. 54) The humiliated saint falls into the lap of a woman and proclaims her

[332] His influence on the visual culture of the later Middle Ages was occasionally ambivalent - J.F. HAMBURGER, *The Visual and the Visionary: Art and Female Spirituality in Late Medieval Germany*, New York – Cambridge, MA, 1998, pp. 113, 121-123. In his Apologia, Bernard had recommended an imageless devotion for monks. Pictures were to be used only for the less sophisticated mass audience, for simple-minded people, unable to imagine the higher truths of Christianity. Bernard also refers to the Incarnation in his argument in favor of the use of images – an argument which had been known for almost thousand years by the time of his life: The invisible God of the Old Testament wanted to be seen and loved in the corporeal form of Jesus or at least in his image.

[333] Fol. 89v: *"quedam vetula trusuit beatam elizabet in lutum."*

visionary encounter with the Savior calling to her from an open Heaven.[334] The historical roots of such mystical experiences can be traced back to St Bernard of Clairvaux, who fostered a very close personal relationship with Christ in order to bring about a visionary experience.[335] According to Bernard, a soul at prayer needed a sacred image (*sacra imago*) of the God-man before it – an image with which the soul is consubstantial.[336] This image should bind the soul with a love of virtue and expel carnal vices and temptations. Bernard's persuasive rhetoric paved the way for self-identification with the Bride of Christ. On this basis, many late medieval nuns could imitate the Bride of the Canticle: the *imitatio Sponsae* has been added to the well-known *imitatio Christi*. Elizabeth attempted to follow this ideal without retreating to the cloister as "sister in the world" (*soror in saeculo*).[337]

Although the influence of St. Bernard is incontestable, a more immediate inspiration for a mystical experience of Christ may be found in the *devotio moderna,* a movement which reached Bohemia through Geert Groote, its founder, and Master Eckhart, a significant predecessor.[338] However, Eckhart had been in Bohemia too early (a few years after 1307) and Groote was too young (born 1340) to have had an immediate impact on the *Liber depictus*. In comparison to *devotio moderna* which began in the absence of any institutions, the Cistercians, worshipping and propagating Bernard as their founder, controlled a large network of institutions, including 16 monasteries and five nunneries in Bohemia.[339]

[334] Fol. 90r. with an additional inscription: "*sancta eli(zabet) iacebat cuidam domine in sinu per magna debilitate et risit. domina interrogabat eam quare risiset. respondit: video celum apertum et jesum ad me clamantem.*"

[335] M.C. PUTNA, *Órigenés z Alexandrie: kapitola z dějin vztahů mezi antikou a křesťanstvím, nebo též pokus o pohled do tváře*, Prague, 2001, p. 48.

[336] Serm. Cant. LXXX, PL 183, 1166-1171.

[337] See further C. BERTELSMEIER-KIERST, *Bräute Christi – Zur religiösen Frauenbewegung des 12. und 13. Jahrhunderts*, in C. BERTELSMEIER-KIERST (ed.), *Elisabeth von Thüringen und die neue Frömmigkeit in Europa*, Frankfurt-am-Main, 2008, 1-32, p. 10.

[338] SCHMIDTBERGER, *Die Verehrung der Heiligen Elisabeth in Böhmen und Mähren bis zum Ende des Mittelalters*, p. 24.

[339] *Ibid.* pp. 29-30; F. MACHILEK, *Klöster und Stifte in Böhmen und Mähren von den Anfängen bis in den Beginn des 14. Jahrhunderts*, Cologne, 1992.

2.12. Temporality of the Earthly Marriage

Shortly after the visionary encounter with her Heavenly Bridegroom, the saint is confronted with the loss of her earthly husband. The sequence starts on the right-hand side of the central register with an image of a bishop sending a her-ald to Elizabeth.[340] The lower register of the double page is visually impressive, but its meaning remains somewhat unclear. At the left, Elizabeth sits with her three maids in a horse-drawn carriage. (Fig. 53) She is in discussion with another rider, who is the messenger sent by the bishop. The inscription states that Elizabeth is to be given to her husband.[341] This accounts for why the event has often been interpreted – mistakenly in my view – as a retrospective reminder of her journey to Thuringia, thereby pinpointing an inconsistency in the picto-rial narrative.[342] Such an interpretation does not explain why the princess, who was four years old at the time the journey was undertaken, was represented as an adult, as in the previous and subsequent images.

To the right, the bones of Ludwig are being transported to their final resting place in the Abbey of Reinhardsbrunn, the traditional burial ground of the Ludovingian landgraves.[343] A horse and two carriages move from the right toward the left, toward the spine of the book. Behind the carriage in which the bones are placed another carriage is visible. Elizabeth and her three maids are facing the center in prayer. The landgravine, wishing to meet her husband, is shown about to attend a funeral. Unlike the early cycles in Marburg, there are no fellow-crusaders bringing back Ludwig's bones. This is in keeping with the general trend of the *Liber depictus* where importance attributed to spiritual bat-tles replaces the emphasis on crusading. On the same page where Elizabeth meets her Heavenly Bridegroom she bids farewell to her earthly husband. Indeed, this sequence represents Elizabeth's final homage to her beloved Lud-wig. What appears to be an inconsistency in fact results in intensifying the meaning. The pictorial narrative does not aim at simple mechanical chronol-ogy. Otherwise, the meeting with the ungrateful beggar, which was accompa-nied by an extraordinary visionary experience, would not have been painted in

[340] Fol. 90r: "*Episcopus quidam mittit nunccium ad s. Elizabeth*"

[341] Fol. 89v: "*Hic sancta eli(zabet) pergit in curu ut traderetur marito.*"

[342] GECSER. *Aspects of the Cult of St. Elizabeth of Hungary with a Special Emphasis on Preach-ing, 1231-c.1500*, pp. 121-122.

[343] Fol. 90r.: "*hic ducuntur ossa mariti sancte elizabet et fuerunt sepulta in quodam monaste-rio.*" On Elizabeth's journey to the burial of Ludwig REBER, *Elisabeth von Thüringen, Landgräfin und Heilige. Eine Biografie*, pp. 136-137. For another image of a burial see fol. 101v.

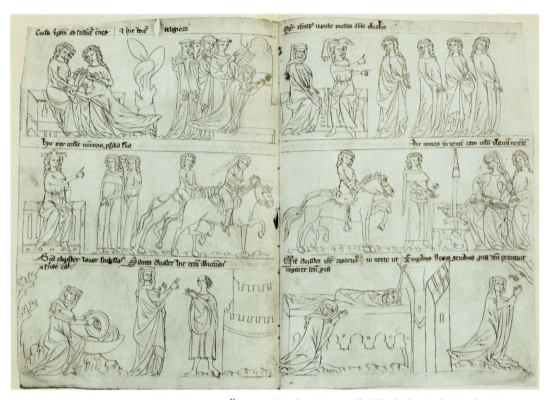

Fig. 55, *Liber depictus, c.* 1350, Vienna, Österreichische Nationalbibliothek, Cod. Vind. 370, fol. 90v–91r. From *Der Krumauer Bildercodex.*

the middle register. Its position in the historical chronology of Elizabeth's life had been, and would always be, after the death of Ludwig and the subsequent expulsion of Elizabeth from Wartburg.

2.13. Miracles and the Pictorial Narrative

Elizabeth appears to be the protagonist in several miracles in the *Liber depictus*. Next to the image with the saint washing dishes, we see her restoring a blind man's sight. (Fig. 56) The composition calls to mind a healing miracle of St Giles in the same manuscript.[344] Sometimes the miracles offer a kind of heavenly confirmation for a model of behavior uncommon for someone of her status.

[344] Fol. 90v: "*Sancta Elizabet hic cecum illuminavit.*"; healing miracles of St. Giles – fol. 63v.

Elizabeth manifests the power to intercede on behalf of a dead person and this was important to people planning to pray to her. In a vision the spirit of her own mother, who had been murdered by Hungarian aristocrats, implores the saint to intercede on her behalf to God.[345] Elizabeth offers a petitionary prayer before the bed in which her dead mother lies in a solitary dialogue with the beneficent hand of God emerging from a cloud.[346] Thus, the visionary piety of the saint is represented as something that can help others in the most important matters of life and death, perdition or salvation.[347]

On the next double page Elizabeth continues to perform miracles. (Fig. 56) First, she finds a lame man lying on the grass, prays for him and – after a short conversation to establish the cause of his affliction the man, now healed, stumbles to his feet.[348] What follows is yet another example of how Elizabeth cares for sick people. She starts by asking the patient what he needed.[349] He wanted some fish so she spoke with the person in charge and caught some fish.[350] At the beginning of the lowermost register, she is finally able to provide for the sick man who is sitting, his hands folded in prayer. She brings him fish on a plate.[351]

The death of Elizabeth in the subsequent picture comes as a surprise to any reader who might have expected a chronological narrative. Several important events in her later life, which are depicted elsewhere, are not illustrated in this codex. Two people lower her body into a sarcophagus; a tonsured cleric blesses the deceased and reads the *officium*. The inscription refers to a vision of Christ, but we only see Elizabeth's soul borne aloft by a pair of angels.[352] The viewer is

[345] This event and the two miracles on the subsequent page are based on B.O. TRENT, *Liber epilogorum in gesta sanctorum,* in E. PAOLI (ed.), *Edizione nazionale dei testi mediolatini,* Tavarnuzze (Florence), 2001; GECSER, *Aspects of the Cult of St. Elizabeth of Hungary with a Special Emphasis on Preaching, 1231-c.1500,* p. 28.

[346] Fol. 91r: "*Sanctae Elizabet mater apparuit in nocte ut rogaret Deum pro ea. Evigilans flexis genibus pro ea deum exoravit.*"

[347] Comp. FLAHERTY, *The Place of the Speculum Humanae Salvationis in the Rise of Affective Piety in the Later Middle Ages.*

[348] Fol. 91v: "*Sancta Elizabet invenit paraleticum et multum exorans Christum. Precipio tibi ut dicas mihi quod oberit tibi. Ille surgens respondit sic.*" A parallel can be seen in a miracle, performed by Elijah and depicted on fol. 11r of this codex.

[349] Fol. 91v: "*Sancta Elizabet interrogabat infirmum quid vellet.*"

[350] Fol. 91v: "*Hic loquitur cum procuratore. Hic haurivit de fonte pisces.*"

[351] Fol. 91v: "*Sancta Elizabet hic dat pisces pauperi.*" WARR, *The Golden Legend and the Cycle of the 'Life of Saint Elizabeth of Thuringia – Hungary,* pp. 161-162; RENER (ed.), *Die Vita der heiligen Elisabeth des Dietrich von Apolda,* pp. 94-95.

[352] Fol. 91v: "*Hic Christus apparuit sibi et sepelitur.*"

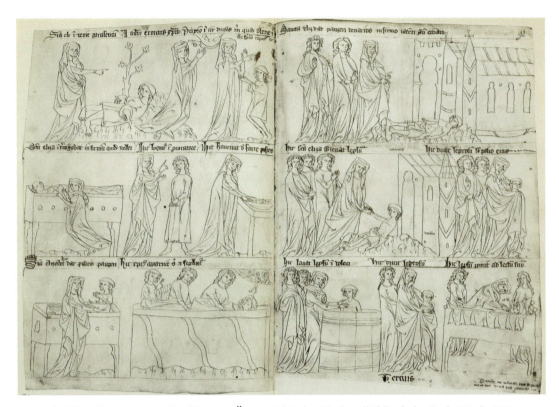

Fig. 56, *Liber depictus*, *c.* 1350, Vienna, Österreichische Nationalbibliothek, Cod. Vind. 370, fol. 91v–92r. From *Der Krumauer Bildercodex*

entitled to wonder where Christ is. The following pages of the manuscript provide the answer: He is to be found among the poor.

The usual pattern of narration is interrupted on this double page. The story does not continue across both pages. Rather than the registers continuing from the left page to the right, each page must be read as a separate unit. No satisfactory explanation for this change in the narrative pattern has been given. The position occupied by miracles in medieval hagiography may provide a simple solution to this conundrum. It was common practice to separate the saintly life (*vita*) from a collection of miracles (*miracula*). Such may be the case here too. First, the life of the saint is narrated up to the end on the left side of the double page. Then, starting on the right-hand side, a long meditative sequence offers a speculative commentary on the relationship between earthly and Heavenly marriage by means of longer miracle stories. Having understood the division in

the center of the page as a slight change of genre inconsistencies between the two parts are not a cause for concern. Nor is there any need to comment on inconsistencies in the chronology, such as the return of the previously dismissed maids, or even about the mysterious resurrection of Elizabeth and Ludwig. There is a change of emphasis in the question being asked – the reader is now offered insight into the deeper mystery of Elizabeth's personal relationship with Christ. Moreover, the monastic audience was offered a lesson on the relative importance of deep religious affinity and earthly marriage, the latter occupying an inferior position in the hierarchy.

The mysterious story begins on the right side (92r). (Fig. 43) It refers to almost all the topics discussed in the preceding *vita* by means of a short narrative, culminating in the upper register of the next double page (92v–93r). Elizabeth disregarded the boundary between the worlds of the rich and poor in a most scandalous manner, placing a beggar in her own marital bed.[353] The story begins as an example of simple charity, when Elizabeth gives money to a pauper whom she found lying in front of a church.[354] The reader is already aware of the fact that such distanced normal behavior is not an expression of the deeply radical forms of love Elizabeth shows to the marginalized. So it comes as no surprise when, on the occasion of an even more emotive encounter (given that the pauper is seriously ill), she extends her hands toward the leper and raises him from the ground.[355] Yet this is not enough – in the next image, their touching hands are replaced by an even more intimate position for the sick man: directly under the saint's gown.[356]

The layout of the second episode is similar to the afore-mentioned image; the most significant difference being the mantle, which Elizabeth gave the pauper after bathing him. Shortly before the end of the cycle, the symbolic gesture of giving a mantle (or a sleeve as a *pars pro toto*) assumes even greater significance. The last image of the page, which shows the landgravine putting the leper into her marital bed, was so scandalous that even the scribe of the manuscript felt the need to pray to God to avoid being led into temptation or incurring the wrath of God.[357] In all these images, the needy man is shown as

[353] This scandalous story was the most popular episode from Elizabeth's life in the Late Middle Ages.

[354] Fol. 92r: "*Sancta Elizabet dat pauperi denarios infirmo iacenti ante ecclesiam.*"

[355] Fol. 92r: "*hic sancta elisabet sublevat leprosum.*"

[356] Fol. 92r: "*hic ducit leprosum sub palio eius.*"

[357] Fol. 92r: "*hic leprosum ponit ad lectum suum.*"

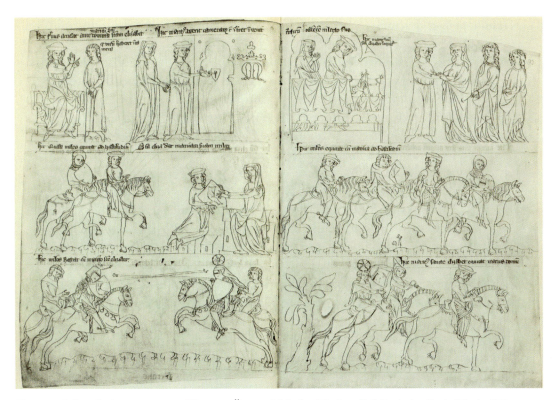

Fig. 57, *Liber depictus*, *c.* 1350, Vienna, Österreichische Nationalbibliothek, Cod. Vind. 370, fol. 92v–93r. From *Der Krumauer Bildercodex*.

a substantially smaller figure than Elizabeth, perhaps an innocent child rather than a full-grown man.

The next opening of the codex uses the well-known pattern of exposition across three registers, spreading across the whole breadth of the manuscript. (Fig. 57) The first register shows the culmination of the scandalous story. First, a servant stands before the landgrave and accuses Elizabeth of having a man in her room.[358] In the next pair of images Ludwig leads his wife to the bedroom and opens the door with a key and sees a crucifix in the bed.[359] The miracle

[358] Fol. 92v: "*Hic servus accusat ante maritum dominae suae sanctam Elisabeth quod virum haberet in camera.*"

[359] Fol. 92v-93r: "*Hic maritus apperit cameram, cum intraret invenit crucifixum iacentem in lecto suo.*"

results in is a peaceful conversation between the couple at the far right-hand side of the register.[360]

The image of the Crucified in bed recalls aspects of the visionary lives of mystically inspired aristocratic ladies whose emotional needs formed an integral part of their religious lives. This kind of spiritual creativity reached its apogee in the cloisters of Central Europe.[361] The nuns sometimes played with figures of the child Jesus, imitating maternal love. Margarethe Ebner (1291–1351) is reported to have taken a life-size crucifix into her bed at night and to have laid it upon her body.[362] The experience of Ita von Hutwil, a visionary who lived around 1300 in the Nunnery of Oetenbach in Zurich, is vividly depicted in the famous picture of the so-called Rothschild Canticles.[363] The Christ in her vision was identified with the sun, whose burning flames allegedly delivered ineffable knowledge to her. Divine light had suffused her such an abundance of divine sweetness, wisdom, joy and love, that she was unable to accept any more. In such a *visio beatifica*, she experienced how it might feel to be in Heaven already in her earthly life.[364] In spite of the sublime theological explanation, such visions held a significant erotic charge, which was conveyed in the expressive qualities of the gestures and faces of both Christ and the woman. The emotional aspects of contemplative devotion are also referred to in the Rothschild manuscript by the quotation from St Augustin's Confessions: "I call you, my God, into my soul that prepares to seize you out of the desire you have inspired within it".[365] Bernard of Clairvaux, whose ideas also inspired Ita's visionary experience, insisted that "the bedroom of the king is to be sought in the mystery of divine contemplation".[366] The marked influence of similar experiences

[360] Fol. 93r: "*Hic maritus cum sancta Elizabet loquitur.*"

[361] See e.g. J.F. HAMBURGER (ed.), *Frauen – Kloster – Kunst. Neue Forschungen zur Kulturgeschichte des Mittelalters. Beiträge zum internationalen Kolloquium vom 13. bis 16. Mai 2005 anlässlich der Ausstellung "Krone und Schleier",* Turnhout, 2007.

[362] D. FREY, *Kunstwissenschaftliche Grundfragen: Prolegomena zu einer Kunstphilosophie,* Wien, 1946, p. 124; H. BELTING, *Bild und Kult: eine Geschichte des Bildes vor dem Zeitalter der Kunst,* München, 1990, pp. 464-466.

[363] Beinecke Rare Book and Manuscript Library of [the] Yale University, Ms. 404, fol. 65v. The whole picture can be understood as a metaphor referring to an extraordinary spriritual experience, but the spiritual marriage (connubium spirituale) has taken a very concrete form, whose human aspects are reminiscent of the classical experience of Danae. P. DINZELBACHER, *Himmel, Hölle, Heilige: Visionen und Kunst im Mittelalter,* Darmstadt, 2002, p. 143.

[364] *Ibid.,* p. 116.

[365] Augustine, Conf. 13,1.

[366] HAMBURGER, *The Visual and the Visionary: Art and Female Spirituality in Late Medieval Germany,* p. 143.

and ideas is testified not only through the representation of Elizabeth's vision-
ary experience in the *Liber depictus*, but also through the whole structure of this
pictorial narrative, culminating in the conflict between different forms of mar-
riage. The result provides a synthesis, preserving the rights of the defeated hus-
band, but describing the final victory of Christ which, from an eschatological
view, was far more important.

2.14. The Final Combat

The next sequence, which comprises one of the most original parts of the nar-
rative, opens with an image where a knight, accompanied by his varlet, rides to
a tournament.[367] (Fig. 57) Before he arrives at the site of the combat he pays a
visit to Elizabeth, who gives him her sleeve. The knight is portrayed kneeling
while holding his shield on which Elizabeth has attached the sleeve (in the pre-
vious scene the shield was unadorned) .[368] On the right-hand side, the knight
rides to the tournament with three varlets, one of whom holds the newly deco-
rated shield and another a helmet (still unembellished).[369] At the beginning of
the lowermost register, we encounter the knight engaged in combat with the
saint's husband.[370] On this occasion it is the knight rather than Ludwig who
carries the sleeve (or its image) on his shield and helmet. The representation of
the sleeve on the helmet functions as a sign which allows the viewer to differ-
entiate between the knight and Ludwig, who has a rose on his helmet. Moreo-
ver, the fighters are differentiated by their shields: the anonymous knight has
a sleeve on his shield, while Ludwig's shield remains unadorned. In the next
image the fight is over and Ludwig, who has lost, rides home crestfallen.[371] The
only extant textual source of this sequence survives in a German version of
Dietrich's legend which has come down to us as a manuscript, now in Bam-
berg. This manuscript contains an anecdote, which was added to the translation
of a lost Latin version of the legend.[372] Unlike the *Liber depictus*, this anecdote

[367] Fol. 92v: "*hic quidam miles equitat ad hastiludium*"

[368] Fol. 92v: "*sancta elizabet dat manicam suam militi*"

[369] Fol. 93r: "*hic miles equitat cum manica ad hastiludium*"

[370] Fol. 92v: "*hic miles hastat cum marito sanctae elizabet.*" Comp. JENNI, *Die Elisabeth-Legende im Krumauer Bildercodex*, p. 378.

[371] "*hic maritus sanctae elizabet equitat iratus domum.*" For possible meanings of decorated
helmets in the manuscript JENNI, *Realistische Elemente im Krumauer Bildercodex*, p. 269.

[372] Bamberg, Staatliche Bibliothek, Msc. Hist. 148; SCHMIDTBERGER, *Die Verehrung der
Heiligen Elisabeth in Böhmen und Mähren bis zum Ende des Mittelalters*, p. 142; H. FROMM, *Eine*

has the sleeve given by Elizabeth to a beggar, who later gives it to the knight. Also missing in the Bamberg version of the legend is the final combat with Ludwig; – this motif seems to be an original addition in the *Liber depictus*.[373] These facts prompt several questions. What was the meaning of the combat? Was the representation of the charitable work omitted in deference to the knightly culture of courtly love? Alternatively, was this motif omitted only because similar deeds had been represented several times before? Can the mysterious knight be identified with the beggars and poor people who Elizabeth helped?

2.15. Courtly Love Re-evaluated

Scholars have hitherto not been able to account for the lowermost three rows of the legend in which the landgrave Ludwig unsuccessfully fights with another knight. Precisely why this episode was included is worthy of our attention. The reason why a crusader was transformed into a knight jousting to receive a lady's favor should be resolved. Rather than fighting infidels, we see the knight in combat with another Christian knight in a manner resembling the illustrations of Middle High German Minnesang poetry. This Middle German love poetry is exemplified in the famous Manesse Codex in Zurich, which predates the Viennese manuscript by several decades (1304–1340).[374] Unlike the *Liber depictus*, many of the illustrations in the Manesse codex focus on the erotic relationship between the knight and his lady. Although mostly poetic, the knight's desire seems to be grounded within this world – a gentle touch was enough to please him. In this secular ambience, some downright profane, or even neo-pagan associations appear whereas the *Liber depictus* used motifs with clear religious meanings. One of the knights, the well-known poet Ulrich von

mittelhochdeutsche Übersetzung von Dietrichs von Apolda lateinischer Vita der Elisabeth von Thüringen, [S.l.], 1967, p. 33.

[373] SCHMIDTBERGER, *Die Verehrung der Heiligen Elisabeth in Böhmen und Mähren bis zum Ende des Mittelalters*, p. 142.

[374] Heidelberg, University of Heidelberg Library, Codex Palatinus Germanicus 848. See W. KOSCHORRECK – W. WERNER, *Codex Manesse: die grosse Heidelberger Liederhandschrift: Kommentar zum Faksimile des Codex Palatinus Germanicus 848 der Universitätsbibliothek Heidelberg*, Kassel, 1981; L. VOETZ, *Der Codex Manesse: die berühmteste Liederhandschrift des Mittelalters*, Darmstadt, 2015; H. DEEMING – E.E. LEACH, *Manuscripts and Medieval Song : Inscription, Performance, Context*, Cambridge, 2015, pp. 163-192.

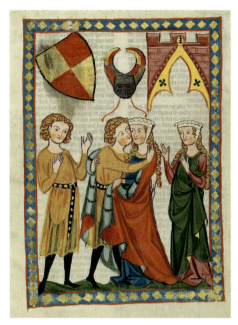

Fig. 58, Codex Manesse, UB Heidelberg, Cod. Pal. germ. 848, fol. 300r. From *Codex Manesse.*

Liechtenstein, was depicted with Venus on his helmet.[375] This neo-pagan symbol – a lady wearing a golden crown over her loose hair, and carrying a burning torch and red arrow – appears at the exact point where the victorious knight had placed Elizabeth's sleeve. The sleeve certainly possessed magical properties, which helped the knight to overcome Ludwig, but this power was clearly embedded in a context of Christian symbolism. A similar trend characterizes not only Elizabeth's legend, but also all the other stories depicted in the Krumlov manuscript.

The differences between the *Liber depictus* and the Manesse Codex can be linked to other familiar motifs; for example the gesture of protection under the mantle. Von Wengen (a knight who is depicted in the manuscript) is taken under the luxurious mantle of his lady.[376] (Fig. 58) The couple are shown cheek to cheek; their faces are brightened by smiles of contentment. Such a gesture of corporeal closeness had a purely erotic meaning, which differs radically from Elizabeth's chaste treatment of the leper, who is portrayed as a small boy, under

[375] Codex Manesse, UB Heidelberg, Cod. Pal. germ. 848, fol. 237r, G. SIEBERT – I.F. WALTHER, *Codex Manesse: die Miniaturen der Grossen Heidelberger Liederhandschrift*, Frankfurt am Main, 2001, Taf. 77.

[376] Codex Manesse, UB Heidelberg, Cod. Pal. germ. 848, fol. 300r; *Ibid.*, Taf. 98.

her mantle.[377] (Fig. 43) In this case, the mantle reinforces the physical distance. The poor youth's ultimate desire does not lie in the bedroom, but in heaven. The illuminator ensured that the correct performance of Elizabeth's radical gesture of mercy was supervised by her two maids. It was probably the draftsman who added a short prayer, appealing to the purity of his thoughts, under the image: "Lord, do not charge me with your anger, do not lead me into your wrath".[378]

Paradoxically, Ludwig's adversary was supported by the sign of a mantle sleeve which had been given to him by St Elizabeth. At a superficial level this appears to be a story of a jealous husband who returns disgruntled after defeat in battle, only to ask his wife to show him the dress with the missing sleeve. In the end, the saint's coat is miraculously restored. What purpose does the story serve? What can be known about the identity of Ludwig's adversary?

Ulrike Jenni has compared this story to a text preserved in Bamberg.[379] She pointed to the enhanced role of courtly love in the narrative in contrast to the focus on charity which permeates the Bamberg text. Although the courtly scenes in the Codex Manesse are closely comparable, the saint's love toward the Heavenly Bridegroom has not been omitted. Indeed, comparison with a mystic parable of a valiant knight from another Bohemian manuscript shows that her love intensified.[380]

Elizabeth believed she was the bride of Christ (*sponsa Christi*). Her legend describes the vision as a punitive miracle, which occurred during a mass. When she looked with pleasure at her earthly husband instead of her Heavenly Bridegroom, the host began to bleed.[381] The Heavenly Bridegroom was jealous and achieved his final victory. The last line of the pictorial narrative, which is placed in the upper register on pages 93v and 94r, is devoted to a sequence known

[377] Condrad of Marburg in the Summa vitae describes Elizabeth's exaggerated care for poor and sick boys – WOLF, *The Life and Afterlife of St. Elizabeth of Hungary. Testimony from her Canonization Hearings*, pp. 93-94.

[378] Fol. 92r: "*domine ne in furore tuo arguas me neque in ire tua coripias me.*"

[379] Bamberg, Staatsbibliothek, msc. hist. 148, fol. 17v – 18r; JENNI, *Die Elisabeth-Legende im Krumauer Bildercodex*, p. 378.

[380] Prague, Státní knihovna ČR, XIV A 17, fol. 3v. G. TOUSSAINT, *Das Passional der Kunigunde von Böhmen: Bildrhetorik und Spiritualität*, Paderborn, 2003, pp. 71-104.

[381] RENER (ed.), *Die Vita der heiligen Elisabeth des Dietrich von Apolda*, p. 55: "*Nam cum sacerdos corpus dominicum elevaret, aspiciens sancta Elyzabeth vidit Christum crucifixum per manus sacerdotis guttas sanguineas distillantem. Qua visione perterrita reatum suum agnoscens ad pedes Jhesu cum Magdalena fundens lacrimas se prostravit ponensque in pulvere os suum et mentem ad deum.*"

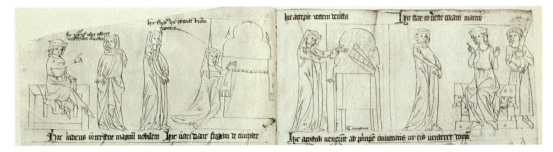

Fig. 59, Miracle with the Mantle, *Liber depictus, c.* 1350, Vienna, Österreichische National-bibliothek, Cod. Vind. 370, fol. 93v–94r. From *Der Krumauer Bildercodex.*

as the Miracle with the Mantle. (Fig. 59) A number of scholars have interpreted this story as an irrelevant, even contradictory, addition or a simple codicil.[382] However, the story provides a meaningful and fitting culmination to the whole narrative, a final visual commentary on the many instances in which Elizabeth donated textiles to the poor, who are identified with Christ and known to the reader from the earlier parts of the legend. This explains why the authors were able to omit other aspects of the story. Instead of introducing unnecessary worldly aspects (such as the depiction of a banquet attended by the Saint) into the pictorial meditation, the authors focus on the relevant context of the miracle. The jealous husband enquires about the whereabouts of the mantle from which the sleeve was given to the knight who had defeated him in combat. When he orders Elizabeth to bring forth the tunic, she overcomes her initial concern (since she know she has given the sleeve away) by praying to the Virgin Mary.[383] Finally, having found the mantle repaired in a chest, the saint stands before her husband, arrayed as he had requested.[384] The mantle is not just a worldly thing – it is now suffused with several strata of symbolic meanings. Elsewhere in the codex we find a very strange pronouncement concerning a union with Christ: "I love you as much as my mantle".[385]

A piece of mantle had already been a victorious sign in the pictorial life of St Martin in Assisi. After giving half of his mantle to a poor beggar, St. Martin

[382] SCHMIDT – UNTERKIRCHER, *Der Krumauer Bildercodex*, p. 11; GECSER, *Aspects of the Cult of St. Elizabeth of Hungary with a Special Emphasis on Preaching, 1231-c.1500*, p. 121.

[383] Fol. 93v: "*Hic maritus eius iubet affere vestem s. Elizabet. Hic turbatur. Hic exorat beatam virginem.*"

[384] Fol. 94r: "*Hic accepit vestem de cista. Hic stat in veste coram marito.*"

[385] Fol. 131v – "*diligo te sicut vestem meam*"

subsequently dreamt of Christ wearing it as a sign of victory in the fight for salvation and eternal life.[386] A similar meaning was associated with the mantle in the pictorial life of St Francis of Assisi in the upper level of the same church, where the life of St Martin was depicted.[387] In the life of the patron of the manuscript, acceptance of the clerical habit was an important ritual, which separated him from earthly marriage and knightly deportment. For Martin the identification with forces more intense than all the pleasures of earthly life was of the utmost importance.

The meaning of the narrative can be interpreted in the context of the waning importance of the crusading themes, which were seldom mentioned. The *Liber depictus* features only one sequence of the landgravine bearing bones of her husband to his final resting place in the Abbey of Reinhardsbrunn.[388] Compared to the prominent role of crusading themes in Marburg, their role in the codex from Krumlov is negligible. This is all the more surprising considering the geographical and chronological proximity of the *Liber depictus* to the pictorial legend of St George in Jindřichův Hradec (Neuhaus in German), painted on the walls of the great hall in the castle around 1338.[389] In both cycles the narration unfurls in long strips with a concise written commentary, but the interests of the patrons differed considerably. The Teutonic knights, who commissioned the murals, decided to represent George, their celebrated male patron. They organized the Northern crusade and the celebration of the military saint was a part of their campaign. Conversely, no mention is made of military campaigns in the *Liber depictus* when Elizabeth's pictorial lives allowed the integration of pictures of crusaders. Instead of the heroic knight, the disconsolate husband is portrayed after losing a fight. The pathos of the military actions against enemies of Christianity has dwindled and is replaced by what, at a cursory glance, appears to be a commonplace scene of jealousy. The image of the landgrave Ludwig has been transformed from a supporting and compas-

[386] P. HELAS, *The Clothing of Poverty and Sanctity in Legends, and their Representations in Trecento and Quattrocento Italy*, in B. BAERT – K.M. RUDY (eds.), *Weaving, veiling, and dressing*, Turnhout, 2007, 245-287.

[387] COOPER – ROBSON, *The Making of Assisi: The Pope, the Franciscans and the Painting of the Basilica*, p. 154 and fig. 137.

[388] fol. 90r.

[389] The cycle is dated by inscription. See I. GERÁT, *Dying Again and Again: Remarks on the Legend of Saint George in Jindřichův Hradec (Neuhaus)*, in *Ikon: časopis za ikonografske studije* 4 (2011) 175-183; E. VOLGGER, *Sankt Georg und sein Bilderzyklus in Neuhaus/Böhmen (Jindřichův Hradec): historische, kunsthistorische und theologische Beiträge*, Marburg, 2002.

sionate husband to a loser.[390] The Rosenberg coat-of-arms appears twice in a highly significant location – the helmet of Ludwig during his final fight. (Fig. 57) It is noteworthy that the Rosenberg family, as patrons of the codex, placed their emblem – the five-petal rose and a letter M with a crown – in that precise location rather than elsewhere in the manuscript.[391] How could it not be shameful for Ludwig to lose this fight?

One of the most prominent members of his noble family, Peter I of Rosenberg (†1347), was brought up and educated at the Cistercian Abbey in Vyšší Brod. Later, he became one of the foremost patrons of the monastery, which was the traditional familial burial place. His relationship to the cloister is reflected by his image, accompanied by the same heraldic rose, in the Nativity scene on the famous retable from Vyšší Brod (*c.* 1346–1347).[392] (Fig. 60) But for Peter, the self-representation as a loser would not be an ideal choice since it might raise doubts about his role as a husband and knight. There is every reason to continue the search within the family. The five-petaled rose, as the crucial component of the Rosenberg's coat of arms, is often encountered in southern Bohemia. The symbol of the Roseberg rose appears on the family's seal on the rider's shield and on his helmet. (Fig. 57) A similar image can be seen on the gravestone in the sanctuary of the cloister church in Vyšší Brod.[393] The question of who would derive satisfaction from seeing a knight from their family defeated by Christ merits our attention. One plausible candidate comes to mind. One of Peter's sons, Peter II of Rosenberg (1326–1384), made personal donations to the hospital of St Elizabeth in Vyšší Brod in 1361 and 1371. A provost of the All Saints Chapel at Prague Castle from 1355, Peter II would have been familiar with the legends of other saints depicted in the codex.[394] Since he chose a clerical career, he was compelled to abandon the customary

[390] SCHMIDT – UNTERKIRCHER, *Der Krumauer Bildercodex*, p. 11.

[391] JENNI, *Die Elisabeth-Legende im Krumauer Bildercodex*, p. 353.

[392] See e.g. J. PEŠINA, *The Master of the Hohenfurth Altarpiece and Bohemian Gothic Panel Painting*, London – New York, NY, 1989. The iconography of this altarpiece refers to some of the ideas of Bernard of Clairvaux.

[393] J. KUTHAN – P. PAVELEC, *Der Rosenberger Reiter*, in M. GAŽI – J. PÁNEK – P. PAVELEC – V. ROSENBERG, *Die Rosenberger: eine mitteleuropäische Magnatenfamilie*, České Budějovice, 2015, 30-33.

[394] The pictorial legends form a kind of bridge between the devotion of the learned and lay population, which is addressed by preachers – NODL, *Tři studie o době Karla IV.*, p. 110-111. Other important reasons for Peter II to be considered as the patron of the manuscripts are given by D. SOUKUP – L. REITINGER, *The Krumlov Liber Depictus. On its Creation and Depiction of Jews*, in *Judaica Bohemiae* 50 (2015) 5-44, pp. 11-13.

aristocratic lifestyle, which included marriage and participation in military activities or tournaments. The victory of Christ over the knight in the *Liber depictus* can be understood as a spiritual representation of the career choice of the patron, Peter II. Further, this decision resonates with a cultural shift in the Prague court, which took place in 1350. In that year Emperor Charles IV became infirm and abandoned courtly tournaments, which had been a traditional

Fig. 60, The Nativity scene from Vyšší Brod altarpiece (*c.* 1346/47), panel painting (99×93 cm), Prague, National Gallery. Photo: Google Art Project.

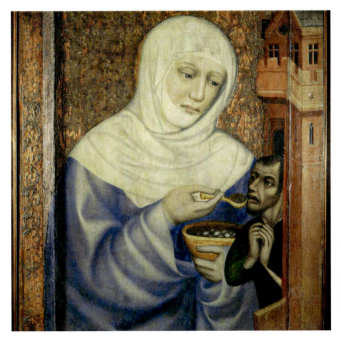

Fig. 61, Master
Theodoric of Prague,
Saint Elizabeth with a
beggar, panel painting,
Karlstejn Castle. From
Magister Theodoricus.

pastime in the court in Prague at least since the time of his father John of Lux-
embourg (1310–1346).[395]

The increased devotion, which provided a welcome alternative, included
a special reverence for St. Elizabeth. When Emperor Charles IV undertook a
pilgrimage to the tomb of St. Elizabeth in 1357, Peter II of Rosenberg and his
brothers numbered amongst the prominent participants.[396] There are many
moments in which the *Liber depictus* manifests cults, which were important at
Charles's court. For example, it features extant legends of Saints Wenceslas and
Ludmila, whose stories were cherished by the Emperor. Their legends are
painted on the walls of the staircase leading to Charles's private chapel in the
great tower of the imperial castle of Karlštejn. Anyone climbing the narrow

[395] SCHMIDTBERGER, *Die Verehrung der Heiligen Elisabeth in Böhmen und Mähren bis zum
Ende des Mittelalters*, p. 142.

[396] On the occasion of this pilgrimage the Emperor promulgated a charter for the brothers,
which put an end to a number of conflicts. P. WÖRSTER, *Überlegungen zur Pilgerfahrt Kaiser
Karls IV. nach Marburg 1357*, in H. GÖDECKE (ed.), *St. Elisabeth – Kult, Kirche, Konfessionen.
700 Jahre Elisabethkirch in Marburg 1283 – 1983*. Marburg, 1983, pp. 27-34., p. 28; KUBÍK-
OVÁ, *Rožmberské kroniky – krátký a sumovní výtah od Václava Březana*, p. 108.

staircase leading to the All Saints' Chapel would have seen these hagiographic images from a very close distance on their way to the private Heavenly Jerusalem, accessible only to the Emperor and his most intimate circle. In the 1360s the walls of the most sacred chapel of the whole empire were embellished with images of saints, painted by the famous magister, Theodoricus.[397] Saint Elizabeth appears among the saints selected, her head covered with a white scarf, her shining blue mantle resembling that of the Virgin Mary. (Fig. 61) The saint, known for her merciful attitude towards the poor, feeds a praying beggar. The lasting imprint of Elizabeth's pious actions was left in one of the most sacred places of the Bohemian Kingdom and of the whole Holy Roman Empire.

[397] J. FAJT, *Magister Theodoricus, Court Painter to Emperor Charles IV: The Pictorial Decoration of the Shrines at Karlstejn Castle*, Prague, 1998, pp. 410-411.

PART 3.
THE SAINT AND THE CITY

In several towns of late medieval Europe Saint Elizabeth's veneration spread to larger circles of town inhabitants. Of enormous importance were the image cycles created in and for parish churches and hospitals. In the new context, one of the concerns was that the visual cult of the saint should reflect the needs of municipal communities, but how exactly this happened is not clear. Who were the most important supporters of the cult? Which media were used and why? Did the new environment influence the iconography and style of pictorial narratives? Did the translation of visual narratives into new surroundings influence the historical functions of images? What was the specific role played by Elizabeth's pictorial lives in the imagination of town inhabitants? These and similar questions will be addressed in relation to the town of Košice which, as we shall see, was the most important center of Elizabeth's cult in the late Middle Ages.

3.1. Elizabeth and Municipal Identity in Košice

The free royal town of Košice was almost as large as Buda, the capital of the Hungarian kingdom. It was inhabited by the original Slavs and Hungarians and the settlers, most of whom came from German lands.[398] Since early in the town's evolution the parish church of Saint Elizabeth had been situated between the community of original inhabitants and that of the colonists.[399] As patron saint, Elizabeth provided a valuable identity symbol for the town. For example, she was depicted on the greater seal of the town, standing in the center of a triptych-like architectonic structure, flanked by two angels. (Fig. 62) The seal's legend "+S(ancta)+ELISABET+SIGILLUM+CIVIVM+DE+CASSA" confirms the importance of the Saint to the citizens.[400] The earlier building of

[398] Although each of the groups had its specially designated name for the city, the names were similar – Cassa or Cassovia in Latin, Kaschau in German, Kassa in Hungarian, Košice in Slovak. Historical introduction in B. WICK, *Kassa története és műemlékei*, Kassa, 1941; O.R. HALAGA, *Počiatky Košíc a zrod metropoly*, Košice, 1992.

[399] *Ibid.*, p. 191.

[400] The seal, which was used on documents from the years 1383, 1385 and 1408, is preserved in the municipal archive in Košice – see WICK, *Kassa története és műemlékei*, , p. 35. In the author's opinion the image of the seal depicts the retable of the former parish church. R. RAGAČ, *Pečať mesta Košice*, in D. BURAN (ed.), *Gotika. Dejiny slovenského výtvarného umenia*,

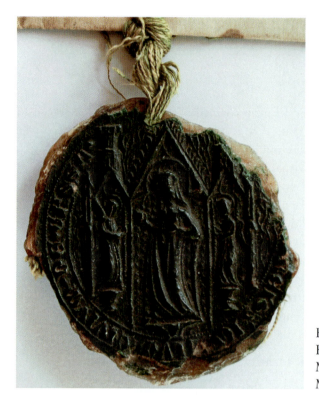

Fig. 62, Greater Seal of
Košice, before 1383, Košice,
Municipal Archive, Photo:
MA Košice.

the parish church was destroyed in a fire at the end of the fourteenth century,
thus the new construction must have been begun shortly thereafter. But Eliza-
beth's cult remained an identity symbol for different ethnic and social groups
of the town irrespective of the afore-mentioned conflagration. Such a symbol of
unity was vital in overcoming growing national tensions and animosities. The
possibility of such disorder was real, as witnessed by events in the capital of the
kingdom.[401]

This identity symbol could also help in the collaboration of the free royal
town with the king. It was especially during his time as Holy Roman Emperor
that Sigismund of Luxembourg assumed a key role in peace negotiations among
different national and ethnic groups in Hungary, of which he had been
the king since 31 March 1387, when he had been crowned at Székesfehérvár.

Bratislava, 2003, p. 796 dates the seal to the turbulent period c. 1300 (cf. also J. NOVÁK, *Erby
miest vyhlásených za pamiatkové rezervácie*, Bratislava, 1986, pp. 45-57.
[401] E. MÁLYUSZ, *Kaiser Sigismund in Ungarn: 1387-1437*, Budapest, 1990, p. 218-219.

Cooperation among the different parts of his empire was in the best interest of this ruler who, given his immense sphere of influence, had to fight for his power on a number of fronts.

The cult of Saint Elizabeth was known to Sigismund through family tradition. This tradition can be traced back at least to his father Charles IV who, as we have seen, took part in the pilgrimage to Marburg, accompanied by Mary, the Hungarian Queen. The personal interest of Sigismund may well account for Saint Elizabeth's increasingly important role in Hungarian iconography at that time.[402] Certainly, the concrete form of the pictorial cult reflected both the king's contribution as well as the different interests of several groups and individuals with their own social status, ethnicity, religious orientation and even gender.

The town was in need of royal support in its fight against powerful aristocrats. The earliest documents from Sigismund's royal house in the town, dated 15–17 September 1379, mark the beginning of a fruitful mutual collaboration.[403] The city had been a creditor of Sigismund for many years, helping him to finance his wars and campaigns. The king had a special account in the town, named "König Siegmunds Register". In order to avoid the possibility of oligarchs supervising his financial transactions, some of these were confidential.[404] The indebted king expressed his gratitude for the town's support by granting economic and legal privileges, including the donations of villages, or even of an entire castle with its estate. Among the economic privileges the king granted to the town, the most important would seem to be the fustian monopoly which covered the territory of the whole former Hungary.[405] As an example of legal documents, the town's coat of arms (1423) should be mentioned, not only because of its aesthetic appeal, but also because of the statues of the town

[402] A figure of the saint was featured in the 1392 frescoes by Johannes Acquila in Keszthely, Čerín (Cserény) or Martjanci (Mártonhely), as well as in a panel now in the Bratislava Municipal Gallery (Galéria Mesta Bratislavy) – see M. PAULY – F.O. REINERT, *Sigismund von Luxemburg: ein Kaiser in Europa: Tagungsband des internationalen historischen und kunsthistorischen Kongresses in Luxemburg, 8.-10. Juni 2005*, Mainz am Rhein, 2006.

[403] O.R. HALAGA, *Kaschaus Rolle in der Ostpolitik Siegmunds von Luxemburg I. (1387 – 1411)*, in U. BESTMANN – F. IRSIGLER – J. SCHNEIDER (eds.), *Hoffinanz – Wirtschaftsräume – Innovationen. Festschrift für Wolfgang von Stromer*, Trier, 1987, 383-410, p. 387.

[404] *Ibid.*, p. 390.

[405] O.R. HALAGA, *A Mercantilist Initiative to Compete with Venice: Kaschau's Fustian Monopoly (1411)*, in *The Journal of European Economic History* 12 (1983) 407-435, here 413; Cf. Also Z. TEKE, *Kassa külkereskedelme az 1393 – 1405. évi kassai bírói könyv belejegyzései alapján*, in *Századok* 137 (2003) 381-404, p. 384.

council, which were commissioned by the same individuals.[406] Some of the king's economic initiatives were directly connected with the financing of the rebuilding of the parish church, while others supported it only indirectly.[407] The financing of this project – even if only partially documented – sheds new light on the pictorial cult of Saint Elizabeth.

Pope Boniface IX was also in close contact with Stephanus de Caseda, rector of the parish church, elected by the burghers of Košice, to whom he guaranteed the right to adjudicate in all questions pertaining to religious services in the church by a letter dated March 9, 1402.[408] Is it not to be excluded that Stephanus de Caseda was personally responsible for choosing the scenes from the life of Saint Elizabeth as a theme for the reliefs of the northern portal.[409]

3.2. Hungarian Images of Elizabeth before Sigismund

Given the variety of clearly identifiable male saints in the visual arts of the Angevin period, it is even more surprising that there are no prominent or legible narrative images of the saint. The preserved works of Angevin courtly art do not substantially change this sense of incompletion. None of the known pages of the so-called Hungarian Angevin Legendary is dedicated to Elizabeth, even though she is likely to have been represented in the original codex.[410] In the completely preserved *Chronicon Pictum,* Saint Elizabeth appears only among the king's children, depicted anachronistically in the coronation image of her father Andrew II, crowned 1205, about two years before her birth.[411] (Fig. 63)

[406] On the social context of these statues see M. Tischlerová, *Stredoveký richtár Hanns Hebenstreyt v Košiciach*, in *Historica, Zborník FFUK Bratislava* 26 (1975) 51-75.

[407] E. Marosi, *Tanulmányok a kassai Szent Erzsébet templom építéstörténetéhez*, in *Művészettörténeti Értesítő* 18 (1969) 1-45, 89-127, p. 30f; Mályusz, *Kaiser Sigismund in Ungarn: 1387-1437*, p. 317.

[408] Monumenta Vaticana Historiam regni Hungariae illustrantia I, t. IV, CCCCLXXXII, p. 423 – 424.

[409] He was probably also responsible for the addition of the standing figure of Saint Elizabeth to the embroideries of the *casula* from his parish church (today Budapest, Magyar Nemzeti Múzeum/Hungarian National Museum Inv. Nr. 1953.147) – see E. Wetter, *Kazula z Košíc*, in D. Buran (ed.), *Gotika. Dejiny slovenského výtvarného umenia*, Bratislava, 2003, p. 807.

[410] Hungarian Angevin Legendary; B.Z. Szakács, *The Visual World of the Hungarian Angevin Legendary*, Budapest, 2016, p. 39; F. Levárdy (ed.), *Magyar Anjou Legendárium*, Budapest, 1973.

[411] Budapest, Schéchényi könyvtár, Cod. 404, p. 123. Cf. D. Dercsényi – K. Csapodiné Gárdonyi – L. Mezey – L. Geréb (eds.), *Képes krónika. Faksimile*, Budapest, 1964. Several aspects of the illustrations were analyzed by E. Marosi, *Kép és hasonmás*, Budapest, 1995, pp. 31-66. Comp. Werner, *Mater Hassiae – Flos Ungariae – Gloria Teutoniae. Politik und*

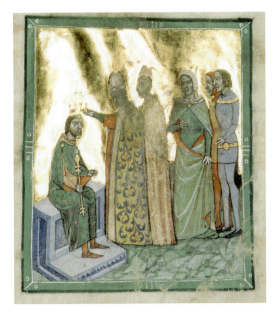

Fig. 63, Andrew II with his
children. Chronicon Pictum,
c. 1358, Budapest, Schéchényi
könyvtár, Cod. 404, p. 123.
Photo: OSzK Budapest.

In view of the extensive treatment of the male Arpadian saints in the Chronicle
this neglect might appear somewhat surprising. The absence of domestic images
featuring the saint is perhaps to be attributed to the widespread destruction of
Hungarian mediaeval art including in particular the art of Buda, the capital
of the kingdom.[412] The possibility that the inhabitants of the country were
forced to invest their energies in other directions after the devastating invasion
of Tatars in 1241 should not be ruled out. The settlers from the Germanic
lands, who were to become major supporters of the cult, arrived in the country
only after that date. It was at that time that the consolidation of urban life in
Hungary and the main social basis of Elizabeth's cult started to develop.

In 1402, Pope Boniface IX issued a special indulgence allowing the construc-
tion of the Church of Saint Elizabeth in Košice.[413] Sigismund was fighting this

Heiligenverehrung im Nachleben der hl. Elisabeth von Thüringen, p. 525. For the anti-German
nuances in the program of the chronicle see I. GERÁT, *Angels, Demons and the Politics of Late
Mediaeval Pictorial Hagiography,* in *Acta Historiae Artium Hungariae* 48 (2007) 263-271.

[412] Unsurprisingly, this is one of the foremost concerns of modern Hungarian art historiog-
raphy. See X. BARRAL I ALTET – P.L. LŐVEI – V. LUCHERINI – I. TAKÁCS, *The Art of Medieval
Hungary,* Roma, 2018.

[413] *Monumenta Vaticana Historiam regni Hungariae illustrantia* I, T. IV, CCCCLXXV,
pp. 417-418. Cf. V. WICK, *Dóm svätej Alžbety v Košiciach,* Košice, 1936, pp. 24-26; P. ZUBKO,
Kult Svätej krvi v Košiciach. Rozprávanie o stratených stredovekých relikviách, Košice, 2013,
pp. 45-46.

Pope, who supported Ladislas of Naples, the favorite candidate of the oligarchs for Hungarian throne, but in Košice events took a different turn. Despite mutual animosity the Pope and the king collaborated on the building of the church.

This was one of the reasons why Sigismund collaborated with the (Anti-)Pope John XXIII.[414] John XXIII even organized a mission of legate Branda with the aim of curtailing the influence of those Franciscans who backed Boniface IX.[415] The remarkable way Košice parish church was supported by the both enemies – even during the turbulent period between 1399 and 1403 – seems to have been influenced by the well-balanced religious orientation of the town council. Given that her cult was well received by both enemies Saint Elizabeth may have played a role in the argumentation of the city fathers. As suggested earlier, for Sigismund, this was a part of a long-established family tradition. Boniface's motivation can be explained, at least in part, by his collaboration with the Franciscan order, of which the Saint was traditionally one of the most important patrons.

3.3. Elizabeth Portrayed on the Portal of her Church

The parish church of Saint Elizabeth is the most important Gothic church, preserved on the territory of the former Hungarian kingdom.[416] The Northern entrance of the church was the one most frequently used by many influential burghers. It was orientated toward the town hall, but also toward the new Franciscan church (consecrated in 1405). The close cooperation between the two *chantiers* is evident on a number of art-historical grounds, including close stylistic analogies in the sculptural decoration.[417]

[414] O.R. Halaga, *Kaschaus Rolle in der Ostpolitik Siegmunds von Luxemburg I. (1387 – 1411)*, in U. Bestmann – F. Irsigler – J. Schneider (eds.), *Hoffinanz – Wirtschaftsräume – Innovationen. Festschrift für Wolfgang von Stromer*, Trier, 1987, 383-410, p. 391.

[415] *Ibid.*, p. 395.

[416] T. Juckes, *The Parish and Pilgrimage Church of St. Elizabeth in Košice: Town, Court and Architecture in Late Medieval Hungary*, Turnhout, 2011; Marosi, *Tanulmányok a kassai Szent Erzsébet templom építéstörténetéhez*, pp. 1-45, 89-127; S. Tóth, *Kaschau, Elisabethkirche von der Westfassade her betrachtet*, in *Művészettörténeti értesítő* 42 (1993) 113-139. See also R. Recht – A. Châtelet, *Ausklang des Mittelalters: 1380-1500*, München, 1989, pp. 22-23, fig. 15.

[417] Attempts have been made to differentiate hands in the workshop which was responsible for the both portals – e.g. L. Gerevich, *A kassai Szent Erzsébet templom szobrászata a XIV-XVI. században*, Budapest, 1935, pp. 30-35 argued in favor of one master with two apprentices. Extensive damage to the surface of the figures complicates this analysis. On the Franciscan church and the reliefs discovered during its restoration, see H. Haberlandová, *Stredoveký*

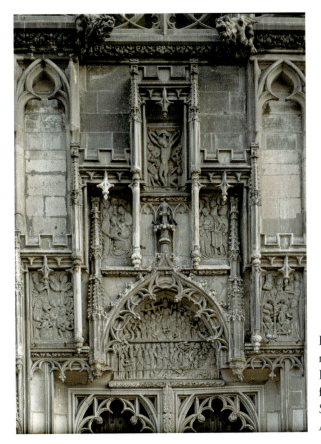

Fig. 64, The reliefs of the northern porch, *c.* 1410, Košice, the cathedral and former parish church of Saint Elizabeth, Photo: Alexander Jiroušek,

The unusual architecture of the northern porch of the parish church integrates the five rectangular slabs into the tiered superstructure of the portal. (Fig. 64) In this framework, the works of mercy and a miracle of St Elizabeth, depicted in lateral reliefs, make a Christological interpretation possible.

The three central reliefs are devoted to the Crucifixion. There are three crosses in the central panel. The central one shows Christ and the two thieves who were crucified with him. Their souls are borne heavenward by an angel and a devil, respectively, in accordance with their last words, in which they confirmed or denied Christ's divinity. This emphasis on salvation can be

kláštor františkánov v Košiciach, in *ARS* 18 (1984) 81-95; J. KRCHO – G. SZEKÉR, *Adalékok a kassai ferences templom középkori építéstörténetéhez*, in A. HARIS (ed.), *Koldulórendi építészet a középkori Magyarországon. Tanulmányok. Művészettörténet – Műemlékvédelem*, Budapest, 1994, 333-358.

compared to the reliefs of the Church of Our Lady before Týn in Prague.[418]
Thus, on the central vertical axis of the portal, the importance of Christ's sac-
rifice for the salvation of mankind is underscored and is further enhanced by its
placement above the image of the Last Judgment, to be found – in keeping
with convention – in the tympanum.[419] The suffering of the body, crucified on
a roughly worked fork cross in the above image, is not omitted in the triumphal
image of the Savior's return. The angels are celebrating Christ's suffering by
carrying the *arma Christi* – a large cross and a whip – behind the ruler of the
universe, seated with the sun, moon and stars beneath his feet at the center of
the image, but proudly bearing the wounds on his hands, feet and side. Thus,
the suffering, which is associated with Savior's sacrifice for mankind, acquires
a cosmological dimension. In order to grasp Saint Elizabeth's activities, which
are depicted in the two lateral reliefs of the portal superstructure, two levels
below the central Crucifixion, this eschatological dimension in the portal pro-
gram must be considered.

The two reliefs at the middle level expound on the central Crucifixion scene
by featuring its witnesses. On the right-hand side of Christ, Mary, having wit-
nessed her son's death, is supported by the other holy woman, and sinks to her
feet, which emphasizes the pain she suffered. Saint John, standing on the other
side in front of some soldiers, is portrayed with his hand drawn to his cheek.
His head is slightly inclined. These figures enhance another crucial idea of the
program – compassion, which is also of foremost importance in understanding
Elizabeth's charitable actions.

These individual scenes are depicted without any concern for the unities of
place and time. A traditional continuous mode of narrative stressed the impor-
tance of eternal values in interpreting Elizabeth's activities as a part of the Salva-
tion History. The two reliefs differ markedly in the clothing styles. In the slab
positioned on the "better" side to the right of Christ Elizabeth is shown bathing
and feeding the poor and the hungry. (Fig. 65) She is clad in a simple tunic,

[418] See the chapter "Sochařská výzdoba kostela P. Marie před Týnem a zejména tympanonu
severního týnského portálu" in: J. HOMOLKA, *Studie k počátkům krásného slohu v Čechách
(K problematice sociální funkce výtvarného umění v předhusitských Čechách)*, Praha, 1976, 55-97,
p. 69.

[419] The composition of the Last Judgment resembles the relatively recent versions of the
theme from Rottweil or Ulm – see MAROSI, *Tanulmányok a kassai Szent Erzsébet templom épí-
téstörténetéhez*, pp. 118-121. On the reliefs, see further GEREVICH, *A kassai Szent Erzsébet temp-
lom szobrászata a XIV-XVI. században*, pp. 22-35; J. BAKOŠOVÁ, *Reliéfna výzdoba severného
a západného portálu košického dómu*, in ARS 16 (1982) 30-53.

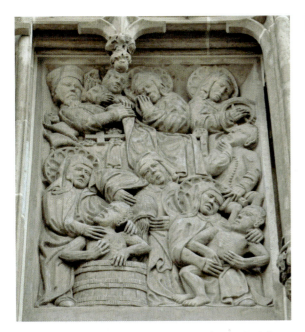

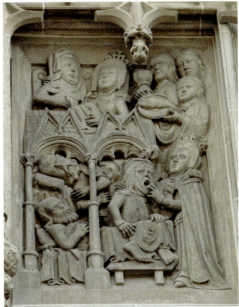

Fig. 65, Charitable works of Saint Elizabeth, The left-side relief of the northern porch, *c.* 1410, Košice, the cathedral and former parish church of Saint Elizabeth, Photo: author.

Fig. 66, Charitable works of Saint Elizabeth, The right-hand side relief of the northern porch, *c.* 1410, Košice, cathedral and former parish church of Saint Elizabeth, Photo: author.

which might resemble the modest clothing of the third order of Saint Francis. The humility and simplicity of her attire is in stark contrast with her ceremonial wear in the relief to the left of Christ. (Fig. 66) This contrast is perhaps even more apposite in view of the Saint's personal spiritual development, as a testimony of her growing modesty, which was even more evident following the loss of her husband. This spiritual way served as an example for all believers, in particular poor widows, for whom she provided a prominent role model. Some of Elizabeth's activities may convey even more meanings; for example, the analogy between bathing a pauper and the rite of baptism. Elizabeth, sitting with a naked man on her lap might allude to a sculptural type that was widespread around 1400 – a figural group of the pietà.[420] In this way, Elizabeth with a poor man was represented analogically to the Virgin Mary with Jesus.

[420] MAROSI, *Tanulmányok a kassai Szent Erzsébet templom építéstörténetéhez*, p. 117.

The artists focused on important messages, mainly on the expressions of individuals portrayed and their mutual interaction, while jettisoning all superfluous earthly details of represented events and situations. In all these respects, the traditional medium of portal sculpture offered efficient visual structures and language enabling the construction of an unambiguous spiritual framework for the representation and understanding of the saint's legend *sub specie aeternitatis*. When making decisions about the placement and appearance of individual scenes the spiritual dimension was of foremost importance.

The idea of compassion expressed the central message of the Saint's charitable actions; her generosity (*largitio*) and self-humiliation (*labor*) were equally important.[421] Those aspects of her life were primarily relevant in connection with the eschatological ideas, defined in the center of the portal.

Yet, the theological and artistic messages can also be understood as an integral part of the ideological context which influenced the functions of her images in contemporary society. The spiritual ideals were vital in the daily life of the city. For example, Elizabeth offered an example to believers, who were expected to behave humbly and to contribute generously to the functioning of charitable institutions.

Košice was known for its wealthy cosmopolitan merchants. Their commercial activities were widespread throughout Europe, but even in the town, lucrative practices took place and these were perceived as a threat to the salvation of their souls by the Church.[422] Nevertheless, a high percentage of tax was levied in the case of any suspicious activities, and the proceeds were used to the benefit of the Church. The love Elizabeth showed toward the poor might have offered an example of how to support an institution attached to the parish church – an example intended to help the poor and ill directly – the town hospital, *Hospitalis Pauperum ville de Cassa Ecclesie Sancte Elisabet*.[423] A miniature architectural structure occupied by poor and ailing people, who were helped by the Saint Elizabeth can be seen in the left-side relief. This can be read as a visualization on Elizabeth's Marburg foundation, but simultaneously it could indicate the indirect promotion of the local hospital. The activity of an institution administered by the town was legitimized by emphasizing the

[421] VAUCHEZ, *Charité et pauvreté chez Sainte Elisabeth de Thuringe d'après les actes du procès de canonisation*, pp. 163-173.

[422] HALAGA, *Kaschaus Rolle in der Ostpolitik Siegmunds von Luxemburg I. (1387–1411)*, p. 386.

[423] The relevant archival sources were published by WICK, *Dóm svätej Alžbety v Košiciach*, pp. 13-14.

most theologically justified aspect, namely care for the poor and sick within the context of a saint's life.[424]

The fusion of the spiritual and practical aspects of Elizabeth's cult by means of the portal sculpture was an efficient way of disseminating emotionally charged messages in the public sphere even in a period when the rebuilding of the parish church was incomplete. Several decades later the new sanctuary of the spectacular edifice was completed. This period witnessed the inauguration of an even more resplendent visual celebration of the saint in a medium, which started to blossom at that time – the winged altarpiece.

3.4. The Altarpiece Commissioned for the High Altar

The growth of the cities during the fifteenth century in Central Europe created favorable conditions for the flourishing of altarpieces. These stunning artistic creations were mostly realized as municipal commissions. Within the complex system of altar decoration, figures of the patrons were frequently represented in the central part of the altarpiece (corpus), while the panel paintings on the movable wings of the altar retables narrated the events from the legendary lives of saints.[425] Since the early part of the century the medium of panel painting had undergone substantial technical and artistic innovations in the Lower Countries.[426] In the course of the century, a number of these novel features were assimilated by artistic workshops in Central Europe, thus substantially changing the ways images were produced and perceived. The legends of Saint Elizabeth offer several possibilities for studying the interconnectedness of these complex processes within the traditional hagiographic narrative.

[424] Hospitals could also be organized to provide rich burghers with care in their old age – see e.g. W.W. MORITZ, *Das Hospital im späten Mittelalter*, Marburg, 1983, p. 93; A. KUBÍNYI, *Fragen der städtischen Gesundheitspflege in den mittelalterlichen Städten Ungarns*, in B.B. KIRCHGÄSSNER – J. SYDOW (eds.), *Stadt und Gesundheitspflege*, Sigmaringen, 1982, 101–117. The previous connection of a hospital with St. Elizabeth's Church in Košice is confirmed by a letter from Pope Martin IV as early as 1283 (text and translation in WICK, *Dóm svätej Alžbety v Košiciach*, pp. 11-13).

[425] J. BRAUN, *Das christliche Altar in seiner geschichtlichen Entwicklung*, München, 1924; V. FUCHS, *Das Altaransemble. Eine Analyse des Kompositcharakters früh- und hochmittelalterlicher Altarausstattung*, Weimar, 1999; D.L. EHRESMANN, *Some Observations on the Role of Liturgy in the Early Winged Altarpiece*, in *Art Bulletin* 64 (1982) 359-369; B. WILLIAMSON, *Altarpieces, Liturgy, and Devotion*, in *Speculum* 79 (2004) 341-406.

[426] T. BORCHERT – J. CHAPUIS (eds.), *Van Eyck to Dürer: The Influence of Early Netherlandish Painting on European Art, 1430-1530*, London – New York, NY, 2011.

These revolutionary technological and artistic changes opened up a new dimension in the interrelationships between images and the imagination of individuals and society. Before examining what this meant for the altarpiece in Košice, we must turn our attention to those responsible for these processes.

One of the largest retables with two pairs of movable wings in Central Europe was created for the high altar of the parish Church of Saint Elizabeth in Košice between 1474 and 1478.[427] (Fig. 67) This significant municipal investment is comparable with important examples from the Holy Roman Empire of which those in Münster, Ulm and St. Wolfgang belong to the finest surviving. The sumptuous retable was created with the king's support, though it would be an exaggeration to claim it was a royal commission.[428] King Matthias Corvinus, who ruled in the historical Kingdom of Hungary between 1458 and 1490, supported the cult of Elizabeth and the construction of her church in Košice. He explained his motivation in terms of devotion to the patron of the church and he was therefore hopeful that he would be a beneficiary of her help.[429] Despite his steadfast support, he was not the only decision-maker. Since the construction and decoration of the parish church were supervised on a daily basis by the priest, who had been elected by the townspeople, the work of art had to meet their needs and concerns, too.

[427] The archival sources were published by L. KEMÉNY, *Kassa város régi számadáskönyvei 1431 – 1533*, Kassa, 1892, pp. 14-15; more on the dating J. EISLER, *Megfontolások és javaslatok a kassai szent Erzsébet templom főoltárának datalásához*, in *Ars hungarica* 23 (1995) 189-203. For a technical analysis of the retable, M. SPOLOČNÍKOVÁ, *On the Altar of St. Elizabeth*, in I. VAŠKO (ed.), *The Cathedral of St. Elizabeth in Košice*, Košice, 2000, 40-79. On the church of St. Elizabeth JUCKES, *The Parish and Pilgrimage Church of St. Elizabeth in Košice: Town, Court and Architecture in Late Medieval Hungary*.

[428] On the altar as royal commission R. SUCKALE, *Maľby retabula hlavného oltára v kostole sv. Alžbety v Košiciach*, in D. BURAN (ed.), *Gotika. Dejiny slovenského výtvarného umenia*, Bratislava, 2003, 364-373; R. SUCKALE, *The Central European Connections of Matthias Corvinus' Patronage of Late Gothic Art*, in P. FARBAKY – A. VÉGH (eds.), *Matthias Corvinus the King*, Budapest, 2008, 101-111; R. SUCKALE, *Über einige nordalpine Vorbilder der Hofkunst des ungarischen Königs Matthias Corvinus*, in U. BORKOWSKA – M. HÖRSCH (eds.), *Hofkultur der Jagiellonendynastie und verwandter Fürstenhäuser*, Ostfildern, 2010, 261-279.

[429] "*Quod nos ob devotionem et spem nostram ad Beatam Elisabeth in cujus glorioso nomine ecclesia parochialis Cassoviensis fundata existit, gerimus…*" – from the letter by Matthias Corvinus, 28 September 1466. For this and others letters sent by the king see in JUCKES, *The Parish and Pilgrimage Church of St. Elizabeth in Košice: Town, Court and Architecture in Late Medieval Hungary*, pp. 37 and 229-230.

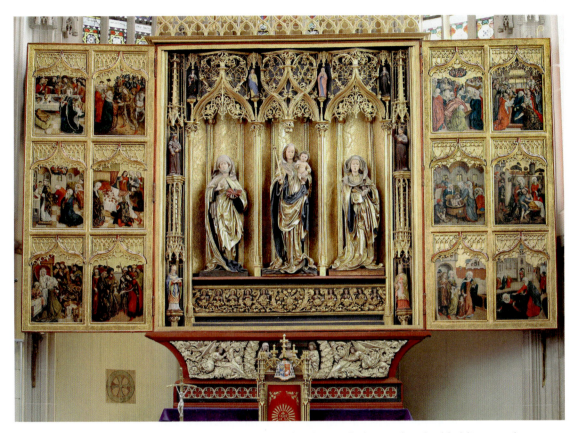

Fig. 67, The high altarpiece with opened wings, 1474–1477. polychromed and gilded limewood, 1260×810 cm, Košice, cathedral and former parish church of Saint Elizabeth, Photo: Alexander Jiroušek.

3.5. The Saintly Women

There are three large limewood sculptures of saintly women placed in polygonal niches under richly carved filigree baldachins in the central part of the altar (the *corpus*).[430] (Fig. 68) The Virgin Mary stands on the main vertical axis of the retable, flanked by the statues of St Elizabeth of Hungary, the titular saint of the church and the biblical St Elizabeth, her name patron. All the three figures are of superlative quality with their eyes cast downward, narrow noses, small mouths, rounded chins and other signs of idealization in keeping with the

[430] For terminology see M. BAXANDALL, *The Limewood Sculptors of Renaissance Germany*, New Haven, CT, 1980, pp. 66-67.

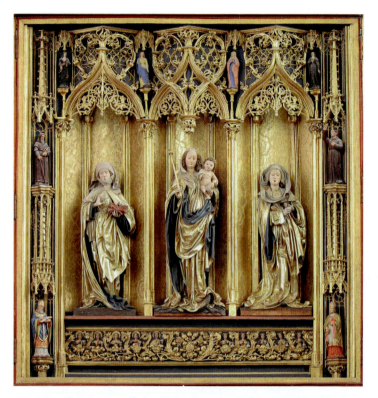

Fig. 68, The corpus of the high altarpiece with opened wings,
1474–1477, polychromed and gilded limewood, 437×408 cm,
Košice, the cathedral and former parish church of Saint
Elizabeth, Photo: Alexander Jiroušek.

most refined tastes of the period. The carver and his workshop responsible for
the refined polychromes and gilded surfaces of the figures represented a power-
ful testimony of their perception of female sanctity, centered on the archetype
of the holy mother of Jesus. The exquisite artistic language of these art works
allows us to attribute the statues unequivocally to the closest circle of the most
prominent artists of the time. It is highly likely that the leading master of the
workshop (probably Hans Kamensetzer) belonged to the circle of Nicolas Ger-
haert van Leyden, who was working for Emperor Frederick III in Austria.[431]

[431] On the style of the sculptures G. Török, *Zu Fragen des skulpturalen Ausstattung des Altars
der hl. Elisabeth in Kaschau*, in H. Krohm (ed.), *Flügelaltäre des späten Mittelalters. Die Beiträge
des internationalen Colloquiums „Forschung zum Flügelaltar des späten Mittelalters", veranstaltet*

While the artists were remarkably skilled in imitating forms and rendering the expressive qualities of human bodies, their aim was not to achieve an appearance which would seem as if copied directly from life. Rather than focusing on the close observation of the physical logic of human anatomy or on the smallest details of the bodies, they attempted to create slightly supernatural appearances. These could have been perceived as appropriate for women, who were portrayed standing against the gilded background of the corpus, which would have been understood as a representation of the glittering beauty of Heavenly Jerusalem. The saints have successfully reached Paradise – the glamorous destination of their journey through the vale of tears, this glorious and miserable world. While the most amazing events from the life of the Virgin Mary could only be seen when the retable wings were fully closed, twelve scenes from the momentous story of Elizabeth, the Hungarian princess, flanked the holy group at the center of the altarpiece. The life of this woman, the closest of the three, exemplifies Christian mysteries and their practical impact on the daily life of the citizens of Košice.

3.6. The Legend

Each of the wings of the retable comprises six panels. Thus, the legend of Saint Elizabeth is narrated on twelve panels, three pairs positioned above each other on both inner wings.[432] The narrative starts in the lower left corner and progresses always to the right in each line on each wing. This similar pattern is repeated six times, as far as the culmination of the story in the upper right corner. As the narrative focusses on several themes which were important for the visual cult of the saint in the town, the cycle can be divided into four sequences. The division follows a scheme, starting and ending with a single pair of images, with a double pair in the middle (2+4+4+2). A separate subchapter

vom 1.-3. Oktober 1990 in Münnerstadt in Unterfranken, Berlin, 1992, 157-166; K. CHAMON-IKOLASOVÁ, Recepcia diela Nicolausa Gerhaerta van Leyden na Slovensku v poslednej tretine 15. storočia, in D. BURAN (ed.), Gotika. Dejiny slovenského výtvarného umenia, Bratislava, 2003, 373-382; L. SCHULTES, Das Relief der Geburt Christi aus Freistadt/Hlohovec, die Wiener Burgkapellenfiguren und die Skulpturen des Kaschauer Hochaltars, in Galéria – Ročenka Slovenskej národnej galérie v Bratislave 2004–2005 (2004) 247-264; S. ROLLER, Niclaus Gerhaert und seine Bedeutung für die Bildhauerkunst Mitteleuropas, in S. ROLLER (ed.), Niclaus Gerhaert. Der Bildhauer des späten Mittelalters, Petersberg, 2011, 109-133.

[432] When the first pair of wings is closed one of the most extensive Christological cycles in medieval Hungary is visible. This comprises 24 scenes; the twelve images of the fully closed wings are devoted to the key events from life of the Virgin Mary.

dealing with the important iconographic innovations in individual scenes will be devoted to each of the sequences.[433]

3.6.1. Connecting Families and Countries

The importance of the saint for the municipal identity of Košice citizens has been outlined above. The first pair of images on the main altar retable wings emphasize the connections between her Hungarian dynastic roots and the dynastic politics which established the connection with Thuringia.

Elizabeth's birth in the Hungarian royal family places emphasis on the noble origin of the infant. (Fig. 69) Queen Gertrude, the saint's mother lies with her crowned head resting on a sizable red cushion. It has recently been suggested that this motive should be interpreted as a reference to her murder by Hungarian aristocrats in 1213.[434] Above the mother's bed, a kneeling woman shows the holy princess, wrapped in expensive brocade cloth, to her father King Andrew II, who stands behind the bed with respectful courtiers. His gaze is fixed on the new-born princess, whose head is adorned with a halo. Apart from the various figures, the luxurious objects, jewelry and brocade hangings in the background enhance the opulent effect of the scene. The references to the saint's royal origin might have public-spirited and patriotic significance in the royal borough of Košice. The picture's artistic language draws on the achievements of Netherlandish painters, who showed the meticulous surface detail of various materials.

The picture of Elizabeth's meeting with her future family is commonly interpreted as the arrival of the saint in Thuringia, but the possibility that the two delegations met in Bratislava on the frontier between the Kingdom of Hungary and Duchy of Austria should not be excluded.[435] (Fig. 70) The place of the action is not precisely identified in the picture – the golden background shows a low wall behind which one tree can be seen. Elizabeth is depicted as a small but mature-looking girl joining her hands with an adult man in ceremonial attire. This is a novel feature, for, as we have seen, in Lübeck the engaged

[433] The following descriptions are partly based on my book GERÁT, *Legendary Scenes: An Essay on Medieval Pictorial Hagiography.*

[434] SUCKALE, *Maľby retabula hlavného oltára v kostole sv. Alžbety v Košiciach*, pp. 366-367.

[435] REBER, *Die Gestaltung des Kultes weiblicher Heiliger im Spätmittelalter; die Verehrung der Heiligen Elizabeth, Klara, Hedwig und Birgitta*, p. 54; for Bratislava as the place where the marriage contract was drawn up see I. TAKACS, *Die Verehrung der Hl Elisabeth in Ungarn*, in *Franziskanische Studien* 18 (1931) 242-258, p. 243.

Fig. 69, Birth of Saint Elizabeth, 1474–1477, panel painting, 126,5×81cm, Košice, cathedral and former parish church of Saint Elizabeth, Photo: Alexander Jiroušek.

Fig. 70, Elizabeth's betrothal to Ludwig, 1474–1477, panel painting, 126,5×81cm, Košice, the cathedral and former parish church of Saint Elizabeth, Photo: Alexander Jiroušek.

couple were portrayed as children.[436] This new iconography prompts us to consider the question of identity: who is the older man? Apparently, the figure represents the Count of Thuringia Herman II, father of Elizabeth's future husband Ludwig IV, who – likewise still a youth – stands in the background.[437]

[436] See I. GERÁT, *De Lübeck à Košice. Les transferts iconographiques et stylistiques entre deux cycles iconographiques consacrés à Élisabeth de Thuringe vers 1450*, in J. DUBOIS – J.-M. GUILLOUET – B. VAN DEN BOSSCHE (eds.), *Les transferts artistiques dans l'Europe gothique: repenser la circulation des artistes, des oeuvres, des themes et des savoir-faire (XIIe-XVIe siecle)*, Paris, 2014, 319-336.
[437] M. SPOLOČNÍKOVÁ, *Oltár svätej Alžbety,* Košice, 1995, p. 47.

The saint is welcomed by her future father-in-law; the meeting of the two delegations can be understood as an iconographic testimony to the nature of medieval marriage. Elizabeth and Herman focus their gaze upon each other, their hands are joined. The captivated landgrave inclines towards the princess – a gesture akin to that of the priest who receives Mary in the Temple on the altar of the Scottish Abbey (Schottenstift) in Vienna.[438] However, in contrast to the priest, Herman is a secular noble figure in appearance and comportment. The message is clear: if the Hungarian princess was accepted with respect by highly-placed members of society in Thuringia, there is no reason to doubt that the well-to-do citizens of the free royal town are perceived as members of one social group irrespective of their ethnic origin.

A further commentary on Elizabeth's marriage is provided in the depiction of the engagement ceremony on the altar of St. Elizabeth in Bardejov. (Fig. 71) In this most unusual picture, the engaged couple are shown in reduced scale as children. They do not even reach the shoulder of the bishop, who joins their hands. The decisive protagonists of the ceremony are the two fathers, depicted at the sides heading the groups of witnesses. The sacred nature of the scene is underscored by its location in a Gothic chapel.

It might seem that the first sequence has placed excessive emphasis on the political aspects of the narrative. Nevertheless, as had frequently been the case, these aspects were skillfully combined with the spiritual and artistic ones. A comparison with the key works of the Master of the Life of the Virgin (Meister des Marienlebens) illustrates these aspects. The Master created his eponymous Life of the Virgin for the Church of St. Ursula in Cologne around 1460.[439] The Košice birth of Elizabeth strongly resembles his painting of the Birth of the Virgin Mary.[440] The second picture uses a vast pictorial space but this can be explained by differences in the format of the paintings. The formal analogies are numerous – the resemblance of female figural types, their scarves and mantles, hands and faces; the oblique arrangement of the mother's bed

[438] Comp. A. SALIGER, *Der Wiener Schottenmeister*, München, 2005; C. REITER (ed.), *Festschrift zur Eröffnung des Museums im Schottenstift*, Wien, 1994; A. SIMON, *Österreichische Tafelmalerei der Spätgotik. Der niederländische Einfluß im 15. Jahrhundert*, Berlin, 2002, pp. 244-250.

[439] See A. SCHERER, *Neues zum Meister des Marienlebens*, in F.M. KAMMEL – C.B. GRIES (eds.), *Begegnungen mit alten Meistern*, Nürnberg, 2000, 123-137. There were lively commercial and cultural contacts between Košice and the metropolis of the Rhineland during this period. The sources even mention some painters wandering between the towns. Research has not been able to identify them as the authors of specific artworks.

[440] Munich, Alte Pinakothek Inv.-Nr. WAF 619.

Fig. 71, Master of the Life of the Virgin (Meister des Marienlebens): The Birth of Mary Munich, Alte Pinakothek Inv.-No. WAF 619. Photo: The Yorck Project (2002) 10.000 Meisterwerke der Malerei (DVD-ROM), distributed by DIRECT-MEDIA Publishing GmbH. ISBN: 3936122202.

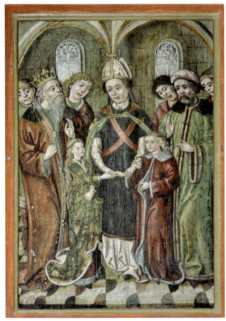

Fig. 72, Elizabeth's betrothal to Ludwig, *c.* 1480, panel painting, Bardejov, Photo: author.

with the midwife and maidservant in the foreground; the metal vessels and the way in which they are depicted, the decorative floor pattern, and the brocade curtain hanging behind the king's suite with the drapery over Anne's bed. Even without analyzing further this formal closeness up to the level of master's personal style it is possible to note the resemblance of the artistic language and the way a similar solution to artistic problems created a solemn atmosphere for the birth of a saintly person. Once again, the Mariological aspect of Elizabeth's sanctity shines as the main spiritual message in this comparison.

It is harder to find such a close comparison to the highly original picture of the meeting of the delegations, but when looking at the works of the Master, we can see his inventive work with the compositions of figural groups around a central pair in his Presentation of Mary, Marriage of the Virgin, and Presentation of Jesus at the Temple.[441] The master who created Košice paintings demonstrated a similar level of skill and creativity in this specific aspect.

3.6.2. Negotiating Social Borders of the Castle

A slightly different type of political problem is the topic of second sequence, which comprises the remaining four images of the retable's left wing. The micropolitics of the seat of the landgrave family become the focus of attention. The religious motivations of the saint and her husband resulted in significant changes in the handling of social borders and the norms of behavior typical in aristocratic society. As Elizabeth's religious motivation was stronger than social pressure, she was able to transcend these invisible limits and to act against the prevailing conventions. The new language of painting offered new possibilities for the artistic rendering of power relations around Elizabeth's actions.

The story of the repulsive-looking sick beggar brought by the Saint into the castle was depicted in the garden where trees cast shadows on the wall, behind which the towers and roofs of the castle buildings are visible.[442] (Fig. 73)

[441] Munich, Alte Pinakothek, Inv.-Nr. WAF 620 and Inv.-Nr. WAF 621; London, National Gallery NG 706.

[442] HUYSKENS (ed.), *Libellus de dictis quattuor ancillarum s. Elisabeth confectus*, p. 17 (lines 431 – 444): "*Item beata Elysabeth adhuc existens in habitu glorie secularis quendam mendicum infirmum horrendum aspectu, capitis infirmitate laborantem, secrete assumpsit, propriis manibus tondens horridos capillos ipsius, capite suo in sinu eius reclinato, posteo lavit caput eius in secreto loco pomerii sui, hominum volens vitare aspectum. Super quo ab ancillis supervenientibus correpta ridebat.*"; RENER (ed.), *Die Vita der heiligen Elisabeth des Dietrich von Apolda*, Lib. II, Cap. VI.

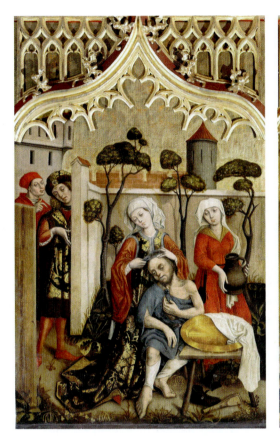

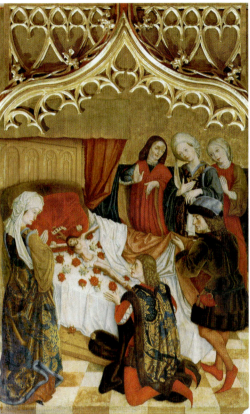

Fig. 73, Elizabeth cuts a sick man's hair, 1474–1477, panel painting, 126,5×81cm, Košice, cathedral and former parish church of Saint Elizabeth, Photo: Alexander Jiroušek;

Fig. 74, Miracle of the cross and the roses, 1474–1477, panel painting, 126,5×81cm, Košice, cathedral and former parish church of Saint Elizabeth, Photo: Alexander Jiroušek.

A marked social difference is evident at the center of the painting: the handsome young saint in a brocade cloak stands close behind the back of an unsightly bearded man partly covered by a grey-blue cloak. Below the water-bowl we see his clogs and a rattle of the kind that lepers used to warn people of their presence. The descriptive painterly language enabled the artist to express the contrast between the physical appearance of the figures – their faces, clothing and skin – which undoubtedly sharpened the emotional impact of the picture on contemporary viewers. The immense social divide is bridged by Elizabeth's gesture – she touches the man's head and cuts his hair. No indication of identity

of the beggar with Christ is given in the painting. The motif of the witnesses of the saintly princess's outrageous deed is well developed: Ludwig peacefully observes his wife's scandalous action from a doorway in the wall around the garden, speaking with another man clad in red (probably his servant). The landgrave's calm reaction contributes substantially to the poetic atmosphere of the whole picture. Owing to the lyricism of the scene, which takes place in a garden with trees casting shadows on the wall, the saint's scandalous behavior seems to be normal. In this painting identification of the beggar with Christ is to be excluded.[443]

It would have been unthinkable to exclude the identification of the beggar with Christ from the popular scene of the miracle, in which the poor man, mercifully sheltered by Elizabeth in the marital bed, was transformed into an image of the Crucified in Ludwig's vision. (Fig. 74) Unlike in the previous painting, the situation is dramatically conveyed. Elizabeth stands in front of the bed, looking at her husband, who kneels at the bedside, his half-opened mouth and raised hands indicate surprise and wonder. A man standing in an expensive costume removes the bed cover to reveal something extraordinary – the cruci-fied Christ among red and white roses, with traces of blood covering his emaci-ated body. The beams of the cross resemble rough branches to show that the cross had once been a tree; as in the north portal at Košice a theological inter-pretation is implied in the cross as the tree of life. Only the disproportionately small figure of Christ points to the extraordinary status of the vision as a sepa-rate sphere of reality, which in this case is separated neither by a band of color nor by clouds. The strategy of emphasizing the supernatural by means of differ-ences in scale was not uncommon in fifteenth-century art, even where a high degree of realism was involved. The Košice crucifix resembles a work of art.[444] Since the vision occurs exactly between Ludwig and Elizabeth it is they (and the viewer standing in front of the picture) who are awarded the privilege to under-stand. None of the secondary figures in the picture appears to be enthralled by the immediate presence of Christ. According to the text of the legend, God opened Ludwig's inner eyes (*"interiores oculos"*) in order that contemplation might

[443] This motive reappeared in the picture at the Hospice of the Holy spirit in Tallinn (1483), where the rays from the halo of the poor man whom Elizabeth is tending form a typical Christ's cross.

[444] On the influence of pictures and sculptures on late medieval mystical piety see M. CAMILLE, *The Gothic Idol: Ideology and Image-Making in Medieval Art*, Cambridge – New York, NY, 1989, pp. 197-219; G.B. KLANICZAY, *Az uralkodók szentsége a középkorban*, Budapest, 2000., p. 219.

give him spiritual comfort (he was *"contemplatione consolatus"*).[445] There is no mention of other people and the events which follow Ludwig's passing away (depicted on the other wing of the retable) indicate that Elizabeth's transgression of social borders was no longer acceptable at the castle. However, during the landgrave's lifetime the miracles continued to support his wife's eccentric behavior.

According to the Franciscan biographers of the saint, Ludwig repeatedly invited Elizabeth to come and greet important guests. She initially refused because of her inappropriately modest attire, but then she saw an angel bearing a shining crown and cloak as a gift from her heavenly bridegroom.[446] Dietrich says that when Elizabeth came to the palace, a beggar was lying on the steps and she had nothing to give him except for her precious cloak. The impatient guests, who were waiting for the procrastinating Elizabeth, informed the lord of the house that his wife did not have a cloak. When Ludwig came to summon Elizabeth, he casually asked about the cloak. Once again, a miracle saved the saint from being excessively reprimanded: "Then a servant ran off and found the cloak, which Elizabeth had given to the poor man. It came to its hook from heaven. The heavenly woman went to the feast dressed in it."[447]

The miraculous return of the cloak Elizabeth had given to the beggar illustrates the promise of heavenly reward for works of mercy. Parallels for this scene can be found in the pictorial legends of St. Martin and St. Francis of Assisi. Unlike these pictorial legends and the altar of St. Elizabeth from 1513 in Marburg the charitable motif is omitted in the cycles in Košice and Bardejov. The robe of the saint attending the feast is carried by angels. (Fig. 75) The splendor of the rich dark blue hue, gilt embroidery and fur lining gave bodied forth the idea rhetorically conveyed by Dietrich at the end of the passage cited above: "Thus, the Heavenly Father dressed his lily Elizabeth as not even Solomon in his glory could have done". The worldly effect of the saint's exceptional appearance is evident in the gestures and facial expressions of the lords

[445] RENER (ed.), *Die Vita der heiligen Elisabeth des Dietrich von Apolda*, p. 40: *"aperuit deus devoti principis interiores oculos viditque in thoro suo positum crucifixum. Qua contemplacione consolatus pius princeps rogavit sacram coniugem suam, ut in stratu suo tales leprosos frequenter collocaret. Intellexit enim, quod in membris suis infirmis suscipitur Christus dominus et fovetur."*

[446] *"vidit angelum cum veste et corona splandente dicentem sibi: 'His ornare, que tibi celestis sponsus transmisit de coelis."* – LEMMENS, *Zur Biographie der heiligen Elisabeth, Landgräfin von Thüringen*, p. 16; GECSER, *Aspects of the Cult of St. Elizabeth of Hungary with a Special Emphasis on Preaching, 1231-c.1500*, p. 32.

[447] RENER (ed.), *Die Vita der heiligen Elisabeth des Dietrich von Apolda*, p. 44: *"Currens autem ancillula mantellum, quod pauperi tribuerat, in partica reperit celitus reportatum. Quo induta celestis femina ad convivium processit."*

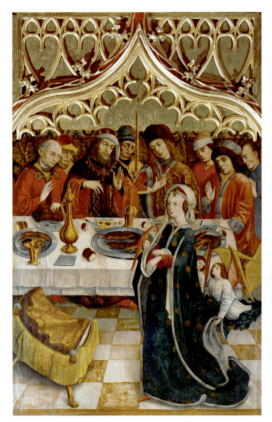

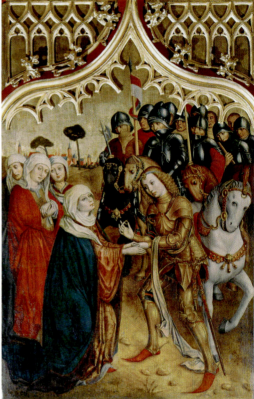

Fig. 75, Miracle of the ceremonial robe, 1474–1477, panel painting, 126,5×81cm, Košice, cathedral and former parish church of Saint Elizabeth, Photo: Alexander Jiroušek.

Fig. 76, The farewell, 1474–1477, panel painting, 126,5×81cm, Košice, cathedral and former parish church of Saint Elizabeth, Photo: Alexander Jiroušek.

portrayed behind the sumptuously laid table. Further, expensive textiles would have served to attract the attention of the craftsmen and merchants who attended the church in Košice. The significance of the scene, which transmuted the Christian ideal of mercy into a form acceptable to the time, was also connected with its reception. The number of scenes in Bardejov is one third less than in Košice (8 instead of 12), but the miraculous arrival at the feast still figures, perhaps because it was an indirect argument in favor of maintaining the existing social difference.

The pictorial legends of St. Elizabeth in Košice and Bardejov include two scenes which convey the change in the saint's social position following the loss

of her husband in a crusade.[448] With respect to the Košice scene the husband whom the saint leaves is portrayed clad in opulent knightly armor, distinguished by its golden color from the armor of the soldiers in the background. (Fig. 76) Ludwig is no longer the virile Christian warrior to be found in earlier versions of the theme. Carefully arranged golden curls, tied together with a decorative ribbon, and the diadem on his forehead bespeak courtly elegance more than a soldier's coarseness. The young landgrave's face shows affinity with one of the angels on the Ghent Altar. While the painters created the changed image of the soldier in accordance with what they had learned during their apprenticeship, it is not to be excluded that they had been influenced by personal encounters with noble cavaliers accompanying king Mathias on his journeys through the land.

The young man's beauty may have helped the viewer to identify more strongly with the loss Elizabeth experienced on parting from her husband. Regarding the separation, Dietrich mentioned "an explosion of sorrow, pitiful lamentation, heartbroken crying, and weeping," an unbearable and disconsolate state, accompanied by tears, trembling, disturbance of the bowels, mourning and so on.[449] The Košice painter has not achieved the same detailed expressiveness. He did not depict Elizabeth's horror on finding the cross or the later outbursts of emotion. Only the maid at the left edge of the painting is wiping away her tears. In the center of the picture it is as though the saint had already emerged from her painful decision: "Finally, she blocks the flood of emotion and her love for the Creator became as strong as death".[450] In keeping with his predominantly lyrical style, the Košice painter has underlined the dreamy melancholy of the parting. Although the couple's expression of love and commitment still emerges in the picture, their closeness is more subtly portrayed than in the Marburg relief. In Košice, the central figures of the scene are placed further apart and extend their hands to each other. However, the intense eye contact remains. Ludwig holds up a ring against a dark background in his right

[448] According to the *Golden Legend*, Elizabeth herself urged her husband to use the strength of his weapons to defend the faith in the Holy Land. See VARAZZE, *Legenda aurea*, p. 1304: "*Cupiens uero beata Elizabeth ut uir suus in fidei defensionem potentie sue arma conuerteret, ipsum salubri exhortatione induxit ut ad terram sanctam pergeret uisitandam.*"

[449] RENER (ed.), *Die Vita der heiligen Elisabeth des Dietrich von Apolda*, p. 66: "*Erat ibi mestitudo maxima, luctus et planctus ingens, voces miserabiles, larga lacrimarum effusio cum rugitu anxio et clamore.*"

[450] RENER (ed.), *Die Vita der heiligen Elisabeth des Dietrich von Apolda*, p. 67: "*Rupit tamen moras affectionis fortis ut mors dillectio conditoris.*"

hand. According to Dietrich, this showed the image of an *Agnus Dei* with a flag and served as a private seal to confirm Ludwig's decrees or to confirm news of his death. The landgrave places his left hand between the hands of Elizabeth, who appears to be buckling at the knees under the weight of her sumptuous robe. Although her gaze is still focused on the face of her departing husband, her head is tilted upwards. Her bodily position accurately renders the ambivalent feelings described in Dietrich's text. On the one hand she wished to break her ties with this world, while on the other, she experienced the pain of parting as a wife. In the depiction of the group of soldiers ranged behind Ludwig the painter displays his expertise in handling contrast. The heads of the soldiers in dark helmets contrast with Ludwig's golden hair. Their dark armor and black and brown horses contrast with his gleaming golden armor and white horse. Elizabeth's husband surpasses his fellow warriors in beauty, refinement, and wealth. The group of three grieving women standing behind the saint may represent the emotional reaction of her ladies-in-waiting. The painter of the parallel composition in Bardejov has replaced the group of women with a figure holding Elizabeth's cloak. Moreover, he has omitted the landscape from the picture thereby affording a more restrained rendering of the theme.

3.6.3. Humiliation and Visions

After the loss of her husband, Elizabeth's life was marked by several humiliating events which she perceived as a challenge to coming closer to Christ. The visions she was granted during or after the tribulations of her earthly pilgrimage confirmed this closeness. Simultaneously, the visual environment in which the events of her life were depicted mirrored more closely the everyday experience of Košice citizens, or more specifically, their experiences in a hospital environment. Thus the saintly life could be more easily perceived as a prominent example to be followed in everyday life.

Elizabeth's expulsion from the court of Wartburg marked the beginning of the most arduous phase of her life (Fig. 77) Dietrich referred to her expulsion in the chapter titled, "On the patience she showed after being pitifully expelled":[451] "Some vassals of the dead prince (...) forgot their fear of God, justice, their own honor and appropriate behavior and bullied the woman tested by God. They added to her painful spiritual injuries by expelling her from the

[451] "*De paciencia, quam miserabiliter eiecta exhibuit*" – M. RENER (ed.), *Die Vita der heiligen Elisabeth des Dietrich von Apolda*, pp. 71-72.

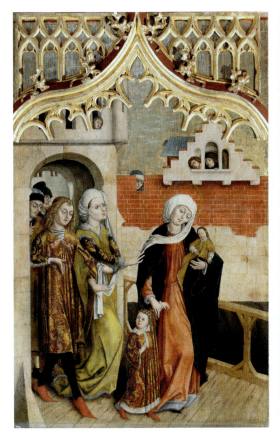

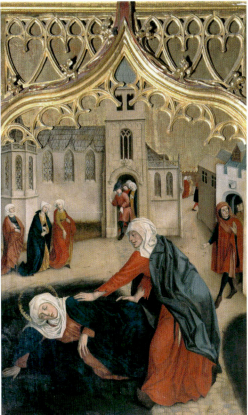

Fig. 77, Expulsion from Wartburg castle, 1474–1477, panel painting, 126,5×81cm, Košice, cathedral and former parish church of Saint Elizabeth, Photo: Alexander Jroušek.

Fig. 78, Elizabeth and the ungrateful woman, 1474–1477, panel painting, 126,5×81cm, Košice, cathedral and former parish church of Saint Elizabeth, Photo: Alexander Jroušek.

castle and depriving her of all her property. And so the king's daughter went sadly and in tears with her people down the hill to the small town lying at its foot." The painter has included only a small part of the castle and omits the town completely. The event takes place on a short slanting bridge in front of the castle gate. The indication of the boundary of the gate and the physical and social activity on the inclined bridge exemplify the painter's skill in expressing the departure in dramatic terms. This close-up view has allowed the scale of the figures to be retained, and this was essential for the clear visibility of the scene from the church nave. The painter has also paid close attention to the active

figures. The presence of children appeals once again to the viewer for sympathy. This detail is not to be found in Dietrich's text which does not mention that Elizabeth was accompanied by children on her way from Wartburg. The source seems to be Cesarius of Heisterbach, who mentions the presence of children and a handmaid, while praising Elizabeth's abundant patience and strength in tolerating this bitter fate.[452] Unlike in the text of the legend, Elizabeth's attendants are absent. Two ostentatiously dressed people – a man and woman behind the saint – are not to be interpreted as Elizabeth's retinue. The gestures of this couple indicate contradicting emotions: the woman extends her hand behind the departing saint, while the man restrains her. The significance of the woman's gesture is heightened through its position on the central axis of the composition, at the mid-point of the undulating line started by Elizabeth's white scarf. At the end of this line the man's subtle but deliberate movement prevents the woman from stepping forward. The gesture of his other hand suggests he is explaining the situation to her. The increased ambiguity in the picture's message, which is evident in comparison with the handling of the same theme in the Lübeck version, may be interpreted positively as a more realistic expression of the complicated and tense reactions of the three protagonists. Despite her downcast eyes Elizabeth does not depart humbly bowed but retains a stature comparable to the figures standing behind her. In the Lübeck version, Elizabeth reaches the height of the other figures even when strongly bowed, so that she appears to be larger.[453] The Košice picture differs even more significantly from the expulsion scene in the Naples fresco cycle, both in the composition of the figural scene and its visual prominence within the cycle. The expulsion scene in Naples is not independent but integrated into a smaller scale within a single space where other episodes are represented in larger format. In Košice, smaller figures look out from the castle battlements, like those in the earlier painting of the Nativity form Master Albrecht's altar in Vienna. The painter shows their saddened faces in reduced scale because they are merely part of the background to the main action and meant to distract the viewer's attention.

[452] "*Nam post mortem mariti sui de castro et ceteris possessionibus dotalicii sui cum liberis et ancillis suis miserabiliter satis eiecta est, sed quia 'mulier fortis' fuit, equanimiter universa tolleravit.*" – Sermo de translatione beate Elyzabeth. In: CAESARIUS – KÖNSGEN, *Das Leben der Heiligen Elisabeth: [und andere Zeugnisse]*, p. 96.

[453] C. SAUMWEBER. *Der spätgotische Elisabethzyklus im Lübecker Heiligen-Geist-Hospital. Studien zu Stil und Ikonographie*, Thesis/dissertation: Microfiche, 1994, p. 221.

The humiliation of the saint reaches its culmination in the next scene, which is devoted to her meeting with an ungrateful beggar woman. (Fig. 78) An old woman dressed in rags pushes the saint into the muddy puddle, as if oblivious of the charity from which she has previously benefited.[454] The depiction of her baseness was expected to provoke the opposite feelings to those elicited by the traditional identification of the beggars with Christ. The customary relationship between poor and the rich is here reversed. The poor woman shows contempt towards the princess, but the latter retains her humanity and religious rectitude, without overreacting. A slight frown is visible. The large-scale depiction of this theme represented a clear and influential statement within a public space. Instead of the religiously motivated identification of the pauper with Christ, it offered a more skeptical and perhaps more realistic portrayal of life. The negative image of the poor old woman did not aim to elicit viewers' sympathy, but rather constituted a sober observation of everyday reality and critical thinking. Increased empirical observation and realistic representation appeared in Košice not only in way the ungrateful woman was depicted – her angry expression and torn clothes, but also in the more faithful depiction of the surroundings, which brought the scene closer to the citizens. The visual language is similar to that of the Visitation scene on the altar for the Scottish monks in Vienna.[455] The new function of the picture of the ingratitude of the poor is not to be attributed to the Košice painter's expertise. Far less artistic skill is discernible in the Bardejov painter's rendering of the same scene, where the saint is painted without a halo and where the unsympathetic features of the beggar woman verge on caricature. A similar visual transformation could intensify the effect of a picture on contemporary viewers whereas an unfavorable representation of poor folk may have served to dissuade well-to-do citizens from performing spontaneous individual actions in support of the poor. This critical observation of reality ushered in a process involving both the use of rational methods to identify the real needs and problems of the less privileged as well as the organization of charitable activity.

Elizabeth's work in the hospital, which had been depicted on the northern porch of the church, is to be found again on the high altar (Fig. 79). The saint bathing a beggar in a tub is placed at the center of the scene while other patients are lying in beds in the background. The motif of the identification of the sick,

[454] RENER (ed.), *Die Vita der heiligen Elisabeth des Dietrich von Apolda*, pp. 72-73; HUYSKENS (ed.), *Libellus de dictis quattuor ancillarum s. Elisabeth confectus*, p. 35.
[455] SALIGER, *Der Wiener Schottenmeister*, pp. 80, 147-151.

or the beggar, with Christ by means of a cross combined with a halo, known for example from Cologne, is absent.[456] However, the painter's portrayal of Elizabeth's activity in the hospital, in which unprecedented illusionistic effects are used, may have focused renewed attention on the saint's activities and emphasized their topical meaning.

The scene is placed is placed near an altar in front of which another beggar is sitting. The way the head is tilted to one side was gravid with expressive meaning, while also underscoring the logic of the composition. On the right-hand side a sick man in bed provides a counterbalance to the altar table on the left behind which two men with crutches are conversing. The obliquely placed edge of another patient's bed behind Elizabeth's back balances the obliquely arranged heads of the two men behind the altar, while also indicating part of the outer frame of the composition. Whether intentional or not, the two compositional circles also have a deeper symbolic meaning. These indicate that in the final stage of her life, the saint devoted herself exclusively to caring for the sick. In the Košice picture, the saint's body is subordinate to the expression of the underlying idea of concentration. Her back is humbly inclined in the direction of the compositional circles; her caring hands are directed towards the suffering person at the center.

The faces and bodies of the people depicted bespeak the burden of the human condition. The skin of the ailing man at the center of the picture is flecked with wounds or boils. The downturned outh, bowed head and help-lessly positioned hands convey misery and suffering. Although Elizabeth's face does not show despair, nor does it show any joy. Humble acceptance of fate is conveyed as well as compassion for human suffering. The inspiration for this position through Christ's sacrifice on the cross is made present in the picture by the inclusion of the Crucifixion group on the altar. Despite the pervasively gloomy atmosphere, the painter has nevertheless expressed the contrast between the sick people and the saint. He has given Elizabeth more refined features while the patient's physiognomy is coarser. Of significance is distinction by skin color: the saint's paler complexion emphasizes her noble, upper-class descent. Compared with the above-mentioned scene of the cutting a beggar's hair in the castle garden, however, her clothing is far less luxurious: the

[456] Cologne, Wallraf-Richartz Museum (inv. n. WRM 35-37); Ludwigshafen (Wilhelm-Hack-Museum, inv. n. 457/35); G. JACOBS, *Elisabeth beherbergt Fremde,* in D. BLUME – M. WERNER (eds.), *Elisabeth von Thüringen – eine europäische Heilige. Aufsätze,* Petersberg, 2007, pp. 395-397; F.G. ZEHNDER, *Katalog der Altkölner Malerei,* Köln, 1990, pp. 120-124.

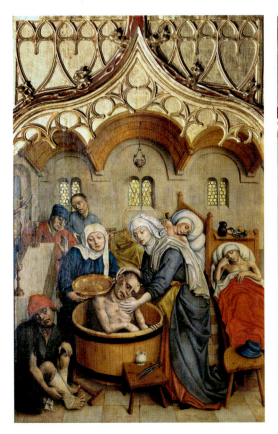 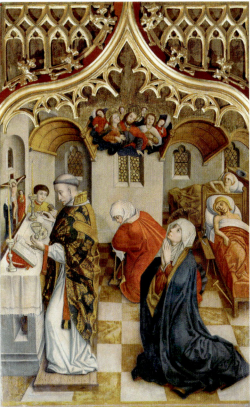

Fig. 79, Elizabeth bathes a sick man, 1474–1477, panel painting, 126,5×81cm, Košice, cathedral and former parish church of Saint Elizabeth, Photo: Alexander Jiroušek.

Fig. 80, Elizabeth's vision, 1474–1477, panel painting, 126,5×81cm, Košice, cathedral and former parish church of Saint Elizabeth, Photo: Alexander Jiroušek.

fur-trimmed brocade pelerine has been replaced with a simple blue-grey habit. Elizabeth bathes the sick man who is hunched up in a tub. Her hands are placed on his head and chest while an assistant is about to pour water from behind. These actions are reminiscent of images of baptism. Physical and spiritual care here coalesce, thereby pointing to Elizabeth's characteristic approach to suffering. The painter's rendering of the theme also brings out the psychological aspect. The new pictorial language has resulted in an altogether more compelling and precise representation of the bodies of patients, whose facial expressions betray endurance and affliction. Painful expressions and the realistic

depiction of blemished skin may have elicited a more intense emotional response from viewers, who were expected to feel sympathy similar to that expressed by Elizabeth and the other nurses. The Košice artists have found an original way of heightening the emotional tension in the picture of a comforting vision.

Medieval visionaries and many of the people around them understood the content of a vision not as the product of fantasy, but as a genuine extra-psychic reality.[457] Theologians distinguished illumination – the function of which was to raise the thinking of a person so that he or she could perceive divine mysteries – from natural experience with fantasy, such as daydreaming or dreaming at night. Visions were interpreted as signs of extraordinary divine grace which confirmed the proximity of the saint to God.[458] The theological and philosophical approach of some thinkers to these questions changed significantly during the Late Middle Ages. It may appear as though the personal sphere of reality began to eclipse with the empirically visible world. For example, Nicholas of Cusa emphasized the paradox that the invisible, and, above all, elevated God, could be seen by anybody, anywhere, from any vantage point.[459] In this context, apparently ordinary people began to open themselves up to the possibility of experiencing encounters with God in otherwise ordinary everyday life.[460]

The Košice picture of St. Elizabeth's vision during the celebration of mass in the hospital represents the painter's synthesis of various stories about the saint's extraordinary visionary experiences.[461] (Fig. 80) This unique composition is based on a triangular or pyramidal scheme in which the figures of the saint and the celebrating priest are depicted in the lower register, while the apex is given over to Elizabeth's vision of Christ as a crowned king and Mary as queen of heaven. Christ extends his hand towards Elizabeth. A blue cloud defines the

[457] P. DINZELBACHER, *Mittelalterliche Visionsliteratur,* Darmstadt, 1989, p. 6.

[458] REBER, *Die Gestaltung des Kultes weiblicher Heiliger im Spätmittelalter. Die Verehrung der Heiligen Elisabeth, Klara, Hedwig und Birgitta,* p. 162.

[459] *De visione dei,* cap. 12: "*Tu igitur, deus meus invisibilis, ab omnibus videris et in omni visu videris; per omnem videntem in omni visibili et omni actu visionis videris, qui es invisibilis et absolutus ab omni tali et superexaltatus in infinitum.*"

[460] I. BOCKEN, *Performative Vision: Jan van Eyck, Nicholas of Cusa and the devotio moderna,* in G. JARITZ (ed.), *Ritual, Images, and Daily Life. The Medieval Perspective,* Zürich, Berlin, 2012, 95-106, p. 96.

[461] These appear in many texts, including the canonization documents from the time of Pope Gregory IX or RENER (ed.), *Die Vita der heiligen Elisabeth des Dietrich von Apolda,* p. 107; see REBER, *Die Gestaltung des Kultes weiblicher Heiliger im Spätmittelalter; die Verehrung der Heiligen Elisabeth, Klara, Hedwig und Birgitta,* pp. 182, 209-212; KLANICZAY, *Az uralkodók szentsége a középkorban,* p. 219.

lower margin of the vision, but otherwise the golden background extends behind the heavenly group. Elizabeth mentioned her experience to the noble and pious Isentrud: "I saw heaven open and my sweetest Lord Jesus Christ, who leaned down to comfort me about the various trials and tribulations, which surrounded me."[462] The motif of escape from difficulties is also in keeping with Elizabeth's exhausting life style, which included her work in the hospital. The vision helped Elizabeth come to terms with her own suffering and that of the poor and sick for whom she cared. After her vision, rather than of concentrating on transitory earthly difficulties, she focused on love for her eternal heavenly bridegroom. Two sick people in bed can be seen in the background on the right-hand side of the Košice picture. Elizabeth kneels, hands folded in prayer, with her back to the sick people. Her gaze is directed upwards and she concentrates on a vision only she can see. A kneeling woman in the center of the background looks toward the ground, absorbed in prayer. The priest standing on a low platform in front of the altar is turned away from the other figures and devotes his attention to the liturgy. His bowed and tonsured head and the solemn, age-worn expression bear witness to a lengthy experience in the life and rituals of the Church. Although the central mystery of the mass is literally in his hands, the heavenly kingdom is out of his reach. The personal devotion of the young female saint takes precedence over the sacramental piety of the experienced priest. The specific meaning of the Košice composition is all the more evident when compared with depictions of the visions of other saints. An illumination to a manuscript of the Revelations of St. Bridget of Sweden, now preserved in New York, originated as early as *c.* 1400.[463] As in our picture, we see in the bottom left-hand corner a priest in front of an altar, but on the Elevation of the Host, he also experiences a Eucharistic vision. Heaven opens up to the meditating saint in the bottom right-hand corner and rays of light from the hands of Jesus and Mary stream toward her. The painter is more preoccupied with a rich detailed depiction of the content of the vision, rather than with its surroundings. The Košice picture of St. Elizabeth's vision places it in a hospital

[462] RENER (ed.), *Die Vita der heiligen Elisabeth des Dietrich von Apolda*, p. 74: "*Vidi celum apertum et dominum meum Iesum Christum dulcissimum inclinantem se ad me et consolantem me de variis angustiis et tribulacionibus que circumdederunt me.*"

[463] Pierpont Morgan Library MS 498, fol. 4v, Naples, Italy, last quarter of 14th century; see M. CAMILLE, *Gothic Art: Glorious Visions*, New York, NY, 1996, fig. 8; J.F. HAMBURGER, *The Rothschild Canticles: Art and Mysticism in Flanders and the Rhineland circa 1300*, New Haven, CT, 1990; for literary sources – REBER, *Die Gestaltung des Kultes weiblicher Heiliger im Spätmittelalter; die Verehrung der Heiligen Elisabeth, Klara, Hedwig und Birgitta*, pp. 212-213.

rather than, for example, in a church. Presenting a hospital as the location of a wonderful vision contributed to the promotion of the desired image of the similar institution administered by the town.

3.6.4. The Triumph

The last pair of images represents the final triumph of the saint. First, the visions and auditions represented in the image of her dying continue the thematic line of the previous sequence but they also stand out as a celebration of her birth for the heavenly kingdom. Second, the extraordinary feat of translation combines the political recognition, expressed through the Emperor's presence, with the liturgical celebration, showing the exemplary reverence to the saint.

The first picture can be better understood when compared with the illustrated tract on the Art of Dying Well (*Ars bene moriendi*), which was published several times during the fifteenth century.[464] The illustrations show demonic forces struggling with angels over the fate of the dying person's soul. The accompanying texts, which are based on the ideas of John Gerson, give these confrontations an ethical dimension. However, the pictures of the exceptional deaths of saints are not necessarily accompanied by dramatic struggles with demons, and the saints could attain the beatific vision even before leaving this world.

There are no demons surrounding the dying St. Elizabeth in the Košice picture (Fig. 81). The visionary elements are multiplied. As though it were not enough to see the open heaven in the upper part of the picture, a group of chanting angels accompanies the dying saint behind the substantial wooden bed-head. The written sources clarify this abundance of supernatural features. Conrad's letter, written shortly after Elizabeth's death on 17 November 1231, mentions that the witnesses at the Saint's death heard "the sweetest song, which the saint produced without moving her lips".[465] Dietrich's legend mentions the lovely song of the heavenly hosts awaiting Elizabeth's passing. "A wonderful

[464] Schneider 1996. See also the cycle *Ars moriendi* in W.L. STRAUSS – C. SCHULER – A.V. BARTSCH, *German Book Illustration before 1500*, New York, NY, 1981, pp. 419-429. For general information also A.E. IMHOF, *Ars moriendi: die Kunst des Sterbens einst und heute*, Wien, 1991.

[465] HUYSKENS, *Quellenstudien zur Geschichte der hl. Elisabeth, Landgräfin von Thüringen*, p. 149: "*dulcissimum cantum sine motu labiorum in gutture eius audierint*". See DINKLER-VON SCHUBERT, *Der Schrein der hl. Elisabeth zu Marburg. Studien zu Schrein-Ikonographie*, p. 175.

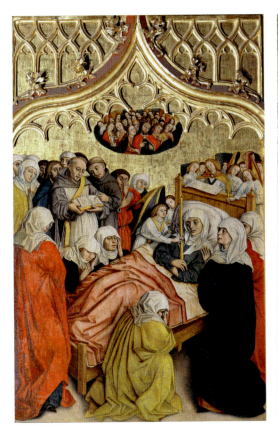

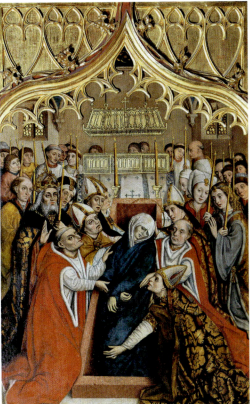

Fig. 81, Elizabeth on her deathbed, 1474–1477, panel painting, 126,5×81cm, Košice, cathedral and former parish church of Saint Elizabeth, Photo: Alexander Jiroušek.

Fig. 82, The elevation and translation of Elizabeth's remains, 1474–1477, panel painting, 126,5×81cm, Košice, cathedral and former parish church of Saint Elizabeth, Photo: Alexander Jiroušek.

thing! In her throat, they heard sweet words although her lips did not move. Those sitting around asked her: What is it? She answered by asking: 'Did you hear me singing with others?' None of the believers could doubt that she was hearing the gentle song of the heavenly hosts awaiting her passing. She was joining in and gently singing with them to the glory of the Lord."[466] Behind

[466] RENER (ed.), *Die Vita der heiligen Elisabeth des Dietrich von Apolda*, p. 112: "*Mira res: Tunc voces suavissime sine omni motu labiorum in eius gutture audiebantur. Cumque circumsedentes ab ea quererent, quid hoc esset, requisivit ab eis dicens: 'Numquid audistis mecum aliquos decantantes?' Hic nulli fidelium dubitare conceditur, quin supercelestium agminum eius exitum prestolan-*

the bed angels offer open scrolls bearing musical notation to the dying saint. The depiction of scroll-bearing angels expressing unusual acoustic phenomenon does not belong to the standard iconography of Elizabeth's death; for example, the angels do not appear on the altar from 1510 at Smrečany. The cycle *Ars moriendi* from Cologne,[467] which was published in 1475, means it must be contemporary with the Košice altar, thereby providing a particularly apposite comparison with our picture.[468] These illustrations, or similar ones, may have inspired such motifs as the angel placing a lighted candle in the crossed hands of the saint. By the fourteenth century, *ordinaria* prescribed that a candle should be placed in the hands of the dying person or held in front of him or her. These and similar rules testify to a belief in the apotropaic power of candles; moreover, the motif recalls the lamps of the wise virgins in the biblical parable.[469] The Košice picture does not represent the *viaticum* or the sacrament of anointing of the sick; it is inspired only by the liturgy. The saint's final struggle is accompanied by the chanting or reading of monks. Despite the requirement in the *Ordo visitandi* for a cross to be held by the officiating priest, no such cross is evident here.[470] The saint did not need a man-made image because she experienced direct spiritual contact with the supernatural world. The picture of Elizabeth's vision was intended to provide the viewer with an idea of the blessedness accompanying the departure of the saint from the earthly "vale of tears" to the heavenly kingdom. In contrast to the *Ars moriendi*, the Elizabeth in the Košice picture does not examine her conscience in respect to

tium suavem et mulcibrem, cui concinutit tam dulciter, audierit armoniam cantans cum ipsis gloriam domini."

[467] It also shows historical stylistic connections with the work of the Meister des Marienlebens. See A. HEKLER, *Ungarische Kunstgeschichte*, Berlin, 1937, p. 78. Most of the works of the Meister des Marienlebens are now preserved in the Alte Pinakothek in Munich.

[468] STRAUSS – SCHULER – BARTSCH, *German Book Illustration before 1500*, pp. 419-429. The pictures in this cycle are contradictory in structure; pictures of the temptation are followed by pictures of temptation overcome. After victory over lack of faith, despair, worldly vanity, impatience and miserliness, the dying person achieves complete victory over temptation.

[469] C. SCHNEIDER, *Ars moriendi*, Berlin – Mainz, 1996, p. 14–37. The association with the wise virgins is also relevant to the case of St. Elizabeth. The mass in her honor describes her as a bride of Christ and calls on her to accept the crown that the Lord has prepared for her: "*veni sponsa Christi (…) accipe coronam quam tibi Dominus preparavit in aeternum.*" DINKLER-VON SCHUBERT, *Der Schrein der hl. Elisabeth zu Marburg. Studien zu Schrein-Ikonographie*, p. 11.

[470] DINKLER-VON SCHUBERT, *Der Schrein der hl. Elisabeth zu Marburg. Studien zu Schrein-Ikonographie*, pp. 77-81 analyzes various *Ordines ad visitandum infirmum*. On the role of pictures and the sacraments in the medieval understanding of death see also H. FUHRMANN, *Bilder für einen guten Tod*, München, 1997, pp. 9-17 and P. BINSKI, *Medieval Death: Ritual and Representation*, Ithaca, NY, 1996, p. 40.

various temptations, and the angels did not have to struggle against attacks from demons.[471]

The veneration of relics is also expressed forcefully on the Košice altar of St. Elizabeth, where the ceremonial *elevatio* and *translatio* constitute the theme of the final scenes in the pictorial legend of the saint. (Fig. 82) The ritual expression of veneration for the saint's body contrasts with the humiliation to which she was subjected in life. Five mitered bishops in brocade wearing their ecclesiastical vestments together with two monastic dignitaries hold Elizabeth's body above a grave fashioned from red marble. The tomb, in which the saint (clothed in similar fashion to the clothing elsewhere in the cycle) was buried, is painted from an elevated vantage point in order that the saint's incorrupt body stands out. The kneeling ecclesiastical dignitaries, who wear pious expressions, hold up the precious body. The Church as the authorized bearer and administrator of the cult has the body literally and pictorially in its hands. The grey-bearded crowned Emperor stands among the faithful, who participate in the celebration holding tapers. Despite his privileged position, the Emperor is already a little more distant from the center of the cult and the salvation-bringing power.[472] The presence of the Emperor is a sign which clearly differentiates this image from a burial of the saint. No Emperor was present at Elizabeth's burial (1231). To understand his presence, the viewer's imagination needs help from a different medium, mostly a textual narrative, delivered either in written or spoken form. Caesarius of Heisterbach recorded the information that the Holy Roman Emperor Frederick the Second himself found time to be present at the ceremonial translation, during which Elizabeth's body was elevated from the original grave and transferred into a shrine.[473] Caesarius' text offers a solid basis for an understanding of the image, but – there are still some very interesting contradictions between his text and the image. Caesarius relates that the Emperor, despite his power and wealth, came barefoot in a simple grey tunic.[474] This formulation might have referred to a fact, but it might only be

[471] The depiction of a demonic attack on the death of a saint is not to be excluded: see e.g. the picture of the death of St. Martha by Leonardo of Brixen (c. 1460–1470, Neustift, Stiftsgalerie).

[472] The relationship of the Emperor to the saint in direct connection with the elevation of her remains is analyzed by BEUMANN, *Friedrich II. und die heilige Elisabeth. Zum Besuch des Kaisers in Marburg am 1. Mai 1236, Sankt Elisabeth. Fürstin, Dienerin, Heilige. Aufsätze, Dokumentation, Katalog*, pp. 151-166.

[473] See above, chapter 1.3.

[474] *Sermo de translatione beate Elyzabeth*, in CAESARIUS – KÖNSGEN, *Das Leben der Heiligen Elisabeth: [und andere Zeugnisse]*, 94-115.

a pious wish of the learned Cistercian monk. The patrons and painters Košice preferred to see the Emperor in a precious brocade gown with a large fur collar and a heavy golden chain around his neck. The inhabitants of the rich town did not share the ideals of poverty presented by the monastic writer.

Other contradictions between the narrative and the image lead in a different direction. Caesarius reported that clergymen who were preparing the translation found Elizabeth's body whole and without any sign of corruption, but before the translation the flesh and skin with hair on her detached head had to be separated from the bones so as not to repel the faithful. It is unlikely that the whole and incorrupt head – judging by the pious narratives – would provoke greater horror in the participants at the feast than would a naked skull. But the Košice image presents the holy body whole and without any signs of corruption. The preservation of an incorrupt body was taken to be proof of the holiness of the person. The faithful associated sanctity with the idea of force (*virtus*) inherent in the bodies of saints. It also prevented the normal decay of the corpse.[475] Even Elizabeth's blue tunic and white scarf are those she wore as a young widow. They seem to be in pristine condition despite reports shortly after Elizabeth's death that enthusiastic believers tore away pieces of material. In the composition of the picture, the clergymen hold the body on display, as if urging the viewer to look at the power of miracles and admire the Lord who performed them through this saint. All the gruesome details of the textual narrative and the tragic contingencies associated with the body of the deceased saint, have been omitted from the picture, where the emphasis is placed on the great mystery, which perfectly harmonizes with other great narratives of Christianity.

A reliquary, in which the fragile holy body is about to be placed, can be seen in the background, on the central axis of the painting, on the altar covered by an embroidered cloth. Monks and deacons wearing white robes stand in solemn attendance. The coffin lid hangs on ropes in readiness for the lowering of the transferred body during the ritual of the *depositio*. The reliquary was to become the center of the cult and the scene of many miracles.[476] Thus, the composition

[475] VAUCHEZ, *La sainteté en Occident aux derniers siècles du Moyen Age: d'après les procès de canonisation et les documents hagiographiques*, p. 499.

[476] In Elizabeth's case, the number of reports of miracles at her grave is extraordinary. The first is a modest report of miracles between 20 November 1231 and 18 March 1232, published in HUYSKENS, *Quellenstudien zur Geschichte der hl. Elisabeth, Landgräfin von Thüringen*, p. 150. The most extensive report was produced by the Papal commission in connection with the process of her canonization completed in January 1235 (ibid, pp. 155-266). Dietrich of Apolda also

of the picture presents the elevation and subsequent translation of the remains as their elevation in both the literal and metaphorical senses. The depicted celebration stands at the beginning of the annual celebration of the feast day of the Elevation of the Body of St. Elizabeth. The significance of the feast day for Košice is demonstrated by the Bull of Pope Boniface IX of 1 March 1402, which specified that pilgrims coming to the church in Košice on that day would be granted the same indulgence as if they had completed the pilgrimage to Venice or Assisi.[477]

The anonymous ideators responsible for the iconographical program of the high altar in Košice were certainly familiar with the teachings of Saint Francis on poverty. It is well known that the Franciscans were present in the town. They were depicted on the altar singing with the angels at the death of the Saint. However, the patrons did not wish to see Elizabeth giving garments, money, or food to the poor. Instead, they preferred to see her caring for the sick. Moreover, the poor were represented by a demonic-looking old woman, pushing Saint Elizabeth into the mud. Thus, the poor woman constantly offended the feelings of the faithful by showing her lack of respect towards the Saint and also ingratitude, because – so the legend goes – she had previously accepted Elizabeth's alms.[478] The hidden political implications of the legend of the Saint in municipal life led to a revision of her previous pictorial legend. The new iconographic focus on the visionary experience of the saint reflects the growing importance of personal devotion in the period. The angelic action, which was originally intended to manifest a heavenly reward for the charitable action, was depicted also to enable an alternative reading, stressing the religious and ethical superiority of a richly dressed lady to the problematic poor one. The finest paintings of the retable testify to the moderate yet decisive reception of the achievements of early Netherlandish painters in depiction of figures, space, and the materiality of things, analogous in many respects to the Viennese Schottenmeister, even if preserving a more lyrical than descriptive tone. The material and artistic qualities of the retable contradict any radical reading of Elizabeth's love of poverty.

drew on these sources – see THEODORICUS, *Vita S. Elyzabeth,* in M. RENER (ed.), *Die Vita der heiligen Elisabeth des Dietrich von Apolda,* Marburg, 1993, p. 114.

[477] *Archivio Segreto Vaticano,* Anni XIII, Liber c. f. 76. Transcription in *Monumenta Vaticana Historiam Regni Hungariae Illustrantia.*Ser. l, T. 4. Budapestini 1889, 417–418. See also JUCKES, *The Parish and Pilgrimage Church of St. Elizabeth in Košice: Town, Court and Architecture in Late Medieval Hungary,* pp. 32-33.

[478] RENER (ed.), *Die Vita der heiligen Elisabeth des Dietrich von Apolda,* pp. 72-73. HUYSKENS (ed.), *Libellus de dictis quattuor ancillarum s. Elisabeth confectus,* p. 35.

CONCLUSION

The images analyzed in this book offer valuable insights into the history of individual and collective imagination at several levels. These interrelated levels can frequently be identified and described within a single image.

It can be argued that the images reveal a dialogue between various individual imaginations and traditional iconography. The images discussed in this book give each viewer the possibility to interact with Saint Elizabeth's unique spiritual way. Elizabeth's spiritual growth was nurtured by various sources, including moments of spontaneous spiritual inspiration. Examples of this inspiration were conveyed by legends and other narratives to religious leaders who went on to imagine and commission a visual image. In some sense Elizabeth's spiritual leaders – including both Conrad, who was so close to her, and the influential Pope – were always aware of the possible impact of the saint's story on wider audiences and the problems they were confronted with as people occupying leading positions in the Church and society. It was probably these leaders who first identified the enormous potential associated with the religious zeal of the extraordinary noble lady. In terms of spiritual care and issues of dogma, Elizabeth was a shining example offering new paths towards Christian charity. The spiritual leaders of the time – above all Conrad and the Papal commissioners – were the first to document an extract from the narratives on her exceptional life. Recording what they heard they prepared a unique set of narratives which was to influence further creative processes, including creativity in the sphere of the visual arts. Materialized images have mediated these experiences further. When they represented one of the saint's radical practical actions viewers were able to imagine something that would perhaps otherwise never have occurred to them spontaneously. A perception of the image created an interval in their imagination – a space between the spontaneously produced fantasies and visual memories nurtured by the images.

This broadened imagination has conveyed new concepts and value hierarchies, the images have continued to invite people to see and contemplate. The radical understanding of Christian love presented by Elizabeth has been a source of inspiration to many of her admirers. The images represent an important testimony of what happened, or rather how the artist or patron imagined events from the saint's life. Elizabeth's extraordinary individual charity was anchored in her desire to draw nearer to Christ. She was one of the chosen few to be

medialized by legendary narratives and visual images as the prominent example of the Christian ideal of unlimited love and kindness for subsequent generations. Her desire to alleviate the suffering of people around her enriched the imagination and sensibility of individuals. This vivid imagination continues to motivate individual actions and a search for solutions which could be applied on a broader social scale. These creative efforts repeatedly transcended the sphere of individual imagination and resulted in artifacts which have carried the message of saintly life not only to individuals, but to whole communities.

The artists and their patrons who influenced the process of social mediation must have experienced and considered the needs and desires which characterized their period and the communities they were serving. Once again there has been a significant interval between over-temporal needs or values and contingent historical situations with changing constellations of interests, medial landscapes and rules of political game. The message conveyed to crusaders necessarily differed from that conveyed to noble women shut up in a monastery or the rich merchants who played pivotal roles in municipal life. Despite the changing communities and situations immediately surrounding a pictorial cycle, the medieval cult of saint Elizabeth awakened the interest of the most influential political figures of the time. In each of the situations described in this book a prominent and influential emperor or a king had a personal interest in the saint and her cult – Frederic II, Charles IV, Sigismund of Luxemburg and Mathias Corvinus being the most important political personalities to cite in this context. Their individual dialogues with the saint conveyed resonant spiritual messages, which were valid for the duration of any individual's lifespan, with transient concerns about political struggles, military fights, or materialistic considerations. As a result, the images are multilayered products reflecting human needs and longings on several levels. These multilayered messages of images have occupied the thoughts of iconologists for centuries. The author of this book would like to contribute, albeit modestly, to the transhistorical effort to understand the lively interactions between prototypes, images and viewers, their changing roles and positions in course of their unique individual life pilgrimage. The physical life of Elizabeth was short, but she has left a trace, which continues to open up, elevate and deepen our appreciation of, and attitude toward, the most important human concerns. This book is a testimony from this endless flux of feelings, observations and meditations in an effort to broaden slightly the limited range of human experience.

ILLUSTRATIONS

Fig. 1, Head reliquary of the Saint, *c.* 1235, agate bowl, gold, gilded silver, gemstones, pearls (*c.* 45×25,8 cm), Stockholm, Statens Historiska Museum, Inv. Nr. 1, Photo: Ola Myrin, National Historical museums, Sweden.

Fig. 2, The choir window, *c.* 1235–1250, stained-glass, Marburg, Church of Saint Elizabeth. Photo: Horst Fenchel, Bildarchiv Foto Marburg, fmc188621.

Fig. 3, The shrine of Saint Elizabeth, Maiestas side, *c.* 1235–1250, gilded copper and silver on oak-wood core (h: 135 cm, l: 187 cm, w: 63 cm), Marburg, Church of Saint Elizabeth, Photo: Bildarchiv Foto Marburg, fmbc31745_09.

Fig. 4, The crowning of Saints Elizabeth and Francis, stained-glass, *c.* 1235–1250, Marburg, Church of Saint Elizabeth, Photo: Bildarchiv Foto Marburg, fmc426937.

Fig. 5, Benedetto Antelami (workshop), works of mercy, after 1196, the west portal of the baptistery, Parma, Photo: author.

Fig. 6, Saint Elizabeth feeding the hungry, *c.* 1235–1250, stained-glass, Marburg, Church of Saint Elizabeth, Photo: Bildarchiv Foto Marburg, fmc188615.

Fig. 7, Saint Elizabeth washing the feet of a poor man, drinking of the thirsty, and feeding of the hungry, *c.* 1235–1250, gilded copper, Marburg, Church of Saint Elizabeth, Photo: Bildarchiv Foto Marburg, fmc411686.

Fig. 8, Saint Radegond of Poitiers washing the feet of a poor man, *c.* 1050, painting on parchment, Poitiers, Bibliothèque municipale, manuscrit 250, fol. 29v. From La vie de sainte Radegonde par Fortunat. Photo: author.

Fig. 9, Saint Elizabeth clothing the naked, stained-glass, *c.* 1235–1250, Marburg, Church of Saint Elizabeth, Photo: Bildarchiv Foto Marburg, fmc426930.

Fig. 10, Saint Elizabeth clothing the naked, the return of the Ludwig's bones, *c.* 1235–1250, gilded copper, Marburg, Church of Saint Elizabeth, Photo: Bildarchiv Foto Marburg, fmbc3173713.

Fig. 11, Saint Elizabeth housing strangers, stained-glass, *c.* 1235–1250, Marburg, Church of Saint Elizabeth, Photo: Bildarchiv Foto Marburg, fmc426928.

Fig. 12, Saint Elizabeth caring for the sick, stained-glass, *c.* 1235–1250, Marburg, Church of Saint Elizabeth, Photo: Bildarchiv Foto Marburg, fmc426935.

Fig. 13, Saint Elizabeth visiting prisoners, stained-glass, *c.* 1235–1250, Marburg, Church of Saint Elizabeth, Photo: Bildarchiv Foto Marburg, fmc426936.

Fig. 14, Saint Elizabeth giving alms, stained-glass, *c.* 1235–1250, Marburg, Church of Saint Elizabeth, Photo: Bildarchiv Foto Marburg, fmc426936.

Fig. 15, Saint Elizabeth giving alms and accepting tunic, *c.* 1235–1250, gilded copper, Marburg, Church of Saint Elizabeth, Photo: Bildarchiv Foto Marburg, fmbc31740_07.

Fig. 16, The shrine of Charlemagne, 1182–1215, Aachen, Cathedral Treasury, Photo: Bildarchiv Foto Marburg, fm63434.

Fig. 17, The shrine of Virgin Mary, 1220–1239, Aachen, Cathedral Treasury, Photo: Bildarchiv Foto Marburg, fm131928.

Fig. 18, Nicholas of Verdun, The shrine of the Three Kings, before 1230, Cologne, Rheinisches Bildarchiv Köln, rba_c002806, Photo: Bildarchiv Foto Marburg.

Fig. 19, Saint Elizabeth, *c.* 1235–1250, gilded copper, Marburg, Church of Saint Elizabeth, Photo: Bildarchiv Foto Marburg, fmlac4241_18.

Fig. 20, Virgin Mary, *c.* 1235–1250, gilded copper, Marburg, Church of Saint Elizabeth, Photo: Bildarchiv Foto Marburg, fmlac4240_08.

Fig. 21, The shrine of Saint Elizabeth, Crucifixion side, *c.* 1235–1250, gilded copper and silver on oak-wood core (h: 135 cm, l: 187 cm, w: 63 cm), Marburg, Church of Saint Elizabeth, Photo: Bildarchiv Foto Marburg, fmlac4240_13.

Fig. 22, Taking up the cross and the farewell, *c.* 1235–1250, gilded copper, Marburg, Church of Saint Elizabeth, Bildarchiv Foto Marburg, Foto: Fenchel, Horst, fmbc31733_16.

Fig. 23, The farewell, *c.* 1235–1250, stained-glass, Marburg, Church of Saint Elizabeth, Photo: Bildarchiv Foto Marburg, fmc188611.

Fig. 24, Return of the Ludwig's bones, *c.* 1235–1250, stained-glass, Marburg, Church of Saint Elizabeth, Photo: Bildarchiv Foto Marburg, fmc426927.

Fig. 25, Saint Elizabeth accepting tunic, *c.* 1235–1250, stained-glass, Marburg, Church of Saint Elizabeth, Photo: Bildarchiv Foto Marburg, fmc426938.

Fig. 26, The marriage of Saint Elizabeth, Bibliothèque nationale de France, Paris, Nouvelle acquisition latine 868, fol. 6r., Photo : BNF Paris.

Fig. 27, *Liber depictus, c.* 1350, Vienna, Österreichische Nationalbibliothek, Cod. Vind. 370, fol. 85v-86r.

Fig. 28, Life of Saint Elizabeth, *c.* 1320, Church of Santa Maria Donna Regina, Naples.

Fig. 29, Astrologer studying the stars, *Liber depictus, c.* 1350, Vienna, Österreichische Nationalbibliothek, Cod. Vind. 370, fol. 85v.

Fig. 30, The birth of Ludwig, *Liber depictus, c.* 1350, Vienna, Österreichische Nationalbibliothek, Cod. Vind. 370, fol. 86r.

Fig. 31, The birth of Saint Elizabeth, *Liber depictus, c.* 1350, Vienna, Österreichische Nationalbibliothek, Cod. Vind. 370, fol. 85v.

Fig. 32, *Liber depictus, c.* 1350, Vienna, Österreichische Nationalbibliothek, Cod. Vind. 370, fol. 86v-87r.

Fig. 33, Elizabeth accepting Saint John as her patron, *Liber depictus, c.* 1350, Vienna, Österreichische Nationalbibliothek, Cod. Vind. 370, fol. 86v.

Fig. 34, Elizabeth receiving a grey tunic, *Liber depictus, c.* 1350, Vienna, Österreichische Nationalbibliothek, Cod. Vind. 370, fol. 87r.

Fig. 35, The marriage of Saint Elizabeth, *c.* 1320, Church of Santa Maria Donna Regina, Naples.

Fig. 36, Elizabeth's marital life, *Liber depictus, c.* 1350, Vienna, Österreichische Nationalbibliothek, Cod. Vind. 370, fol. 87v-88r.

Fig. 37, The married life of Saint Radegund, Poitiers, Bibliothèque municipale, manuscrit 250, fol. 24r.

Fig. 38, The flagellation of Christ, *Liber depictus, c.* 1350, Vienna, Österreichische Nationalbibliothek, Cod. Vind. 370, fol. 18r.

Fig. 39, Conrad of Marburg flogging Saint Elizabeth, *c.* 1260, Paris, Bibliothèque Sainte-Geneviève, Ms 2689, fol. 12r, Photo: BSG Paris.

Fig. 40, The flagellation of Saint Hedwig, 1353, Los Angeles, Getty Museum, MS Ludwig XI 7, fol. 38v. From: Der Hedwigs-Codex von 1353. Photo: author.

Fig. 41, Flagellants in medieval Hungary, *c.* 1358, Budapest, Széchényi könyvtár, Cod. 404, pag. 126. Photo: OSzK Budapest.

Fig. 42, Presentation of Jesus in the temple, *Liber depictus, c.* 1350, Vienna, Österreichische Nationalbibliothek, Cod. Vind. 370, fol. 3v.

Fig. 43, The story of Saint Elizabeth and the leper, *Liber depictus, c.* 1350, Vienna, Österreichische Nationalbibliothek, Cod. Vind. 370, fol. 92r.

Fig. 44, Duccio, Mary of Mercy, Siena, Pinacoteca Nazionale, no. 20.

Fig. 45, Virgin Mary protecting the hermit, *Liber depictus, c.* 1350, Vienna, Österreichische Nationalbibliothek, Cod. Vind. 370, fol. 123v-124r.

Fig. 46, Virgin Mary giving gifts to the poor, Meditations on the Life of Christ, Paris, Bibliothèque Nationale, cod. Ital. 115, fol. 30v, Photo : BNF Paris.

Fig. 47, *Liber depictus, c.* 1350, Vienna, Österreichische Nationalbibliothek, Cod. Vind. 370, fol. 88v–89r. From *Der Krumauer Bildercodex.*

Fig. 48, Virgin Mary at work and in prayer, Meditations on the Life of Christ, Paris, Bibliothèque Nationale, cod. Ital. 115, fol. 16v. Photo : BNF Paris.

Fig. 49, The work of St Wenceslas, *Liber depictus*, *c.* 1350, Vienna, Österreichische Nationalbibliothek, Cod. Vind. 370, fol. 33v–34r. From *Der Krumauer Bildercodex*.

Fig. 50, Saint Elizabeth milking a cow, *Liber depictus*, *c.* 1350, Vienna, Österreichische Nationalbibliothek, Cod. Vind. 370, fol. 88v. From *Der Krumauer Bildercodex*.

Fig. 51, Saint Elizabeth carding wool, *Liber depictus*, *c.* 1350, Vienna, Österreichische Nationalbibliothek, Cod. Vind. 370, fol. 91r. From *Der Krumauer Bildercodex*.

Fig. 52, Saint Elizabeth washing dishes, *Liber depictus*, *c.* 1350, Vienna, Österreichische Nationalbibliothek, Cod. Vind. 370, fol. 90v. From *Der Krumauer Bildercodex*.

Fig. 53, *Liber depictus*, *c.* 1350, Vienna, Österreichische Nationalbibliothek, Cod. Vind. 370, fol. 89v–90r. From *Der Krumauer Bildercodex*.

Fig. 54, The vision of Saint Elizabeth, *Liber depictus*, *c.* 1350, Vienna, Österreichische Nationalbibliothek, Cod. Vind. 370, fol. 90r. From *Der Krumauer Bildercodex*.

Fig. 55, *Liber depictus*, *c.* 1350, Vienna, Österreichische Nationalbibliothek, Cod. Vind. 370, fol. 90v–91r. From *Der Krumauer Bildercodex*.

Fig. 56, *Liber depictus*, *c.* 1350, Vienna, Österreichische Nationalbibliothek, Cod. Vind. 370, fol. 91v–92r. From *Der Krumauer Bildercodex*.

Fig. 57, *Liber depictus*, *c.* 1350, Vienna, Österreichische Nationalbibliothek, Cod. Vind. 370, fol. 92v–93r. From *Der Krumauer Bildercodex*.

Fig. 58, Codex Manesse, UB Heidelberg, Cod. Pal. germ. 848, fol. 300r. From *Codex Manesse*.

Fig. 59, Miracle with the Mantle, *Liber depictus*, *c.* 1350, Vienna, Österreichische Nationalbibliothek, Cod. Vind. 370, fol. 93v–94r. From *Der Krumauer Bildercodex*.

Fig. 60, The Nativity scene from Vyšší Brod altarpiece (*c.* 1346/47), panel painting (99×93 cm), Prague, National Gallery. Photo: Google Art Project.

Fig. 61, Master Theodoric of Prague, Saint Elizabeth with a beggar, panel painting, Karlstejn Castle. From *Magister Theodoricus*.

Fig. 62, Greater Seal of Košice, before 1383, Košice, Municipal Archive, Photo: MA Košice.

Fig. 63, Andrew II with his children. Chronicon Pictum, *c.* 1358, Budapest, Schéchényi könyvtár, Cod. 404, p. 123. Photo: OSzK Budapest.

Fig. 64, The reliefs of the northern porch, *c.* 1410, Košice, the cathedral and former parish church of Saint Elizabeth, Photo: Alexander Jiroušek.

Fig. 65, Charitable works of Saint Elizabeth, The left-side relief of the northern porch, *c.* 1410, Košice, the cathedral and former parish church of Saint Elizabeth, Photo: author.

Fig. 66, Charitable works of Saint Elizabeth, The right-hand side relief of the northern porch, *c.* 1410, Košice, cathedral and former parish church of Saint Elizabeth, Photo: author.

Fig. 67, The high altarpiece with opened wings, 1474–1477. polychromed and gilded limewood, 1260×810 cm, Košice, cathedral and former parish church of Saint Elizabeth, Photo: Alexander Jiroušek.

Fig. 68, The corpus of the high altarpiece with opened wings, 1474–1477, polychromed and gilded limewood, 437×408 cm, Košice, the cathedral and former parish church of Saint Elizabeth, Photo: Alexander Jiroušek.

Fig. 69, Birth of Saint Elizabeth, 1474–1477, panel painting, 126,5×81cm, Košice, cathedral and former parish church of Saint Elizabeth, Photo: Alexander Jiroušek.

Fig. 70, Elizabeth's betrothal to Ludwig, 1474–1477, panel painting, 126,5×81cm, Košice, the cathedral and former parish church of Saint Elizabeth, Photo: Alexander Jiroušek.

Fig. 71, Master of the Life of the Virgin (Meister des Marienlebens): The Birth of Mary Munich, Alte Pinakothek Inv.-No. WAF 619. Photo: The Yorck Project (2002) 10.000 Meisterwerke der Malerei (DVD-ROM), distributed by DIRECTMEDIA Publishing GmbH. ISBN: 3936122202.

Fig. 72, Elizabeth's betrothal to Ludwig, *c.* 1480, panel painting, Bardejov, Photo: author.

Fig. 73, Elizabeth cuts a sick man's hair, 1474–1477, panel painting, 126,5×81cm, Košice, cathedral and former parish church of Saint Elizabeth, Photo: Alexander Jiroušek.

Fig. 74, Miracle of the cross and the roses, 1474–1477, panel painting, 126,5×81cm, Košice, cathedral and former parish church of Saint Elizabeth, Photo: Alexander Jiroušek.

Fig. 75, Miracle of the ceremonial robe, 1474–1477, panel painting, 126,5×81cm, Košice, cathedral and former parish church of Saint Elizabeth, Photo: Alexander Jiroušek.

Fig. 76, The farewell, 1474–1477, panel painting, 126,5×81cm, Košice, cathedral and former parish church of Saint Elizabeth, Photo: Alexander Jiroušek.

Fig. 77, Expulsion from Wartburg castle, 1474–1477, panel painting, 126,5×81cm, Košice, cathedral and former parish church of Saint Elizabeth, Photo: Alexander Jiroušek.

BIBLIOGRAPHY

Hungarian Angevin Legendary.

B.F. ABOU-EL-HAJ, *The Medieval Cult of Saints. Formations and Transformations*, New York, NY, 1994.

M.P. ALBERZONI, *Elisabeth von Thüringen, Klara von Assisi und Agnes von Böhmen. Das franziskanische Modell der Nachfolge Christi diesseits und jenseits der Alpen*, in M. WERNER – D. BLUME (eds.), *Elisabeth von Thüringen: eine europäische Heilige. Aufsätze*, Petersberg, 2007, pp. 47-55.

A. ANDERSON, *Media, Environment and the Network Society*, London, 2014.

A. ANGENENDT, *Corpus incorruptum. Eine Leitidee der mittelalterlichen Reliquien-verehrung*, in *Saeculum* 42 (1991) 320-348.

A. ANGENENDT, *Heilige und Reliquien: die Geschichte ihres Kultes vom frühen Christen-tum bis zur Gegenwart*, München, 1994.

K. ANHEUSER – C. WERNER, *Medieval Reliquary Shrines and Precious Metalwork: Pro-ceedings of a Conference at the Musée d'art et d'histoire, Geneva, 12-15 September 2001 / Châsses-reliquaires et orfèvrerie médiévales: actes du colloque au Musee d'art et d'histoire, Genève, 12-15 septembre 2001*, London, 2007.

P. ARIÈS, *Centuries of Childhood: A Social History of Family Life*, New York, NY, 1962.

S.G. ARMISTEAD – I.J. KATZ – J.E. KELLER – J.T. SNOW, *Studies on the Cantigas de Santa Maria: Art, Music, and Poetry. Proceedings of the International Symposium on the Cantigas de Santa Maria of Alfonso X, el Sabio (1221-1284) in commemora-tion of its 700th anniversary year – 198l (New York, November 19-21)*, Madison, WI, 1987.

U. ARNOLD – H. LIEBING (eds.), *Elisabeth, der Deutsche Orden und ihre Kirche: Fest-schrift zur 700 jährigen Wiederkehr der Weihe der Elisabethkirche Marburg 1983*, Marburg, 1983.

I. ARNSTEIN, *Das Leben der heiligen Elisabeth: die volkssprachliche Elisabeth-Vita „Der lieben Fröwen Sant Elysabeten der Lantgrefin Leben" – Text, Übersetzung und Untersuchung*, Marburg, 2013.

K.M. ASHLEY – P. SHEINGORN, *Writing Faith: Text, Sign & History in the Miracles of Sainte Foy*, Chicago, IL, 1999.

B. BAERT, *Kairos or Occasion as Paradigm in the Visual Medium: "Nachleben", Iconogra-phy, Hermeneutics*, Leuven, 2016a.

B. BAERT, *Pneuma and the Visual Medium in the Middle Ages and Early Modernity: Essays on Wind, Ruach, Incarnation, Odour, Stains, Movement, Kairos, Web and Silence*, Leuven – Paris – Bristol, CT, 2016b.

M. BAGNOLI – H.A. KLEIN – G.C. MANN – J. ROBINSON (eds.), *Treasures of Heaven: Saints, Relics, and Devotion in Medieval Europe*, Cleveland, OH – Baltimore – London – New Haven, CONN, 2010.

J. BAHLCKE – K.I. BOBKOVÁ – J.I. MIKULEC, *Religious Violence, Confessional Conflicts and Models for Violence Prevention in Central Europe (15th-18th centuries) / Religiöse Gewalt, konfessionelle Konflikte und Modelle von Gewaltprävention in Mitteleuropa (15.-18. Jahrhundert)*, Praha – Stuttgart, 2017.

J. BAHLCKE – S. ROHDEWALD – T. WÜNSCH, *Religiöse Erinnerungsorte in Ostmittel-europa: Konstitution und Konkurrenz im nationen- und epochenübergreifenden Zugriff*, Berlin, 2013.

J. BAKOŠOVÁ, *Reliéfna výzdoba severného a západného portálu košického dómu*, in *ARS* 16 (1982) pp. 30-53.

F. BALKE – B. SIEGERT – J. VOGL, *Medien des Heiligen*, Paderborn, 2015.

R. BANZ, *Christus und die minnende Seele, zwei spätmittelhochdeutsche mystische Gedichte; im Anhang, ein Prosadisput verwandten Inhaltes. Untersuchungen und Texte*, Breslau, 1908.

M. BARASCH, *Giotto and the Language of Gesture*, Cambridge, 1987.

F.D.R. BARBIER, *Gutenberg's Europe: The Book and the Invention of Western Modernity*, Cambridge, UK – Malden, MA, 2017.

P. BARNET – M. BRANDT – G. LUTZ, *Medieval Treasures from Hildesheim*, New York, NY, 2013.

X. BARRAL I ALTET – P.L. LŐVEI – V. LUCHERINI – I. TAKÁCS, *The Art of Medieval Hungary*, Roma, 2018.

P. BARTHEL – G.H. KOOTEN, *The Star of Bethlehem and the Magi: Interdisciplinary Perspectives from Experts on the Ancient Near East, the Greco-Roman World, and Modern Astronomy*, Leiden – Boston, MA, 2015.

H. BAUER, *St. Elisabeth und die Elisabethkirche zu Marburg*, Marburg, 1990.

M. BAXANDALL, *The Limewood Sculptors of Renaissance Germany*, New Haven, CT, 1980.

M. BEER – M. WOELK – J. MICHAEL, *The Magi: Legend, Art and Cult: Catalogue Published for the Exhibition at the Museum Schnütgen, Cologne, 25 October 2014 – 25 January 2015*, Munich, Cologne, 2014.

W. BEHRINGER, *Mediale Konstruktionen in der Frühen Neuzeit*, Affalterbach, 2013.

V. BELGHAUS, *Der erzählte Körper. Die Inszenierung der Reliquien Karls des Grossen und Elisabeths von Thüringen*, Berlin, 2005.

H. BELTING, *Bild und Kult: eine Geschichte des Bildes vor dem Zeitalter der Kunst*, München, 1990.

H. BELTING, *An Anthropology of Images: Picture, Medium, Body*, Princeton, NJ, 2011.

D. BERG, *Armut und Geschichte: Studien zur Geschichte der Bettelorden im Hohen und Späten Mittelalter*, Kevelaer, 2001.

D.F. BERG – L. LEHMANN (eds.), *Franziskus-Quellen: die Schriften des Heiligen Franziskus, Lebensbeschreibungen, Chroniken und Zeugnisse über ihn und seinen Orden*, Kevelaer, 2009.

C. BERTELSMEIER-KIERST (ed.), *Elisabeth von Thüringen und die neue Frömmigkeit in Europa*, Frankfurt am Main, 2008.

H. BEUMANN, *Friedrich II. und die heilige Elisabeth. Zum Besuch des Kaisers in Marburg am 1. Mai 1236, Sankt Elisabeth. Fürstin, Dienerin, Heilige. Aufsätze, Dokumentation, Katalog*, Sigmaringen, 1981, pp. 151-166.

M. BIERSCHENK, *Glasmalereien der Elisabethkirche in Marburg: die figürlichen Fenster um 1240*, Berlin, 1991.

P. BINSKI, *Medieval Death: Ritual and Representation*, Ithaca, NY, 1996.

D. BLUME – M. HAFFNER – W. METZGER, *Sternbilder des Mittelalters: der gemalte Himmel zwischen Wissenschaft und Phantasie*, Berlin, 2012.

D. BLUME – G. JACOBS – A. KINDLER, *Wechselnde Blickwinkel. Die Bildzyklen der Heiligen Elisabeth vor der Reformation*, in D. BLUME – M. WERNER (eds.), *Elisabeth von Thüringen – eine europäische Heilige. Aufsätze*, Petersberg, 2007, pp. 271-292.

D. BLUME – D. JONEITIS, *Eine Elisabethhandschrift vom Hof König Alfons' X. von Kastilien*, in D. BLUME – M. WERNER (eds.), *Elisabeth von Thüringen – eine europäische Heilige. Aufsätze*, Petersberg, 2007, pp. 325-339.

L. BOBKOVÁ – M. BLÁHOVÁ – L. BOBKOVÁ – V. VANÍČEK, *Velké dějiny zemí Koruny české*, Praha, 2003.

S. BONAVENTURA, *Works of Saint Bonaventure. 1: St. Bonaventure's on the Reduction of the Arts to Theology*, translated by Zachary Hayes, St. Bonaventure, NY, 1996.

S. BONAVENTURA, *Works of St. Bonaventure. 2: Itinerarium Mentis in Deum*, 2002.

BONAVENTURE – J.G. BOUGEROL – C.B. DEL ZOTTO – L. SILEO – CONFERENZA ITALIANA MINISTRI PROVINCIALI O.F.M., *Opere di san Bonaventura*, Roma, 1990.

N. BORGER-KEWELOH, *Die Liebfrauenkirche in Trier: Studien zur Baugeschichte*, Trier, 1986.

T. BORCHERT – J. CHAPUIS (eds.), *Van Eyck to Dürer: The Influence of Early Netherlandish Painting on European Art, 1430-1530*, London – New York, NY, 2011.

K. BOSL, *Das Armutsideal des heiligen Franziskus als Ausdruck der hochmittelalterlichen Gesellschaftsbewegung*, in H. KÜHNAL – H. EGGER (eds.), *800 Jahre Franz von Assisi. Franziskanische Kunst und Kultur des Mittelalters: Niederösterreichische Landesausstellung, Krems-Stein, Minoritenkirche, 15. Mai-17 Obt. 1982*, Wien, 1982, pp. 1-12.

F. BOTANA, *The Works of Mercy in Italian Medieval Art (c. 1050 – c. 1400)*, Turnhout, 2011.

L. BOURDUA, *The Franciscans and Art Patronage in Late Medieval Italy*, Cambridge – New York, NY, 2004.

J. BRAUN, *Das christliche Altar in seiner geschichtlichen Entwicklung*, München, 1924.

J. BRAUN, *Die Reliquiare des christlichen Kultes und ihre Entwicklung*, Freiburg i.B., 1940.

W. Braunfels – P. Moraw, *Der Hedwigs-Codex von 1353: Sammlung Ludwig*, Berlin, 1972.

A. Bräm, *„Fratrum minorum mater". Heiligenbilder als Angleichung und zum Patronat in Frankreich und Flandern und in der Anjou – Hofkunst Neapels*, in D. Blume – M. Werner (eds.), *Elisabeth von Thüringen – eine europäische Heilige. Aufsätze*, Petersberg, 2007, pp. 309-324.

K.T. Brown, *Mary of Mercy in Medieval and Renaissance Italian Art: Devotional Image and Civic Emblem*, Abingdon, 2017.

J.A. Brundage, *Medieval Canon Law and the Crusader*, Madison, 1969.

C. Bruzelius, *The Architectural Context of Santa Maria Donna Regina*, in J. Elliott – C. Warr (eds.), *The Church of Sta. Maria Donna Regina: Art, Iconography and Patronage in Fourteenth-Century Naples*, Aldershot – Burlington, VT, 2004a, pp. 79-92.

C. Bruzelius, *The Stones of Naples. Church Building in Angevin Italy, 1266–1343*, New Haven, CT, 2004b.

C. Bruzelius, *From Empire to Commune to Kingdom. Notes on the Revival of Monumental Sculpture in Gothic Italy*, in C. Hourihane (ed.), *Gothic Art & Thought in the Later Medieval Period*, University Park, PA, 2011, pp. 134-155.

G. Buffon, *Storia dell'ordine francescano: problemi e prospettive di metodo*, Roma, 2013.

R.V. Bühren, *Die Werke der Barmherzigkeit in der Kunst des 12.–18. Jahrhunderts. Zum Wandel eines Bildmotivs vor dem Hintergrund neuzeitlicher Rhetorikrezeption*, Hildesheim – Zürich – New York, NY, 1998.

M. Büchsel, *Licht und Metaphysik in der Gotik – noch einmal zu Suger von Saint-Denis*, in E. Badstübner (ed.), *Licht und Farbe in der mittelalterlichen Backsteinarchitektur des südlichen Ostseeraums*, Berlin, 2005, pp. 24-37.

P. Burke, *Is There a Cultural History of Emotions?*, in P. Gouk – H. Hills (eds.), *Representing Emotions*, Surrey – Burlington, VT, 2005, pp. 35-47.

D. Burr, *The Spiritual Franciscans: From Protest to Persecution in the Century after Saint Francis*, University Park, PA, 2001.

W. Busch, *Kunst und Funktion – Zur Einleitung in die Fragestellung*, in W. Busch (ed.), *Funkkolleg Kunst. Eine Geschichte der Kunst im Wandel ihrer Funktionen*, München, 1997, pp. 5-26.

C.W. Bynum, *Holy Feast and Holy Fast: The Religious Significance of Food to Medieval Women*, Berkeley, CA, 1987.

Caesarius – E. Könsgen, *Das Leben der Heiligen Elisabeth: [und andere Zeugnisse]*, Marburg, 2007.

H. Caesarius von, *Dialogus Miraculorum*, in H. Schneider – N. Nösges (eds.), Turnhout, 2009

M. Camille, *The Gothic Idol: Ideology and Image-Making in Medieval Art*, Cambridge – New York, NY, 1989.

M. Camille, *Gothic Art: Glorious Visions*, New York, NY, 1996.

J. CANNON, *Religious Poverty, Visual Riches: Art in the Dominican Churches of Central Italy in the thirteenth and fourteenth Centuries*, New Haven, CT, 2013.

M.E. CARRASCO, *Spirituality in Context: The Romanesque Illustrated Life of St. Radegund of Poitiers*, in *The Art Bulletin* 72 (1990) pp. 414-435.

M.H. CAVINESS, *Paintings on Glass: Studies in Romanesque and Gothic Monumental Art*, Aldershot, Great Britain, 1997.

M.J. CLEAR, *Maria of Hungary as Queen, Patron and Exemplar*, in J. ELLIOTT – C. WARR (eds.), *The Church of Santa Maria Donna Regina. Art, Iconography and Patronage in Fourteenth-Century Naples*, Aldershot – Burlington, VT, 2004, pp. 45-60.

D. COOPER, *'In loco tutissimo e firmissimo': The Tomb of St. Francis in History, Legend and Art*, in W.R. COOK (ed.), *The Art of the Franciscan Order in Italy*, Leiden, 2005, pp. 1-37.

D. COOPER – J. ROBSON, *The Making of Assisi: The Pope, the Franciscans and the Painting of the Basilica*, New Haven, CT, 2013.

D.L. D'AVRAY, *Medieval Marriage: Symbolism and Society*, Oxford, 2005.

G. DALLI REGOLI, *Il gesto e la mano: convenzione e invenzione nel linguaggio figurativo fra Medioevo e Rinascimento*, Firenze, 2000.

M. DANIELEWSKI – R.T. TOMCZAK (eds.), *Odkrywanie Europy Środkowej – od mitologii do rzeczywistości*, Poznań, 2016.

C. DAVIDSON (ed.), *Gesture in Medieval Drama and Art*, Kalamazoo, MICH, 2001.

P. L. DE CASTRIS, *Pietro Cavallini: Napoli prima di Giotto*, Napoli, 2013.

H. DEEMING – E.E. LEACH, *Manuscripts and Medieval Song: Inscription, Performance, Context*, Cambridge, 2015.

A. DEHMER, *Passio und Compassio: Geisselungsrituale italienischer Bussbruderschaften im späten Mittelalter*, in J.F.v. DIJKHUIZEN – K.A.E. ENENKEL (eds.), *The Sense of Suffering: Constructions of Physical Pain in Early Modern Culture*, Leiden – Boston, 2009, pp. 221-251.

D. DERCSÉNYI, *Képes krónika és kora*, in K. CSAPODINÉ GÁRDONYI – D. DERCSÉNYI – L. GERÉB – L. MEZEY (eds.), *Képes krónika*, Budapest, 1964, pp. 7-44.

D. DERCSÉNYI – K. CSAPODINÉ GÁRDONYI – L. MEZEY – L. GERÉB (eds.), *Képes krónika. Faksimile*, Budapest, 1964.

F. DICKMANN, *Das Schicksal der Elisabethreliquien, St. Elisabeth – Kult, Kirche, Konfessionen. Katalog 700 Jahre Elisabethkirche in Marburg 1283–1983*, Marburg, 1983, pp. 35–38.

G. DIDI-HUBERMAN, *Devant le temps: histoire de l'art et anachronisme des images*, Paris, 2014.

G. DIDI-HUBERMAN, *The Surviving Imag : Phantoms of Time and Time of Phantoms: Aby Warburg's History of Art*, University Park, PA, 2017.

E. DINKLER-VON SCHUBERT, *Der Schrein der hl. Elisabeth zu Marburg. Studien zu Schrein-Ikonographie*, Marburg, 1964.

P. DINZELBACHER, *Himmel, Hölle, Heilige: Visionen und Kunst im Mittelalter*, Darmstadt, 2002.

G. DUBY, *Love and Marriage in the Middle Ages*, Chicago, 1994.

L.G. DUGGAN, *Was Art really the "Book of the Illiterate"?*, in *Word and Image* 5 (1989) pp. 227-251.

J.R. DÜNNE – H. DOETSCH – R. LÜDEKE, *Von Pilgerwegen, Schriftspuren und Blickpunkten: Raumpraktiken in medienhistorischer Perspektive*, Würzburg, 2004.

D.L. EHRESMANN, *Some Observations on the Role of Liturgy in the Early Winged Altarpiece.* in *Art Bulletin* 64 (1982) pp. 359-369.

J. EISLER, *Megfontolások és javaslatok a kassai szent Erzsébet templom főoltárának datalásához*, in *Ars hungarica* 23 (1995) pp. 189-203.

D. ELLIOTT, *Proving Woman. Female Spirituality and Inquisitional Culture in the Later Middle Ages*, Princeton, NJ – Oxford, 2004.

L. ELSBREE, *Ritual Passages and Narrative Structures*, New York, NY, 1991.

T. ERTL, *Religion und Disziplin: Selbstdeutung und Weltordnung im frühen deutschen Franziskanertum*, Berlin, 2006.

J. FAJT, *Magister Theodoricus, Court Painter to Emperor Charles IV: The Pictorial Decoration of the Shrines at Karlstejn Castle*, Prague, 1998.

D. FALVAY, *The Multiple Regional Identity of a Neapolitan Queen. Mary of Hungary's Readings and Saints*, in S. KUZMOVÁ – A. MARINKOVIĆ – T. VEDRIŠ (eds.), *Cuius Patrocinio Tota Gaudet Regio: Saints'Cults and the Dynamics of Regional Cohesion*, Zagreb, 2014, pp. 213-229.

W. FAULSTICH, *Medien und Öffentlichkeiten im Mittelalter, 800-1400*, Göttingen, 1996.

H. FINTER, *Medien der Auferstehung*, Frankfurt am Main, 2012.

C. FISCHER, *Die „Meditationes vitae Christi": Ihre handschriftliche Ueberlieferung und die Verfasserfrage*, Firenze, 1932.

H.M. FLAHERTY, *The Place of the Speculum Humanae Salvationis in the Rise of Affective Piety in the Later Middle Ages,* PhD, University of Michigan, Ann Arbor, 2006.

C.A. FLECK, *'Blessed the Eyes that See Those Things you See': The Trecento Choir Frescoes at Santa Maria Donnaregina in Naples*, in *Zeitschrift für Kunstgeschichte* 67 (2004a) pp. 201-224.

C.A. FLECK, *'To exercise yourself in these things by continued contemplation': Visual and Textual Literacy in the Frescoes at Santa Maria Donna Regina*, in J. ELLIOTT – C. WARR (eds.), *The Church of Santa Maria Donna Regina. Art, Iconography and Patronage in Fourteenth-Century Naples*, Aldershot – Burlington, VT, 2004b, pp. 109-128.

S. FLEMMIG, *Hagiografie und Kulturtransfer: Birgitta von Schweden und Hedwig von Polen*, Berlin, 2011.

S. FLEMMIG – N. KERSKEN (eds.), *Akteure mittelalterlicher Aussenpolitik: das Beispiel Ostmitteleuropas*, Marburg, 2017.

G.D. FLOOD, *The Ascetic Self: Subjectivity, Memory, and Tradition*, Cambridge – New York, NY, 2004.

H. FLORA, *The Devout Belief of the Imagination: The Paris Meditationes Vitae Christi and Female Franciscan Spirituality in Trecento Italy*, Turnhout, 2009.

J. FOLDA, *The Art of Crusaders in the Holy Land 1098-1187*, Cambridge – New York, NY – Melbourne, 1995.

J. FOLDA, *Crusader art in the Holy Land: From the Third Crusade to the fall of Acre, 1187-1291*, Cambridge, UK, 2005.

J. FOLDA, *Crusader Art: The Art of the Crusaders in the Holy Land, 1099-1291*, Aldershot, 2008.

V.H.C. FORTUNATUS – R. FAVREAU, *La vie de sainte Radegonde par Fortunat: Poitiers, Bibliothèque municipale, manuscrit 250 (136)*, Paris, 1995.

V. FRAKNÓI, *Mária, V. István király leánya, nápolyi királyné*, in *Budapesti szemle* 34 (1906) pp. 321-358.

T. FRANKE, *Zur Geschichte der Elisabethreliquien im Mittelalter und in der frühen Neuzeit, Sankt Elisabeth. Fürstin, Dienerin, Heilige*, Sigmaringen, 1981, pp. 167-179.

C. FREEMAN, *Holy Bones, Holy Dust: How Relics Shaped the History of Medieval Europe*, New Haven, CT, 2011.

O. FREIBERGER, *Asceticism and its Critics: Historical Accounts and Comparative Perspectives*, Oxford – New York, NY, 2006.

D. FREY, *Kunstwissenschaftliche Grundfragen: Prolegomena zu einer Kunstphilosophie*, Wien, 1946.

B. FRICKE, *Fallen Idols, Risen Saints: Sainte Foy of Conques and the Revival of Monumental Sculpture in Medieval Art*, Turnhout, 2015.

H. FROMM, *Eine mittelhochdeutsche Übersetzung von Dietrichs von Apolda lateinischer Vita der Elisabeth von Thüringen*, [S.l.], 1967.

C. FRUGONI, *Vivere nel Medioevo : donne, uomini e soprattutto bambini*, Bologna, 2017.

C. FRUGONI – A. DIETL, *Benedetto Antelami e il Battistero di Parma*, Torino, 1995.

H. FUHRMANN, *Bilder für einen guten Tod*, München, 1997.

V. FUCHS, *Das Altaransemble. Eine Analyse des Kompositcharakters früh- und hochmittelalterlicher Altarausstattung*, Weimar, 1999.

D. GANZ, *Medien der Offenbarung: Visionsdarstellungen im Mittelalter*, Berlin, 2008.

J. GARDNER, *The Tomb and the Tiara: Curial Tomb Sculpture in Rome and Avignon in the later Middle Ages*, Oxford – New York, NY, 1992.

J. GARDNER, *Giotto and his Publics: Three Paradigms of Patronage*, Cambridge, MA, 2011.

S.N. GAYK, *Image, Text, and Religious Reform in fifteenth-century England*, Cambridge – New York, NY, 2010.

M. GAŽI – J. PÁNEK – P. PAVELEC – V. ROSENBERG, *Die Rosenberger: eine mitteleuropäische Magnatenfamilie*, České Budějovice, 2015.

O. Gecser, *Aspects of the Cult of St. Elizabeth of Hungary with a Special Emphasis on Preaching, 1231-c.1500*, Doctor of Philosophy in Medieval Studies, Budapest, 2007

O. Gecser, *The Feast and the Pulpit: Preachers, Sermons and the Cult of St. Elizabeth of Hungary, 1235-ca. 1500*, Spoleto, 2012.

U. Geese, *Die Elisabethreliquien in der Wallfahrtskirche*, in H.J. Kunst (ed.), *Die Elisabeth-kirche – Architektur in der Geschichte*, Marburg, 1983, pp. 15-18.

U. Geese, *Reliquienverehrung und Herrschaftsvermittlung. Die mediale Beschaffenheit der Reliquien im frühen Elisabethkult*, Darmstadt, 1984.

R.A. Genovese, *La chiesa trecentesca di Donnaregina*, Napoli, 1993.

I. Gerát, *Angels, Demons and the Politics of Late Mediaeval Pictorial Hagiography*, in *Acta Historiae Artium Hungariae* 48 (2007) pp. 263-271.

I. Gerát, *Dying Again and Again: Remarks on the Legend of Saint George in Jindřichův Hradec (Neuhaus)*, in *Ikon: časopis za ikonografske studije* 4 (2011) pp. 175-183.

I. Gerát, *Legendary Scenes: An Essay on Medieval Pictorial Hagiography*, Bratislava, 2013.

I. Gerát, *De Lübeck à Košice. Les transferts iconographiques et stylistiques entre deux cycles iconographiques consacrés à Élisabeth de Thuringe vers 1450*, in J. Dubois – J.-M. Guillouet – B. Van den Bossche (eds.), *Les transferts artistiques dans l'Europe gothique: repenser la circulation des artistes, des oeuvres, des themes et des savoir-faire (XIIe-XVIe siecle)*, Paris, 2014, pp. 319-336.

I. Gerat – M. Zervan, *Flagellation in Medieval Imagination and Thinking*, in *Kultúrne dejiny* 2019 (2019) pp. 25-41.

L. Gerevich, *A kassai Szent Erzsébet templom szobrászata a XIV-XVI. században*, Budapest, 1935.

R. Goffen, *Spirituality in Conflict: Saint Francis and Giotto's Bardi Chapel*, University Park, PA, 1988.

I.F. Görres, *Gespräch über die Heiligkeit: ein Dialog um Elisabeth von Thüringen*, Freiburg, 1940.

J. Green, *Printing and Prophecy: Prognostication and Media Change, 1450-1550*, Ann Arbor, MI, 2012.

R.B. Green – I. Ragusa, *Meditations on the life of Christ: An Illustrated Manuscript of the Fourteenth Century, Paris, Bibliothèque nationale, Ms. Ital. 115*, Princeton, N.J., 1977.

E.G. Grimme, *Der Karlsschrein und der Marienschrein im Aachener Dom*, Aachen, 2002.

B. Grojs – P. Weibel, *Medium Religion: Faith, Geopolitics, Art*, Köln, 2011.

G.B. Guest, *A Discourse on the Poor: The Hours of Jeanne d'Evreux*, in *Viator* 26 (1995) pp. 153-180.

A.I.A.K. Gurevich – J. Howlett, *Historical Anthropology of the Middle Ages*, Chicago, IL, 1992.

S. HAARLÄNDER, *Zwischen Ehe und Weltentsagung. Die verheiratete Heilige – Ein Dilemma der Hagiographie*, in C. BERTELSMEIER-KIERST (ed.), *Elisabeth von Thüringen und die neue Frömmigkeit in Europa*, Frankfurt am Main, 2008, pp. 211-229.

H. HABERLANDOVÁ, *Stredoveký kláštor františkánov v Košiciach*, in *ARS* 18 (1984) pp. 81-95.

A. HADRAVOVÁ – P. HADRAVA, *Reflection of Ancient Greek Tradition in the 13th c. Premyslid Celestial Globe Saved in Bernkastel-Kues*, in G. KATSIAMPOURA (ed.), *Scientific Cosmopolitanism and Local Cultures: Religions, Ideologies, Societies*, Athens 2014, pp. 45-50.

C. HAHN, *Portrayed on the Heart. Narrative Effect in Pictorial Lives of Saints from the Tenth through the Thirteenth Century*, Berkley, CA, 2001.

C.J. HAHN, *Strange Beauty: Issues in the Making and Meaning of Reliquaries, 400-circa 1204*, University Park, PA, 2012.

O.R. HALAGA, *A Mercantilist Initiative to Compete with Venice: Kaschau's Fustian Monopoly (1411)*, in *The Journal of European Economic History* 12 (1983) pp. 407-435.

O.R. HALAGA, *Kaschaus Rolle in der Ostpolitik Siegmunds von Luxemburg I. (1387 - 1411)*, in U. BESTMANN – F. IRSIGLER – J. SCHNEIDER (eds.), *Hoffinanz – Wirtschaftsräume – Innovationen. Festschrift für Wolfgang von Stromer*, Trier, 1987, pp. 383-410.

O.R. HALAGA, *Počiatky Košíc a zrod metropoly*, Košice, 1992.

J.F. HAMBURGER, *The Rothschild Canticles: Art and Mysticism in Flanders and the Rhineland circa 1300*, New Haven, CT, 1990.

J.F. HAMBURGER, *Nuns as Artists: the Visual Culture of a Medieval Convent*, Berkeley, CA, 1997.

J.F. HAMBURGER, *The Visual and the Visionary: Art and Female Spirituality in Late Medieval Germany*, New York, N.Y. – Cambridge, MA, 1998.

J.F. HAMBURGER (ed.), *Frauen – Kloster – Kunst. Neue Forschungen zur Kulturgeschichte des Mittelalters. Beiträge zum internationalen Kolloquium vom 13. bis 16. Mai 2005 anlässlich der Ausstellung „Krone und Schleier"*, Turnhout, 2007.

B. HAMM – V. LEPPIN – G. SCHNEIDER-LUDORFF, *Media Salutis: Gnaden- und Heilsmedien in der abendländischen Religiosität des Mittelalters und der Frühen Neuzeit*, Tübingen, 2011.

F. HARTMANN (ed.), *Brief und Kommunikation im Wandel: Medien, Autoren und Kontexte in den Debatten des Investiturstreits*, Köln, 2016.

A. HASELOFF, *Die Glasgemälde der Elisabethkirche in Marburg*, Berlin, 1906.

A. HEKLER, *Ungarische Kunstgeschichte*, Berlin, 1937.

P. HELAS, *The Clothing of Poverty and Sanctity in Legends, and their Representations in Trecento and Quattrocento Italy*, in B. BAERT – K.M. RUDY (eds.), *Weaving, veiling, and dressing*, Turnhout, 2007, pp. 245-288.

D. Henniges, *Vita sanctae Elisabeth, Landgraviae Thuringiae auctore anonymo nunc primum in luce edita*, in *Archivum Franciscanum Historicum* 2 (1909) pp. 240-268.

D. Henniges, *Die Heilige Messe zu Ehren der Heiligen Elisabeth*, in *Franziskanische Studien* 9 (1922) pp. 158-171.

B. Herzogenrath, *Media Matter: The Materiality of Media, Matter as Medium*, New York, NY, 2015.

P. Hlaváček, *Čeští františkáni na přelomu středověku a novověku*, Praha, 2005.

P. Hlaváček, *Die böhmischen Franziskaner im ausgehenden Mittelalter: Studien zur Kirchen- und Kulturgeschichte Ostmitteleuropas*, Stuttgart, 2011.

W. Hofmann – H.-O. Mühleisen, *Kunst und Macht: Politik und Herrschaft im Medium der bildenden Kunst*, Münster, 2005.

J. Homolka, *Studie k počátkům krásného slohu v Čechách (K problematice sociální funkce výtvarného umění v předhusitských Čechách)*, Praha, 1976.

C. Hourihane – D.L. Drysdall, *The Routledge Companion to Medieval Iconography*, London, 2017.

M. Hradilová, *Příspěvky k dějinám knihovny minoritů v Českém Krumlově v době předhusitské (On the History of the Minorite Library in Český Krumlov during the pre-Hussite period)*, Praha, 2014.

A. Huyskens, *Quellenstudien zur Geschichte der hl. Elisabeth, Landgräfin von Thüringen*, Marburg, 1908.

A. Huyskens (ed.), *Libellus de dictis quattuor ancillarum s. Elisabeth confectus*, Kempten – München, 1911.

K. Chamonikolasová, *Recepcia diela Nicolausa Gerhaerta van Leyden na Slovensku v poslednej tretine 15. storočia*, in D. Buran (ed.), *Gotika. Dejiny slovenského výtvarného umenia*, Bratislava, 2003, pp. 373-382.

K. Charvátová, *Dějiny cisterckého řádu v Čechách 1142 – 1420*, Praha, 2002.

A.E. Imhof, *Ars moriendi: die Kunst des Sterbens einst und heute*, Wien, 1991.

G. Jacobs, *Elisabeth beherbergt Fremde*, in D. Blume – M. Werner (eds.), *Elisabeth von Thüringen – eine europäische Heilige. Aufsätze*, Petersberg, 2007, pp. 395-397.

K.L. Jansen, *The Making of the Magdalen: Preaching and Popular Devotion in the later Middle Ages*, Princeton, N.J., 2000.

G. Jaritz – T. Jørgensen – K. Salonen – Ecclesia Catholica. Sancta Sedes, *The Long Arm of Papal Authority: Late Medieval Christian Peripheries and their Communication with the Holy See*, Bergen, 2004.

C. Jäggi, *Frauenklöster im Spätmittelalter: die Kirchen der Klarissen und Dominikanerinnen im 13. und 14. Jahrhundert*, Petersberg, 2006.

U. Jenni, *Realistische Elemente im Krumauer Bildercodex*, in K. Benešovská (ed.), *King John of Luxembourg and the Art of his Era (1296–1346)*, Prague, 1998, pp. 260-269.

U. JENNI, *Die Elisabeth-Legende im Krumauer Bildercodex*, in D. BLUME – M. WERNER (eds.), *Elisabeth von Thüringen – eine europäische Heilige. Aufsätze*, Petersberg, 2007, pp. 353-380.

U. JENNI – M. THEISEN, *Mitteleuropäische Schulen III (ca. 1350–1400): Böhmen-Mähren-Schlesien-Ungarn*, Wien, 2004.

T. JUCKES, *The Parish and Pilgrimage Church of St. Elizabeth in Košice: Town, Court and Architecture in Late Medieval Hungary*, Turnhout, 2011.

E. H. KANTOROWICZ, *Frederick the Second, 1194-1250*, New York, 1957.

J. KAŠPÁRKOVÁ, *Úhelný kámen zakládání a života. Regula pro sorores minores inclusae v Českém Krumlově (The Cornerstone of Foundation and Life: Regula pro sorores minores inclusae in Český Krumlov)*, in D. RYWIKOVÁ – R. LAVIČKA (eds.), *Ordo et paupertas. Českokrumlovský klášter minoritů a klarisek ve středověku v kontextu řádové zbožnosti, kultury a umění*, Ostrava, 2017, pp. 63-74.

M.R. KATZ, *The Non-Gendered Appeal of Vierge Ouvrante Sculpture: Audience, Patronage, and Purpose in Medieval Iberia*, in T. MARTIN (ed.), *Reassessing the Roles of Women as 'Makers' of Medieval Art and Architecture*, Leiden – Boston, 2012, pp. 35-91.

J.E. KELLER – A.G. CASH, *Daily life depicted in the Cantigas de Santa Maria*, Lexington, 1998.

L. KEMÉNY, *Kassa város régi számadáskönyvei 1431–1533,* Kassa, 1892.

W. KEMP, *Sermo corporeus: die Erzählung der mittelalterlichen Glasfenster*, München, 1987.

W. KEMP, *The Narratives of Gothic Stained Glass*, Cambridge, 1997.

W. KEMP, *Narrative,* in R.S. NELSON – R. SHIFF (eds.), *Critical Terms for Art History.* 2nd ed., Chicago, IL, 2010, pp. 62-74.

P. KIDSON, *Panofsky, Suger and St. Denis*, in *Journal of the Warburg and Courtauld Institutes* 50 (1987) pp. 1-17.

R. KIECKHEFER, *Repression of Heresy in Medieval Germany*, Philadelphia, PA, 1979.

C. KIENING, *Fülle und Mangel: Medialität im Mittelalter*, Zürich, 2016.

G.B. KLANICZAY, *Az uralkodók szentsége a középkorban*, Budapest, 2000.

G.B. KLANICZAY, *Holy Rulers and Blessed Princesses: Dynastic Cults in Medieval Central Europe*, Cambridge – New York, NY, 2002.

G. KOCH, *Imaginäre Medialität – immaterielle Medien*, München, 2012.

B. KOPIČKOVÁ, *Eliška Přemyslovna: královna česká, 1292-1330*, Praha, 2008.

W. KOSCHORRECK – W. WERNER, *Codex Manesse: die grosse Heidelberger Liederhandschrift: Kommentar zum Faksimile des Codex Palatinus Germanicus 848 der Universitätsbibliothek Heidelberg*, Kassel, 1981.

A. KÖSTLER, *Die Ausstattung der Marburger Elisabethkirche: zur Ästhetisierung des Kultraums im Mittelalter*, Berlin, 1995.

O. KRAFFT, *Kommunikation und Kanonisation: die Heiligsprechung der Elisabeth von Thüringen 1235 und das Problem der Mehrfachausfertigung päpstlicher Kanonisa-*

tionsurkunden seit 1161, in *Zeitschrift des Vereins für Thüringische Geschichte* 58 (2004) pp. 27-82.

J. KRÁSA, *Review of* SCHMIDT/UNTERKIRCHER *1967*, in *Umění* 16 (1968) pp. 419-422.

S. KRÄMER – A. ENNS, *Medium, Messenger, Transmission: An Approach to Media Philosophy*, Amsterdam, 2015.

J. KRCHO – G. SZEKÉR, *Adalékok a kassai ferences templom középkori építéstörténetéhez*, in A. HARIS (ed.), *Koldulórendi építészet a középkori Magyarországon. Tanulmányok. Művészettörténet – Műemlékvédelem*, Budapest, 1994, pp. 333-358.

R. KROOS, *Zu frühen Schrift- und Bildzeugnissen über die helige Elisabeth als Quellen zur Kunst- und Kulturgeschichte, Sankt Elisabeth. Fürstin, Dienerin, Heilige*, Sigmaringen, 1981, pp. 180-239.

A. KUBÍKOVÁ, *Rožmberské kroniky – krátký a sumovní výtah od Václava Březana*, České Budějovice, 2005.

A. KUBÍKOVÁ, *Petr I. z Rožmberka a jeho synové*, České Budějovice, 2011.

A. KUBÍNYI, *Fragen der städtischen Gesundheitspflege in den mittelalterlichen Städten Ungarns*, in B.B. KIRCHGÄSSNER – J. SYDOW (eds.), *Stadt und Gesundheitspflege*, Sigmaringen, 1982, pp. 101–117.

B. KÜHNEL, *From the Earthly to the Heavenly Jerusalem: Representations of the Holy City in Christian Art of the First Millennium*, Freiburg im Breisgau, 1987.

B. KÜHNEL – G. NOGA-BANAI – H. VORHOLT, *Visual Constructs of Jerusalem*, Turnhout, 2015.

J. KUTHAN, *Počátky a rozmach gotické architektury v Čechách. K problematice cicterciácké stavební tvorby*, Praha, 1983.

R. LAMBERTINI, *La povertà pensata: evoluzione storica della definizione dell'identità minoritica da Bonaventura ad Ockham*, Modena, 2000.

E. LANC, *Corpus der mittelalterlichen Wandmalereien. Österreich I. Wien und Niederösterreich*, Wien, 1983.

O. LANG, *Katalog der Handschriften in der Stiftsbibliothek Einsiedeln. Zweiter Teil, Codex 501-1318*, Basel, 2009.

C. H. LAWRENCE, *The Friars: The Impact of the Early Mendicant Movement on Western Society*, London, 1996.

J. LE GOFF, *Time, Work & Culture in the Middle Ages*, Chicago, IL, 1980.

M. LEEDER, *The Modern Supernatural and the Beginnings of Cinema*, London, 2017.

A. LEGNER (ed.), *Ornamenta Ecclesiae: Kunst und Künstler der Romanik: Katalog zur Ausstellung des Schnütgen-Museums in der Josef-Haubrich-Kunsthalle*, Köln, 1985.

A. LEGNER, *Reliquien in Kunst und Kult zwischen Antike und Aufklärung*, Darmstadt, 1995.

J. LEINWEBER, *Das kirchliche Heiligsprechungsverfahren bis zum Jahre 1234. Der Kanonisationsprozeß der Heilige Elisabeth von Thüringen, Sankt Elisabeth. Fürstin, Dienerin, Heilige; Aufsätze, Dokumentation, Katalog*, Sigmaringen, 1981, pp. 128-136.

L. LEMMENS, *Zur Biographie der heiligen Elisabeth, Landgräfin von Thüringen*, in *Mittheilungen des Historischen Vereins der Diözese Fulda* 4 (1901) pp. 1-24.

E. LEPPIN, *Die Elisabethkirche in Marburg. Ein Wegweiser zum Verstehen. 700 Jahre Elisabethkirche in Marburg 1283 - 1983, vol. E.*, Marburg, 1983.

F. LEVÁRDY (ed.) *Magyar Anjou Legendárium*, Budapest, 1973.

A.-J. LEVINE – D.C. ALLISON, JR. – J.D. CROSSAN, *The Historical Jesus in Context*, Princeton, N.J., 2006.

M. LÓPEZ SERRANO, *Cantigas de Santa María de Alfonso X el Sabio, Rey de Castilla*, Madrid, 1974.

J. LOWDEN, *The Making of the Bibles Moralisées*, University Park, PA, 2000.

F. MACHILEK, *Klöster und Stifte in Böhmen und Mähren von den Anfängen bis in den Beginn des 14. Jahrhunderts*, Köln, 1992.

E.M. MAKOWSKI, *Canon Law and Cloistered Women: Periculoso and its Commentators, 1298-1545*, Washington, D.C., 1997.

E. MÁLYUSZ, *Kaiser Sigismund in Ungarn: 1387-1437*, Budapest, 1990.

M.J. MAREK – S. KIMMIG-VÖLKNER – E. PLUHAŘOVÁ-GRIGIENĖ – K. WENZEL, *Gestaltungsräume: Studien zur Kunstgeschichte in Mittel- und Ostmitteleuropa: Festschrift zu Ehren von Prof. Dr. Michaela Marek*, Regensburg, 2017.

A. MARCHI - A. MAZZACCHERA, *Arte francescana : tra Montefeltro e papato, 1234-1528*, Milano, 2007.

E. MAROSI, *Tanulmányok a kassai Szent Erzsébet templom építéstörténetéhez*, in *Művészettörténeti Értesítő* 18 (1969) pp. 1-45, 89-127.

E. MAROSI, *Kép és hasonmás*, Budapest, 1995.

F. MARTIN, *Die heilige Elisabeth in der Glasmalerei. Vermittlungsstrategien eines weiblichen Heiligenmodelles*, in D. BLUME – M. WERNER (eds.), *Elisabeth von Thüringen – eine europäische Heilige. Aufsätze*, Petersberg, 2007, pp. 293-308.

A. MATĚJČEK – J. ŠÁMAL, *Legendy o českých patronech v obrázkové knize ze XIV. století*, Praha, 1940.

R. MCKITTERICK, *Charlemagne: The Formation of a European Identity*, Cambridge, UK, 2008.

S. MCNAMER, *Affective Meditation and the Invention of Medieval Compassion*, Philadelphia, PA, 2010.

H.-R. MEIER – D.S. SCHÜRMANN – S. ALBRECHT – G. BONO – P. BURCKHARDT – K. MUSEUM KLEINES, *Schwelle zum Paradies: die Galluspforte des Basler Münsters*, Basel, 2002.

T. MICHALSKY, *Mater Serenissimi Principis: The Tomb of Maria of Hungary*, in J. ELLIOTT – C. WARR (eds.), *The Church of Santa Maria Donna Regina. Art, Iconography and Patronage in Fourteenth-Century Naples*, Aldershot – Burlington, VT, 2004, pp. 61-77.

L. MITCHELL. *"Through Marriage Marvelously Blended": Visual Representations of Matrimonial Rituals in the Burgundian and Habsburg Netherlands, 1384 to 1555*, MA, University of Ottawa, 2014.

J.R.H. MOORMAN, *A History of the Franciscan Order: From its Origins to the Year 1517*, Oxford – New York, NY, 1968.

W. MORITZ, *Das Hospital im späten Mittelalter*, Marburg, 1983.

A.F. MOSKOWITZ, *Nicola Pisano's Arca di San Domenico and its legacy*, University Park, PA, 1994.

A.F. MOSKOWITZ, *Italian Gothic Sculpture: c. 1250-c. 1400*, New York, NY, 2001.

K.P.F. MOXEY, *Visual Time: The Image in History*, Durham, NC, 2013.

J. MUELLER, *The Privilege of Poverty: Clare of Assisi, Agnes of Prague, and the Struggle for a Franciscan Rule for Women*, University Park, PA, 2006.

A.V. MURRAY, *The Crusades: An Encyclopedia*, Santa Barbara, CA, 2006.

F. MÜTHERICH, *Der Schrein Karls des Grossen: Bestand und Sicherung 1982–1988*, Aachen, 1998.

D. NASTASOIU, *Political Aspects of the Mural Representations of sancti reges Hungariae in the Fourteenth and Fifteenth Centuries*, in *Annual of Medieval Studies at CEU* 16 (2010) pp. 1-27.

B.R. NĚMEC, *Rožmberkové: životopisná encyklopedie panského rodu*, České Budějovice, 2002.

M. NODL, *Tři studie o době Karla IV.*, Praha, 2006.

P. NOLD, *Two Views of John XXII as a Heretical Pope*, in M.F. CUSATO – G. GELTNER (eds.), *Defenders and Critics of Franciscan Life. Essays in Honor of John V. Fleming*, Leiden, 2009, pp. 139-158.

J. NOVÁK, *Erby miest vyhlásených za pamiatkové rezervácie*, Bratislava, 1986.

N. OHLER, *Alltag im Marburger Raum zur Zeit der heiligen Elisabeth*, in *Archiv für Kulturgeschichte* 67 (1985) pp. 1-40.

N. OHLER, *The Medieval Traveller*, Woodbridge, 2010.

H.V. OS, *Der Weg zum Himmel. Reliquienverehrung im Mittelalter*, Regensburg, 2001.

E. PANOFSKY, *Abbot Suger on the Abbey Church of St.-Denis and its Art Treasures*, Princeton, NJ, 1979.

S. PAONE, *Gli affreschi in Santa Maria Donnaregina Vecchia: percorsi stilistici nella Napoli angioina*, in *Arte Medievale* 2 (2004) pp. 87-118.

D. PARELLO, *Zum Verhältnis von Architektur und Glasmalerei am Beispiel der Marburger Elisabethkirche*, in *ARS* 37 (2004) pp. 19-39.

D. PARELLO – D. HESS, *Die mittelalterlichen Glasmalereien in Marburg und Nordhessen*, Berlin, 2008.

D. PARELLO – R. TOUSSAINT, *Die Elisabethkirche in Marburg*, Regensburg, 2009.

A. PATSCHOVSKY, *Die Anfänge einer ständigen Inquisition in Böhmen: ein Prager Inquisitoren-Handbuch aus der ersten Hälfte des 14. Jahrhunderts*, Berlin – New York, NY, 1975.

A. PATSCHOVSKY, *Quellen zur böhmischen Inquisition im 14. Jahrhundert*, Weimar, 1979.

M. PAULY – F.O. REINERT, *Sigismund von Luxemburg: ein Kaiser in Europa: Tagungsband des internationalen historischen und kunsthistorischen Kongresses in Luxemburg, 8.-10. Juni 2005*, Mainz am Rhein, 2006.

P. PERDRIZET, *La Vierge de Miséricorde; étude d'un thème iconographique*, Paris, 1908.

J. PEŠINA, *The Master of the Hohenfurth Altarpiece and Bohemian Gothic Panel Painting*, London – New York, NY, 1989.

J.R. PETERSOHN (ed.), *Politik und Heiligenverehrung im Hochmittelalter*, Sigmaringen, 1994.

L. PIEPER, *Saint Elizabeth of Hungary: The Voice of a Medieval Woman and Franciscan Penitent in the Sources for her Life*, New York, NY, 2016.

A. PINKUS, *Patrons and Narratives of the Parler School: The Marian Tympana 1350-1400*, München – Berlin, 2009.

M.R. PROKOPP, *Szent Erzsébet falképciklus a nápolyi Santa Maria Donnaregina-templomban*, in G. KLANICZAY – B. NAGY (eds.), *A középkor szeretete: történeti tanulmányok Sz. Jónás Ilona tiszteletére*, Budapest, 1999, pp. 414-423.

M.R. PROKOPP – Z.N.G.R. HORVÁTH, *Nápoly középkori magyar emlékei a XIII-XV. századból / Ricordi ungheresi medievali dei secoli XIII – XV a Napoli*, Budapest, 2014.

M.C. PUTNA, *Órigenés z Alexandrie: kapitola z dějin vztahů mezi antikou a křesťanstvím, nebo též pokus o pohled do tváře*, Praha, 2001.

R. RAGAČ, *Pečať mesta Košice*, in D. BURAN (ed.), *Gotika. Dejiny slovenského výtvarného umenia.* Bratislava, 2003, pp. 796.

G. RAMSHAW, *The Three-Day Feast : Maundy Thursday, Good Friday, Easter*, Minneapolis, MIN, 2004.

O. REBER, *Die Gestaltung des Kultes weiblicher Heiliger im Spätmittelalter; die Verehrung der Heiligen Elizabeth, Klara, Hedwig und Birgitta*, Hersbruck, 1963.

O. REBER, *Die heilige Elisabeth. Leben und Legende*, St. Ottilien, 1982.

O. REBER, *Elisabeth von Thüringen, Landgräfin und Heilige. Eine Biografie*, Regensburg, 2009.

W.M. REDDY, *The Navigation of Feeling: A Framework for the History of Emotions*, Cambridge – New York, NY, 2001.

R. RECHT – A. CHÂTELET, *Ausklang des Mittelalters: 1380-1500*, München, 1989.

C. REITER (ed.), *Festschrift zur Eröffnung des Museums im Schottenstift*, Wien, 1994.

M. RENER (ed.), *Die Vita der heiligen Elisabeth des Dietrich von Apolda*, Marburg, 1993.

M. RENER, *The Making of a Saint*, in C. BERTELSMEIER-KIERST (ed.), *Elisabeth von Thüringen und die neue Frömmigkeit in Europa*, Frankfurt am Main, 2008, pp. 195-210.

I. M. RESNICK, *Peter Damian on the Restoration of Virginity: A Problem for Medieval Theology*, in *Journal of Theological Studies* 39 (1988) pp. 125-134.

B. REUDENBACH, *Kopf, Arm und Leib. Reliquien und Reliquiare der heiligen Elisabeth*, in D. BLUME – M. WERNER (eds.), *Elisabeth von Thüringen – eine europäische Heilige. Aufsätze*, Petersberg, 2007, pp. 193-202.

B. REUDENBACH, *Visualizing Holy Bodies: Observations on Body-Part Reliquaries*, in C. HOURIHANE (ed.), *Romanesque art and thought in the twelfth century*, Princeton, NJ, 2008, pp. 95-106.

B. REUDENBACH – G. TOUSSAINT, *Reliquiare im Mittelalter*, Berlin, 2011.

B. ROEST, *Order and Disorder: The Poor Clares between Foundation and Reform*, Leiden – Boston, 2013.

B. ROEST, *Franciscan Learning, Preaching and Mission c. 1220-1650: cum scientia sit donum dei, armatura ad defendendam sanctam fidem catholicam*, Boston, MA, 2014.

S. ROLLER, *Niclaus Gerhaert und seine Bedeutung für die Bildhauerkunst Mitteleuropas*, in S. ROLLER (ed.), *Niclaus Gerhaert. Der Bildhauer des späten Mittelalters*, Petersberg, 2011, pp. 109-133.

B.H. ROSENWEIN, *Emotional Communities in the Early Middle Ages*, Ithaca, N.Y., 2006.

S. ROUSH – C.L. BASKINS, *The Medieval Marriage Scene: Prudence, Passion, Policy*, Tempe, AR, 2005.

H. RÜCKERT, *Das Leben des heiligen Ludwig, Landgrafen in Thüringen, Gemahls der heiligen Elisabeth*, Leipzig, 1851.

C. RUDOLPH – BERNARD, *The "things of greater importance": Bernard of Clairvaux's Apologia and the Medieval Attitude toward Art*, Philadelphia, PA, 1990.

D. RYWIKOVÁ (ed.), *Klášter minoritů a klarisek v Českém Krumlově. Umění, zbožnost, architektura*, České Budějovice, 2015.

K. SACHS-HOMBACH, *Bild und Medium: kunstgeschichtliche und philosophische Grundlagen der interdisziplinären Bildwissenschaft*, Köln, 2006.

A. SALIGER, *Der Wiener Schottenmeister*, München, 2005.

W. SAUERLÄNDER, *Two Glances from the North: The Presence and Absence of Frederick II in the Art of the Empire; the Court Art of Frederick II and the Opus Francigenum*, in W. TRONZO (ed.), *Intellectual Life at the Court of Frederick II Hohenstaufen*, Washington, DC, 1994, pp. 189-209.

C. SAUMWEBER, *Der spätgotische Elisabethzyklus im Lübecker Heiligen-Geist-Hospital. Studien zu Stil und Ikonographie*, PhD thesis, Kiel, 1994.

P. SÄGER, *Der Weg der Hl. Elisabeth von Thüringen, 800 Jahre Franz von Assisi. Franziskanische Kunst und Kultur des Mittelalters Katalog des NÖ Landesmuseums*, Wien, 1982.

E. SEARS, *The Ages of Man: Medieval Interpretations of the Life Cycle*, Princeton, NJ, 1986.

X.J. SEUBERT – O.V. BYCHKOV, *Beyond the Text: Franciscan Art and the Construction of Religion*, St. Bonaventure, NY, 2013.

A. SCHERER, *Neues zum Meister des Marienlebens*, in F.M. KAMMEL – C.B. GRIES (eds.), *Begegnungen mit alten Meistern*, Nürnberg, 2000, pp. 123-137.

G. SCHMIDT, *Die Fresken von Strakonice und der Krumauer Bilderkodex*, in *Umění* 41 (1993) pp. 145-152.

G. SCHMIDT – M. ROLAND, *Malerei der Gotik: Fixpunkte und Ausblicke*, Graz, 2005.

G. SCHMIDT – F. UNTERKIRCHER, *Der Krumauer Bildercodex*, Graz, 1967.

H.S. SCHMIDTBERGER, *Die Verehrung der Heiligen Elisabeth in Böhmen und Mähren bis zum Ende des Mittelalters*, Marburg, 1992.

F. SCHMOLL, *Die heilige Elisabeth in der bildenden Kunst des 13. bis 16. Jahrhunderts*, Marburg, 1918.

C. SCHNEIDER, *Ars moriendi*, Berlin – Mainz, 1996.

P.E. SCHRAMM, *Herrschaftszeichen und Staatssymbolik Beiträge zu ihrer Geschichte vom dritten bis zum sechzehnten Jahrhundert*, Stuttgart, 1954.

L. SCHULTES, *Das Relief der Geburt Christi aus Freistadt/Hlohovec, die Wiener Burgkapellenfiguren und die Skulpturen des Kaschauer Hochaltars*, in *Galéria – Ročenka Slovenskej národnej galérie v Bratislave 2004–2005* (2004) pp. 247-264.

A. SCHÜTZ, *Das Geschlecht der Andechs-Meranier im europäischen Hochmittelalter*, in J. KIRMEIER – E. BROCKHOFF (eds.), *Herzöge und Heilige: das Geschlecht der Andechs-Meranier im europäischen Hochmittelalter*, Regensburg, 1993, pp. 22-187.

M.V. SCHWARZ, *Visuelle Medien im christlichen Kult: Fallstudien aus dem 13. bis 16. Jahrhundert*, Wien, 2002.

G. SIEBERT – I.F. WALTHER, *Codex Manesse: die Miniaturen der Grossen Heidelberger Liederhandschrift*, Frankfurt am Main, 2001.

A. SIMON, *Österreichische Tafelmalerei der Spätgotik. Der niederländische Einfluß im 15. Jahrhundert*, Berlin, 2002.

T. SINDBÆK ANDERSEN – B. TÖRNQUIST PLEWA, *Disputed Memory: Emotions and Memory Politics in Central, Eastern and South-Eastern Europe*, Berlin – Boston, 2016.

P. SKUBISZEWSKI, *Un Manuscrit peint de la «Vita Radegundis» conservé à Poitiers les idées hagiographiques de Venance Fortunat et la spiritualité monastique du XIe siècle*, Treviso, 1993.

D. SOUKUP – L. REITINGER, *The Krumlov Liber Depictus. On its Creation and Depiction of Jews*, in *Judaica Bohemiae* 50 (2015) pp. 5-44.

G. SPIEGEL, *History as Enlightenment: Suger and the Mos Anagogicus*, in P. LIEBER GERSON (ed.), *Abbot Suger and Saint-Denis a symposium*, New York, NY, 1986, pp. 151-158.

M. SPOLOČNÍKOVÁ, *Oltár svätej Alžbety*, Košice, 1995.

M. SPOLOČNÍKOVÁ, *On the Altar of St. Elizabeth*, in I. VAŠKO (ed.), *The Cathedral of St. Elizabeth in Košice*, Košice, 2000, pp. 40-79.

B. STARK, *Elisabeth von Thüringen: Die Entdeckung individueller Züge in der Biographie einer Heiligen*, in J. AERSTEN – A. SPEER (eds.), *Individuum und Individualität im Mittelalter*, Berlin – Boston 1996, pp. 704-721.

K. STEJSKAL – J. KRÁSA, *Astralvorstellungen in der mittelalterlichen Kunst Böhmens*, in *Sborník prací Filozofické fakulty brněnské univerzity. F, Řada uměnovědná* 13 (1964) pp. 61-84.

W.L. STRAUSS – C. SCHULER – A.V. BARTSCH, *German Book Illustration before 1500*, New York, NY, 1981.

J.H. STUBBLEBINE, *Duccio di Buoninsegna and his School*, Princeton, N.J., 1979.

G. SUCKALE-REDLEFSEN, *Zwei Bilderpsalter für Frauen aus dem frühen 13. Jahrhundert*, in F.O. BÜTTNER (ed.), *The illuminated psalter*, Turnhout, 2004, pp. 249-258, 521-524.

R. SUCKALE, *Die Hofkunst Kaiser Ludwigs des Bayern*, München, 1993.

R. SUCKALE, *Maľby retabula hlavného oltára v kostole sv. Alžbety v Košiciach*, in D. BURAN (ed.), *Gotika. Dejiny slovenského výtvarného umenia*, Bratislava, 2003, pp. 364-373.

R. SUCKALE, *The Central European Connections of Matthias Corvinus' Patronage of Late Gothic Art*, in P. FARBAKY – A. VÉGH (eds.), *Matthias Corvinus the King*, Budapest, 2008, pp. 101-111.

R. SUCKALE, *Über einige nordalpine Vorbilder der Hofkunst des ungarischen Königs Matthias Corvinus*, in U. BORKOWSKA – M. HÖRSCH (eds.), *Hofkultur der Jagiellonendynastie und verwandter Fürstenhäuser*, Ostfildern, 2010, pp. 261-279.

K. SULLIVAN, *The Inner Lives of Medieval Inquisitors*, Chicago – London, 2013.

P. SUROWIEC – V.C. STETKA, *Social Media and Politics in Central and Eastern Europe*, London – New York, 2018.

B.Z. SZAKÁCS, *The Visual World of the Hungarian Angevin Legendary*, Budapest, 2016.

R. ŠIMŮNEK – R. LAVIČKA, *Páni z Rožmberka 1250 – 1520: jižní Čechy ve středověku: kulturněhistorický obraz šlechtického dominia ve středověkých Čechách*, České Budějovice, 2011.

T. ŠTÍTNÝ ZE ŠTÍTNÉHO, *Život svaté Alžběty*, in J. KOLÁR (ed.), *Život svaté Alžběty*, Praha, 2006

D. TABOR, *The Holy City: Idea and Representation in the Medieval Art of Central Europe*, in J. WENTA – M. KOPCZYŃSKA (eds.), *Sacred Space in the State of the Teutonic Order in Prussia*, Toruń, 2013, pp. 243-256.

I. TAKACS, *Die Verehrung der Hl Elisabeth in Ungarn*, in *Franziskanische Studien* 18 (1931) pp. 242-258.

N.P. TANNER (ed.), *Decrees of the Ecumenical Councils*, Washington, DC, 1990.

Z. TEKE, *Kassa külkereskedelme az 1393–1405. évi kassai bírói könyv belejegyzései alapján*, in *Századok* 137 (2003) pp. 381-404.

W. TELESKO, *Imitatio Christi und Christoformitas. Heilsgeschichte und Heiligengeschichte in den Programmen Hochmittelalterlicher Reliquienschreine*, in G. KERSCHER (ed.), *Hagiographie und Kunst*, Berlin, 1993, pp. 369-384.

Theodoricus, *Vita S. Elyzabeth*, in M. Rener (ed.), *Die Vita der heiligen Elisabeth des Dietrich von Apolda*, Marburg, 1993, pp. 19-130.

A.O.E. Thiofrid – M.C. Ferrari, *Thiofridi Abbatis Epternacensis Flores epytaphii sanctorum*, Turnholti [Belgium], 1996.

E. Thunø, *Image and Relic: Mediating the Sacred in Early Medieval Rome*, Roma, 2002.

D.F. Tinsley, *The Sourge and the Cross: Ascetic Mentalities of the Later Middle Ages*, Paris – Walpole, MA, 2010.

M. Tischlerová, *Stredoveký richtár Hanns Hebenstreyt v Košiciach*, in *Historica, Zborník FFUK Bratislava* 26 (1975) pp. 51-75.

G. Török, *Zu Fragen des skulpturalen Ausstattung des Altars der hl. Elisabeth in Kaschau*, in H. Krohm (ed.), *Flügelaltäre des späten Mittelalters. Die Beiträge des internationalen Colloquiums „Forschung zum Flügelaltar des späten Mittelalters", veranstaltet vom 1.-3. Oktober 1990 in Münnerstadt in Unterfranken*, Berlin, 1992, pp. 157-166.

S. Tóth, *Kaschau, Elisabethkirche von der Westfassade her betrachtet*, in *Művészettörténeti értesítő* 42 (1993) 113-139.

G. Toussaint, *Das Passional der Kunigunde von Böhmen: Bildrhetorik und Spiritualität*, Paderborn, 2003.

B.O. Trent, *Liber epilogorum in gesta sanctorum*, in E. Paoli (ed.), *Edizione nazionale dei testi mediolatini*, Tavarnuzze (Firenze), 2001.

Z. Treppa, *Obraz jako medium wtajemniczające w misterium: na przykładzie obrazów nie-ręką-ludzką-wykonanych i pochodzących z wizji mistycznych*, Gdańsk, 2017.

D.A. Třeštík, *Počátky Přemyslovců: vstup Čechů do dějin, 530-935*, Praha, 1997.

E. Urbánková – K. Stejskal, *Pasionál Přemyslovny Kunhuty; Passionale abbatissae Cunegundis*, Praha, 1975.

I.D. Varazze, *Legenda aurea*, in G.P. Maggioni (ed.), *Legenda aurea. Testo critico riveduto e commento a cura di Giovanni Paolo Maggioni*, Firenze, 2007.

A. Vauchez, *Charité et pauvreté chez Sainte Elisabeth de Thuringe d'après les actes du procès de canonisation*, in M. Mollat (ed.), *Études sur l'histoire de la pauvreté*, Paris, 1974, pp. 163-173.

A. Vauchez, *La sainteté en Occident aux derniers siècles du Moyen Age: d'après les procès de canonisation et les documents hagiographiques*, Rome – Paris, 1981.

A. Vauchez, *Lay People's Sanctity in Western Europe: Evolution of a Pattern*, in R. Kosinski-Blumenfeld – T.R. Szell (eds.), *Images of Sainthood in Medieval Europe*, Ithaca, NY – London, 1991, pp. 21-32.

L. Voetz, *Der Codex Manesse: die berühmteste Liederhandschrift des Mittelalters*, Darmstadt, 2015.

M. Vogt, *Weil wir wie das Schilfrohr im Flusse sind: Begegnungen mit der Heiligen Elisabeth in Hessen und Thüringen*, Regensburg, 2006.

E. Volgger, *Sankt Georg und sein Bilderzyklus in Neuhaus/Böhmen (Jindřichův Hradec): historische, kunsthistorische und theologische Beiträge*, Marburg, 2002.

C. Voss – L. Engell (eds.), *Mediale Anthropologie*, Paderborn, 2015.

H.G. Walther, *Der „Fall Elisabeth" an der Kurie. Das Heiligsprechungsverfahren im Wandel des kanonischen Prozeßrechts unter Papst Gregor IX. (1227-1241)*, in D. Blume – M. Werner (eds.), *Elisabeth von Thüringen – eine europäische Heilige. Aufsätze*, Petersberg, 2007, pp. 177-186.

C. Warr, *The Golden Legend and the Cycle of the 'Life of Saint Elizabeth of Thuringia – Hungary'*, in J. Elliott – C. Warr (eds.), *The Church of Santa Maria Donna Regina. Art, Iconography and Patronage in Fourteenth-Century Naples*, Aldershot – Burlington, VT, 2004, pp. 155-174.

S. Weigelt (ed.), *Elisabeth von Thüringen in Quellen des 13. bis 16. Jahrhunderts*, Erfurt, 2008.

J. Weismayer, *Demut. II. In Kirchen- und Frömmigkeitsgeschichte*, in W. Kasper (ed.), *Lexikon für Theologie und Kirche*, Freiburg – Basel – Wien, 2006, pp. 90-91.

D.H. Weiss, *Art and Crusade in the age of Saint Louis*, Cambridge, 1998.

D.H. Weiss – L. Mahoney (eds.), *France and the Holy Land: Frankish Culture at the End of the Crusades*, Baltimore, 2004.

J. Wenta – M. Kopczyńska (eds.), *Sacred Space in the State of the Teutonic Order in Prussia*, Toruń, 2013.

H. Wenzel, *Mediengeschichte vor und nach Gutenberg*, Darmstadt, 2007.

M. Werner, *Mater Hassiae – Flos Ungariae – Gloria Teutoniae. Politik und Heiligenverehrung im Nachleben der hl. Elisabeth von Thüringen*, in J. Petersohn (ed.), *Politik und Heiligenverehrung im Hochmittelalter*, Sigmaringen, 1994, pp. 449-540.

M. Werner, *Elisabeth von Thüringen, Franziskus von Assisi und Konrad von Marburg*, in D. Blume – M. Werner (eds.), *Elisabeth von Thüringen – eine europäische Heilige. Aufsätze*, Petersberg, 2007, pp. 109-135.

A. Westphälinger, *Der Mann hinter der Heiligen: die Beichtväter der Elisabeth von Schönau, der Elisabeth von Thüringen und der Dorothea von Montau*, Krems, 2007.

E. Wetter, *Kazula z Košíc*, in D. Buran (ed.), *Gotika. Dejiny slovenského výtvarného umenia*, Bratislava, 2003, p. 807.

J. White, *Duccio : Tuscan Art and the Medieval Workshop*, New York, NY, 1979.

B. Wick, *Kassa története és műemlékei*, Kassa, 1941.

V. Wick, *Dóm svätej Alžbety v Košiciach*, Košice, 1936.

B. Williamson, *Altarpieces, Liturgy, and Devotion*, in *Speculum* 79 (2004) pp. 341-406.

M. Woelk, *Benedetto Antelami: die Werke in Parma und Fidenza*, Münster, 1995.

K.B. Wolf, *The Life and Afterlife of St. Elizabeth of Hungary. Testimony from her Canonization Hearings*, New York, NY, 2011.

L. Wolff, *Die heilige Elisabeth in der Literatur des deutschen Mittelalters*, in *Hessisches Jahrbuch für Landesgeschichte* 13 (1963) pp. 23-38.

J. Wollesen, 'Sub Specie Ludi'. Text and Images in Alfonso el Sabio's Libro de Acedrex, Dados e Tablas, in Zeitschrift fuer Kunstgeschichte 53 (1990) pp. 277-308.

S.S. Wolohojian, Closed Encounters: Female Piety, Art, and Visual Experience in the Church of Santa Maria Donna Regina in Naples, Cambridge, MA, 1994

H. Wolter-von dem Knesebeck, Bilder in Büchern – Bilder im Herzen: die Landgrafenpsalterien im Kontext, in C. Bertelsmeier-Kierst (ed.), Elisabeth von Thüringen und die neue Frömmigkeit in Europa, Frankfurt, 2008, pp. 33-51.

P. Wörster, Überlegungen zur Pilgerfahrt Kaiser Karls IV. nach Marburg 1357, in H. Gödecke (ed.), St. Elisabeth – Kult, Kirche, Konfessionen. 700 Jahre Elisabethkirch in Marburg 1283–1983, Marburg, 1983, pp. 27-34.

I. Wurth, The Life and Afterlife of St. Elizabeth of Hungary: Testimony from Her Canonization Hearings, in Austrian History Yearbook 44 (2013) pp. 328-329.

I. Würth, Bericht über die Heilung Mathildes aus Biedenkopf, in D. Blume – M. Werner (eds.), Elisabeth von Thüringen – eine europäische Heilige. Katalog, Petersberg, 2007, pp. 194-195.

D.P.J. Wynands, Der Aachener Marienschrein: eine Festschrift, Aachen, 2000.

A. Wyss, Hessisches Urkundenbuch 1. Urkundenbuch der Deutschordens-Ballei Hessen 1, 1207–1299, Leipzig, 1879.

F.G. Zehnder, Katalog der Altkölner Malerei, Köln, 1990.

P. Zubko, Kult Svätej krvi v Košiciach. Rozprávanie o stratených stredovekých relikviách, Košice, 2013.

INDEX NOMINUM

Index of Places

Index of Persons

ACKNOWLEDGEMENTS

I have been privileged to work with a number of inspiring colleagues and friends who accompanied me during the long journey in writing this book. I am grateful to them for the advice, support and companionship received on the way. In what follows I would like to express my gratitude to at least some of them.

The lectures and seminars of the late Wilhelm Schlink during my doctoral studies in Freiburg provided many insights into possible approaches to complex medieval artistic strategies. Of fundamental importance to the writing of this book was Wilhelm's introduction to the ambiguous religious interpretations of poverty portrayed in and through art.

My research at the Institute of Art History of the Slovak Academy of Sciences would have been inconceivable without the support of Ján Bakoš, one of the Insitute's founding fathers. The Institute and University in Trnava have supported my research which for many years has been focused on medieval iconography. Dušan Buran, chief curator of the Slovak National Gallery, offered valuable advice especially during the time he was working on the great exhibition "Gothic. History of Slovak Visual Art", which took place in 2003.

Garnering material for the present book was further facilitated by a DAAD scholarship in Marburg in July 2000 at the invitation of Katharina Krause. The town of Saint Elizabeth enabled me to consult crucial texts and images from the Bildarchiv Foto Marburg. It has been a pleasure to work with Brigitte Walbe who showed great patience every time I requested yet another photocopy of a text or asked for another image. Lutz Heusinger kindly gave me a copy of Erika Dinkler-von Schubert's book, which is surely the most penetrating analysis of the iconography of Elizabeth's shrine.

During fall 2000 I benefitted immensely from the generous support from the Fulbright Foundation at Princeton University. New horizons for dealing with the artistic landscapes of Central Europe from a perspective free of any national bias were opened up. Prolonged conversations with Thomas DaCosta Kaufmann proved to be most revealing.

Adam Labuda successfully established a link between medieval pictorial legends and the influence of nationalism on the historiography of medieval art in Central Europe. In this respect the section on this topic at the 31st Congress of CIHA (Montreal 2005) was particularly memorable. György Szőnyi and Marina Vicelja have on numerous occasions supported research into important questions

through their active interest which resulted in the organizing of a series of conferences on iconography in Szeged and in Rijeka. These colloquia and seminars provided an opportunity to discuss various points of my research, thus contributing to the evolution of the book. In addition, these events enabled me to meet more colleagues, friends and passionate thinkers. Assaf Pinkus and Barbara Baert provided important examples of theoretical creativity which helped me find my own way in constructing an authentic contemporary approach to the topic. Another line of enquiry guided me through the complicated historiography of earlier art history in Central Europe. Many extended conversations in the framework of the project Art History in the Cold War, moderated by late Michaela Marek, alerted me to the ways in which the social history of art can remain productive.

I am the grateful beneficiary of a number of grants from the VEGA foundation which covered the travel costs associated with attending conferences and inspecting artworks. In addition, the project European dimensions of artistic culture in Slovakia, financed by the European Union, finally enabled me to attend inspiring events like the medieval congresses in Leeds and Kalamazoo.

The work associated with the 2006 exhibition on Sigismund of Luxemburg carried out by a team under the aegis of Imre Takács, informed my understanding of the complex problems of the period. Thus, I had the opportunity to discuss with experts such as Ernő Marosi, Anna Boreczky, or Zsombor Jékely. The longstanding relationships with Hungarian colleagues have accompanied my work throughout. I must also mention the kindness, encouragement and inspiration over a number of years of János Vegh, as well as Mária Prokopp's growing enthusiasm for the topic, and the sound dose of skepticism associated with the expertise of Gyöngyi Török. It goes without saying that the cult of Saint Elizabeth belongs to the precious traditions of the former Hungarian kingdom and several Hungarian colleagues have generously offered me their sincere personal testimonies about their perspective on this tradition.

Gábor Klaniczay, the founder of hagiographic studies at the Central European University in Budapest, facilitated my investigation through many discussions and texts. Ottó Gecser, who probed the deepest layers of sources associated with the preaching on Saint Elizabeth, opened useful avenues of research into the heritage of Saint Elizabeth.

In Vienna Michael Victor Schwarz taught how to look at medieval images as media without being simplistic or anachronistic, or ignorant of earlier traditions of art history. Tim Juckes' patient work confirmed that the Košice church has much to offer.

Alternative perspectives on the influence of Elizabeth's cult, which reach into our own times, have been offered by my friends with professional religious formation, who are also active in academic research and teaching. Those deserving mention include Gabriel Hunčaga with his optimism and historical expertise, Peter Šajda with his research experience in religious philosophy, Reginald Slavkovsky who combines a professional mathematician's rationality with an openness to mystical traditions, and Ladislav Tkáčik, a critically minded modern Franciscan. To all these people, who were generously prepared to discuss I am deeply grateful.

My 2009 habilitation at the University in Trnava elicited valuable comments from the late Milan Togner, Jan Royt and Martin Homza. Of special importance to me was Martin's original approach towards the contested traditions of the late Hungarian kingdom as well as his wide scholarship in female saints. He has been an important discussion partner and friend throughout. Among the reviewers of my first book on the topic, published in Slovak, a distinctive standpoint was taken by Milena Bartlová, whose critical assessment stimulated further research and thinking at crucial stages. Other Czech colleagues, above all Lubomír Konečný and Jan Dienstbier, helped me to delve deeper into traditions of iconology. Peter Megyeši, who has learned a lot from this tradition, offered some valuable comments to his former teacher.

My colleague and friend Marian Zervan who, together with Ivan Rusina, has worked on re-establishing a tradition of iconographic studies in Slovakia, has been a source of inspiration, while remaining sensitive to philosophical problems.

The decision to publish an English-language book has entailed a prolonged engagement with a foreign language and a different academic culture. Several people assisted me in overcoming these hurdles. Julian Gardner directed me to Elizabeth Freeman, whose copy-editing of my previous book was a great learning experience. I am more than happy that she has been able to substantially help me with improving the language and form of this book, too.

Elizabeth Sears encouraged me to gain support from the Weiser Center at the University of Michigan in September 2016. The Medieval colloquium in Ann Arbor provided an invaluable forum for discussing my unpublished text on *Liber depictus*. The chapter on this manuscript is all the better for this discussion. Prolonged discussions with Achim Timmermann were also helpful. I am pleased to have the chance to acknowledge the support of Elizabeth Sears and Renate Blumenfeld-Kosinski during my stay at The Clark Art Institute in Williamstown, Mass. The Clark Fellowship (February-June 2017) provided the ideal conditions in which to complete the writing up, including the opportunity to

present the project in a lecture followed by a lively seminar discussion, an excellent library, and Rebecca Singerman's reliable assistance.

My fellowship at Herder Institute for Historical Research on East Central Europe represented a final important stage in bringing the book to completion. The Institute's publications, which are largely inaccessible elsewhere, were crucial to the completion of the bibliographical references in the book. The Institute's research culture also provided a stimulating environment in which to plan substantial revisions in the book's structure, focusing primarily on the interrelated towns of Marburg, Český Krumlov and Košice. Dr. Dietmar Popp, Director of the visual collections of the institute, was of special importance when discussing the options for future cooperation on the topic. The lively workshop "Saint Elizabeth and Medieval Pictorial Hagiography" on 16 February 2017 generously supported by the institute proved to be an inspiring and fruitful forum for deepening discussions on the pictorial cult of the saint in eastern central Europe between invited experts from Hungary, Slovakia, the Czech Republic and Croatia, substantially enriched by Dr. Kersken from the Herder Institute and the student attendees.